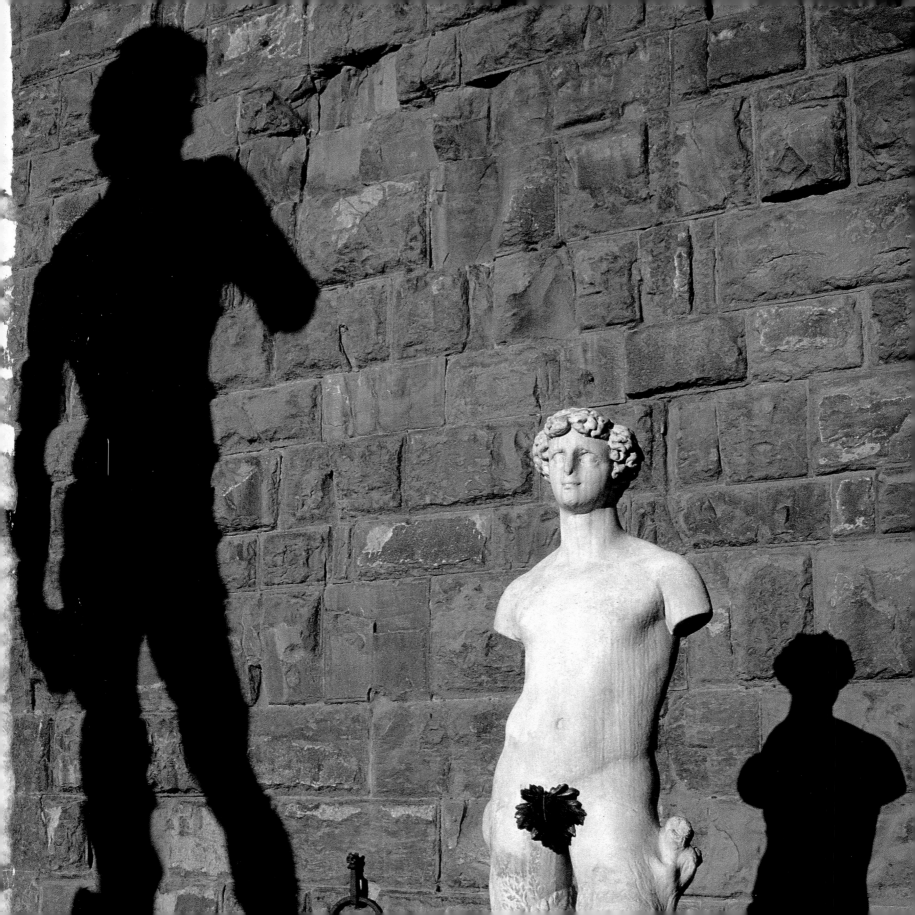

Living in
TUSCANY

BRUNO RACINE

PHOTOGRAPHS BY ALAIN FLEISCHER

Flammarion

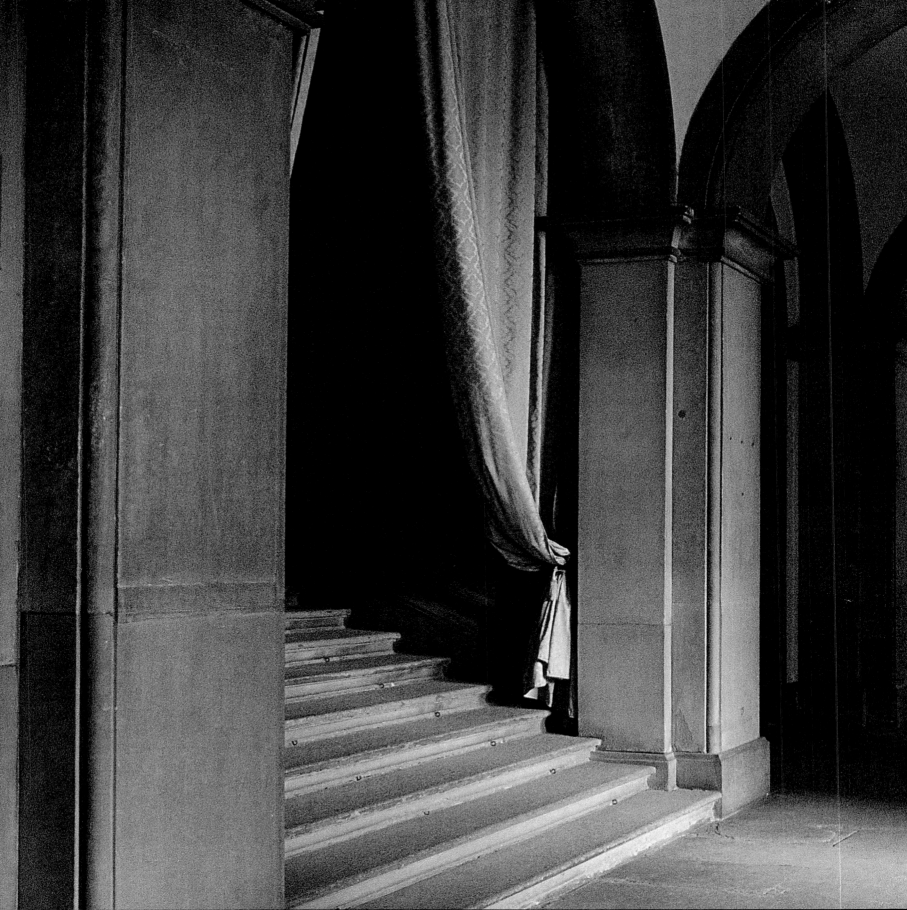

CONTENTS

TUSCANY, AN AUTHENTIC PORTRAIT

In his journal of his travels in Italy, the French writer Montaigne switches from French to Italian when he reaches Tuscany. He recounts the story of an illiterate peasant woman who greets him with an ode composed in his honor, and bids him take a seat at her "nobleman's" table: from birth, she had been imbued by her father with a sense of poetry. In the year 2000, a butcher from a tiny village in the Chianti region has tears in his eyes as he recites verses from *The Divine Comedy* while trimming and preparing his meat. For the past seven hundred years, the genius of Tuscany has been reflected in the qualities of its language—elegance, subtlety, nobility— which were responsible for its irresistible spread throughout the peninsula. Tuscany, the "Garden of Italy" in the words of Goldoni, is also probably the most "civilized" land in Europe: honed since Etruscan times by humankind to the point

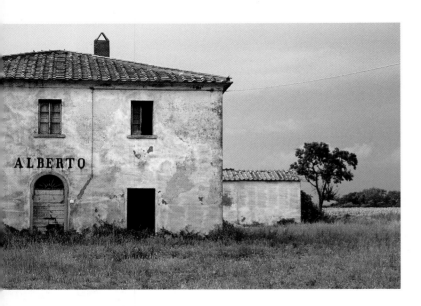

where, as it were, every newborn eye is the eye of an artist. A Tuscan carpenter, asked to make a rectangular tabletop for a set of rounded legs, was incapable of committing this heresy and followed his own instincts. When his angry client demanded an explanation, the carpenter assumed an air of aggrieved innocence, apologizing thus: "*Mi è venuto circolare*"—"It came out round all by itself." The hallmark of Tuscany is the omnipresence of art: a visual and plastic art intimately bound to its materials; a language filled with music. Here, as proved by everything from the roof-beams in a modest farmhouse to the engraving on a Quattrocento medallion, the cleavage between craftsmanship and fine art is less distinct than elsewhere.

As the most visited region in Italy, Tuscany naturally evokes clichéd images—a solitary cypress on a hilltop, the shops along the Ponte Vecchio, a

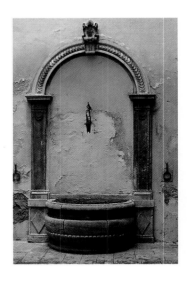

THE SHADOW OF MICHELANGELO'S *DAVID* REFLECTED ON THE GOLDEN STONE OF THE PALAZZO DELLA SIGNORIA IN FLORENCE (PAGE 1). ONE OF THE STATUES REPRESENTING THE FOUR SEASONS GUARDS THE SANTA TRINITA BRIDGE ABOVE THE ARNO. THE CATHEDRAL DOME RISES ABOVE THE NARROW STREETS OF FLORENCE'S HISTORIC CENTER (PAGES 2–3).

A CURTAIN FRAMES THE ENTRANCE TO THE FORMAL STAIRCASE IN THE PALAZZO CORSINI (PAGES 4–5). A FARMHOUSE IN THE MAREMMA INSCRIBED WITH THE FIRST NAME OF ALBERTO DELLA GHERARDESCA, A NINETEENTH-CENTURY FIGURE RESPONSIBLE FOR DRAINING THIS ORIGINALLY INSALUBRIOUS COASTAL MARSHLAND (LEFT). IN SIENA, A NEIGHBORHOOD FOUNTAIN JUTTING FROM AN OCHER WALL (ABOVE). THE SUN ATTEMPTS TO BREAK THROUGH THE CLOUDS ABOVE BORGO SAN JACAPO, THE OLD MEDIEVAL QUARTER OF FLORENCE (RIGHT).

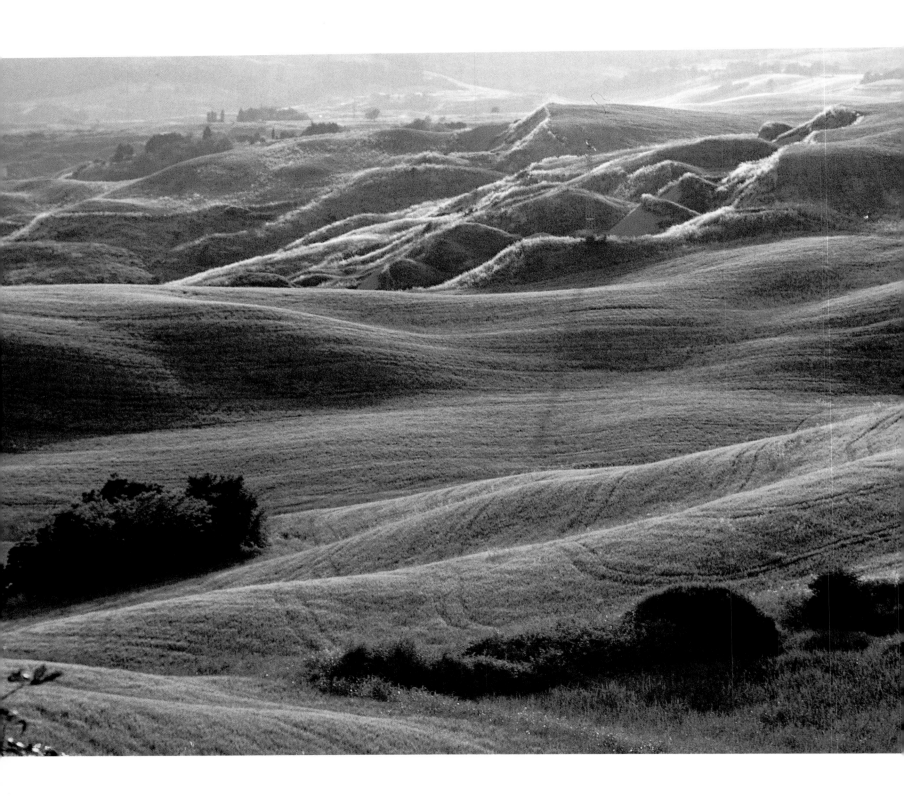

glass of Chianti under a shady arbor—and we need not be ashamed of cherishing these images that haunt our memories when we return to less hospitable climes. But they should not be allowed to obscure Tuscany's profounder reality: its unity and its diversity. For centuries this area, measuring a mere 250 by 100 kilometers, was the arena of relentless conflict: Lucca and Florence pitted against Pisa, Florence against Siena; and, within each city-state, the feudal nobility against the middle class, potentates against the populace, Guelphs against Ghibellines—a mutual destruction in pursuit of power during the course of which Machiavellianism was invented . . . along with virtually every imaginable form of government.

Although the reign of the grand dukes tempered this furor, and although in Florence verbal irony and sarcasm have long since replaced dagger and poison, anyone who has witnessed a game of *calcio storico* (a sort of medieval soccer from which the players often emerge lamed and bleeding) or the frenzy invading the rival districts of Siena before the Palio race will have understood that Tuscany is also a land of barely contained passion and violence. "Beneath this sweetly feminine name," wrote novelist Julien Green of Florence, "lurks the soul of a condottiere."

Despite the profound changes it has undergone since the end of World War II—and despite a rising tide of tourists threatening in some places to submerge it entirely—Tuscany has been able to save itself from the trap of "quaintness," even for events such as the Palio that might appear particularly vulnerable. Today, even more than in the past, two realities coexist: the tourist's Tuscany, a commodity for mass consumption; and the secret Tuscany that—although closely related to the former—remains in the hands of the Tuscans themselves. From the Middle Ages onward, Tuscan traders and bankers extended their operations throughout Europe, and in the eighteenth century Florence became a major stop on the Grand Tour undertaken by cultivated travelers. This long tradition of exchanges with the outside world has made Tuscany a place where outsiders can count on receiving a warm welcome—although it is sometimes tinged with an aloof courtesy that perhaps explains why the English immediately feel so at home here.

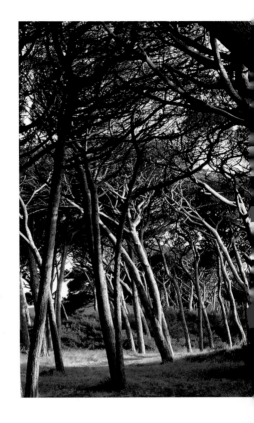

SIENA'S ROLLING COUNTRYSIDE SOMETIMES EXHIBITS SIGNS OF EROSION. TUSCANY, A NATURALLY HARSH LAND THAT HAS BEEN TAMED BY MAN, IS A MODEL OF HARMONY AND BALANCE (LEFT). TALL PARASOL PINES TWISTED BY THE WIND CLING TO THE SAND DUNES OF THE MAREMMA (ABOVE).

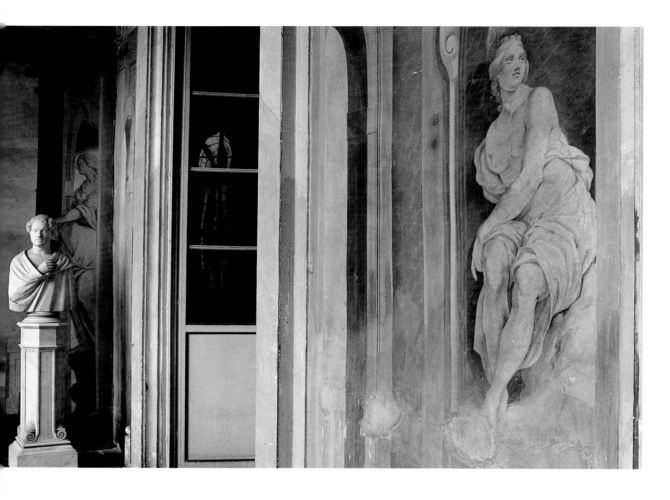

IN THE PALAZZO CORSINI, ONE
OF THE LARGEST IN FLORENCE,
THE VERY SEVERITY OF AN
ANCESTRAL BUST IN CLASSICAL
DRAPERY REFLECTS THE WILLFULLY
PATRICIAN ELEGANCE THAT OTHER
ITALIANS, SOMETIMES NOT WITHOUT
A TINGE OF ENVY, ATTRIBUTE TO
THE TUSCANS (LEFT).
IN THE VILLA DE GEGGIANO NEAR
SIENA, THE DRAWING ROOM SEEMS
STILL TO RING WITH THE PERHAPS
FRIVOLOUS CONVERSATIONS
STENDHAL MAY HAVE HEARD THERE.
IT OPENS ONTO A FOYER DECORATED
WITH EIGHTEENTH-CENTURY
PAINTINGS (RIGHT).

However, the ironic reserve said to be typical of the Tuscans can sometimes melt. In 1966, on November 4th, the angry waters of the flooding Arno devastated Florence. Everyone remembers the heartwarming reaction of young people all over the world who mobilized in massive numbers to save thousands of threatened artistic masterpieces. These dramatic events also, perhaps, afforded a renewed sense of shared identity to the Florentines themselves as they demonstrated their determination to survive, and were made aware of the degree to which their city is valued by the rest of the world.

The Tuscans shun ostentation as systematically as the Romans and Neapolitans court it. It was not until the late nineteenth century that the façade of a monument as distinguished as Florence Cathedral finally received its outer finishing, and it would doubtless have remained in the state of incompletion visible at San Lorenzo, for example, had Florence not been named capital of the ephemeral Kingdom of Italy from 1865 to 1871.

Might this disdain for appearances and visible embellishment be the expression of a superiority complex? The envious would like to think so, although clearly, if such is indeed the case, there is ample justification for it. Today, perhaps, it is merely a defense mechanism, a stubborn determination to avoid the banal—an endeavor with which we are bound to sympathize.

Those who support this endeavor will be richly rewarded. Our book is dedicated to the many people who guided its authors' steps through the authentic Tuscany of the spirit, heart, and art of living.

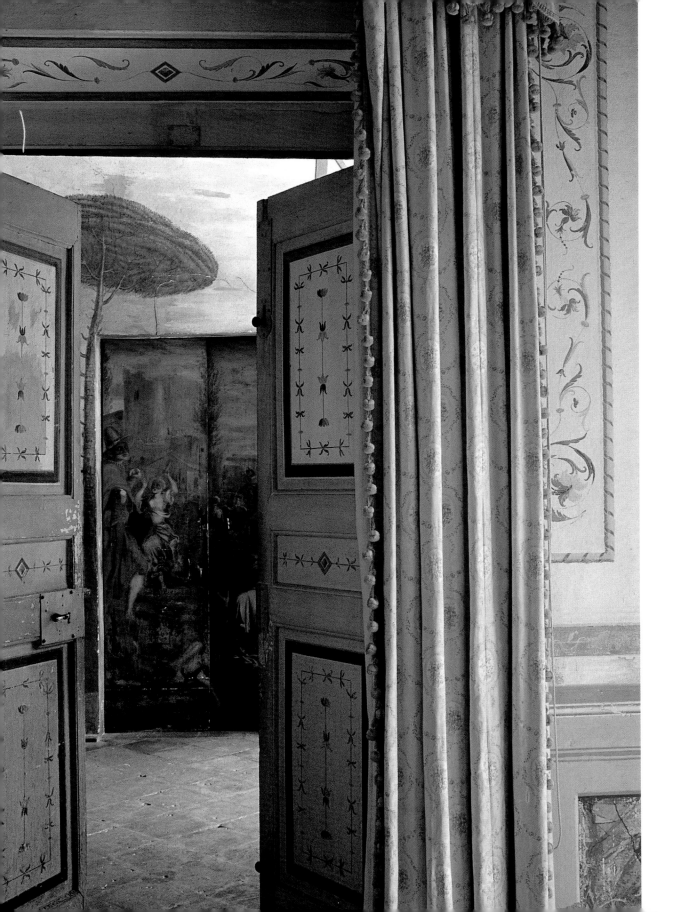

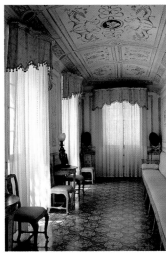

GREAT TUSCAN VILLAS CAN
BE REGAL, LIKE LA PETRAIA,
NEAR FLORENCE (ABOVE, TOP),
OR RUSTIC, AS AT GEGGIANO
(ABOVE, BOTTOM).

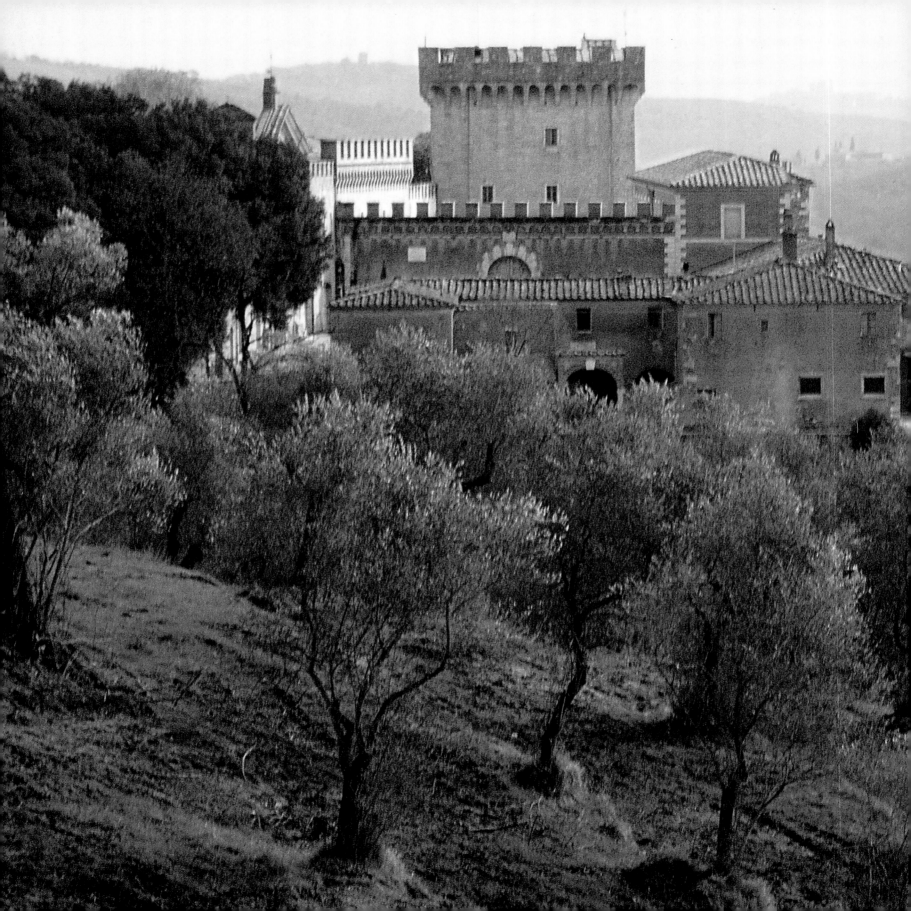

VINEYARDS AND ROLLING HILLS

DUBBED THE "GARDEN OF ITALY" BY GOLDONI,
TUSCANY OFFERS A UNIQUE EXAMPLE OF PERFECT
BALANCE BETWEEN NATURE AND HUMANKIND.
TUSCANY'S CITIES AND LANDSCAPES, CONSTRUCTED
OVER MILLENNIA, REFLECT A LOVE OF BEAUTY AND
OF LIFE.

Although Tuscany is amazingly diverse, its single most characteristic feature, now as in the past, is the close bond between city and country. Even Florence has retained this intimate relationship with the patrician rusticity of the region surrounding it. The Tuscan landscape is one of stark contrasts and infinite variety, from the steep slopes of the Apuan Alps to the fertile plain of Lucca; from the wild coastline of the Maremma to the hills of Volterra; from the forests of the Mugello to the vineyards of Chianti. The following itineraries are not intended to be exhaustive explorations. No one can boast of having traveled through Tuscany without missing something they will have to save for next time—a remote village unchanged since the Middle Ages, a castle or sanctuary hidden amid the vineyards. Each season of the year has its own special charm, displaying Tuscany in a different light: dry and limpid in winter, vividly colorful in spring, radiant but arid in summer, glowingly burnished in the fall. It is to these pleasures, renewed with each journey, that the following few pages invite you.

SOUTH OF SIENA

Must we express a preference? The countryside around Siena and the Val d'Orcia in southern Tuscany perhaps has no equal. Take Montepulciano as your starting-point, and wander idly through the streets of this small town that experienced remarkable development during the Renaissance. The greatest architects of the time left their mark on it. The poet Poliziano was born here. Exiled from Tuscany by the Medici, he was taken in by the court of Mantua and awarded the title of *commensale perpetuo*. Montepulciano's charm greets visitors from the moment they cross the threshold of its medieval gate, the Porta al Prato. An unbroken succession of aristocratic palaces lines its

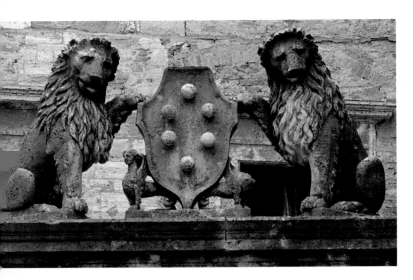

THE MEDICI COAT-OF-ARMS
IS UBIQUITOUS IN TUSCANY.
THIS SHIELD, FLANKED BY TWO
LIONS, STANDS ATOP THE WELL
IN MONTEPULCIANO'S PIAZZA
GRANDE (ABOVE).
THE FORTIFIED MANOR HOUSES
SCATTERED THROUGHOUT TUSCANY
ARE REMINDERS THAT THE REGION
WAS SPLIT INTO WARRING CITY-
STATES BEFORE BEING UNIFIED
UNDER THE MEDICI (PREVIOUS
DOUBLE PAGE).

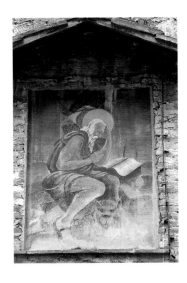

IT IS HARDLY SURPRISING TO FIND
AN EFFIGY OF SAINT JEROME,
PATRON SAINT OF LITERATURE,
IN MONTEPULCIANO. BIRTHPLACE
OF THE POET POLIZIANO,
THIS SMALL TOWN EXPERIENCED
A BRILLIANT CULTURAL FLOWERING
DURING THE RENAISSANCE (ABOVE).
MONTEPULCIANO'S FORTIFIED
GATES, LIKE ITS STRATEGIC HILLTOP
POSITION, RECALL THAT TUSCANY
WAS THE SCENE OF INCESSANT
ARMED CONFLICT THROUGHOUT
THE MIDDLE AGES (RIGHT).

THE TUSCAN COUNTRYSIDE (HERE NEAR PIENZA) OFTEN EXHIBITS THE BEAUTY OF A DRAWING PUNCTUATED BY THE DARK STROKE OF A CYPRESS (ABOVE). LA MADONNA DI SAN BIAGIO IN MONTEPULCIANO IS ONE OF THE MASTERPIECES OF THE TUSCAN RENAISSANCE (RIGHT).

THE LION-AND-GRIFFIN WELL ON THE PIAZZA GRANDE, ANOTHER REMARKABLE WORK FROM THE EARLY SIXTEENTH CENTURY (RIGHT AND CENTER RIGHT). BELOW THE CASTELLO, A PEACEFUL, WINDING STREET LINED WITH HOUSES OF STARK ELEGANCE (FAR RIGHT).

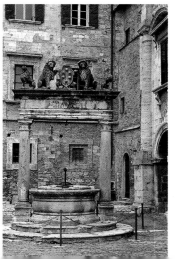

steep, winding main street. When I suggest starting from Montepulciano, it is
not, however, solely because of its charming old streets—a sight that can be
experienced with equal intensity in other Tuscan towns. I do so because of a
gem slightly off the beaten track, at the end of an alley lined with magnificent
cypresses, the Chiesa della Madonna di San Biagio—a masterpiece by
Antonio da Sangallo the Elder typical of the Renaissance ideal as conceived
by Bramante and Michelangelo. You should visit on a fine fall or winter day
when the hilltops pierce the mist clouding the valleys below. The long stone
bench around the building is a perfect place for contemplation. There's a
country restaurant in one of the church's outbuildings, which are also
extremely beautiful. Open only in season, this restaurant will be of special
interest to those who appreciate one of Italy's most famous wines, Vino
Nobile di Montepulciano, which is aged for several years in oak casks.

One of the finest landscapes anywhere lies west of Montepulciano,
where the work of nature seems to have combined with that of humankind
to produce a balance that as yet remains unspoiled. Here and there in the
endless windswept meadows arise the compact and lordly shapes of isolated
farmhouses and hillside villages. It is easy to understand how the artists
raised in this setting became master draftsmen. They painted what they
saw: the undulating yet distinct outline of the hills against the sky, the even
rows of vineyards and olive groves, the narrow irrigation canals, the roads
winding gently through the valleys—and the cypress trees, the very shapes
of which inevitably suggest brushstrokes.

Not far from Montepulciano lies the village of Pienza di Corsignano,
which would no doubt have forever remained the humble village of
Corsignano had a pope not been born there. Pius II, a great humanist,
attempted to transform his birthplace into a utopian city. With "Pienza"
added to its name, it is now a small town possessing a population of no
more than two thousand, but it boasts a monumental town square bearing
the mark of the great Florentine architect Rossellino. The mansions lining
the square were built for the pontiff's favorite cardinals, and reflect the
formation of what was in reality a papal "court." The village stands on a
rocky spur overlooking the Val d'Orcia region to the south. A short stroll

leads to distant views of Monte Amiata and the fortress of Montalcino,
reached through lanes leading off the main street with names evoking
courtly love—Via dell'Amore, Via del Bacio (kiss), Via della Fortuna.
When you stroll through Pienza di Corsignano, your eye will be struck by
the harmony of colors unspoiled by misplaced restoration efforts. The bricks
and the subtle yellow and gray tones of the paint lend a glowing patina to
the whole. You should visit the museum; the cathedral, whose luminous
architecture serves as a perfect foil for magnificent altarpieces; and the
Palazzo Piccolomini, which has remained unchanged since the death in

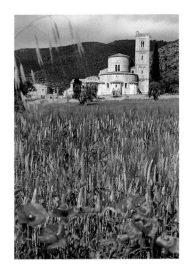

THE ABBEY OF SANT'ANTIMO,
A MASTERPIECE OF ROMANESQUE
ART, RISES FROM THE FOOTHILLS
OF MONTE AMIATA IN THE AS
YET UNSPOILED SOUTHERN REGION
OF TUSCANY (ABOVE).
ON A HILLTOP IN SOUTHERN
TUSCANY, THE VILLAGE OF
SAN CASCIANO DEI BAGNI,
RENOWNED SINCE ANCIENT
TIMES FOR ITS MINERAL SPRINGS,
HUDDLES AROUND ITS CHURCH
AND CASTLE. THIS SIGHT IS
REPEATED, WITH VARIATIONS,
THROUGHOUT TUSCANY (RIGHT).

1962 of the last descendant of the family that had owned it for centuries. A series of gloomy apartments filled with peeling ancestral portraits and a clutter of unusable furniture suddenly opens onto the dazzling loggia—a reminder that some places are better left unrestored, although even here the threat looms. When I first saw Pienza di Corsignano some thirty years ago, it was known only to a handful of art historians. Now, however, it is in the process of becoming as famous as San Gimignano.

In the Middle Ages, the Val d'Orcia region was traversed by the Via Francigena, the pilgrimage route from France to Rome. Today, the best way to appreciate the region's charm is to follow an itinerary of winding back roads rather than taking the direct route to Siena. From San Quirico d'Orcia, head southwest toward the abbey of Sant'Antimo. This extremely ancient Benedictine abbey lies in the valley of a hill overlooked by the medieval village of Castelnuovo dell'Abate. The long-neglected monastery was rebuilt in 1992, and today the abbey church rings once again with the sounds of the Gregorian liturgy. The buildings are constructed partly of alabaster and onyx—a detail that is not obvious at first glance, becoming perceptible only on closer scrutiny. Make a complete circuit of the buildings, skirting the tall cypresses almost as high as the bell tower, wander among the rows of olive trees. This untamed and yet very human spot, virtually deserted for the greater part of the year, is quietly thrilling.

A dirt road winds through vineyards and oak forests from Sant'Antimo to Sant'Angelo in Colle, where it joins the road connecting Grosseto to Siena. The square of this little medieval village is a pleasant place for lunch, especially in the fall and during the hunting season when wild boar—king of the forest in this part of the world—is on the menu. The meal should be accompanied by a Brunello di Montalcino, a highly prized vintage that, like Vino Nobile di Montepulciano, requires years of aging. Montalcino itself is only a few kilometers away. This hilltop village is recognizable from afar because of its fortress, a magnificent example of fourteenth-century military architecture. With the help of a French garrison, this fortified castle was one of the Sienese strongholds that managed to hold out the longest against the invading Florentines.

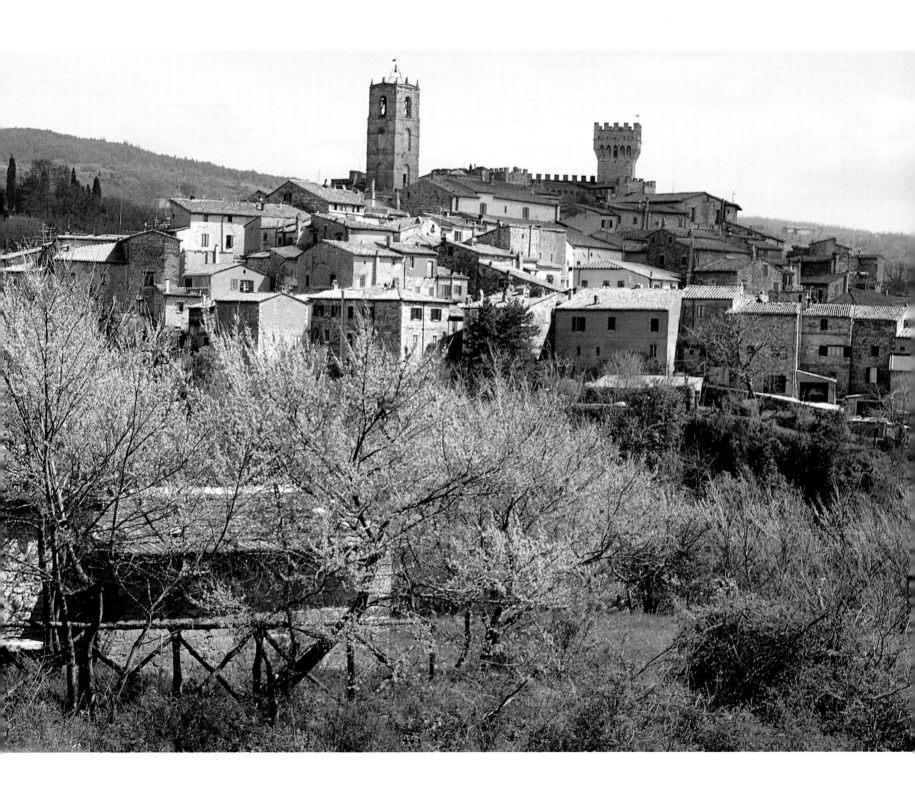

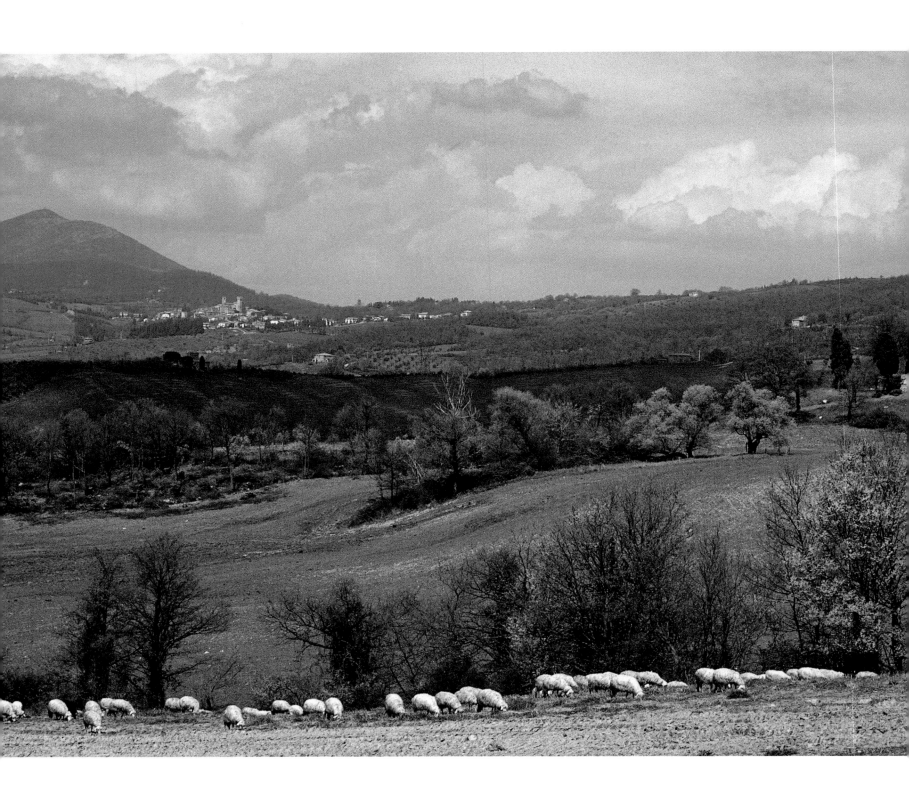

THE WILDS OF MONTE AMIATA

Another good starting-point for touring southern Tuscany is the Val d'Orcia, dominated by the massive shape of Monte Amiata. Here the countryside is relatively untamed, and the climate is harsher than on the coast. Winter lasts several weeks longer, summer nights are cooler. Radicofani and Cetona are just two of the region's extremely ancient villages, often of Etruscan origin, that seem to have remained unchanged since the Middle Ages. The little town of San Casciano dei Bagni—noted by the poet Horace for its mineral springs—has attracted numerous artists seeking a quiet place to live and work. The social life of this remote area has retained the distinctive flavor all too often diluted elsewhere by rampant tourism. Although visitors to the streets of San Casciano may not discover any major historical monuments, they will sense the presence of an authentic civilization. The Bar Centrale has a terrace that overlooks the surrounding countryside, and the hospitality offered by its owner—a kindly French professor, who with his family also manages the adjacent restaurant—is unfailingly warm. When you wander the village's hushed streets, try the door of the little church. A short flight of steps leads to the long and narrow chapel of the Holy Sacrament, where an artist of Iranian descent named Basiri, who lives nearby, has added his own discreet mark to the baroque decor: a feeling for the beautiful is still, even in a spot as modest as this, an abiding one.

The fame of the town's mineral springs is reflected by its extensive thermal baths, although the only vestige of ancient times is the fine Medicean portico. Of even greater interest are the baths at the foot of the village, where the temperature of the water flowing from the springs reaches 40°C (104°F). The largest, *il bagno grande*, has three pools. A mere twenty-five years ago, the village women were still doing their laundry in these pools. At the time, a passing tourist waiting for the women to finish so he could take a dip in the pool was baffled by the number of times they crossed themselves. The reason, it turned out, is that the three little pools were also once used for cleansing the recently deceased. Today, these open-air pools still offer the pleasure of a quick dip in their hot, crystal-clear waters.

IN A TIMELESS LANDSCAPE THAT ATTRACTS NUMEROUS ARTISTS, THE VILLAGE OF SAN CASCIANO DEI BAGNI SEEN FROM AFAR AGAINST THE MASSIVE OUTLINE OF MONTE AMIATA (ABOVE).
EVEN THE SMALLEST TUSCAN FARMHOUSE IS STRIKING FOR THE PURITY AND BALANCE OF ITS FORMAL DESIGN (LEFT).

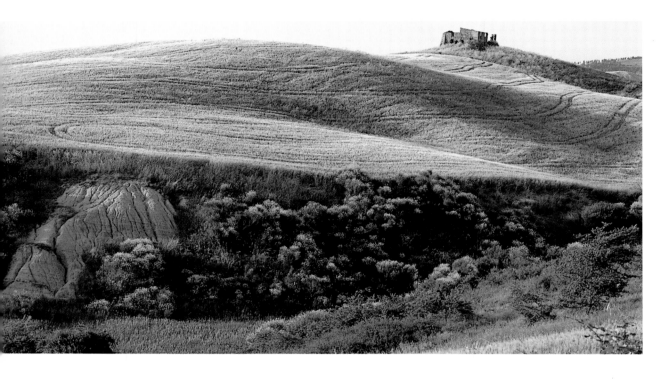

THE CLAY-RICH EARTH OF SIENA FORMS A ROLLING LANDSCAPE IN WHICH EROSION HAS IN SOME SPOTS CARVED DEEP RAVINES. HERE, THE AREA OF THE SIENA HILLS (LEFT).

SIENA AND THE SIENESE HILLS

Although you can reach Siena directly from Montalcino on the main road, the less-traveled detour via the region's back roads is much more appealing. For example, between Pienza and San Quirico d'Orcia, one of these roads (known locally as *strada bianca*) branches off to Cosona. There, in splendid isolation, a tiny hamlet clusters around a castle once belonging to Siena's extremely ancient Forteguerri family. The castle, which was remodeled extensively in the twentieth century, now belongs to the Bichi Ruspoli family. It is not open to the public, but houses fascinating archives, particularly the correspondence of Cardinal Bichi, who was an intimate friend of Mazarin's. While traveling through the strange and often fascinating landscape of the Sienese Hills, or Crete Senesi (*creta* means clay, clayey soil), a little farther north, be sure to visit the medieval villages of San Giovanni d'Asso—famous for its white truffles—and Chiusura. Although the ravines have dug deeply into the clay, leaving scars on the gently undulating hills, the landscape has a distinctive beauty at each season of the year: chalky deposits on the green meadows in winter, the browns of sun-burnt grass blending with earth-tones in summer. Opposite Chiusura stands the abbey of Monte Oliveto Maggiore. The abbey's huge brick buildings—here as imposing as those of Sant'Antimo are modest—nestle in the heart of a forest where the fragrances of cedar, cypress, boxwood, and olive trees intermingle. Still active today as the motherhouse of the Olivetian (Benedictine) order, the immense monastery also displays one of the most remarkable fresco cycles of the Italian Renaissance.

Siena can be approached from the south via the Siena Hills route. Fortunately, recent extensions to this road have not spoiled the outskirts of a medieval town that has earned superlatives from travelers since the dawn of tourism. Siena is known, and rightly so, as "the most important medieval monument in Italy, and perhaps all of Europe." The town center is listed by UNESCO as a World Heritage site. "I have been a listed historical monument ever since I was born," smilingly notes Federico Fusi, an artist passionately attached to his native city.

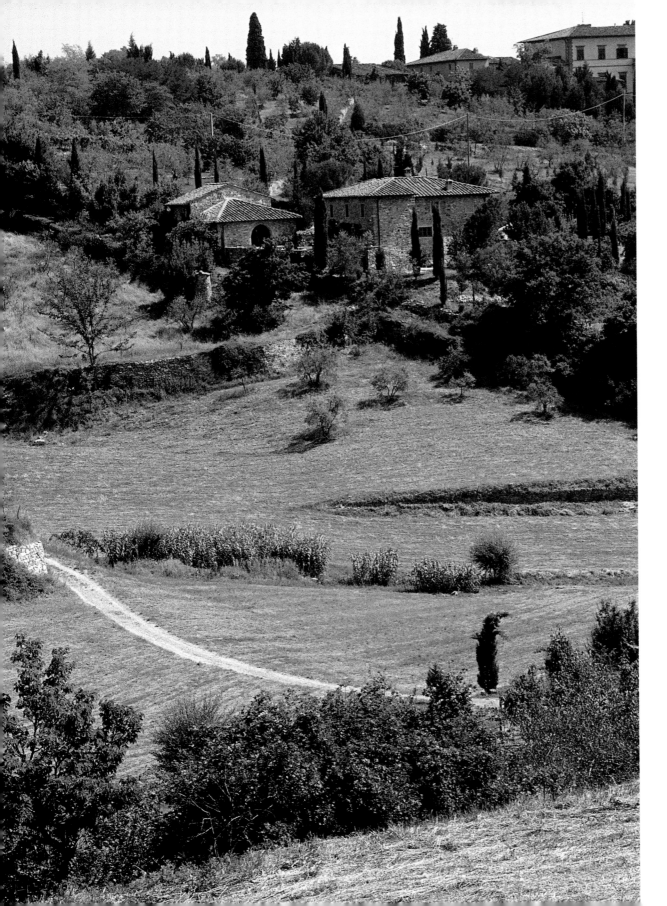

SIENA IS BUILT ALONG A WINDING
RIDGE CUT BY DEEP RAVINES.
THE DISTINCTION BETWEEN
TOWN AND COUNTRY IS UNCLEAR,
SINCE THE MEDIEVAL CITY WALLS
ALSO ENCLOSE VAST STRETCHES
OF GREENERY AND CULTIVATED
FIELDS—A FACTOR THAT ENABLED
SIENA TO RESIST AN INTERMINABLE
SIEGE BEFORE FINALLY SUCCUMBING
IN 1555 TO THE TROOPS OF
CHARLES V, WHO WAS ALLIED
WITH FLORENCE (ABOVE AND LEFT).

A PLAQUE IN VIGNANO RECALLS
STENDHAL'S LOVE FOR THE SIENESE
BEAUTY GIULIA RINIERI (RIGHT).
NUMEROUS STRIKING VIEWS OF
SIENA ARE OFFERED BY VANTAGE
POINTS WITHIN THE CITY ITSELF,
AS HERE, THROUGH THE BRANCHES
OF AN ORCHARD (BELOW).

Before beginning your tour of the city, take a moment to contemplate it from afar, from Vignano on the Chianti road, for example. There's a terrace in front of the hamlet's minuscule church. From this balcony-seat, Siena appears in all of its singularity, amid its maze of hills and ravines: the typical Crete Senesi landscape, here overlaid with a dense crust of brick and stone from which rise the domes and bell towers of the city's churches. The view is of a town that has followed the local topography rather than rejecting it—ever since invading Florentines leveled off the noble towers, which competed with each other to be the tallest and which, had they been allowed to proliferate, would have relegated San Gimignano to the rank of minor curiosity. Nearby stands the imposing villa that was once the scene of a love affair between Stendhal and Giulia Rinieri, which explains how the name "Vignano" acquired immortality in *The Charterhouse of Parma* as a village on the banks of the Po.

Enter the city through one of the monumental gates studding its ramparts. The houses cling to the slopes of the ravines, and the medieval city center faithfully follows the site's natural contour. Siena is built over an extensive network of aqueducts, and laundry pools fed by a stream of extremely pure water can still be seen in the valleys. Vegetable gardens, olive groves, and orchards still grow beneath the sheer brick walls of massive and imposing sanctuaries. "Siena is a mountain town, and we have the mentality of a mountain people," a Sienese friend once remarked. Whereas Florence is a city of the plain that grew horizontally, Siena—the home of saints and financiers—turns its face heavenward, toward abstraction and transcendence. Mysticism and detachment on one side; and, on the other, the dematerialization of money that is the defining characteristic of banks. The distance between the two is perhaps not all that great, after all. It was a Siena native who invented the letter of credit.

The rugged local terrain accounts for one basic characteristic of the Sienese mentality, as alive today as in the Middle Ages: the spirit of competition. Competitiveness is expressed through the division of the community into separate districts, or *contrade*, each with its own emblem, church, and community center. Today the *contrada* still plays a crucial role in

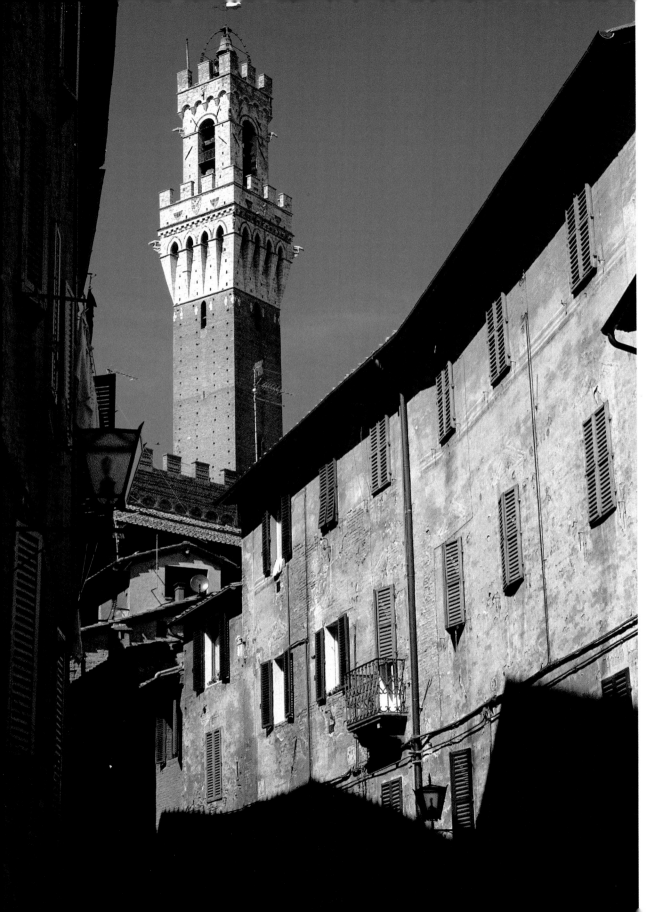

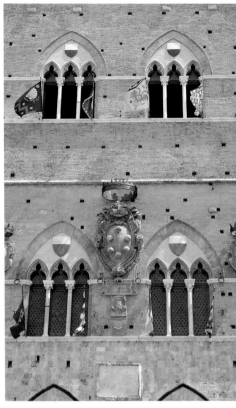

A symbol of the community, the Torre del Mangia rises eighty-eight meters above the narrow streets surrounding the Piazza del Campo (left). The Medici coat-of-arms has not displaced the black-and-white Sienese shields over the windows of the Palazzo Pubblico, where the banners of the city's *contrade* are hung during the Palio (above).

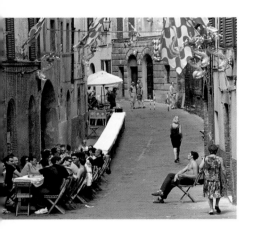

THE BANNERS OF EACH DISTRICT
(CONTRADA) OF SIENA HAVE THEIR
OWN IDENTIFYING COLORS AND
SYMBOLS—HERE, THE PANTHER
(ABOVE, TOP).

IN THE DAYS PRECEDING THE PALIO,
EACH CONTRADA SETS UP TABLES
ON THE STREET FOR DINING IN
THE OPEN AIR (ABOVE, BOTTOM).

managing a system of mutual aid for the benefit of its inhabitants. Relations among the different districts are complex, often exacerbated to the point of paroxysm during the famous Palio. This horse race, preceded by an impressive parade in medieval costume, is held annually on July 2nd and August 16th—a time for the exhibition of team spirit and loyalty (to one's own), overt contempt and hostility (to competitors), and a fierce will to win. *Contrade* headquarters are often found in relatively unpretentious buildings. Most have an emblematic animal, the list of which runs the gamut from goose to panther, rhinoceros, giraffe, unicorn, or caterpillar. Every inhabitant of Siena is thus born with a strong sense of identity, and *contrada* emblems are visible everywhere, even on the utility-company meters affixed to the side of every house. The colors of *contrada* banners are painted on Vespas and, often, on the protective grills covering windows. The second Sienese characteristic noticed by visitors is the melancholy with which the city seems to be imbued, a reflection of the prevailing gloom so aptly described by the great Sienese novelist Federigo Tozzi. Although arguably the result of historic reversals suffered in the distant past, its traces are also visible on the faces of the cherubim carved by Duccio, a master of Siena's golden age.

Like all cities with soul, Siena reveals itself only grudgingly. It is a place of light and shadow, in the exact image of its coat-of-arms: "broken argent and sable," half white, half black—another example of the Sienese spirit's tendency toward abstraction. It is true that Siena possesses another symbol, the she-wolf suckling her cubs. This image of tenderness and charity can be found on innumerable medieval madonnas in a city that early placed itself under the protection of the Virgin.

To know Siena is to feel in one's muscles the incessant change in level; to understand that each winding street has its parallel—above or below—and that it's possible to go from one to another by way of steep little passageways. It is also, in the narrow streets, to observe sunbeams sparkling on the housetops and infinitely replicating the city's hallmark silvery-gray stone (*pietra da torre*) that was first used in medieval times and possesses a marvelous capacity for reflecting light. You have to keep your eyes raised continuously in order to appreciate the beauty of the cornices, the majolica set into the older façades,

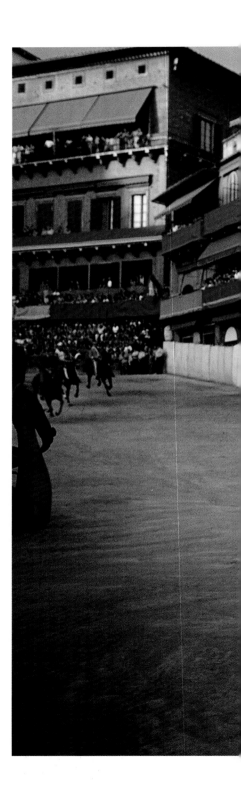

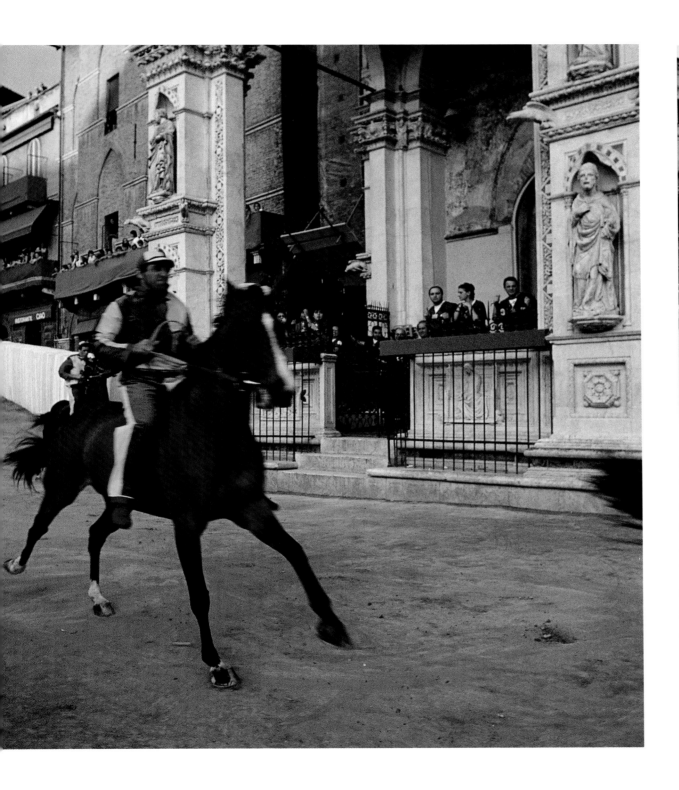

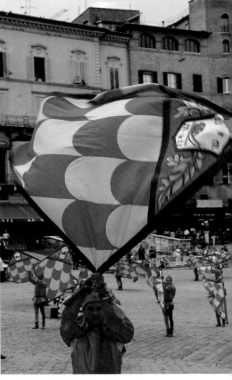

RIDERS PRACTICING ON THE SANDED
TRACK AROUND THE PIAZZA
DEL CAMPO BEFORE THE DECISIVE
COMPETITION HELD ON JULY 2ND
AND AUGUST 16TH (LEFT).
THE RACE IS PRECEDED BY A PARADE
FEATURING BRILLIANTLY COLORED
PERIOD COSTUMES AND TWIRLED
BANNERS (ABOVE).
BEFORE THE FESTIVAL, EXHAUSTIVE
REHEARSALS ARE HELD IN THE
SQUARE (FOLLOWING DOUBLE PAGE).

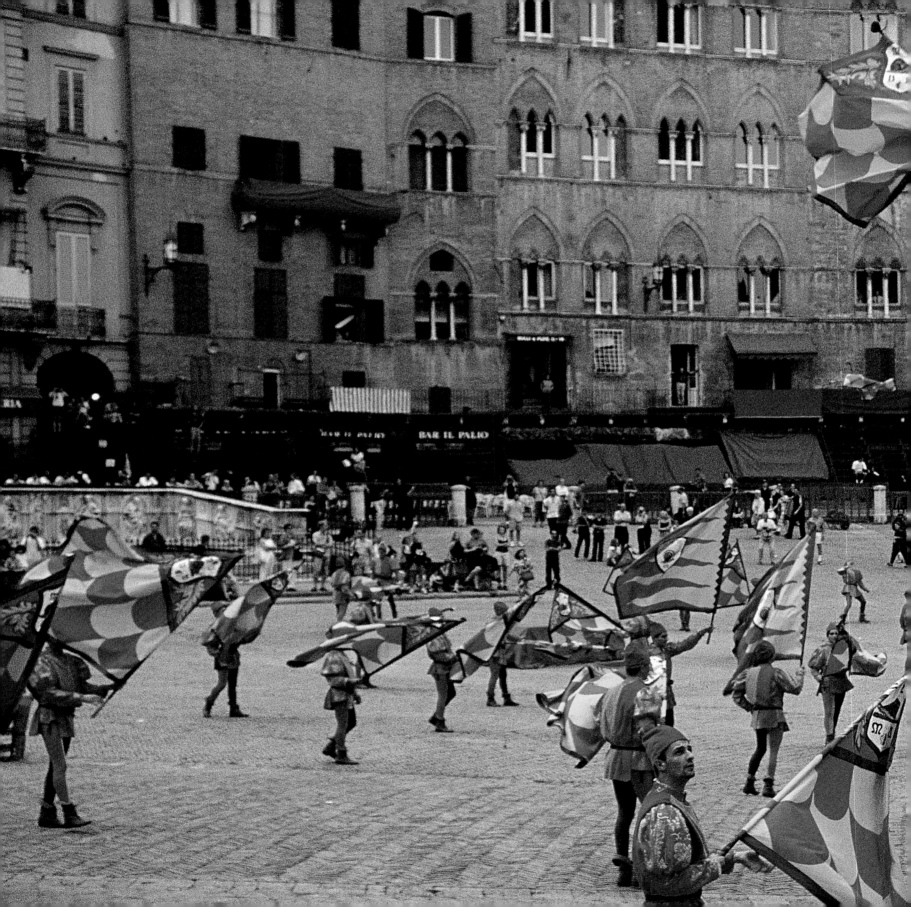

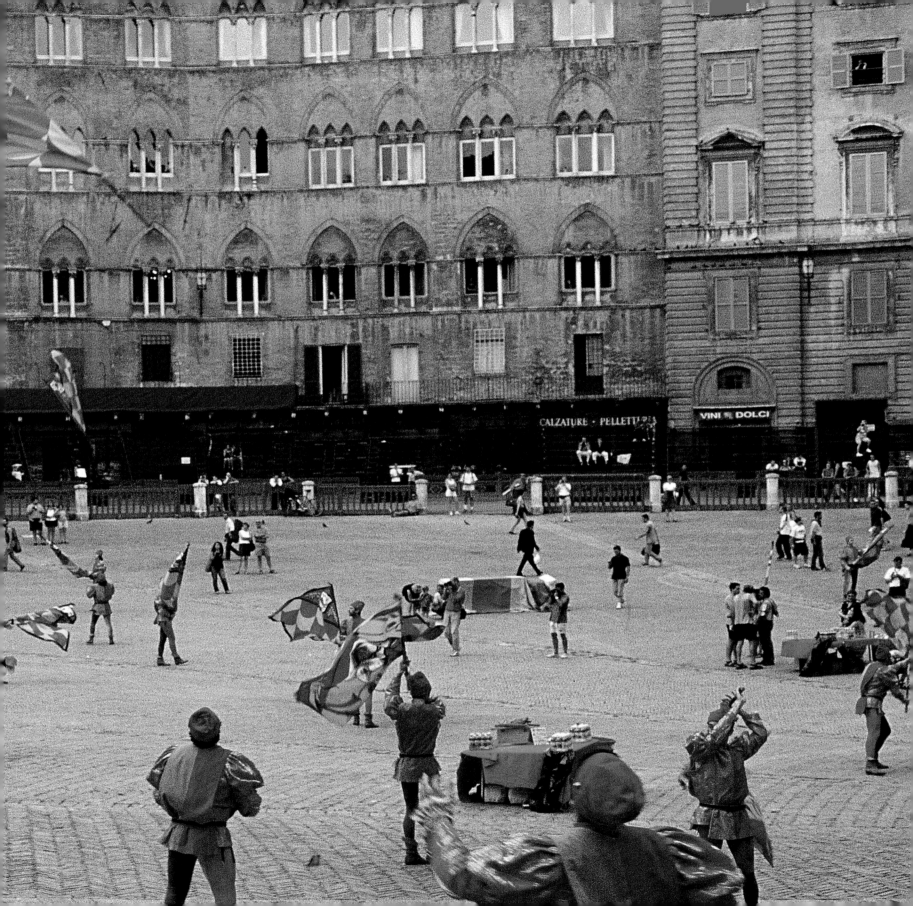

IN SIENA, ALERT OBSERVERS WILL
DISCOVER A HOST OF FASCINATING
SCULPTURES, SUCH AS THIS
SEASHELL EMBLEM ON THE NICCHIO
CONTRADA CHAPEL (ABOVE, TOP),
OR THE STATUES ADORNING
THE MARBLE CHAPEL IN THE PIAZZA
DEL CAMPO (ABOVE, BOTTOM).

the *contrade* emblems, and the symbols for Christ (IHS, "Jesus Savior of Mankind") that Saint Bernardino of Siena scattered everywhere, as if faith required the continuous support of exorcism. "To see Siena properly, you should have yourself carried through it on a stretcher," as an elderly passerby wittily remarked when he saw me gazing up at the Palazzo Piccolomini. Squares punctuate this tangle of streets with radiant open spaces, the sole exception being the Piazza Salimbeni, a chilly nineteenth-century composition too well bred to be genuine. But then there's the Piazza del Campo—scene of the Palio festivities and probably unequaled anywhere in Italy—and its counterpart, unfamiliar to most tourists, the Piazza del Mercato on the other side of the town hall. There's the stunning Piazza Provenzano Salvani, in the center of the district dear to Tozzi, and the sloping and mysterious Piazza Manzoni leading to the Church of Santa Maria dei Servi with its large, truncated, but still living cedar. These sanctuaries resembling fortified strongholds offer the best vantage points for appreciating the city's essence. It would be impossible, in this brief space, to enumerate all of Siena's artistic and architectural masterpieces. But they offer themselves, one after the other, to the stroller's gaze. Visitors undaunted by the endless up-and-down climb will have the thrill of discovering, for example, the large medieval fountains flowing in the ravines. At the center of town is the Castellare degli Ugurgieri, a relic of the fortified manors built by the nobility in the year 1000 to replace their country houses (it is from this juxtaposition that the city grew), today standing at the heart of the *contrada* of the owl, whose oratory replaced a temple to Minerva—the goddess whose emblem is the owl.

Siena may be introspective, but it is far from silent. The avenue leading from the Piazza Salimbeni to the Piazza del Campo fills at nightfall with a youthful, boisterous crowd surging through it in both directions. However, it is during the Palio that the city seems to throb with an extraordinary energy. The race itself lasts only a few seconds, but the preparations leading up to it and the victory celebrations afterward occupy the population for many long days. Although it attracts numerous tourists, there is nothing "quaint" about this festival. It expresses the soul of the city—its unity and its diversity—throughout a ritual in which nothing is left to chance.

EXPLORING THE CITY'S MANY SCULPTED DETAILS IS ONE OF THE JOYS OF STROLLING AROUND SIENA, WHICH BOASTS A HOST OF ORNAMENTAL CARVINGS AND FOUNTAINS, OFTEN BASED ON THE EMBLEMS OF A CONTRADA (FAR RIGHT, TOP-TO-BOTTOM). THE FONTE GAIA, A MASTERPIECE BY JACOPO DELLA QUERCIA, HAS BEEN FLOWING INTO THIS POOL ON THE PIAZZA DEL CAMPO EVER SINCE 1419 (RIGHT).

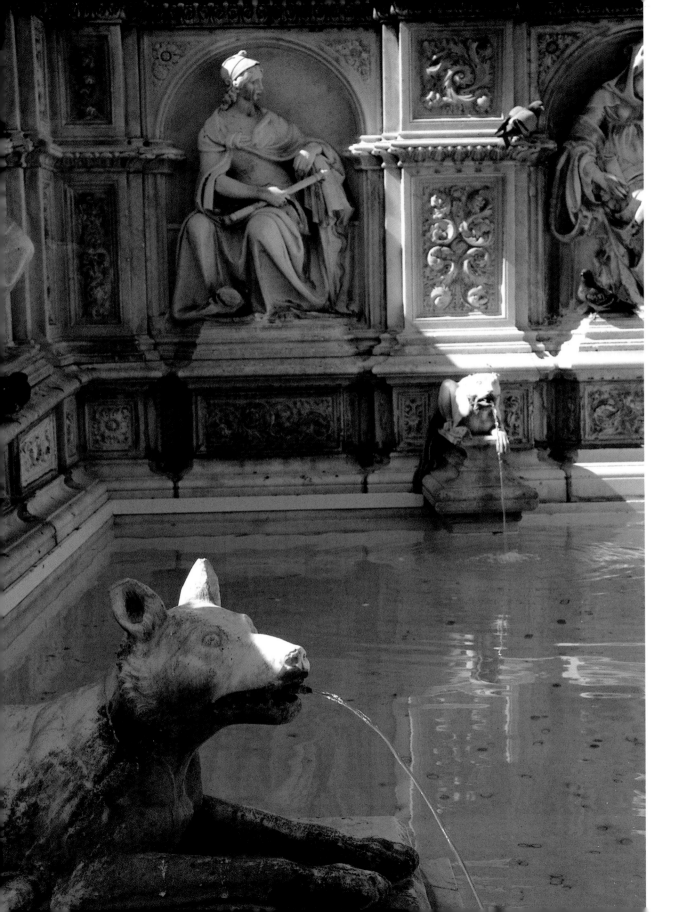

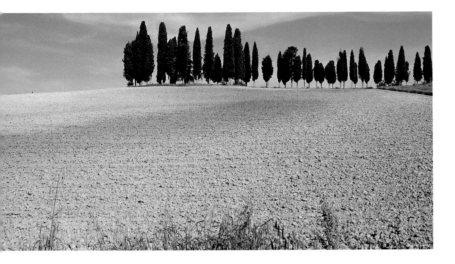

A BRIEF TOUR OF CHIANTI

Siena is the ideal starting-point for a tour of Chianti. The region's name evokes one of the most famous wines in the world, and the distinctive straw-covered, rounded shape (now being progressively abandoned) of its bottles. The wine's stereotypical image has been completely transformed over the past thirty years, and fortunately this rather facile and superficial picturesqueness is being abandoned in a drive for better quality. The Chianti Classico vineyards that form the region's core, today highly esteemed by connoisseurs the world over, were not always as quiet and peaceful as they are now. The area's numerous fortified castles and villages bear eloquent testimony to the lengthy secular conflict between Siena and Florence. The brief itinerary that follows will reveal its modern face as you pass through a countryside boasting a number of renowned estates—Lilliano, Badia, Castello di Ama, Brolio, and many others—where wine-lovers can stop for tastings, especially if they have taken the trouble to make an appointment beforehand.

The most appealing route starts in Siena and follows the Castellina in Chianti road to the north, winding through vineyards and woodlands in a rolling, harmonious landscape. Castellina, dominated by its fourteenth-century fortress, retains a remarkable charm unaffected by swarms of tourists and numerous real-estate agencies—for this is "Chianti-shire,"

A ROW OF CYPRESS TREES ALONG
THE HORIZON NEAR CASTELLINA
IN CHIANTI—A COMMON SIGHT IN
THE REGION AND VIRTUALLY THE
HALLMARK OF TUSCANY (FAR LEFT).
VINEYARDS ABOUND IN CHIANTI.
VAST ESTATES, HERE ON THE
OUTSKIRTS OF LILLIANO, EXTEND
OVER A HILLY LANDSCAPE PLANTED
WITH CAREFULLY TENDED OLIVE
GROVES AND WOODLAND (LEFT).

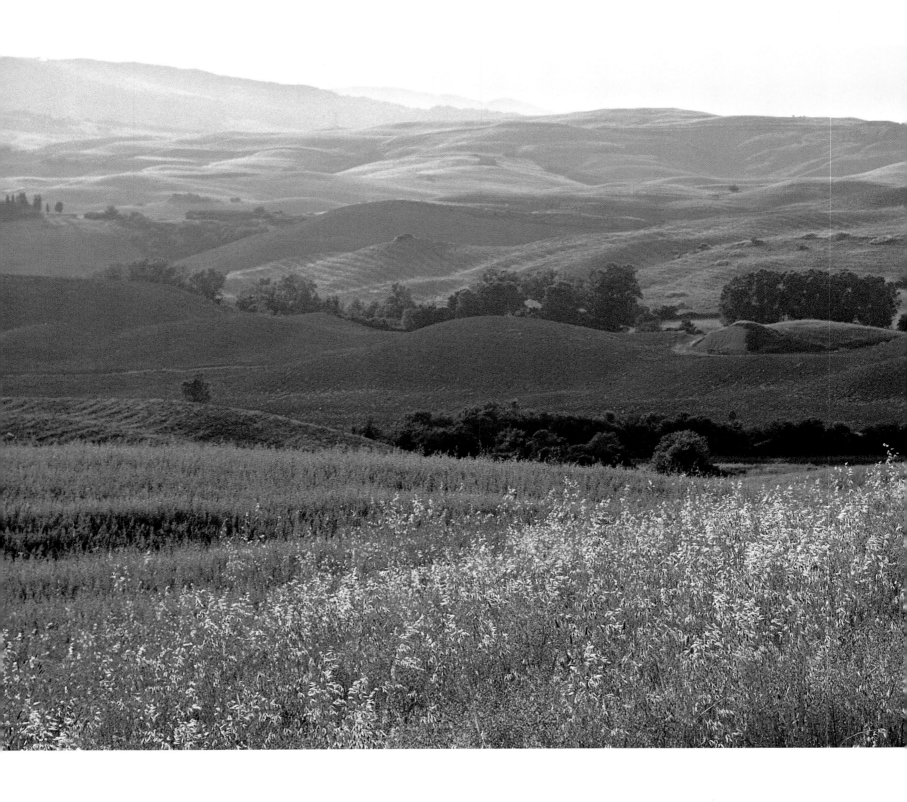

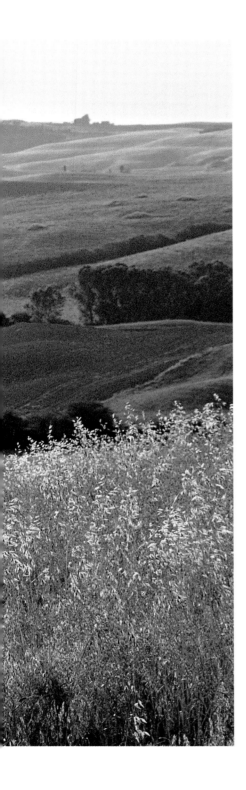

as the English have dubbed it, one of the regions in Italy most favored by foreigners. One of the village streets, Via delle Volte, boasts a stunning succession of unusually wide brick arcades. It leads to the Piazza del Comune, site of one of the region's most delightful restaurants. From Castellina, you should veer due east toward Badia a Coltibuono. A focal point in the land of Chianti Classico and olive oil, this ancient abbey is said to have been constructed in 1049. It was secularized in 1810 and converted into a farmstead, but has retained its fine Romanesque church flanked by an imposing bell tower. Magnificent pine forests, planted by the original monks, encircle the abbey but do not block the panoramic views of the region—which here is semi-mountainous and much wilder in appearance. Because of the rugged terrain, the abbey's vineyards and olive groves are planted lower down, at a fair distance from the sanctuary.

As the road continues southward it skirts the Castello di Meleto, the exterior of which, with its four corner towers, has retained a medieval flavor. The view over the hills is superb. The interior of the castle, closed to the public, contains a charming eighteenth-century theater. Meleto was a fief of the Ricasoli family, another branch of which owned the fortress near Brolio. This fortress was extensively rebuilt during the nineteenth century. The main buildings are brick, the outer wall local Siena stone. This impressive group of buildings occupies a strategic position at the summit of a hill overlooking one of the finest views in Italy, stretching well beyond Siena. The castle dominates the Arbia Valley, which once marked the border separating Florence from Siena. The edifice today bears the mark of Bettino Ricasoli, the "Iron Baron" who supported Cavour and contributed significantly to Italian unity. His descendants have opened the castle's gardens and terraces to the public. At the foot of the castle, a vast array of farm buildings gives some idea of the estate's total area and its productive capacity. Southeast of Brolio, the medieval village of San Gusmè has remained just as it was when the Sienese fortified it more than seven hundred years ago. On the return trip through Castelnuovo Berardenga, the road branches off just before Siena to Vignano—a village made famous by Stendhal offering a magnificent view of the city.

THE HARMONIOUS COUNTRYSIDE AROUND SIENA SEEMS TO HAVE BEEN CREATED TO INSPIRE ARTISTS (LEFT). IN THE VILLAGE OF SAN SANO, A FOUNTAIN RECALLS THE LEGEND OF THE CHIANTI-DRINKING FROG (ABOVE, TOP). FREQUENTLY ENCOUNTERED COATS-OF-ARMS ILLUSTRATE THE IMPORTANCE OF THE GREAT PATRICIAN ESTATES IN CHIANTI (ABOVE, BOTTOM).

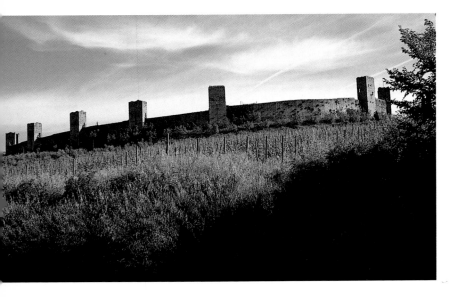

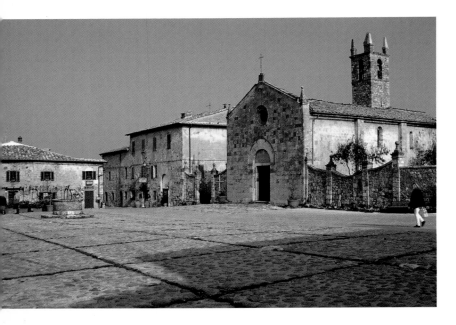

THE TOWERS IN THE WALL SURROUNDING MONTERIGGIONI HAVE REMAINED UNCHANGED SINCE THE MIDDLE AGES (ABOVE, TOP).

THE SIZE OF THE VILLAGE'S MAIN SQUARE REFLECTS THE IMPORTANCE IN THE PAST OF COMMUNAL LIFE (ABOVE, BOTTOM).

FROM SIENA TO VOLTERRA

The road northwest out of Siena passes below Monteriggioni. This little hilltop village has preserved its circular medieval wall and towers. The whole remains more or less as it must have appeared to Dante, who refers to it in Canto XXI of the *Inferno*. Today, its tiny central square and low-slung buildings offer travelers a peaceful refuge during the off-season.

Most visitors bypass Colle di Val d'Elsa in favor of San Gimignano—wrongly, since this little town is one of the most delightful in Tuscany. Colle, although totally Sienese in appearance, was traditionally allied with Florence in the conflict between the two cities, and the old animosity is still alive today. I recently read a graffiti on a modern bus shelter, "Colle odia Siena" ("Colle hates Siena"), which no one, apparently, has thought fit to remove. The town is built on two levels, Colle Alta and Colle Bassa, with the upper part again divided in two. After crossing a bridge, the main street goes through the middle of the magnificent Palazzo Campana, which thus forms an unusual and majestic entranceway to the *castèllo*, or inner town.

Colle di Val d'Elsa recalls Siena at every step, from its hilltop site surrounded by ravines to its architectural style and the materials from which it is built. As in the "hated" city, its main street—Via del Castello—is doubled, and even tripled, by streets running parallel to it. Colle will beguile you with its steep streets, the lovely tint of its stone-and-brick walls, the vivid gray, pink, and white geometry of its pavements, the charm of arcades and squares endlessly alternating light and shadow, the austere beauty of its fortifications, and the treasures of painting and sculpture in its churches. Most of the town's noble towers have been razed, but one survives—the one in which, according to local tradition, Arnolfo di Cambio, the great architect to whom we owe Florence Cathedral, was born. For centuries Colle was a center for the manufacture of paper and crystal. The paper mills are gone, but the crystal factory is still very much alive. A curious gastronomic note: in the Val d'Elsa region, where vineyards and olive groves made a belated appearance, people traditionally cooked with lard rather than olive oil, and pork was the favored meat.

In Monteriggioni,
the emblematic black cock
of Chianti points the way
to a local vintner's shop
(above).
Colle di Val d'Elsa, one of
the Tuscany's most charming
cities, is split in two. The lower
town is built around a large
arcaded square named in
honor of Arnolfo di Cambio,
architect of Florence's
cathedral (right).

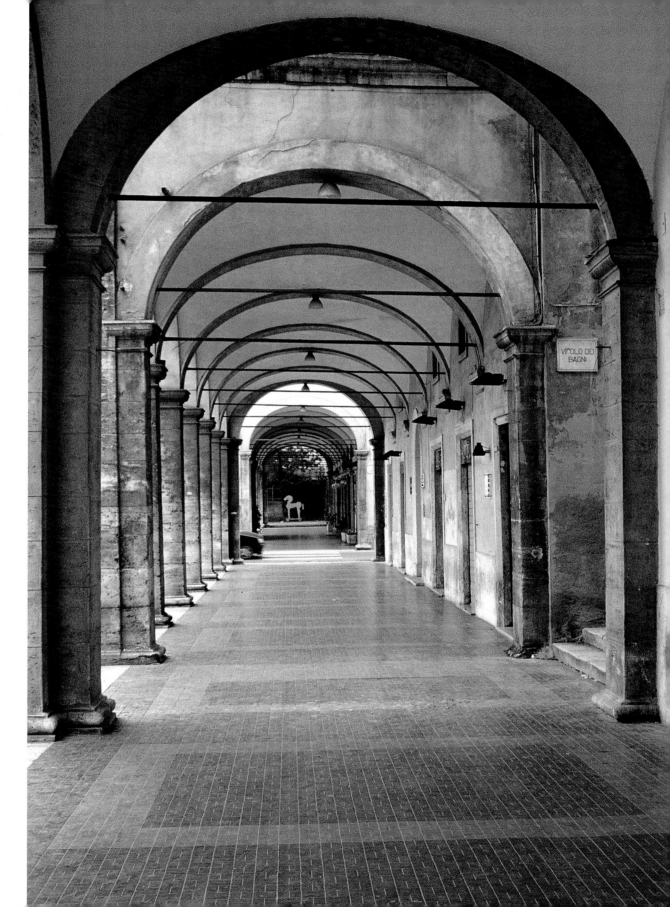

Volterra has preserved
its Roman theater (right).
The city's noble families had
their shields sculpted in stone
(above, top).
Volterra has always been
the capital city of alabaster
(above, bottom).
The city's streets burst into
color for the communal
festival (far right).

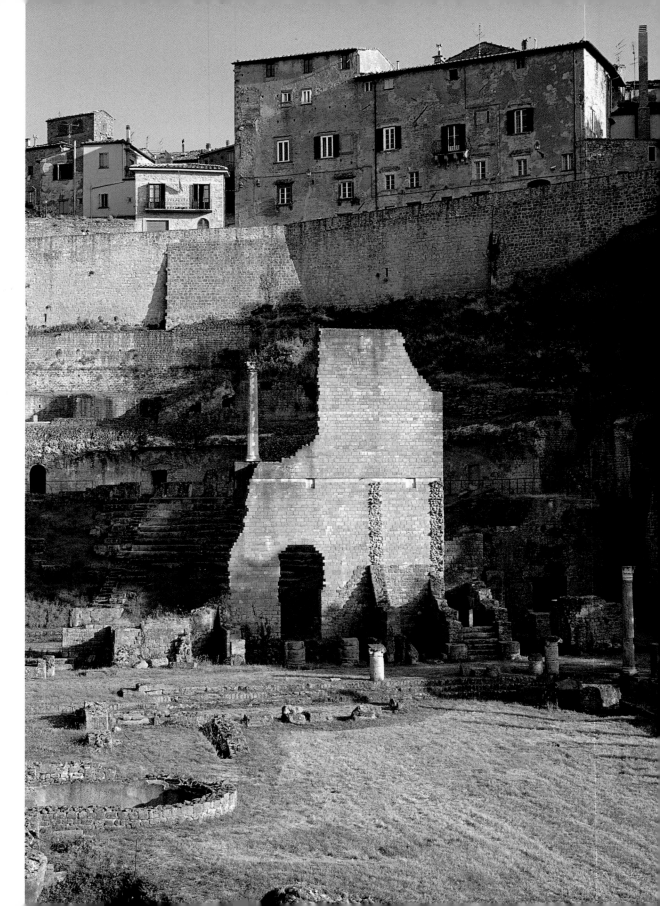

San Gimignano, which people come from all over the world to admire, is unquestionably the best preserved and most spectacular of all the medieval towns lying along the Via Francigena in the Val d'Elsa. Whereas in the others most of the noble towers have been razed, San Gimignano still possesses a considerable number of them. Seen from afar, often veiled in mist, their geometric Gothic patterns seem almost modern. Fame has taken its toll, however: the invasion of tourists, the proliferation of souvenir shops, and the exaggerated tidiness of the many restored residences can be disconcerting. The best time to see San Gimignano is thus on a weekday or in the off-season, when there are fewer tourists and visitors can gain a sense of what the town must have been like during the centuries of religious pilgrimage. In the days of its glory, San Gimignano owed a large part of its prosperity to the production of saffron. Young farmers have recently attempted to renew this tradition and so, if you stop in one of the town's trattorias on a quiet day, be sure to ask the chef if he can offer you a dish seasoned with the local saffron—even if it's not listed on the menu.

Volterra, perched on a ridge furrowed with ravines carved by erosion, was a major Etruscan city. In 400 BC it had a population of 25,000—double the number of its inhabitants today. Long stretches of the surviving Etruscan wall, crumbling in spots due to subsidence, are still visible well beyond the limits of the medieval town. After developing brilliantly during the thirteenth century, Volterra fell victim to Florentine greed. The troops of Lorenzo the Magnificent captured it in 1472 and submitted it to a systematic pillage described in chilling terms by Machiavelli. Volterra's distinctive character reflects its turbulent history. At its heart is the Piazza dei Priori, which remains—despite radical restorations undertaken in the nineteenth century—one of the most evocative medieval squares in Italy, and one of the least ornate. A single concession to decorative exuberance: the many heraldic emblems studding the palace façades. The Torre del Porcellino, for example, owes its name to the little wild boar decorating the upper section of its outside wall. In the realm of gastronomy, wild boar cooked "in the Etruscan manner" is also emblematic of the city. The city's cathedral and Romanesque baptistery, which strollers will discover in their

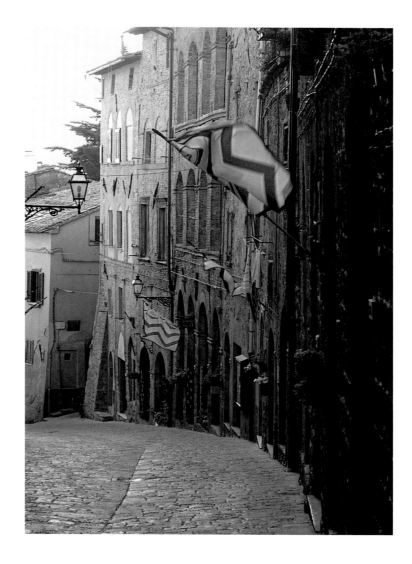

wanderings, its archeological remains and the wealth of its museums make this town a particularly appealing one. The traditional craft of alabaster-carving is very much alive today, and there is a map showing the location of workshops still operating in the town center. The dean of these craftsmen specializes in animal figurines, and he can be seen from the street as he quietly polishes the finished pieces. The final view of Volterra from across the *balze*—the spectacular ravines etched into the hillside—is as stunning as all the rest.

THE ETRUSCAN TOMBS OF ANCIENT
POPULONIA WERE BUILT ON
HILLSIDES SLOPING GENTLY DOWN
TOWARD THE SEA (ABOVE).
A MAJOR PROJECT WAS INITIATED
IN THE NINETEENTH CENTURY
TO DRAIN THE MARSHLANDS OF
THE MAREMMA. THIS FARM ON A
GREAT ARISTOCRATIC ESTATE NEAR
BOLGHERI TODAY OVERLOOKS FIELDS
OF SUNFLOWERS (RIGHT).

DOWN TO THE SEA: FROM MONTE ARGENTARIO TO PISA

The Tuscan coastline, over 250 kilometers long, is highly diverse. Since the
autostrada follows only the northern section, the southern half is relatively
free of tourist traffic—although certain outstanding sites, such as Monte
Argentario, are extremely popular resorts. The Maremma, its name derived
from the Latin word *Maritima*, covers an ancient marshland from which the
human population has more than once been forced to withdraw in response
to the rigors of nature. Painters have frequently been inspired by the
region's topography, its longhorn buffalo and mounted herdsmen. The
Romans who followed the Etruscans attempted to drain and cultivate the
marshes, but their efforts were curtailed by the fall of the Empire. After
centuries of decline and abandon, the area was finally drained successfully
by the grand dukes of Tuscany, the Medici, and (in particular) the princes
of Lorraine. Great agricultural estates rose along the coast, and many
remain in the hands of prominent Tuscan families today. Some produce
respected wines. They are recognizable from afar by the stately rows of
parasol pines and cypresses marking a terrain that is sometimes perfectly flat
and sometimes more rugged.

For example, the little village of Bolgheri between Grosseto and Livorno
lies at the end of a double row of giant cypresses extending for five kilometers.
One enters this tree-lined alley through an ogival arch cut into the castle
itself. It is here that the poet Carducci spent his childhood, immortalizing the
name of the village in a famous ode. Numerous archeological sites, such as
Vetulonia, recall the Etruscan period. The most interesting, in my opinion, is
at Baratti-Populonia. Once a major Etruscan port, Baratti-Populonia is now a
tiny, sparsely populated village clinging to the fortified castle atop a cliff with
a sublime view of the coast. A vast archeological dig lies at the foot of the
ancient acropolis. Populonia is stunning not only for the beauty of its carved-
stone Etruscan tombs, but most of all for the grandeur of its site: the
excavated tombs are scattered over hills sloping gently toward the waters of
the Gulf of Baratti, clasped between two rocky promontories and bordered by
tall pines. As in Greece, this view of the sea lends an additional dimension to

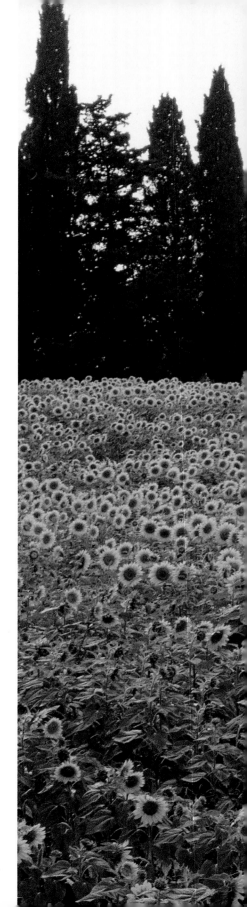

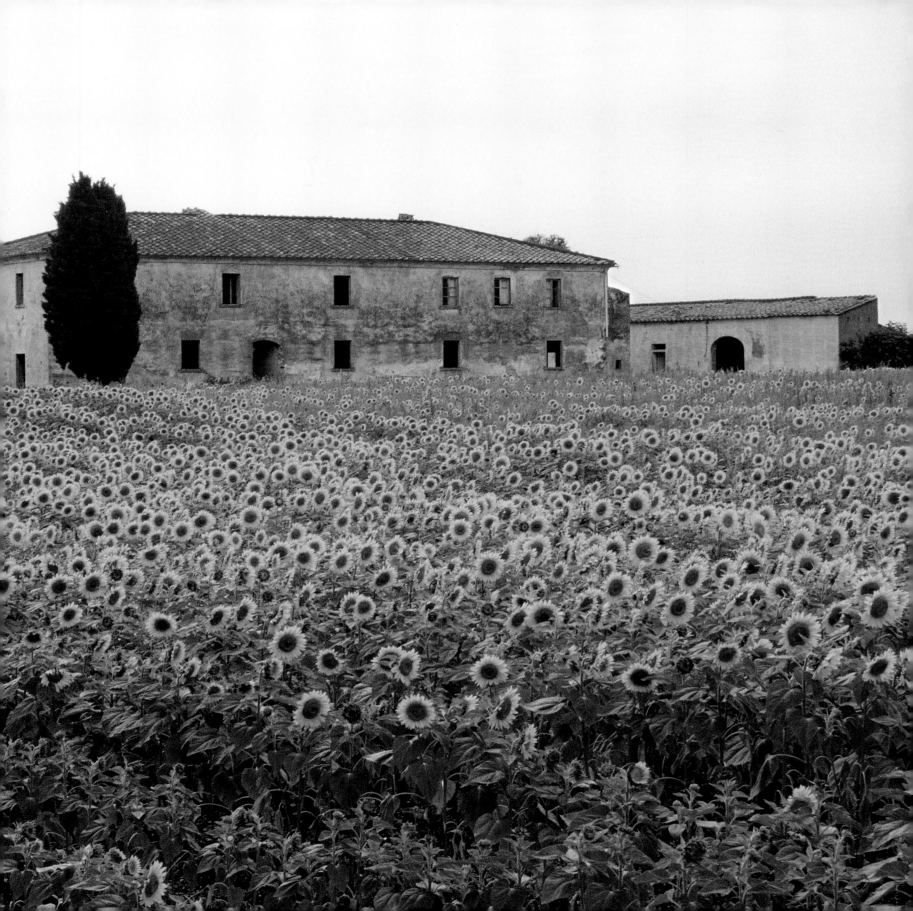

the poetry of the ruins. On the inland side of the tombs, a fairly long path leading to the remains of buildings used for smelting iron ore gives some idea of the extent of the ancient city.

The Maremma nature park, located between Grosseto and Argentario,

is of course the most unspoiled area in the region. It consists of a strip measuring some twenty kilometers long by five to eight kilometers wide, and includes every topographical feature typical of the Tyrrhenian coast, from hills to marshland. A network of pathways provides a means for exploring the park's jealously preserved flora and fauna, but the vestiges of human activity are equally interesting,

notably the watch towers and the impressive ruins of a Romanesque abbey. The proximity of the resort towns of Porto Ercole and Porto Santo Stefano make it necessary to manage the flow of tourist traffic during the summer. For those who don't like to be herded into groups, the best time to visit is fall or early spring. In winter, despite the somewhat depressing appearance of the vegetation and the fog that often shrouds it, the poetic sense of solitude is intensified. Other nature parks, less well known and less crowded, dot the coast as far as Pisa. Thanks to the hospitality offered by some friends of mine in Pisa, I was able to sample the delights of an ideal writer's refuge on the edge of a marsh full of birds, wild boar, and deer. The Bolgheri reserve is open to the public only in winter and early spring. I visited on closing day: a male nightingale had arrived that morning on his flight from Africa and, perched atop his chosen tree, he sang night and day in the hope of attracting a passing female. This solitary experience affected me more strongly than all the clichéd images of the famous *butteri*, the Maremma horsemen who guard the herds of buffalo distinctive for their white hides and lyre-shaped horns.

Livorno, Tuscany's third-largest city, deserves to be better known. Originally a fortified outpost of Pisa, it was transformed during the Middle Ages according to a plan conceived by Cosimo I for creating an ideal city. His architect Buontalenti designed a pentagonal layout for the new city, the construction of which lasted from 1577 until the seventeenth century. Despite numerous incentives and tax exemptions, the population increased only gradually. Livorno welcomed minorities from throughout the Mediterranean basin and even farther afield—primarily Jews, including the precursors of the Modigliani family, as well as English Catholics, Greeks from the Ottoman Empire, and Arabs from Spain and Portugal. The city's expansion during the nineteenth century was conducted in an orderly fashion, extending beyond the boundaries established by Buontalenti but respecting the spirit of his original design. The most striking example of this disciplined reverence is an extremely curious monument: the Cisternino, a neoclassical edifice constructed in 1830 that could have been inspired by the utopian visions of

ALL THAT REMAINS OF POPULONIA TODAY IS THE CASTLE AND ITS IMMEDIATE SURROUNDINGS, THE ELEVATED POSITION OF WHICH MAKE IT ONE OF THE MOST BEAUTIFUL SITES ON THE TUSCAN COAST (FAR LEFT).
THE SALVATI SHIELD RECALLS THE EXTENT OF THE ILLUSTRIOUS FLORENTINE FAMILY'S POSSESSIONS AROUND PISA (LEFT).
CONSTRUCTED IN THE FOURTEENTH CENTURY, THE CASTLE OF POPULONIA OCCUPIES THE ACROPOLIS OF WHAT WAS ONCE THE LARGEST ETRUSCAN PORT (RIGHT).

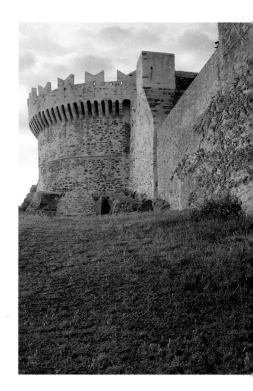

A ROW OF WIND-BLOWN PARASOL PINES ALONG THE MAREMMA'S LOW-LYING COASTLINE (ABOVE, TOP). THE GULF OF BARATTI IS ONE OF THE RARE NATURAL COVES ON THE TUSCAN COAST. VISIBLE IN THE BACKGROUND ARE THE MAREMMA PLAIN AND THE VOLTERRA HILLS (ABOVE, BOTTOM).
A FARM ON THE GULF OF BARATTI, AT THE FOOT OF THE ETRUSCAN NECROPOLIS OF POPULONIA, GLOWS IN THE LIGHT OF THE SETTING SUN (RIGHT).

Etienne-Louis Boullée. Who would ever guess there's a mundane water tank hidden behind a portico surmounted by an open half-dome resembling an architectural cross-section? The Piazza della Repubblica, a vast neoclassical rectangle, is reminiscent of de Chirico's metaphysical works—and, again, who would ever guess that its two-hundred-meter length is actually an arched bridge spanning Livorno's main canal, the Fosso Reale? Nineteenth-century Livorno was a center of intellectual ferment, traces of which still linger in some of the old city's cafés. The Antico Moro restaurant, its original decor intact, still has some Macchiaioli (Italian Impressionist) paintings hanging on its walls. It is also one of the best spots in the area for fish and, in the evenings, serves a coffee punch prepared at a neighboring café.

Whereas Livorno suffers from the fact that most people think of it merely as a port of embarkation for Corsica, one is tempted to say that the problem of Pisa—overwhelmed by the fame of its leaning tower—is just the opposite. In Florence, the crowds are at least split between the city's monuments and its museums, but here everyone heads for a single spot. The Piazza del Duomo actually contains not one but three of Italy's most important medieval monuments: the tower, of course, and also the cathedral and cathedral baptistery. Although Pisa experienced a degree of renewal during the nineteenth century, it has the air of a great city in decline, especially palpable along the banks of the Arno—even though they are here no less majestic than at Florence. Fortunately, the impression of gloom lifts from time to time. In June, the river throbs with the excitement of an annual regatta. And on the Piazza dei Cavalieri in the heart of the old city, a youthful spirit reigns virtually throughout the year. The grandiose Palazzo dei Cavalieri has since 1810 housed a graduate school founded by Napoleon in imitation of the French École Normale Supérieure on the Rue d'Ulm in Paris. Similar animation can be found on the Piazza Dante, seat of the University of Pisa, an institution founded in the twelfth century with support from the Medici family.

Pisa, birthplace of Galileo, has thus managed to retain its role as an intellectual center, with its large student population serving to spare it from the depressing atmosphere of places overwhelmed by the weight of their own past.

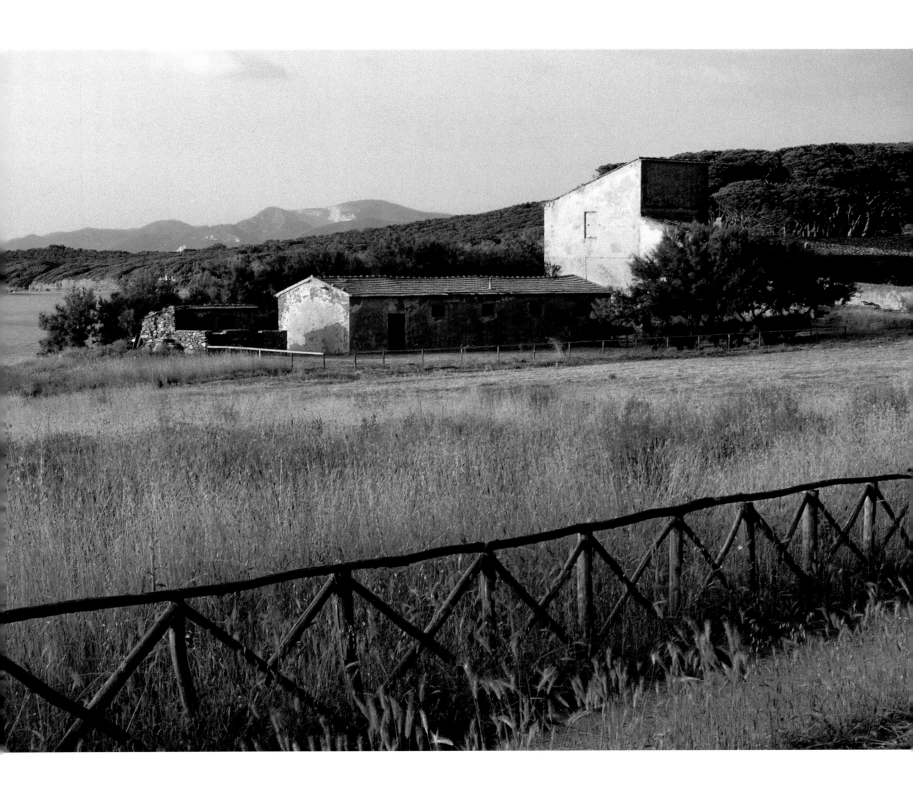

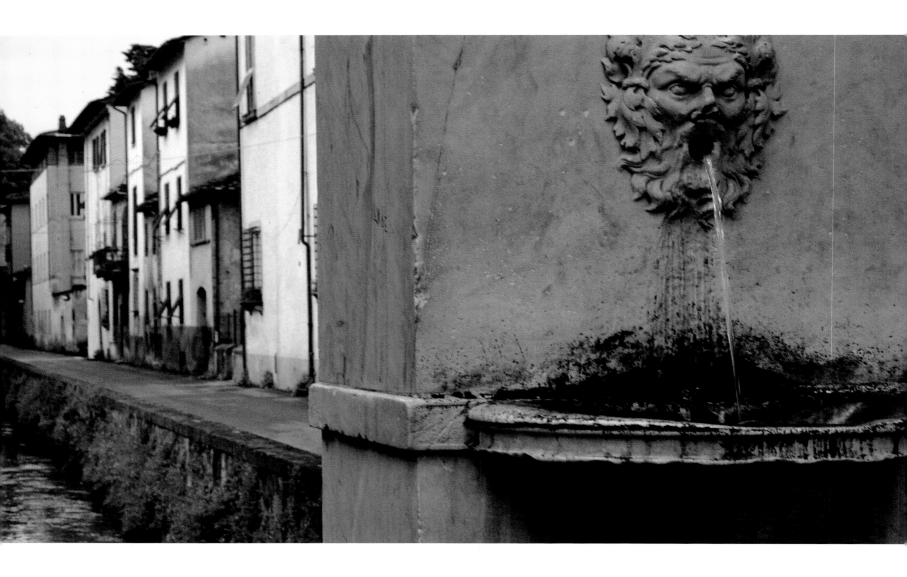

LUCCA IS STILL SURROUNDED BY
THE BRICK WALLS THAT FOR
CENTURIES PROTECTED ITS
INDEPENDENCE. TODAY THE WALL
PROVIDES A MARVELOUS PLACE
FOR STROLLERS (RIGHT).

THE VIA DEL FOSSO, ONCE HOME TO
THE DYERS' TRADE, HAS RETAINED
ITS SOMEWHAT MELANCHOLY CANAL
AND FOUNTAIN (ABOVE).

LUCCA AND ITS REGION

Lucca is a paradoxical town. Its location should make it one of the best-known cities in Italy. And yet this has never been the case—almost as if it has managed to preserve its mystery behind the fortifications built in the sixteenth century to safeguard its freedom. For Lucca never succumbed to the Medici. A rival of Pisa's during the Middle Ages, it remained an independent republic for four centuries. Napoleon made it a principality for his sister Elisa Bacciochi. However, it is not merely the vestiges of this historic past that make strolling through Lucca a unique experience: few other towns have succeeded as well in restoring life to a ground-plan inherited from antiquity. The squares and streets of the modern city basically follow lines laid down two thousand years ago. The magnificent Church of San Michele in Foro opens onto an ancient forum; the Piazza del Mercato follows the elliptical shape of a Roman amphitheater; the busy Via Fillungo—lined with numerous shops that have retained their 1900s décor—follows the *cardo* (north-south axis) of the old Roman city.

But there is nothing static about Lucca's visual impact: medieval monuments, Renaissance and seventeenth-century *palazzi*, and buildings dating from the Napoleonic era create a harmonious whole to which even modest dwellings contribute. Visitors should definitely take a stroll along the charmingly melancholy Via del Fosso and the tranquil canal flowing beside it. This section of the city, which still has a definite working-class flavor, was once the center of the dyers' trade. The area around the fortifications, which in other towns is often disfigured by modern development, has here been turned into a superb public park. Not far from this circular girdle of brick stand numerous cafés and restaurants, some of which are renowned for the particularly delectable local cuisine of Lucca. Admirers of Puccini will want to visit the house where he was born, now a museum. My personal preference, however, is the cathedral. Here we find the tomb of Ilaria del Carretto, deceased in 1405, the youthful wife of a Lucca potentate. The funerary sculpture by Jacopo della Quercia is one of those all-too-rare works in which the perfection of the artistry projects an idea of eternity.

By contrast with other more exuberant regions of Italy, the colors of Lucca — as of Tuscany in general — are relatively muted. Their elegant nuances blend with those of the local stone (above, top and bottom).

The Piazza del Mercato in Lucca is designed to follow the ellipse of the old Roman amphitheater. The houses around it, most of them modest, have retained only a few of their arcades (following double page).

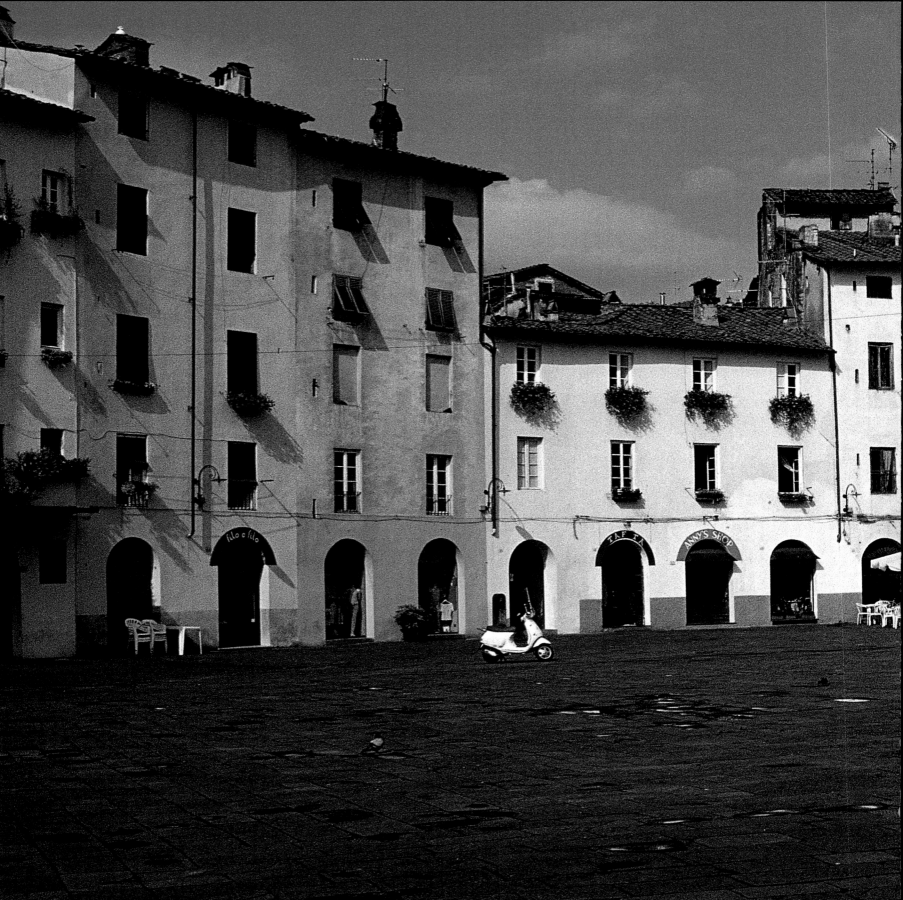

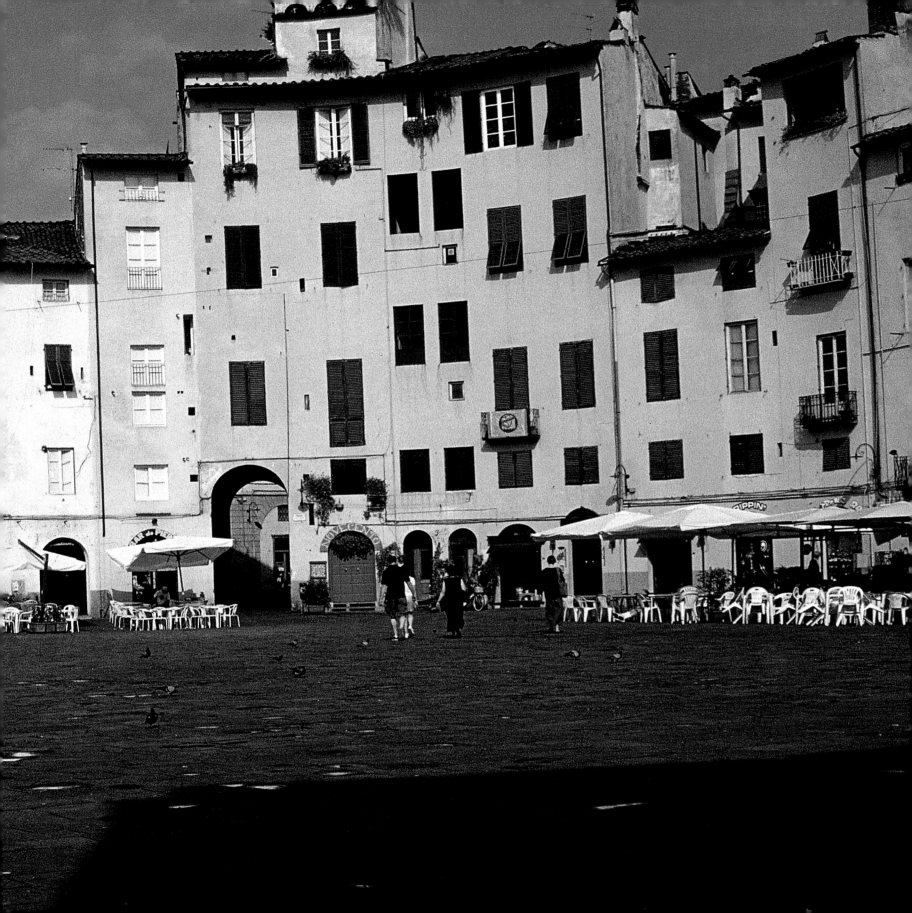

AN INTRIGUING MAZE ETCHED
ONTO THE FAÇADE OF LUCCA'S
CATHEDRAL—A REMINDER OF THE
VICISSITUDES OF EARTHLY LIFE ON
THE ROAD TO SALVATION (ABOVE).
WITH ITS FACING OF MARBLE
EXCAVATED FROM THE QUARRIES
AROUND CARRARA, LUCCA
CATHEDRAL RECALLS THE
CHURCHES OF PISA, ITS GREAT
TWELFTH-CENTURY RIVAL. TODAY
THIS PROFUSION OF MARBLE IS THE
MOST VISIBLE SIGN OF THE FORMER
POWER AND OPULENCE OF THE
OLD ITALIAN CITY-STATES (RIGHT).

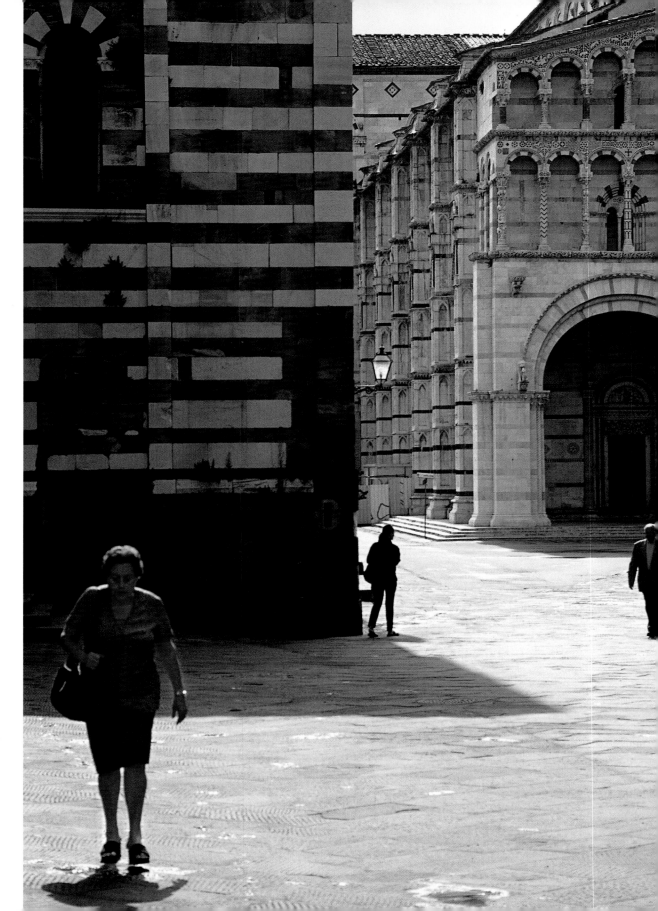

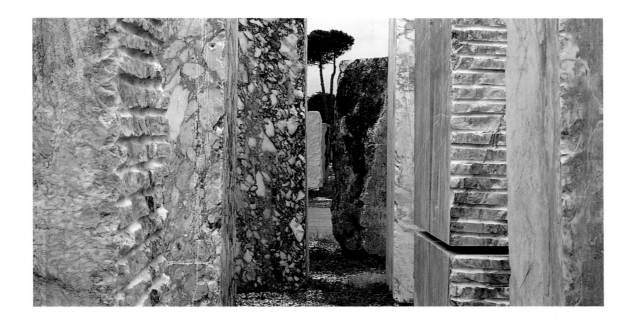

IN PIETRASANTA, STILL HAUNTED

BY THE MEMORY OF MICHELANGELO,

A FOREST OF MARBLE BLOCKS FROM

THE CARRARA REGION EXHIBITS

THE DIVERSITY OF THE VEINS

(SOME OF THEM NOW EXHAUSTED)

YIELDING THE PRECIOUS MATERIAL

(LEFT).

MARBLE COUNTRY

Along the coast northwest of Lucca lies a strip of land that has been the scene of bitter conflict over the centuries. This is Versilia, a coastal plain boasting renowned beaches such as Viareggio and Forte dei Marmi, the cities of Massa and Carrara, and the Apuan Alps. Travelers approaching Tuscany via the Ligurian coast in summertime always wonder if they're dreaming: the peaks and slopes of the steep mountains facing them are white—as if covered in snow. But there is no snow on these jagged crags. What travelers see are the incisions cut and then deepened over two millennia in order to extract the mountains' marble. Man and nature have waged a merciless battle with each other on these cliffs, and it is difficult to imagine, today, how harsh the battle must have been before the invention of modern machinery. It is not by chance that Massa and Carrara have traditionally served as strongholds for the most radical anarchists. Following laborious negotiations, a nature park was finally established on a large part of the Apuan Alps, the peaks of which rise to over 1,800 meters in height. The quarries are particularly impressive on the slopes of Mount Altissimo and Mount Corchia, which have been excavated to a stupefying depth. Here and there, vestiges of the wooden ladders once used to slide the huge blocks of stone down onto the plain can still be seen.

Elsewhere, however, the landscape is almost completely unspoiled. In the mid-summer heat, you might enjoy a dip in the waters of the aptly named Frigido, a stream rising near Forno. Its whirlpools have dug marble swimming pools into the torrent's bed. Serravezza and (especially) Pietrasanta, in the back country around Versilia, are still haunted by the memory of Michelangelo; the marble industry continues to support over one thousand workshops in the region. The little town of Pietrasanta, founded in the thirteenth century by Lucca, has great charm. It has retained its medieval layout and the Duomo with its fine marble façade. The adjacent bell tower remains unfinished: its undressed-brick outer walls produce a highly modern geometric effect. If allowed, you should attempt the climb to its summit. The spiral staircase is one of only two in the world with this type of brick construction, a constant challenge to the laws of equilibrium. The world's greatest sculptors have been drawn to Pietrasanta—Henry Moore visited often—and you're likely to run into some at the Bar Michelangelo, the terrace of which is an ideal spot for viewing the central square.

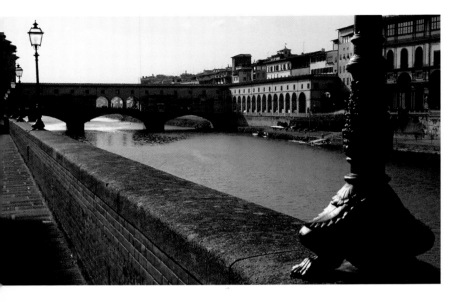

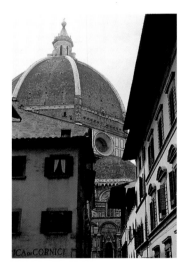

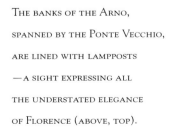

THE BANKS OF THE ARNO, SPANNED BY THE PONTE VECCHIO, ARE LINED WITH LAMPPOSTS —A SIGHT EXPRESSING ALL THE UNDERSTATED ELEGANCE OF FLORENCE (ABOVE, TOP).

THE DUOMO RISES ABOVE NARROW STREETS THAT HAVE RUN THROUGH THE CITY SINCE THE MIDDLE AGES. TODAY, THERE STILL EXIST MANY SILENT, SECRET BYWAYS IN FLORENCE (ABOVE, LEFT AND RIGHT).

BACK TO FLORENCE

Florence is partially concealed, as you approach it, by the sprawling suburbs that now prevent new arrivals from seeing the dome of the cathedral as clearly as they once could. The best vantage point for surveying the capital of Tuscany is from the hills of Castello or Fiesole. Seen from above, Florence appears as flat and horizontal as Rome is steep and vertical, but this expanse provides a dramatic backdrop for the tower of the Palazzo della Signora, the dome of the cathedral, and the lofty bell tower of Santa Maria del Fiore. The city must have looked very different during the Middle Ages, before its noble towers were razed. Perhaps their demolition, a military decision in response to the invention of artillery, may also have expressed deeper imperatives. For Florence, universally renowned, admired, and crowded during most of the year by a dense horde of tourists, is actually one of the most secret of all Italy's great cities. In the historic city center, it's still possible to find places like the Piazza dell'Annunziata that have escaped the tourist invasion. A section of the city such as Santa Croce, despite the importance of the basilica with the same name—the Pantheon to Florentine genius—remains off the beaten track. It is not mere coincidence that some of the restaurants favored by the Florentines themselves are located here—the Enoteca Pinchiorri and the Cibreo, to name the most famous. There are many small squares like the Piazza San Piero, which fills every morning with the sounds and colors of a little street market. Near the Cibreo, the Mercato Sant'Ambrogio is still supplied by farm carts rolling in from the surrounding countryside. It is in this section of the city that one is most likely to find old-fashioned tripe-sandwich (*lampredotto*) vendors, dozens of whom once used to market their wares all over town.

On the opposite bank of the Arno, you have only to take a few steps away from the Pitti Palace and the Via dei Guicciardini linking it with the Ponte Vecchio in order to enjoy the same impression of a "real" city. And yet, even in this less visited Oltrarno district you have the Masaccios in the Church of Santa Maria del Carmine, the architecture of Santo Spirito, the fabulous displays of antiques in shops housed on the ground floor of the

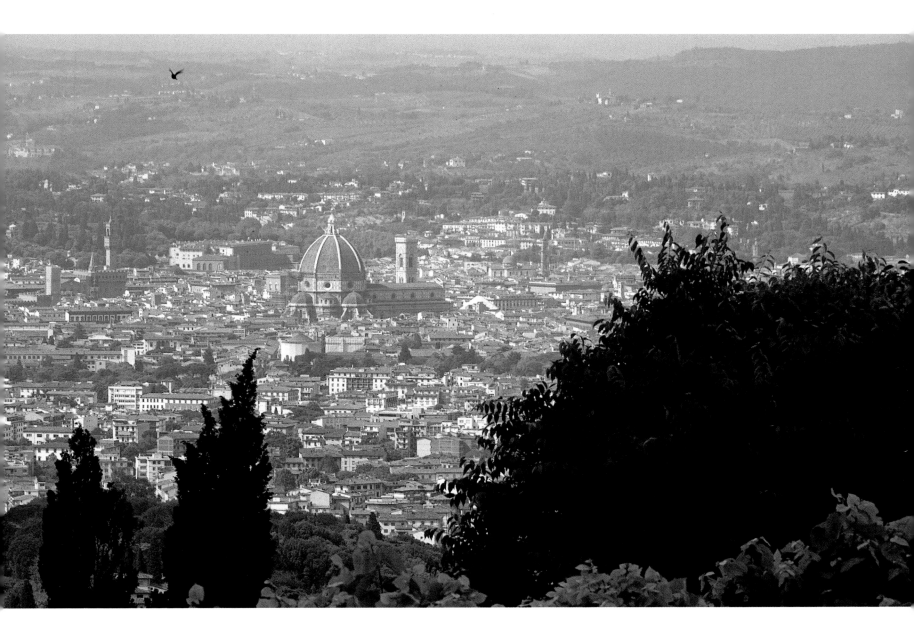

IT IS ALWAYS A THRILL TO VIEW
FLORENCE FROM FIESOLE. EVEN
WHEN THE PLAIN IS VEILED IN MIST,
THE CITY'S MONUMENTS BREAK
THROUGH. BRUNELLESCHI'S DOME
AND GIOTTO'S BELL TOWER STAND
OUT LIKE GUARDIANS OF THE CITY
(ABOVE).
THE PONTE VECCHIO SPANNING THE
ARNO IS AN EMBLEM AS FAMOUS AS
THE TOWER OF PISA. LINED WITH
JEWELERS' SHOPS, THE BRIDGE HAS
RETAINED ITS VIRTUALLY SECRET
UPPER CORRIDOR CONNECTING BACK
ROOMS WITH THE PITTI PALACE AND
HOUSING HUNDREDS OF ARTWORKS
(FOLLOWING DOUBLE PAGE).

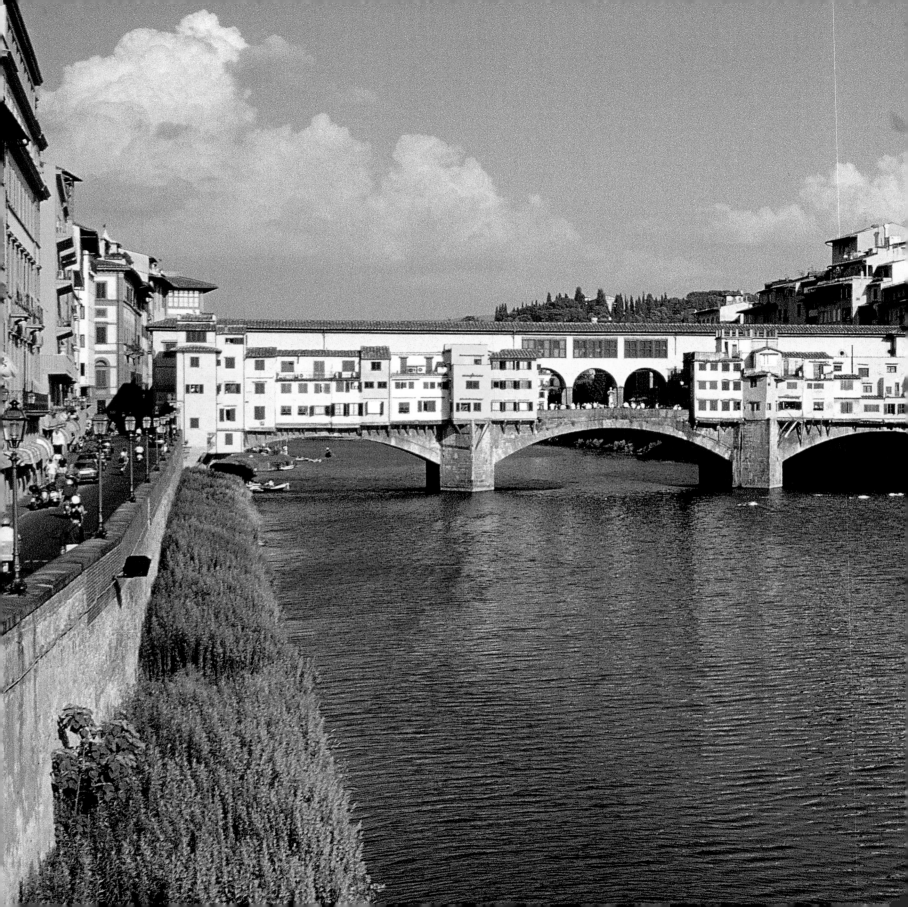

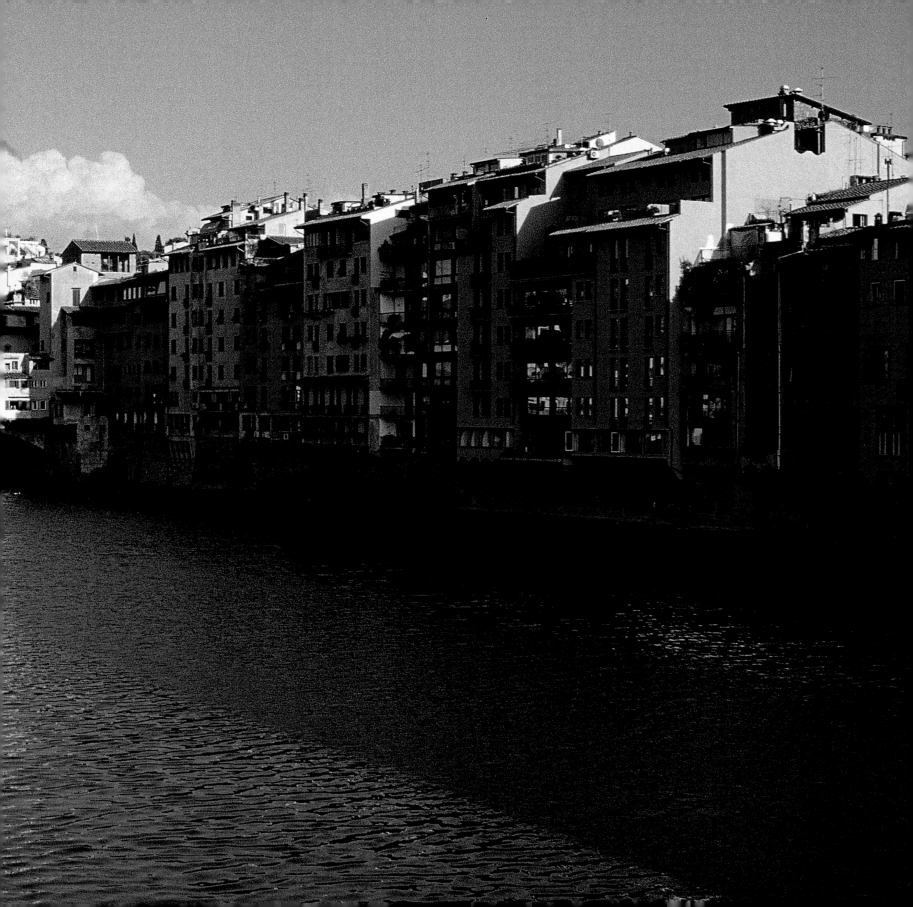

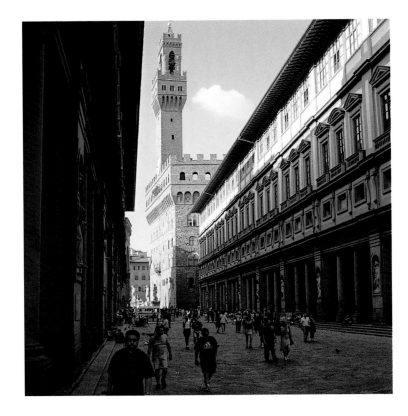

palaces lining the Via Maggio, and the authentic craftsmen who—like those to be found at the Antico Setificio Fiorentino near San Frediano—perpetuate the tradition of ancient skills. When it comes to the more famous museums and monuments, however, it is wise to wait for January or February before venturing a visit, since this is just about the only time of year when you can actually see the works of art. There is one question, however—as Sergio Romano notes—to which there is no definite answer: where do you start when you visit Florence? Julien Green tells us that his first hours in Florence were always devoted to the San Marco convent and the frescoes by Fra Angelico. Bernard Berenson, one of the twentieth century's greatest art historians, had a weakness for Botticelli's extraordinary *Saint Augustine*—which one can almost always view in virtual solitude, although the Church of Ognissanti housing it is right in the middle of town.

People who are not Florentines born-and-bred should plan itineraries

revealing the true spirit of the city. Florence still boasts a maze of mysterious subterranean networks analogous to the aerial passageways that once linked the tops of its towers. For many years the only way to reach Giotto's bell tower from the Duomo was by wooden footbridge, another one of which was used by bishops so they could walk from their palaces to the Baptistery without having to mingle with the crowds in the street. To connect the Palazzo Vecchio with the Palazzo Pitti, Cosimo I commissioned construction of the Corridoio Vasariano, an interminable corridor running under the Arno and wide enough to accommodate a small mule-cart. Following lengthy restoration of the art works lining it over a distance of more one kilometer, it has now finally been reopened to the public.

A sun-drenched city of perfect architectural equilibrium, Florence also disconcerts with its artful play of shadows. The broad avenues inaugurated during the nineteenth century replaced old districts gutted for the purpose—a French urban-development model imported by the Piedmontese that, fortunately, was discontinued after Rome became the country's capital. Florence can dismay both those who find it too sensual and those who find it too cerebral. Théophile Gautier, in his *Voyage en Italie*, emphasized the city's melancholy: "The tall houses, with their somber façades, lack the white southern gaiety one expects to find." To be fair, "severe" would be a better word than "somber," and the austere gray-and-ocher tints of Florence's plaster and stone can at sunset seem to be dusted with gold. This city, perceived as harsh and merciless by observers as various as Savonarola, Dante, Leonardo da Vinci, and Michelangelo, is also indifferent to the opinions of others. And yet, anyone open to the city's inner spirit will discover increasing joy there. Very few outsiders can claim truly to know Florence, but each visit provides an incentive to return. It is an experience available to all: from the surrounding hillsides and "rooms with a view" to the banks of the Arno and garret windows on the rooftops, from the shadows of its narrow streets to its café terraces and the courtyards of its palaces, Florence constantly turns a new face to the observer. As Bernard Comment put it, this is one of the rare cities capable of giving one "the feeling, perhaps, of mastering time, of bathing in the wellspring of eternity."

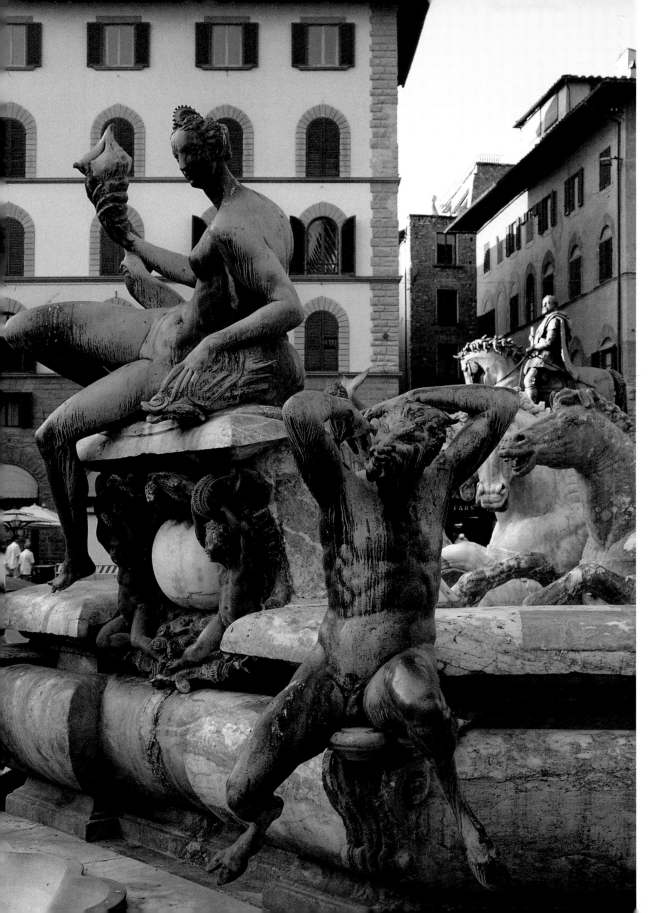

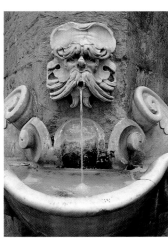

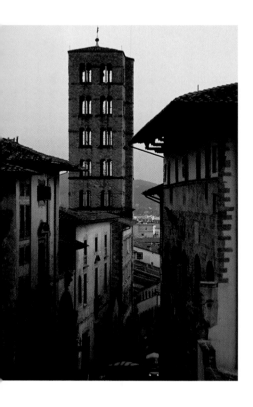

THE OPEN FIVE-STORY BELL TOWER
OF PIEVE DI SANTA MARIA IS ONE
OF AREZZO'S MAJOR LANDMARKS
(ABOVE).

THE APSE OF THE CHURCH OPENS
ONTO THE ARCADED PIAZZA
GRANDE, DESIGNED BY NATIVE
SON VASARI AND ONE OF THE MOST
THEATRICAL IN ITALY. HERE,
ANTIQUE DEALERS FROM ALL
OVER THE WORLD PREPARE FOR
THE ANTIQUES FAIR SCHEDULED
TO OPEN THE NEXT DAY (RIGHT).

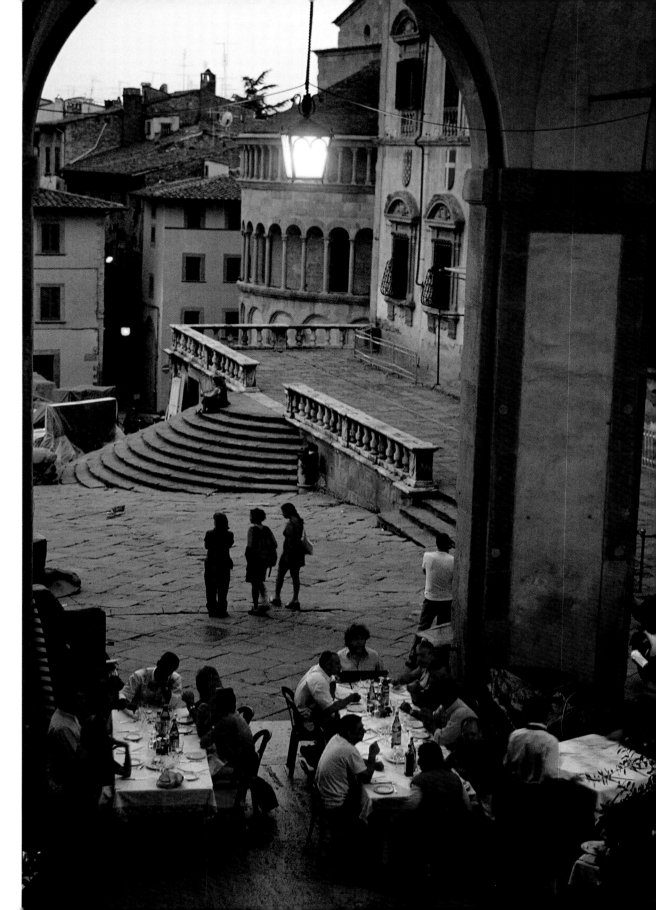

THE ETRUSCAN CITIES OF AREZZO AND CORTONA

As we leave the grandeur of Florence behind us, the road returning to
Montepulciano, our starting-point, holds fresh surprises in store. Arezzo, still
enclosed within its ancient ramparts, is built around the Piazza Grande—in
late August the scene of a tournament dating from medieval times. It is here
that the famous Chimera proudly displayed in the Florence archeological
museum was discovered. This vast square is a lesson in history and
architecture from Roman times to the end of the Renaissance, as exemplified
in the late-sixteenth-century arcades designed by Vasari, a native of Arezzo.
The Piazza Grande, although ancient, is still very much alive. On the first
Sunday of every month it serves as backdrop for one of the most important
antique markets in Italy—an illustration of the Tuscan ability to integrate art
with everyday life. Arezzo would be famous enough merely as the birthplace
of Petrarch and Vasari. Their houses are still standing, and Vasari's (designed
by the master himself) is worth a visit. But the city's true glory is the mark left
on it by one of the greatest geniuses of the Renaissance. Piero della Francesca,
born in Sansepolcro, less than forty kilometers to the northwest, painted the
frescoes in the Church of San Francesco depicting the *Legend of the True
Cross*—from the death of Adam, buried with seeds from the tree said to have
provided the wood for the cross on which Christ died, through discovery of
the three Crosses from Calvary by the Empress Helena. Berenson ranked this
fresco cycle as high as the frieze on the Parthenon.

Cortona is perched on a steep hillside straddling the border between
Tuscany and Umbria, not far from the Lake of Trasimenus (now Trasimeno)
where Hannibal triumphed over the Roman legions. This antique town of
Etruscan origin is perhaps one of the best preserved in the region, and
definitely one of those with the most character. A breeding ground for artists
past and present—from Pietro da Cortona through Severini, three centuries
later—Cortona is similar in many ways to its distant counterpart,
Montepulciano, standing across the mist rising from the Valdichiana. When
strolling through the narrow streets of Cortona, be sure to stop for a quiet
moment of reflection before Fra Angelico's *Annunciation*.

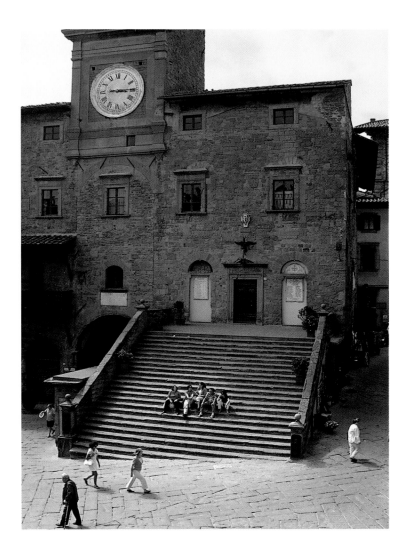

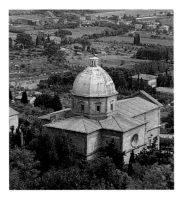

THE COMMUNAL PALACE (TOWN
HALL) OF CORTONA SURMOUNTS
A SWEEPING STAIRCASE. THE SQUARE
HAS STOOD AT THE HEART OF THE
CITY FROM ANCIENT TIMES (ABOVE).
A SHORT DISTANCE FROM
CORTONA, THE MADONNA DEL
CALCINAIO OVERLOOKS THE PLAIN
OF VALDICHIANA (LEFT).

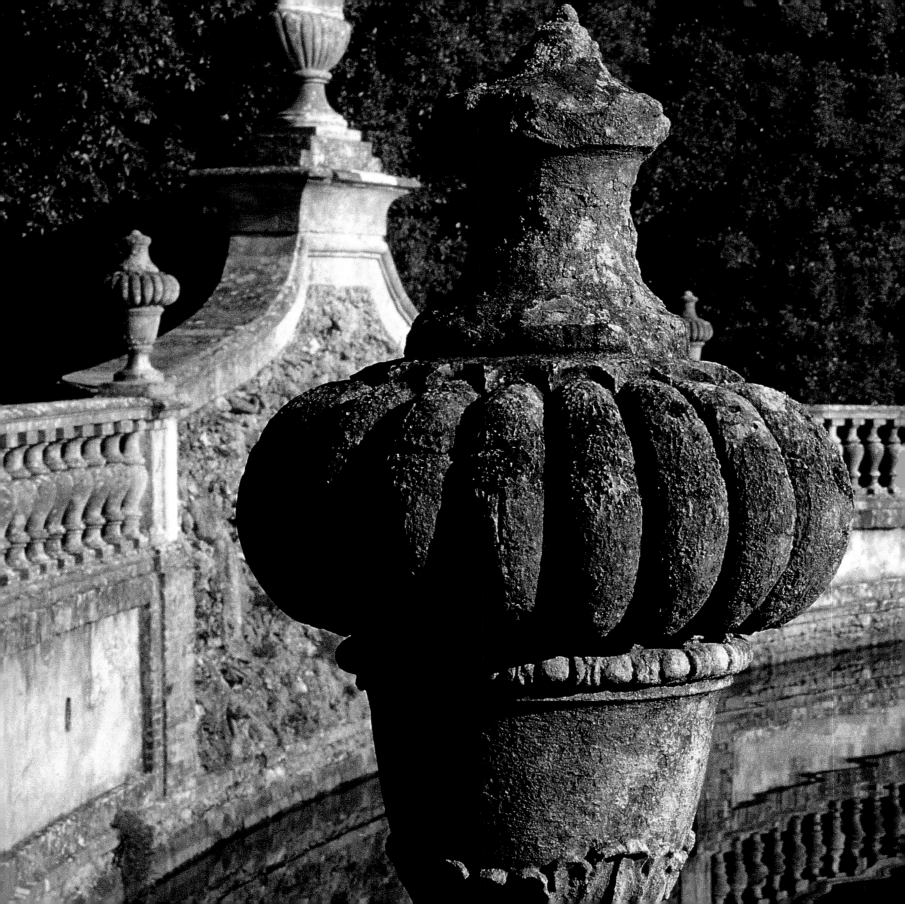

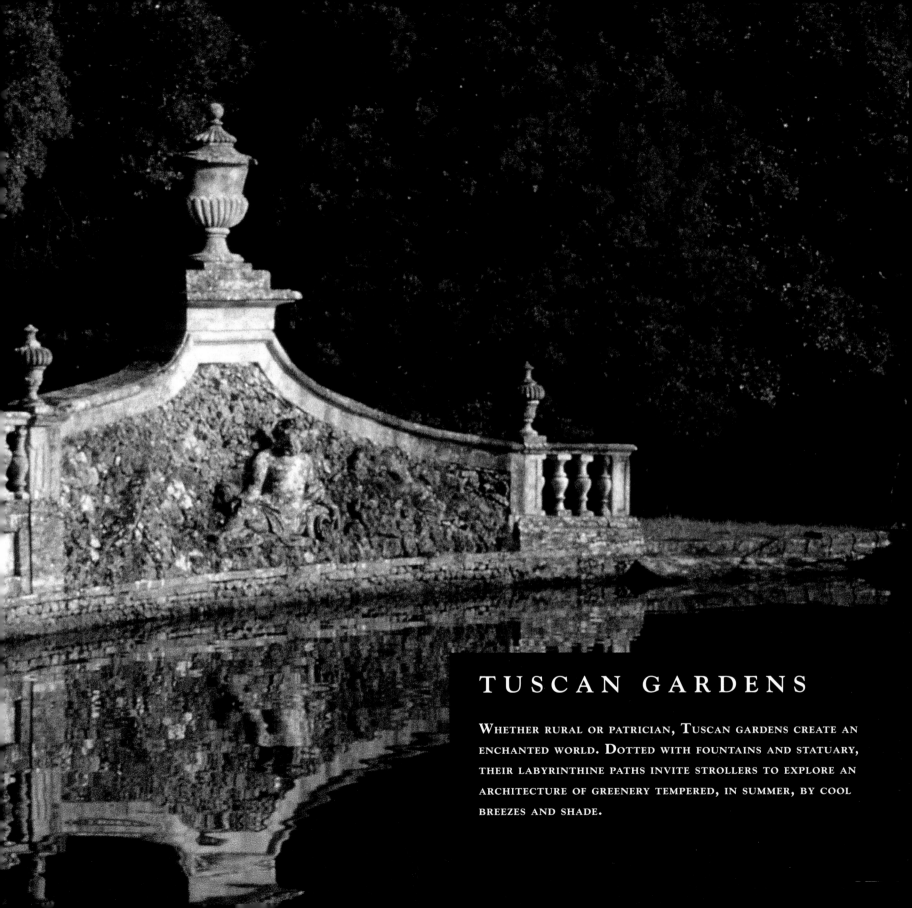

TUSCAN GARDENS

WHETHER RURAL OR PATRICIAN, TUSCAN GARDENS CREATE AN
ENCHANTED WORLD. DOTTED WITH FOUNTAINS AND STATUARY,
THEIR LABYRINTHINE PATHS INVITE STROLLERS TO EXPLORE AN
ARCHITECTURE OF GREENERY TEMPERED, IN SUMMER, BY COOL
BREEZES AND SHADE.

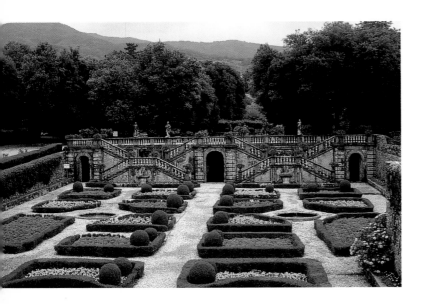

Tuscany is the chosen land of the villa. Perhaps even more so than Venezia, despite Palladio; and definitely more so than Rome, despite Frascati and CastelGandolfo. In the fourteenth century, Florence was already surrounded by villas reputedly numbering in the thousands. With the flowering of the Renaissance, they became even more important: Lorenzo the Magnificent spent much of his youth at Caffagiolo, and chose to end his days at Careggi—where the philosopher Marcilio Ficino, with whom he maintained close bonds of friendship, headed the new Platonic academy. In our own day, La Petraia, Poggio a Caiano (founded by the Medici dynasty), and Gamberaia, all open to the public, exemplify the rise of the Florentine villa.

Florence is not unique in this domain, however. The outskirts of Siena and Pisa (once ruled by their great rival), as well as those of Lucca, are dotted with magnificent villas such as Torrigiani and Mansi. The early nineteenth century witnessed the advent of neoclassicism, followed by the fashion for romantic styles—particularly the neo-Gothic—resulting in the redesign of numerous gardens according to the canons of "English" taste. Paradoxically, in a subsequent phase, it was often erudite Englishmen, such as Harold Acton, who contributed to the return of the "Italian" garden.

As a symbol of the bonds between city and country, and the reflection of a society obsessed with elegance and culture, the Tuscan villa in its most aristocratic guise was of course confined to a small minority; but it was also the ultimate expression of a widespread aspiration that we too, in our own time, find in less opulent forms. Many of these historic villas are privately owned, often by old Tuscan families; others belong to the nation; and still others have been converted into centers for research and scholarship. The following itinerary includes some of the most notable examples of the genre.

THE MEMORY OF VERSAILLES HAUNTS THE VILLA TORRIGIANI GARDEN NEAR LUCCA, BUT ITS COMPOSITION UNDERSCORES THE INTIMACY OF THE SITE AS MUCH AS ITS MAJESTY (ABOVE). IN THE SHADE OF TALL EVERGREEN OAKS AT CELSA, NEAR SIENA, A STONE BALUSTRADE IS REFLECTED IN THE TRANQUIL WATERS OF A POOL (PREVIOUS DOUBLE PAGE).

THE AMPHITHEATER OF GREENERY CURVING BEHIND THE PITTI PALACE IS STUDDED WITH STATUARY —AN INGENIOUS METHOD FOR ENHANCING THE EFFECT OF THE HILL BLOCKING THE VIEW ON ONE SIDE (ABOVE). THE PITTI PALACE, RESIDENCE OF THE GRAND DUKES FOR ALMOST THREE CENTURIES, IS THE LARGEST IN FLORENCE. IT TOOK TWO HUNDRED YEARS TO CONSTRUCT, BUT ITS ARCHITECTURE FAITHFULLY REFLECTS THE INITIAL PLANS OF AMMANNATI, WHOSE FOUNTAINS AND GARDENS SOFTEN ITS SEVERITY (RIGHT).

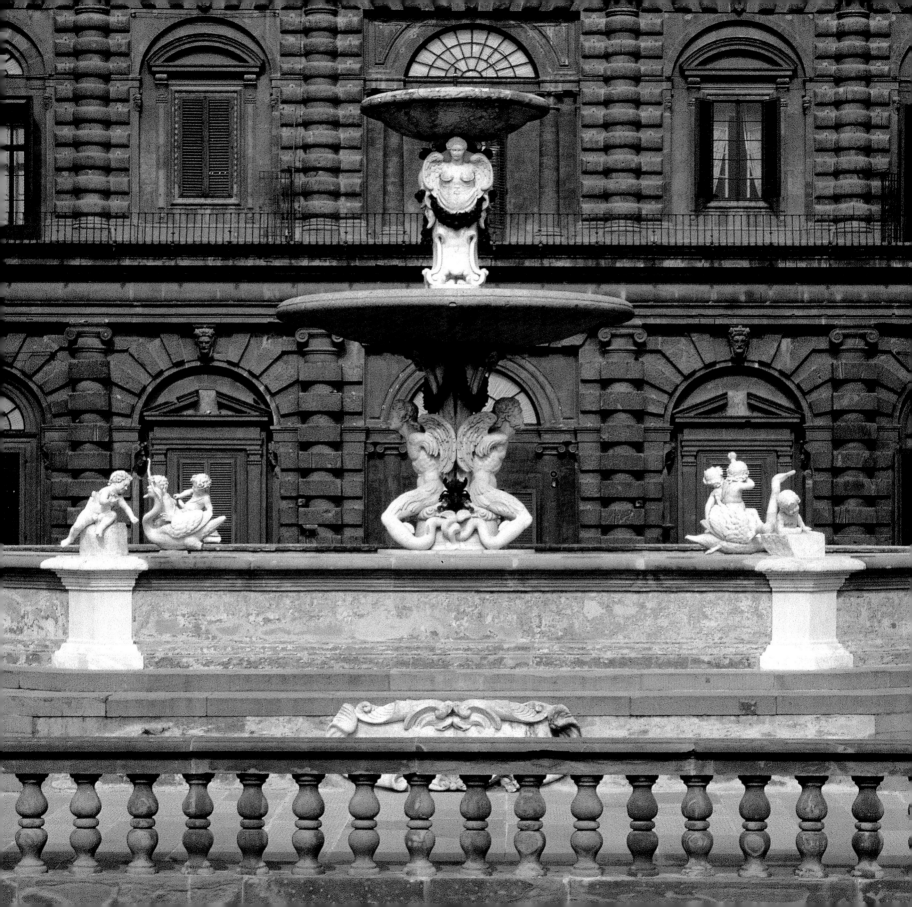

THE GARDENS OF THE MEDICIS

Throughout the rise of their dynasty, the Medici family consistently reserved for their own use in Florence and the surrounding countryside havens of peace and refuges that survive today. Although tucked away in a maze of back roads and therefore difficult to find, these historic villas are well worth the effort involved in seeking them out. Some, such as the Renaissance villas of Castello and La Petraia located in the little town of Castello, and Poggio a Caiano southwest of Florence, are open to the public. The park at Castello contains a remarkable grotto filled with stunningly realistic animal sculptures, and the interior (sadly not open to the public) is the headquarters of the famed Accademia della Crusca that for centuries past has worked to safeguard the purity of the Tuscan language. Other villas are in private hands and can only be toured by appointment. Our journey begins in Fiesole at a privately owned villa with a glorious past, and continues through the less familiar portions of the Boboli Gardens in Florence.

The Villa Medici in Fiesole

The Fiesole hill is universally famous—and rightly so—for its view of Florence. The mist that often veils the city's great monuments enhances the sense of grandeur. It is thus hardly surprising that the Medici chose the slopes of Fiesole as the site for the first villa designed in a new spirit, the first to shed the influence of the Middle Ages. Giovanni de' Medici, son of Cosimo the Elder, commissioned its construction, which lasted from 1451 to 1457. Giovanni was a humanist with close ties to Leon Battista Alberti, and the blueprints for the original villa—probably from the hand of Michelozzo—appear totally consistent with the rules laid down by this great architectural theoretician. The estate was inherited by Lorenzo the Magnificent, who made it (along with the Villa Careggi) a favored meeting place and refuge for the great artists and intellectuals of his time. It is at Fiesole that Poliziano composed his great pastoral poem, *Rusticus*, in honor of Virgil, and where humanist Cristoforo Landino wrote his commentaries on Dante. The villa remained the property of the Medici family until 1671, after which it changed hands repeatedly, ultimately becoming a center for Florence's English community. Horace Walpole's sister, who acquired it in 1772, made substantial changes to both house and garden. Additional renovations were undertaken in the twentieth century by the parents of writer Iris Origo, who in her autobiography *Images and Shadows* recounts the story of her Fiesole childhood. The atmosphere was cosmopolitan in the best sense of the term: the reigning spirit was open, tolerant, and focused on art and culture. The leading lights of Florence's Anglo-American circle, led by Bernard Berenson and Geoffrey Scott, had their headquarters at the villa. It was during this period that architect Cecil Pinsent redesigned part of the garden in a Quattrocento spirit, thus contributing decisively to the renewal of the Italian garden style characteristic of the interwar years. The villa's current owners are dedicated to the restoration and maintenance of this humanistic gem whose original design has survived intact despite successive modifications. Today as in the past, the view of Florence from its terraces is breathtaking, especially from the little belvedere added in the eighteenth century that seems suspended over the void.

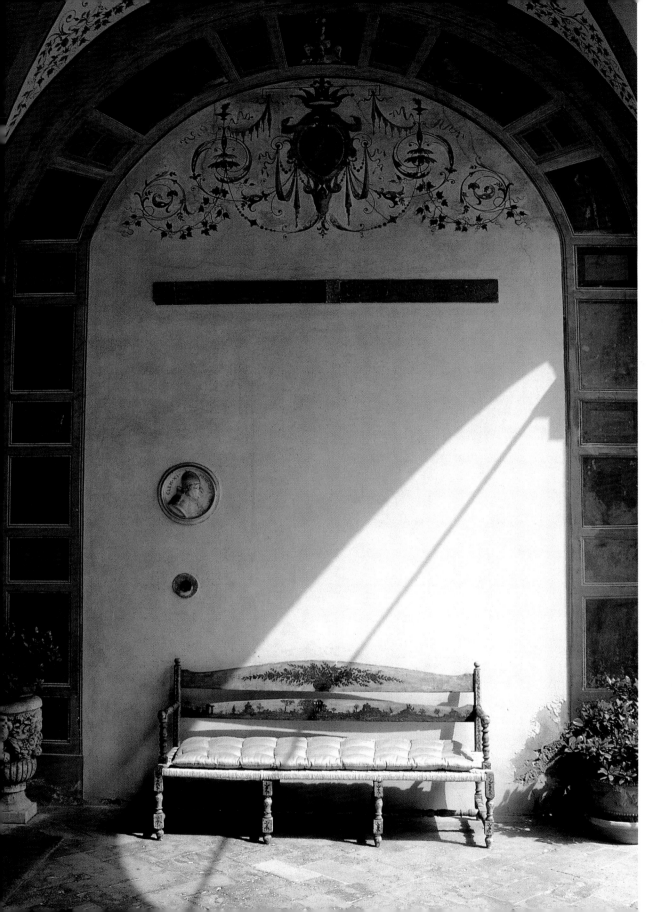

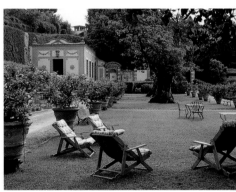

THE VILLA MEDICI IN FIESOLE,
WITH ITS SERIES OF TERRACES BUILT
INTO THE SIDE OF A HILL (FAR LEFT).
UNDER THE LOGGIA, AN EIGHTEENTH-
CENTURY BENCH BATHED IN
SUNLIGHT BENEATH A MEDALLION
DEPICTING A MEDICI POPE (LEFT).
DECK CHAIRS ARE AN INVITATION TO
RELAX (ABOVE, BOTTOM). THIS
STATUE IS HIDDEN IN A CORNER OF
THE GARDEN (ABOVE, TOP).

Boboli, or the Grand Duke's Gardens in Florence

The Boboli Gardens, which extend over an entire hillside behind the Pitti Palace, are a world in themselves. All too many visitors, wilting in the summer heat and choking on the dust, turn back after a painful climb up the lower slopes. Long maintained haphazardly and only recently benefiting from a well thought-out restoration plan, the Boboli Gardens offer thousands of surprises to anyone taking the time to explore them thoroughly. One example is the secret garden to the right of the entrance, built on the same level as the palace's apartments. Although not much wider than a corridor, it offers a brilliant spectacle in March, when its mainly red magnolias—said by some to have been planted in the early nineteenth century—burst into vivid bloom.

The Knight's Garden, planted in the eighteenth century, offers a superb view of the surrounding hills dotted with villas among the trees. The layout of the flower beds has remained unchanged, but the medicinal herbs that once bordered the boxwood hedges have been replaced by roses that produce a magnificent riot of color from April onward. The path running along the medieval garden also has a distinctive charm. At some distance from the garden's main alleys, it is often deserted and beckons the weary to a moment of rest on the rim of the Mostarcini fountain—a long sloping stone trough adorned with figures of monsters. A monumental statue of Jupiter by Giovanni da Bologna serves as a beacon for those seeking this isolated portion of the garden.

The orangery facing this statue is another amazing spot. Constructed in the eighteenth century, during the House of Lorraine period, it is said to be the sole Florentine building to have retained its original color. Its delectably patinated pastel green has survived to remind us that Florence, deprived of its original colors in the nineteenth century in order to achieve a spirit of neo-Renaissance "purism," once turned a less austere face to the world. The orangery is usually closed to the public, but it is clearly visible in all the glory of its original pale green through a fine wrought-iron grill. When its doors are open, visitors can also glimpse the thousands of citrus trees it shelters during the fall and winter. This collection—the largest in Europe—was originally assembled by the Medici family.

A SECRET GARDEN LEADS INTO THE
APARTMENTS OF THE PITTI PALACE.
WHEN WINTER ENDS, IT BLOOMS
WITH A RIOT OF COLORFUL
MAGNOLIAS (FAR LEFT).
A FOUNTAIN ADORNS THE PITTI
PALACE'S SECRET GARDEN. ITS
MAGNOLIAS STAND OUT FROM THE
PALACE'S PATINATED WALLS (LEFT).
THE MEDICI ORANGERY, THE OLDEST
AND FINEST IN EUROPE, HOUSES
A VARIETY OF CITRUS TREES, SOME
OF THEM EXTREMELY RARE (ABOVE).

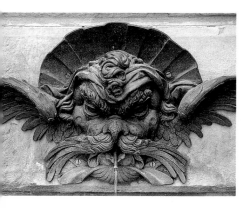

FOUNTAINS ARE OFTEN FED BY
WATER POURING FROM THE MOUTH
OF A BRONZE OR STONE MONSTER.
A FINE EXAMPLE CAN BE FOUND
ON THE MOSTARCINI FOUNTAIN IN
THE BOBOLI GARDENS (ABOVE).
A MAGNIFICENT WROUGHT-IRON
GRILL AT THE END OF AN ALLEY OF
CYPRESS TREES LEADS TO THE POOL
IN THE GARDEN AT CELSA, NEAR
SIENA. THE GARDEN'S COMPOSITION
ILLUSTRATES THE SPIRITUAL
REFINEMENT OF THE EIGHTEENTH
CENTURY (RIGHT).

SIENESE GARDENS

The spirit of the Renaissance—exemplified by the great architect Peruzzi—
spread to Siena before that city's defeat at the hands of the Florentines, when
many medieval dwellings were transformed into country manor houses. Now,
as then, the gardens of Siena maintain a unique relationship with the
surrounding countryside, perhaps the most beautiful in Tuscany. Most have
remained in private hands and still display the charm of family-owned estates.
Three of them, each very different from the others, opened their doors to us.

The Violets of Celsa

To the west of Siena stand the peaks of Monte Maggio and La Montagnola,
separated by a narrow, winding road. And then, far from any village, appears
the fortress-like shape of Celsa. A crenellated tower rises from a massive
construction that at first glance bears little resemblance to a country manor
house. The modern edifice is the successor to a medieval fortress belonging to
the Celsi family. It was first remodeled during the Renaissance and again
during the nineteenth century, to conform with the neo-Gothic style then in
fashion. It was then that the present tower was built, the crenellations
restored, Gothic windows added, and the park given the romantic treatment
it still exhibits today. The historic estate's heir, Livia Aldobrandini, and her
husband Giancarlo Pediconi have spared no effort in improving the property.
Their first priority was to restore the Italian-style garden below the castle.
The terraces descending the hillside have once more been planted with
geometric patterns of clipped boxwood hedge, their elegant design best
viewed from the vantage point of the house. The garden affords a magnificent
view of the surrounding countryside: a vast gap cleaves the two nearest hills,
and the bell towers of Siena—often veiled in mist—are visible from afar. This
view (apart from the modern electric pylons crossing it today) has remained
unchanged since the Renaissance, and even the occasional farmstead draws
the eye to its elegant overall design or some intriguing architectural detail.

The view is totally different on the other side of the castle, to the east.
There, a row of cypress trees crosses a meadow that forms a sort of natural

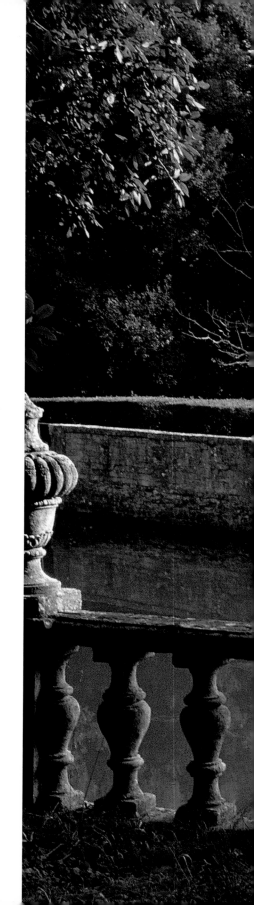

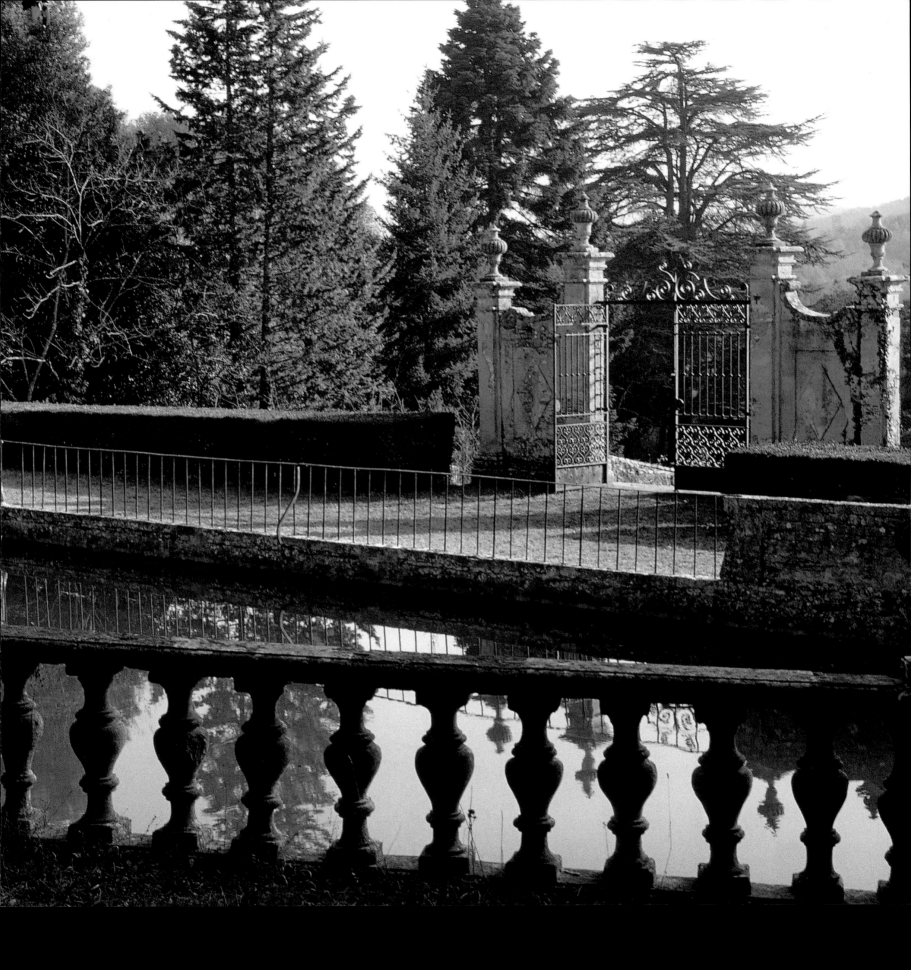

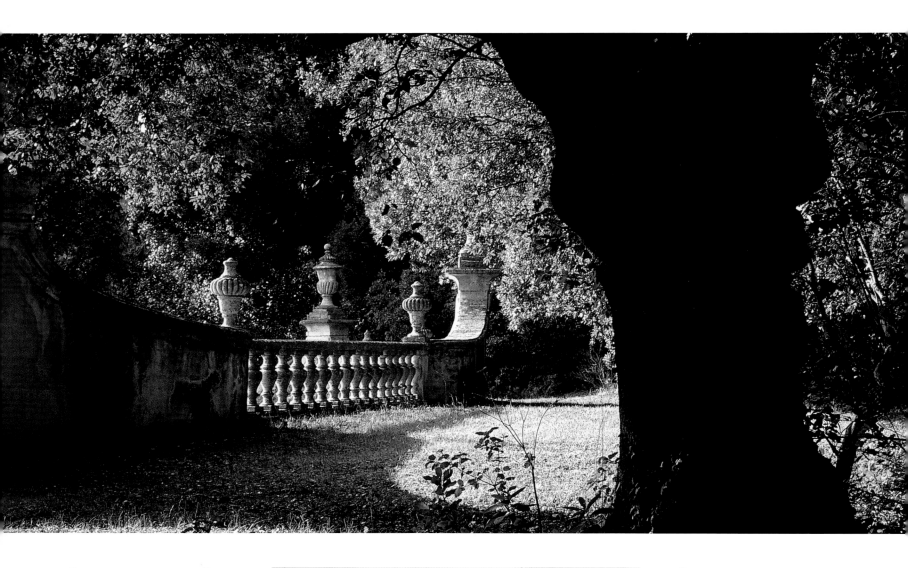

SOME AREAS OF THE PARK AT CELSA
ARE IMBUED WITH A ROMANTIC
ATMOSPHERE, SUCH AS THIS GLADE
LYING BEHIND THE POOL AND
CARPETED WITH VIOLETS IN EARLY
SPRING (ABOVE).

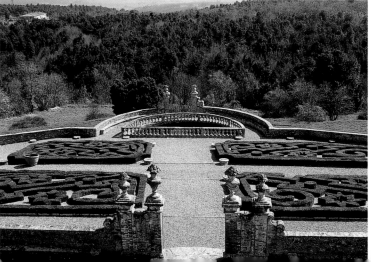

OFFERING A PEERLESS VIEW
OF THE HILLY SIENA LANDSCAPE,
THE TERRACE AT THE FOOT OF
CELSA CASTLE WITH ITS BOXWOOD
ARABESQUES (LEFT).

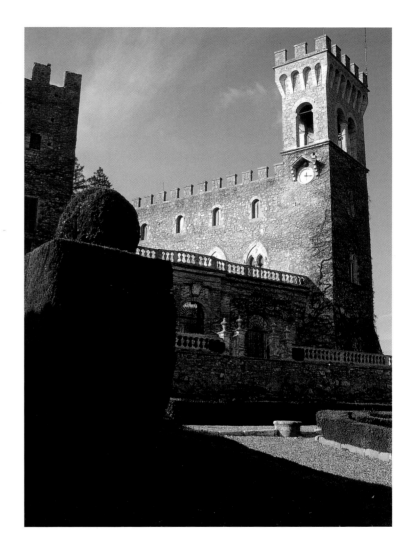

amphitheater below a dense forest. The road wends gently downward, and then climbs again toward a fine wrought-iron grill opening onto a large semicircular pool adorned with sculpture and sheltered by the branches of very ancient evergreen oaks. This eighteenth-century composition possesses a special charm derived from the serenity of the spot, the perception of a natural setting that is neither wild nor completely tamed, and the contrast between the beguiling lightness of the decor and the austere appearance of the castle—which on this side is at its most "Gothic."

The woods surrounding the fountain are crisscrossed by a radiating network of paths leading to such embellishments as an oratory and a semi-ruined tower once used for hawking. One fine spring day, Giancarlo showed me some of the unexpected views that suddenly emerge during walks along these paths. Thousands of violets strike a colorful note on the fallen oak leaves carpeting the ground. When we reached the wall bordering the estate, we came upon a miniature temple that I at first took for a storage shed. But the door was sealed and there was a bull's-eye window set into the building at eye level. When I peered through the lunette, I perceived, lit from some invisible opening, the inscription "MELANCHOLIA" carved on plaques of white marble artfully scattered within. What I had mistaken for a small utilitarian structure is actually an intriguing modern folly designed by artist Vittorio Messina.

CELSA CASTLE IS A COMPOSITE STRUCTURE. ITS INNER COURTYARD, COMPLETELY MEDIEVAL IN SPIRIT (ABOVE, LEFT), CONTRASTS WITH THE ELEGANT RENAISSANCE CHAPEL PROBABLY DESIGNED BY PERUZZI (ABOVE, CENTER).

THE BAROQUE PERIOD HAS LEFT ITS MARK ON THE ENTRANCE PORTICO, WHILE THE NEO-GOTHIC TASTE OF THE NINETEENTH CENTURY CAN BE SEEN IN THE MAIN TOWER (ABOVE, RIGHT).

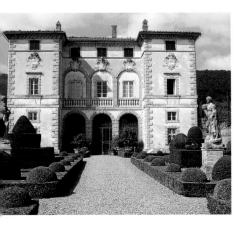

Cetinale, a Cardinal's Magnificent Penitential Retreat

A dirt road through the wild and rugged heart of La Montagnola leads from Celsa to the Villa di Cetinale, formerly owned by the Chigi family. Today this estate is owned by Lord Lambton, who over the past thirty years has spared no effort in restoring the property. The villa itself, commissioned in 1680 by Cardinal Flavio Chigi (nephew of Pope Alexander VII) is located not in the center, but on the outskirts of the park—one of the most extraordinary in Tuscany. Within its rigorously symbolic design, allusions to classical antiquity combine with, or lead to, emblems of Christianity. A long alley of cypress trees ends at the foot of a hill split down its entire length by a stone staircase. At the top of the stairs, a curious edifice with a gigantic crucifix carved on its wall seems to float in midair—the culminating point on a steep *Way of the Cross* the cardinal often climbed in order to atone for some self-perceived lapse in conduct. From this austere building, the Romitorio, he could contemplate the heavens while meditating far from his villa, symbolic of worldly pleasures. He undoubtedly also strolled through the park he designed on the hilltop and named the Thebaid (or refuge), a reference to the Egyptian Anchorites active during the early centuries of the Christian era. Beyond the fringes of the path lurk a collection of stone animals, now worn by erosion and covered in moss and lichen. Imperceptible at first, the shell of a giant snail, the carapace of a turtle, and the scaly hide of a dragon emerge only gradually from their hiding places in the underbrush.

Closer to the villa, the park sheds its sacred character, gaining in elegance while retaining its robust simplicity. The rows of cypresses will all be gone in a few years. In order to restore the view's initial breadth, these aging trees planted in the nineteenth century will not be replaced. The park's original design was based on architectural focal points now hidden by the trees: a monumental brick entranceway adorned with two colossal statues, a small natural theater at the foot of the Calvary, and various busts in the classical style. Above this gently sloping alley stands an olive grove; below it lie the horizontal pleasure gardens progressively added by Lord Lambton. The first is composed of orchards, and the most recent addition is a superb water garden.

THE ARCHITECTURE OF THE VILLA DI CETINALE NEAR SIENA IS A MODEL OF BAROQUE ELEGANCE FROM THE HAND OF CARLO FONTANA, WHO DESIGNED THE FAÇADE OF SAINT PETER'S IN ROME (LEFT, TOP). THIS MONUMENTAL GATEWAY WITH ITS STATUE OF A PRISONER-KING, SYMBOL OF PRIDE BROUGHT LOW, PRECEDES THE BEGINNING OF THE *WAY OF THE CROSS* CARDINAL CHIGI INSTALLED AT CETINALE (LEFT, BOTTOM). NUMEROUS MARVELOUSLY PATINATED STONE STATUES ARE DOTTED AROUND THE GARDENS OF CETINALE, CONTRASTING WITH ITS FLOWERING FRUIT TREES (RIGHT).

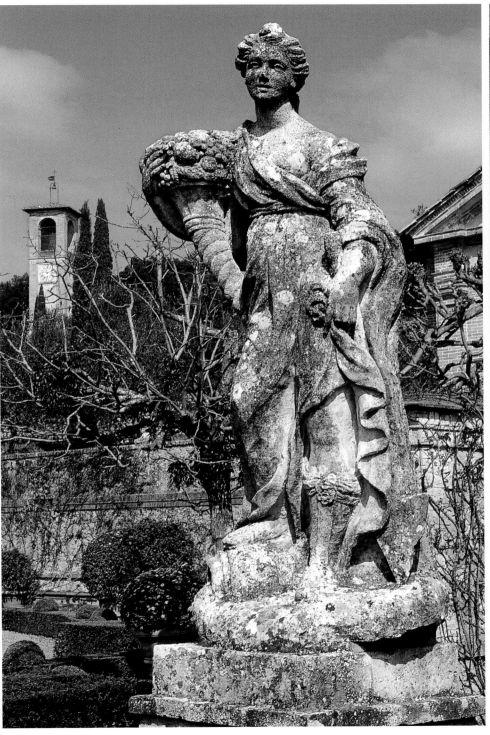

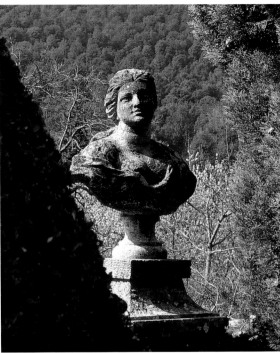

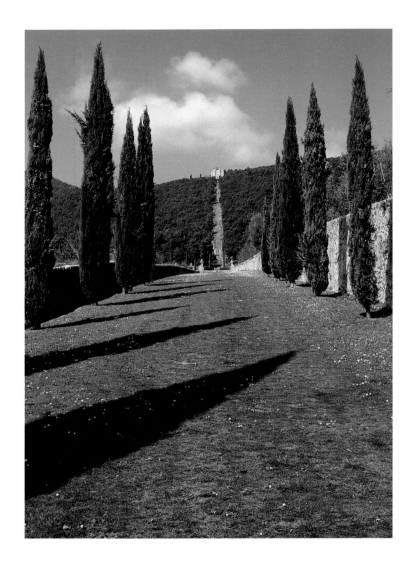

AN ALLEY LINED WITH CYPRESS TREES AND CARPETED WITH DAISIES LEADS TO THE FOOT OF THE HILL INTO WHICH THE *WAY OF THE CROSS* IS CUT. AFTER COMPLETING THE ARDUOUS CLIMB, CARDINAL CHIGI LIKED TO MEDITATE IN THE CURIOUS BUILDING OVERLOOKING THE STAIRCASE AND IN THE NEIGHBORING FOREST, WHERE SCULPTED MONSTERS EATEN AWAY BY TIME LURK IN THE SHRUBBERY. THE PARK AT CETINALE REFLECTS THE CHRISTIAN CONCEPTION OF HUMAN EXISTENCE (ABOVE).

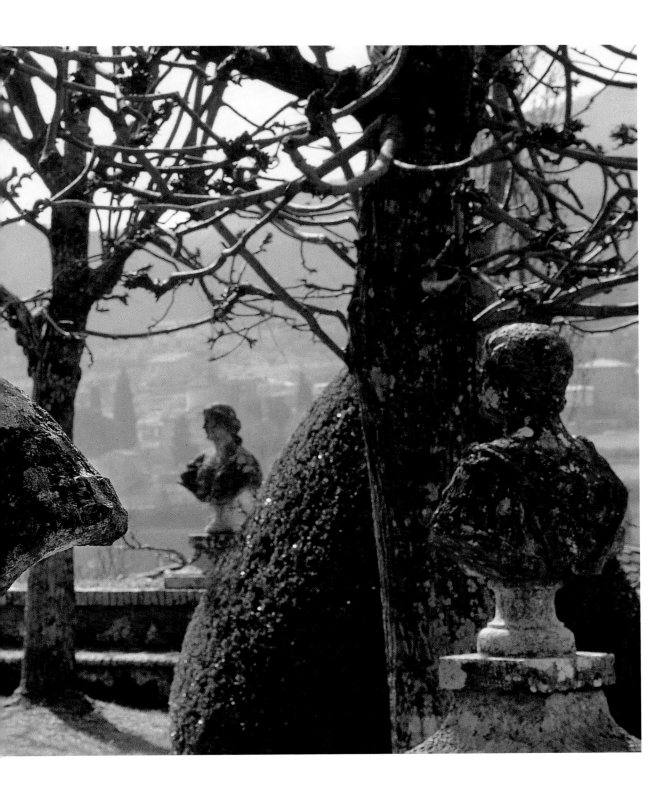

STATUES AND BOXWOOD HEDGES
IN THE CETINALE GARDEN GLOWING
WITH THE LIGHT OF A FINE WINTER'S
MORNING AGAINST THE SLOPES
OF LA MONTAGNOLA, NEAR SIENA
(LEFT).

THE GARDENS OF BADIA BORDER
THE FORTIFIED BUILDINGS OF THE
ABBEY (ABOVE, TOP). THE OWNERS'
PET DOG RESTING AT THE FOOT OF
THE FOUNTAIN (ABOVE, BOTTOM).

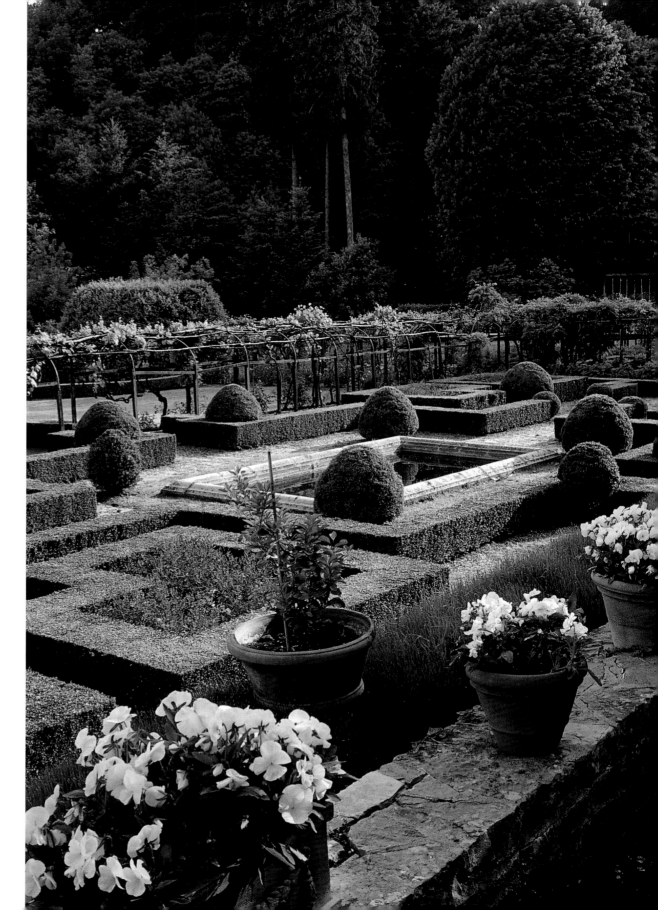

An Abbey Garden

North of Siena the land rises into the Siena Hills and the ridges of Chianti, a varied landscape that near Gaiole in Chianti becomes almost mountainous—as indicated by its stands of pine. It is not surprising that the Benedictine monks of Vallombrosa should have chosen this isolated spot, where Badia a Coltibuono has stood for almost a thousand years. The monasteries were secularized in 1811 under the French occupation, thus enabling members of the Tuscan aristocracy and bourgeoisie to acquire new estates. This is what happened to Badia, formerly dedicated to San Lorenzo—which explains the grill on its coat-of-arms. The setting in which the buildings stand is a magnificent one, severe but harmonious, a sort of natural shell with a rim of woodland sloping downward on one side. The site is striking—isolated and open, like many other Benedictine foundations. The eleventh-century church with its tall, unadorned bell tower has survived virtually intact, and the mark of even earlier centuries is visible in other portions of the buildings, particularly the former refectory with its decorative frescoes dating from 1621–24.

A porte cochere leads to an inner courtyard surrounded by the abbey's living quarters and outbuildings. This enclosed area is drenched in sunlight morning and evening, an inviting vestibule to a world of serenity and contemplation. An arcaded passageway leads to the garden, which is without doubt one of the marvels of Badia. Reconstructed following World War II by the descendants of the family that acquired the estate in 1846, it forms a vast rectangle along the abbey buildings on one side, and overlooks the valley below the hillside on the other. A pergola, or trellised arbor, divides the garden into two halves that are further subdivided into geometric squares outlined by boxwood hedges. However, the garden's symmetry is not total, being interrupted, for example, by a small off-center semicircular pool and a terrace overlooking one of its shorter sides which affords a fine overall view of the flower beds. The Badia a Coltibuono garden, with its southern exposure and the protection of buildings and curving hills, is a model of harmony—a minutely executed microcosm set amid semi-wild nature.

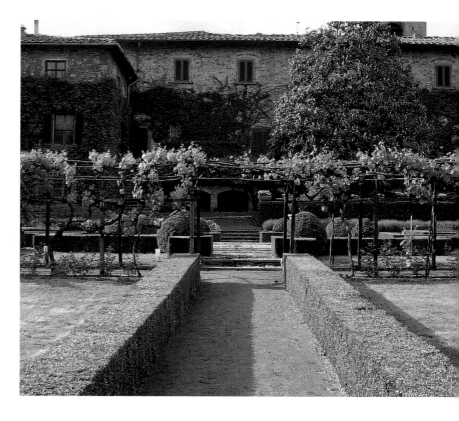

THE FORMER ABBEY HAS LOST NOTHING OF ITS ORIGINAL SIMPLICITY. IT IS NOW THE CENTER OF FAMILY LIFE, IN THE HEART OF A PRESERVED NATURAL ENVIRONMENT. THE STRICT DESIGN OF THE GARDEN IS UNDERSCORED BY GEOMETRICAL BOXWOOD HEDGES. A VINE-COVERED ARBOR RECALLS THAT FOR CENTURIES THE ABBEY WAS RENOWNED FOR THE QUALITY OF ITS WINES. A KITCHEN GARDEN IS USED FOR THE MEALS SUPERVISED BY LORENZA DE' MEDICI (LEFT).

BADIA A COLTIBUONO, FAMOUS FOR ITS VINEYARDS AND THE COOKING SCHOOL RUN BY LORENZA DE' MEDICI, IS A PROSPEROUS COMMERCIAL ENTERPRISE. IT IS BEST EXEMPLIFIED BY ITS GARDEN, THE MAINTENANCE OF WHICH REQUIRES CONSTANT ATTENTION (ABOVE).

ARTIST MARCO BAGNOLI'S
ELEGANT VILLA NEAR EMPOLI,
AN ENLARGED VERSION OF THE
ORIGINAL EIGHTEENTH-CENTURY
STRUCTURE, STILL EXHIBITS THE

COAT-OF-ARMS OF FLORENCE'S
MARCHESE RIDOLFI. THE HOUSE
AND ITS BELVEDERE STAND BELOW
A TERRACED GARDEN BUILT INTO
THE HILLSIDE (ABOVE).

FROM FLORENCE TO LUCCA

An Artist's Garden in the Land of Leonardo da Vinci

From time immemorial, Tuscan gardens have also traditionally been open-air sculpture museums. Raised to its apogee by the Medici, this tradition is still alive today. Lovers of modern art are amply rewarded, for example, by a visit to the Gori collection at the large and historic villa of Celle, near Pistoia; or the collection installed by Niki de Saint-Phalle in southern Tuscany. But I have chosen to take you on a visit to Marco Bagnoli, considered one of the most significant Italian artists of his generation. A Florentine by birth, Bagnoli recently settled in Tuscany, near Empoli, west of Florence. After having lived for many years in the north of Italy, he was finally able to purchase an eighteenth-century villa standing in the open countryside. As we leave Empoli and its industrialized suburbs behind, the road suddenly begins to wind and climb up an unspoiled hillside.

The landscape recalls those painted by Leonardo, whose native village, Vinci, is nearby. Marco, who often produces extremely large sculptures, has installed his main studio in the industrial zone of Empoli, a few kilometers from his villa. The villa's garden is extensive enough to accommodate a number of the sculptor's works. When I visited, he had just finished installing a series of works—recently returned from an exhibition in Spain—inspired by the legend of *The Seven Sleepers of Ephesus*: a group of persecuted Christians who were buried alive and awoke again several centuries later. These anamorphic sculptures, which assume human forms in the play of light and shadow, are surrounded by designs engraved in freshly cast plaster suggesting the outline of the sleepers, but without any specific religious connotation. A nearby sculpture adorns a pool in which only the tiniest splash of flowing water is audible. Elsewhere, a bamboo cane which has been painted red rises from a grove of olive trees—a discreet beacon invisible at first glance to which others will be added later. Marco Bagnoli's garden, springing new surprises on the visitor with each shift in elevation or change of vegetation, exemplifies the vigor of a long tradition joining art inseparably with nature.

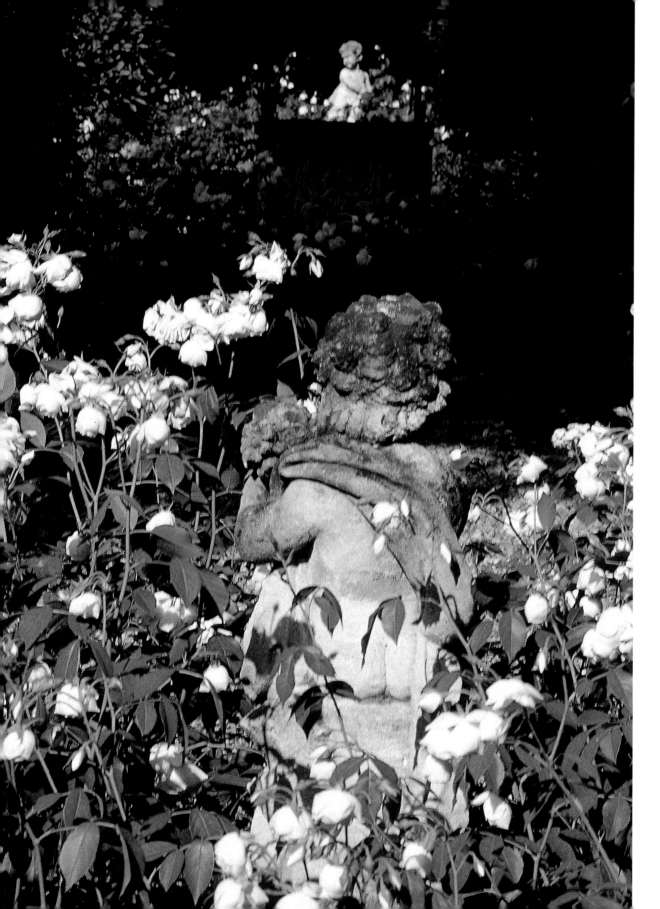

TWO STATUES FACE EACH OTHER
ACROSS THE FLOWER BEDS (LEFT).
THE ARTIST HAS INSTALLED SOME
OF HIS RECENT WORKS IN A GARDEN
PAVILION. THESE BIZARRE,
CUNNINGLY LIT SHAPES, SIMILAR
TO RENAISSANCE OR BAROQUE
ANAMORPHOSES, PROJECT SHADOWS
THAT SEEM ALMOST HUMAN
(ABOVE, TOP).

The Gardens of Lucca

The Lucca region still contains numerous manor houses reflecting the lifestyles of the great families who for centuries directed the affairs of this independent republic. These manors dot the hillsides surrounding the plain, and most are still privately owned. At some, only the gardens are open to the public. This is the case with Elisa Bonaparte's former residence, the Villa Reale de Marlia, the park of which is one of the finest in Tuscany and famous, notably, for its open-air theater. At others, such as the Villa Mansi—perhaps the most imposing architecturally—visitors are also allowed inside.

With so many exceptional estates to choose from, I must confess a weakness for the Villa Torrigiani de Camigliano. When approached from a distance, its visual impact is enhanced by the dramatic contrast between the stately rows of cypresses leading to the villa and the unsightly Lucca road. Although the main house and its grounds have existed since the sixteenth century, Torrigiani earned its renown through the ambitious renovations undertaken by the Marchese Nicolao Santini, the Republic's ambassador to the court of Louis XIV. The façade of the building was rebuilt in the baroque style, and Le Nôtre designed the garden—which explains why the two pools in front of the main entrance recall Versailles. Old blueprints demonstrate the scope of the original project and the magnificence of its flower beds. In the early nineteenth century, the last Santini married a Torrigiani—whose canting coat-of-arms (a tower and three stars) is visible on the villa's walls. Subsequent shifts in taste and problems of maintenance eventually led to major reconstruction of the villa in the less elaborate English style.

However, the open-air theater and the nymph's garden survive as Le Nôtre first designed them. The current owners, a branch of the Colonna family that inherited the Torrigiani estate, have opened the park and the villa's ground-floor seventeenth-century frescoes to the public. The charm of the Villa Torrigiani is partly derived from its scale: the building combines the majestic with the intimate, presenting a play of contrasts between the severity of its cypress-lined alley and the exuberance of its façade; and between the sweeping English-style lawns and Le Nôtre's formal garden, the underlying geometry of which is enlivened by a thousand whimsical touches.

AT THE VILLA TORRIGIANI NEAR LUCCA, A COMFORTABLE GARDEN CHAIR OFFERS A MOMENT OF REPOSE UNDER THE LOGGIA AND EVOKES THE ART OF LIVING AS CONCEIVED BY THE ORIGINAL OWNER OF THE BUILDING, THE MARCHESE SANTINI, AMBASSADOR FROM THE REPUBLIC OF LUCCA TO THE COURT OF THE SUN KING (ABOVE). THE AUSTERELY NOBLE REAR FAÇADE OF THE VILLA REFLECTED IN A POOL. THE PARK IS OF ENGLISH INSPIRATION (RIGHT).

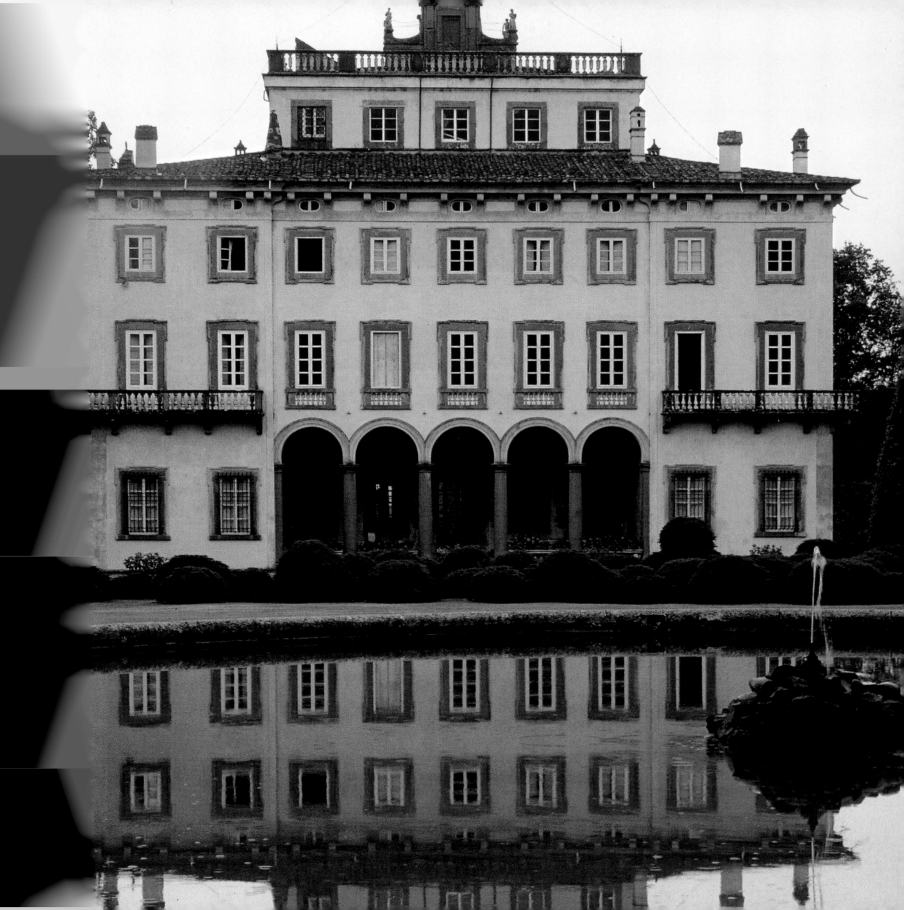

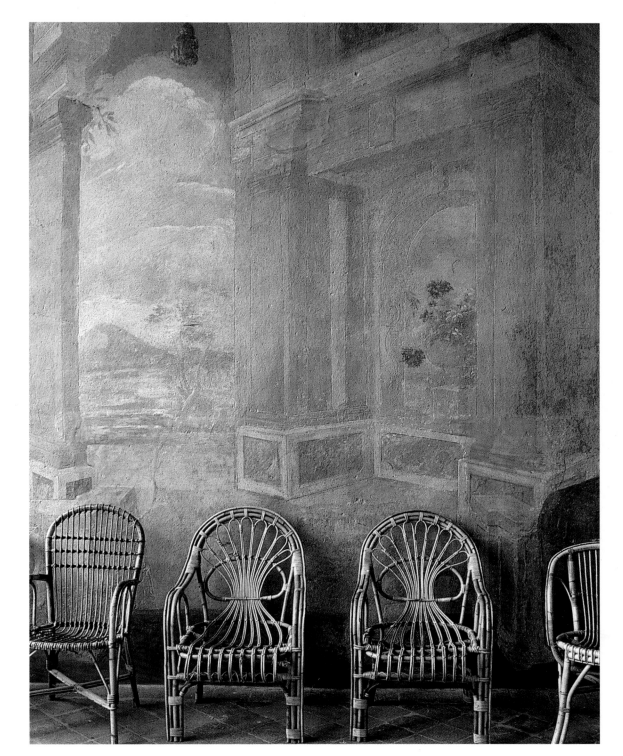

A GROUP OF CHAIRS ON THE LOGGIA
REMINDS US THAT THIS VILLA IS
A FAMILY HOME (LEFT AND RIGHT).
THE STATUE OF AN ANCIENT
DIVINITY AGAINST THE ROCK WALL
OF A GROTTO. A STONE EAGLE
SURVEYS THE FLOWER BEDS
DESIGNED BY LE NÔTRE (ABOVE,
TOP AND BOTTOM).

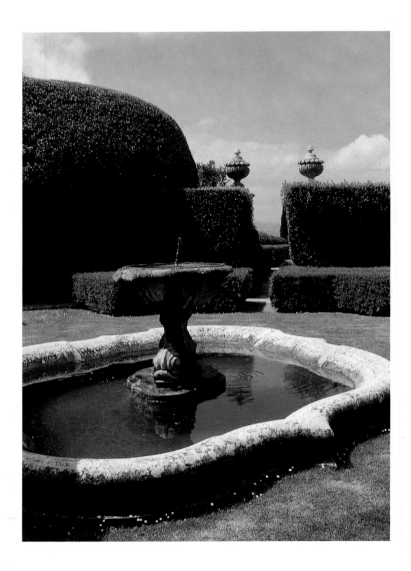

THE GARDEN AT LA FOCE, SOUTH OF
PIENZA, WAS REDESIGNED BETWEEN
THE WORLD WARS, BUT ITS SPIRIT IS
THAT OF THE GREAT SEVENTEENTH-
CENTURY TUSCAN VILLAS (ABOVE).

ENGLISH ARCHITECT CECIL PINSENT
WAS A PIONEER IN THE RE-CREATION
OF THE ITALIAN-STYLE GARDEN.
AT LA FOCE HE MADE SKILLFUL USE
OF CONTRASTS BETWEEN THE ARID
NATURAL BACKGROUND AND THE
GARDEN'S LUSH GEOMETRY (RIGHT).

BETWEEN TUSCANY AND UMBRIA

The Italian Garden Reborn at La Foce, near Pienza

Beginning in the eighteenth century, and increasingly during the
nineteenth, Tuscany became a magnet for unusual individuals fascinated
with the region and its history, and also eager to leave their own mark on it.
It has been a special favorite of the English (later joined by the Americans),
whose passion for gardening is notorious. Interestingly, however, instead of
transplanting the "English garden" to Italy, they set about reviving the spirit
of the Florentine Renaissance. This reconstitution, sometimes more austere
and less flowery than the original, reflects the fascination of these renowned
art lovers and scholars for a period that, indisputably, remains unequaled in
the Western world. Sir Harold Acton's La Pietra and Bernard Berenson's
I Tatti villas are remarkable examples of the phenomenon in Florence. As
legacies willed, respectively, to New York University (by Acton) and
Harvard (by Berenson), they keep the spirit of their founders alive today
through a dedication to research. The wealth of these villas' libraries and
the peerless serenity of their gardens make them ideal retreats for the
scholars invited to stay in them every year.

The history of La Foce is linked to that of I Tatti through the person of
Cecil Pinsent, the British architect who designed both gardens during the
period between the two World Wars. In truth, there could be no more
amazing experience than to happen upon a park as remarkable as this one in
the region of Val d'Orcia, among the bald hills south of Pienza. The original
estate was a vast and anonymous conglomeration once owned by the Santa
Maria della Scala hospital of Siena. Three thousand hectares (about 7,500
acres) of arid land on which fifty-seven isolated, untutored sharecroppers eked
out a living as best they could. However, the fortunes of this extensive but
barren tract of land were reversed during the interwar period, when it struck
the fancy of American Iris Cutting and her Italian husband the Marchese
Antonio Origo. Iris Cutting had spent her childhood in Fiesole at the Villa
Medici, purchased in 1911 by her parents, who made it a focus of Florentine
intellectual life. In *Images and Shadows*, Iris Origo tells how her parents

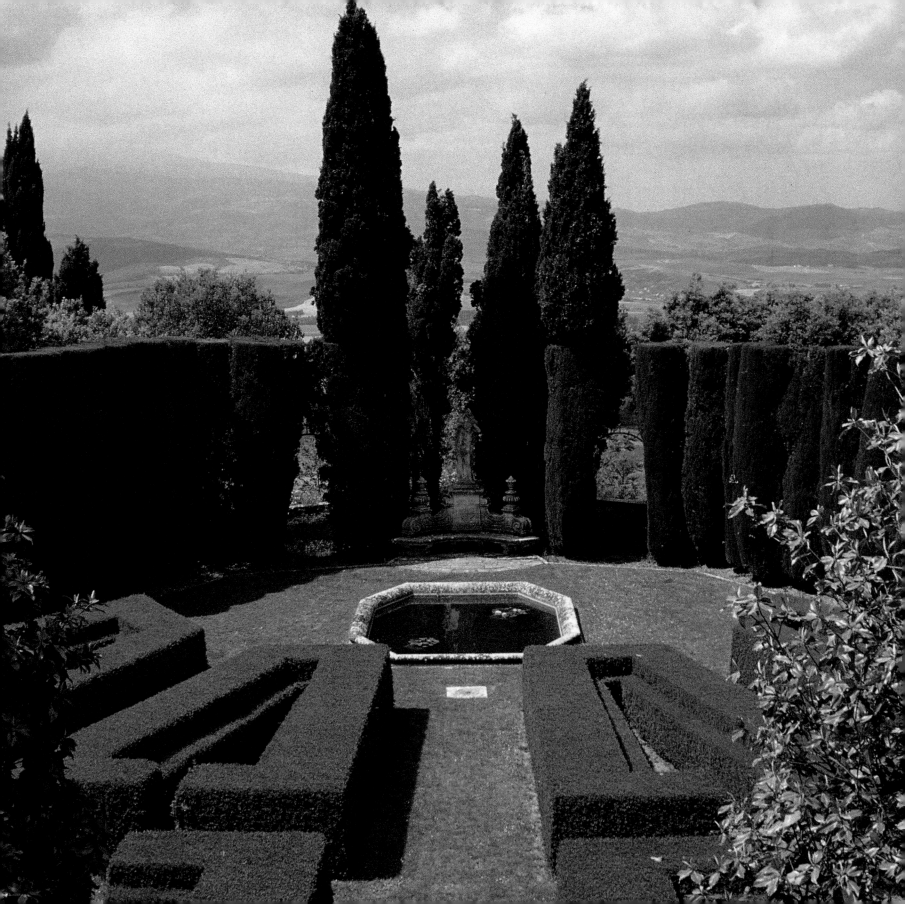

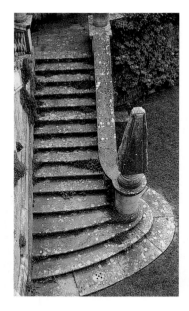

Time has done its work at La Foce, covering the stones of this staircase with a patina that seems at least several centuries old (above). Enclosed spaces alternating with sweeping views of the landscape create the atmosphere of secrecy that constitutes one of La Foce's charms (right). The main house was enlarged in the 1930s. Outside, the landscaping has created a series of greenery-enclosed "rooms," as if house and garden were extensions of each other (far right).

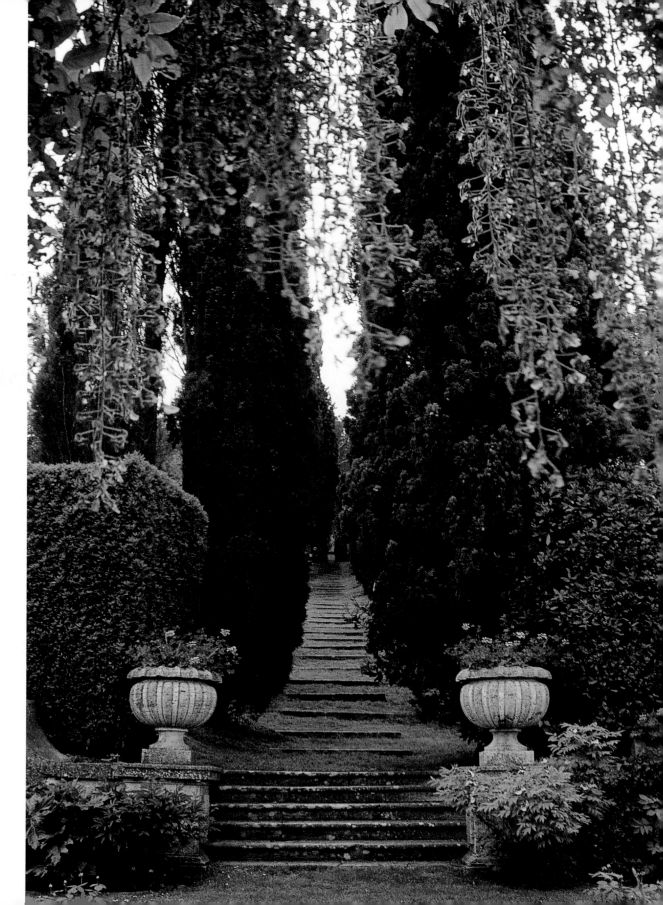

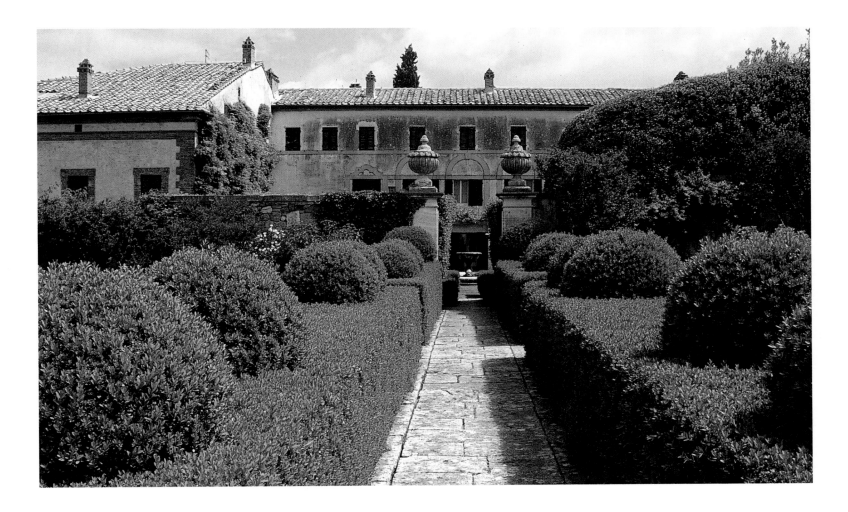

acquired La Foce—which she also evokes in another work, *War in Val d'Orcia*, a chronicle of the years 1943 and 1944. Back in 1923, when the youthful couple assumed ownership of La Foce, they faced a daunting challenge. Everything needed to be done. Not did they have to make the main house livable, but they also had to raise the entire region out of the misery into which it had fallen. It was an unusual venture, especially considering that numerous other "classical" estates were available to the eminent American heiress. Since Iris had exhausted her entire dowry to meet the estate's purchase price, her grandmother stepped in. It was she who, in the guise of a wedding present, paid the cost of constructing the underground aqueduct designed to provide water for both household purposes and

irrigation. Iris and Antonio built roads, renovated farmsteads, founded a school and preschool, and set up a dispensary. The main building was enlarged, and a vast garden planted from scratch. It is at La Foce that Cecil Pinsent's talents can be seen at their best. Although he made changes to the house's interior, it is the site itself that appears to have captured his attention. The garden at La Foce is landscaped on several levels, and conceals a maze of interesting nooks and corners. Whereas the main axis of gardens such as this one generally runs parallel to the longest slope, here it is perpendicular. Pools, pergolas, and flower beds are laid out in a manner that is meticulously ordered and yet constantly unexpected. This highly structured composition forms a perfect contrast with its setting.

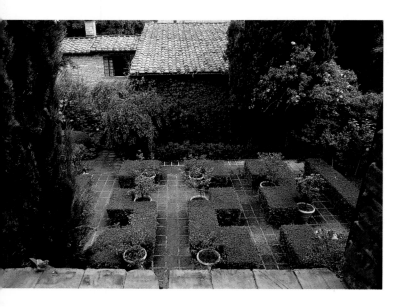

A Rose Garden Near Cetona

Not far from La Foce, but on the other side of the mountain, stands the little Etruscan town of Cetona. Perched on a promontory, it is visible from the unique garden designed some thirty years ago by Federico Forquet and Matteo Spinola. This semi-mountainous region bordering the Valdichiana is extremely cold in winter. Total silence reigns over the countryside, as if the nearby Rome-Florence *autostrada* were only an illusion. In one sense, the Forquet-Spinola garden is the antithesis of La Foce. The ground for it was not leveled, since this would have destroyed the natural surroundings. Instead, the garden's design was adapted to the local topography: it follows the land's steep and irregular contour and appears almost to vanish into the landscape. A maze connects the estate's three houses—all of which have been completely rebuilt, leaving only a few meager vestiges from the past in one of them. However, because their style is totally consistent with that of the surrounding farmsteads, it looks as though they have been standing here forever. Federico, who is one of Italy's most renowned landscape architects, accompanied me on a ramble through the lavender bushes, cherry orchards, and olive groves. In spring, pink and white blossoms burst from the irises and rosebushes—most of them antique varieties. They are joined in late June by the lavender flowering against a background displaying all possible shades of green, from the palest (the olive leaves) to the deepest (the cypresses). Tended carefully but not fanatically, the garden is based on an alternation between enclosed areas and unimpeded views. Federico instinctively invented fresh solutions to make the site's reality match his dreams, which are focused here on studious meditation. He showed me a spot facing the hills where he plans to install two benches, perhaps shaded by a roof of branches or greenery. Cetona is only an hour and a half from Rome, but in this garden time goes by at a slower pace.

THE TIMELESS COUNTRYSIDE OF CETONA AS SEEN FROM THE TERRACE OF THE HOUSE BELONG TO FEDERICO FORQUET AND MATTEO SPINOLA (LEFT, TOP).

VIEWED FROM A ROOM IN THE GUESTHOUSE, THE INNER COURTYARD EXHIBITS A STRICT PATTERN OF BOXWOOD IN WHICH A TURTLE AMBLES BACK AND FORTH (LEFT, BOTTOM).

THE GARDEN AT CETONA CONTAINS REMARKABLE EXAMPLES OF TOPIARY, SUCH AS THIS GROUP OF SPHERICAL SHRUBS THAT SEEM READY TO ROLL DOWN THE HILL (ABOVE).

THE GARDEN CONTAINS A NUMBER OF SECLUDED NOOKS. AT THE END OF A VINE-COVERED BRICK ARBOR, FOR EXAMPLE, THIS STATUE IN A SMALL CLEARING SEEMS TO ENCOURAGE MEDITATION (RIGHT).

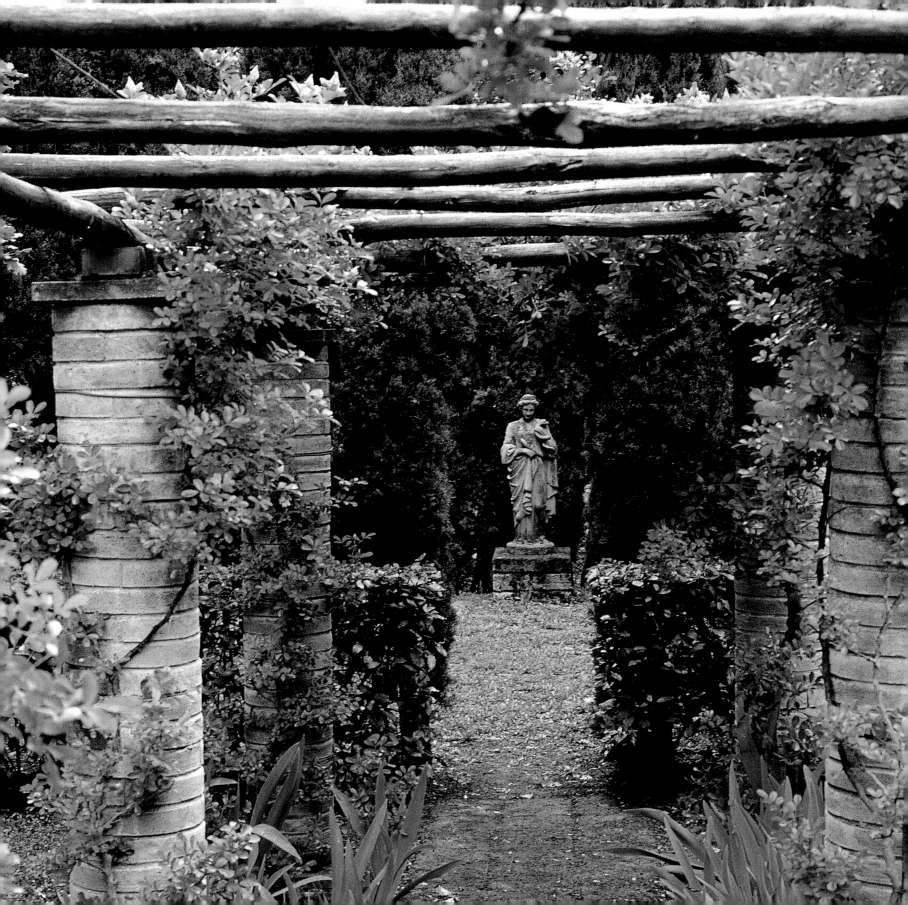

TUSCAN INTERIORS

WHETHER PRINCELY OR RUSTIC, TUSCAN INTERIORS EMBODY
AN IDEAL OF ELEGANCE AND BALANCE, THE FRUIT OF A
CIVILIZATION UNIQUE IN EUROPE. A PASSION FOR BEAUTY IS
HERE COMBINED WITH A RESPECT FOR INTIMACY, AND WORKS
OF ART WITH EVERYDAY LIFE.

Whereas Rome is a city in which opulence is often frankly ostentatious, Tuscany has a well-earned reputation for understatement. Tuscan interiors, not surprisingly perhaps, contain as many gems as Roman ones do, but displayed in a spirit of restraint and attention to physical comfort not unrelated to English or French taste.

There is also a continuous desire, whenever possible—even in the city—to maintain a link with nature. Although the great Medici residences (notably the Pitti and Poggio a Caiano palaces) are easily accessible, Tuscany is nevertheless less forthcoming than Rome. The most famous gardens may be open to the public, but privately owned manors only rarely admit outsiders. The following itinerary will take you inside some of them, in various regions throughout Tuscany. History is often a vivid presence at both palaces and country estates, but more modest dwellings are also imbued with it, and the very land bears its indelible imprint. A special section has been set aside for contemporary artists and intellectuals—whether native to Tuscany or not—who, each in their own way, are links in a chain that has existed unbroken for centuries.

A PALACE WITH A VIEW

Every city in Tuscany contains numerous palaces, still inhabited today, recalling the court life under the grand dukes that enabled the ancient feudal and merchant nobility to lead a life of elegance and refinement. The secret charm of these palaces can be fully appreciated only from the inside. Fortunately, a number of old, established Sienese and Florentine families agreed to open the doors of their homes to us.

THE INNER COURTYARD OF LA PETRAIA, WITH ITS FRESCOES AND MEDICI COATS-OF-ARMS, WAS CONVERTED INTO A BALLROOM BY KING VICTOR EMMANUEL DURING THE BRIEF PERIOD (1865–71) WHEN FLORENCE WAS CAPITAL OF THE KINGDOM OF ITALY (PREVIOUS DOUBLE PAGE).

AN ASTOUNDING BAROQUE GROTTO FEATURING GROUPS OF ANGUISHED STATUES AT FLORENCE'S PALAZZO CORSINI, ON THE BANKS OF THE ARNO. LINED WITH VENETIAN GLASS AND QUARTZ, IT GLEAMS IN A MYSTERIOUS PENUMBRA (LEFT). TWO GILDED WOODEN DOVES GUARD THE SUMPTUOUS SILKEN HANGINGS OVER A DOOR IN SIENA'S PALAZZO D'ELCI (ABOVE). TIME SEEMS TO HAVE BEEN MIRACULOUSLY ARRESTED AT GEGGIANO, NEAR SIENA. THE FORMAL BED IN THIS BEDROOM WITH ITS PERFECTLY PRESERVED *TOILE DE JOUY* WALL COVERINGS AND HANGINGS WAS USED BY POPE PIUS VI DURING THE INVASION OF ITALY BY FRENCH REVOLUTIONARY TROOPS (RIGHT).

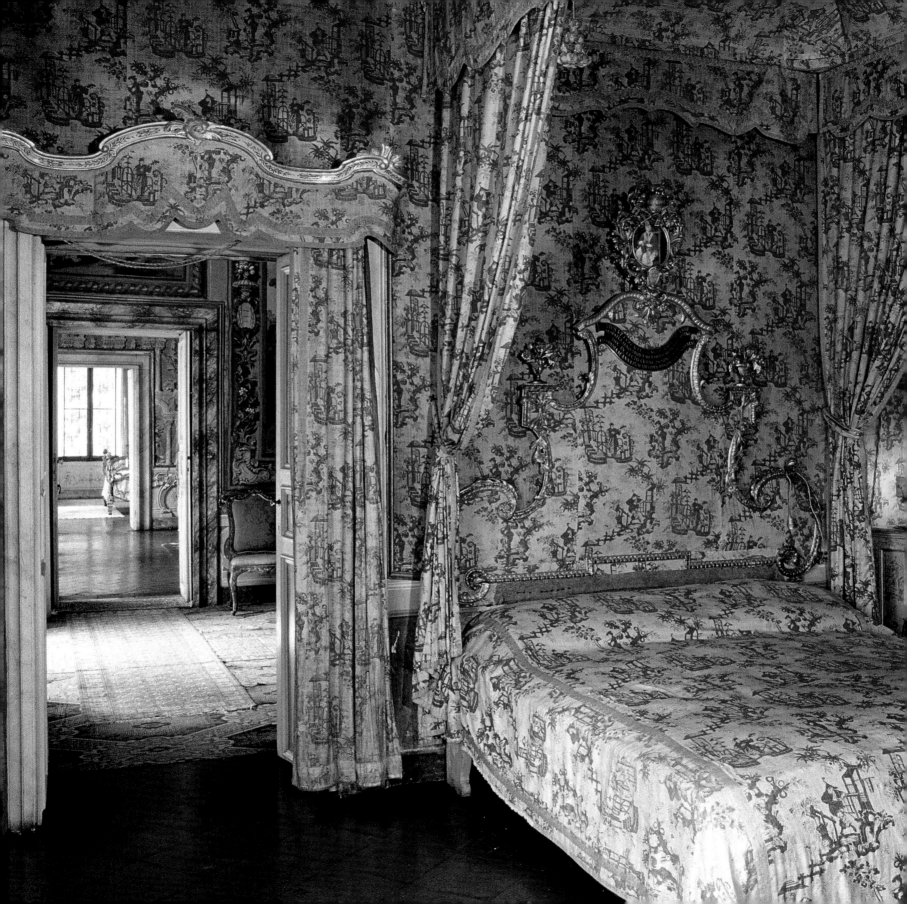

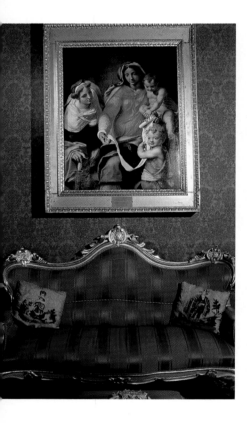

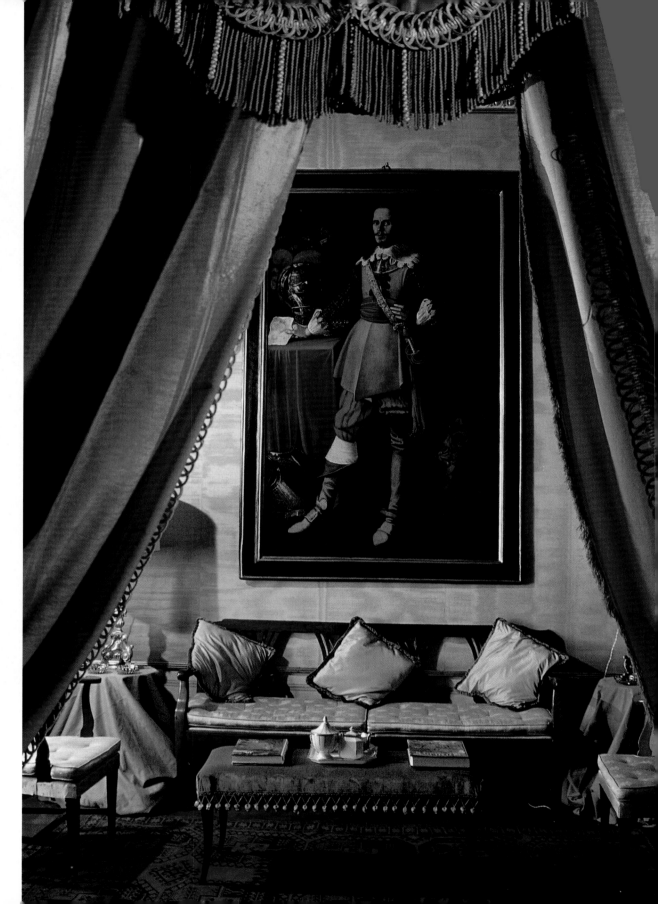

The dominant note in the salon of the Palazzo d'Elci is a work by Daniele da Volterra, one of Michelangelo's most talented pupils (above bottom).

A PAIR OF PINEAPPLE CANDLESTICKS
FRAME AN EXQUISITE FAMILY
PORTRAIT HANGING IN ONE OF THE
PALACE BEDROOMS (FAR LEFT, TOP).
BRILLIANTLY COLORED HANGINGS
LEND EMPHASIS TO A FULL-LENGTH
ANCESTRAL PORTRAIT BELONGING
TO THE PANNOCCHIESCHI D'ELCI
FAMILY, MANY OF WHOSE MEMBERS
APPEAR IN DANTE'S WORKS (LEFT).
THE PALAZZO D'ELCI IS STILL
OCCUPIED AND LOVINGLY
MAINTAINED TODAY. ITS ROOMS
ARE HUMAN IN SCALE, EXUDING
THE WARMTH OF A CENTURIES-OLD
FAMILY HOME (RIGHT).

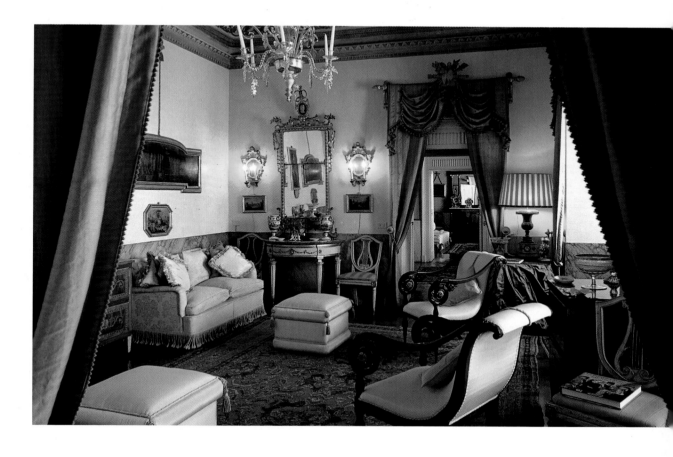

On the Piazza del Campo in Siena

The appearance of the buildings lining Siena's Piazza del Campo has been modified frequently over the centuries. This is especially true of the Palazzo d'Elci, the façade of which is unprepossessing. Archive documents record the destruction of the original edifice by fire in 1149. The palace that replaced it served as a public building for many years before falling into the hands of a succession of old Sienese families. An eighteenth-century Dutch painting shows us how it looked when it was acquired by the Pannocchieschi d'Elci family: the fine Gothic windows are still in place, but there is a disturbing crack in the tower—the scar left in the distant past by an earthquake. In 1798 another earthquake destroyed the palace, which was entirely rebuilt during the first third of the nineteenth century. The Pannocchieschi family has been prominent for centuries—as attested by Dante's *Divine Comedy*—and its

members still occupy the palace: a residence-museum, if you like, but also a *casa amata*, as Cesarine d'Elci puts it. It is true that even the *piano nobile* (principal floor) retains a human scale. The view over the narrow Via di Città on one side, and the Piazza del Campo on the other, is a fresh reminder of the Siena coat-of-arms and its stark contrast between light and shadow. Two magnificent paintings by Daniele da Volterra immediately attract the visitor's eye, and the double doors of the armoire conceal an altar faced in silver and vermeil. This gem was donated by the family to the cathedral, which still holds title to it and can request its return once a year for the Feast of San Giovanni, or Midsummer Day. Facing the altar, two lances and the banner of the goose *contrada* serve to remind us that Count d'Elci won these coveted Palio prizes six times. This record seems destined to stand unchallenged, along with the exploit of his mare, Salomé, who in 1948 won the race . . . riderless.

SUNLIGHT GLEAMS ON THE MARBLE
OF THE PIAZZA DEL CAMPO CHAPEL,
AS GLIMPSED THROUGH THE LACE
CURTAINS AT A WINDOW IN THE
PALAZZO D'ELCI (ABOVE).
ALL OF THE PALACE'S BEDROOMS
ARE EXTREMELY FINE, BUT THE MOST
REMARKABLE WAS DESIGNED IN
THE EARLY NINETEENTH CENTURY
BY SIENESE ARCHITECT
FANTASTICI—THE FORTUNATE
CONSEQUENCE OF AN EARTHQUAKE
THAT DAMAGED A LARGE PART
OF THE PALACE (RIGHT).

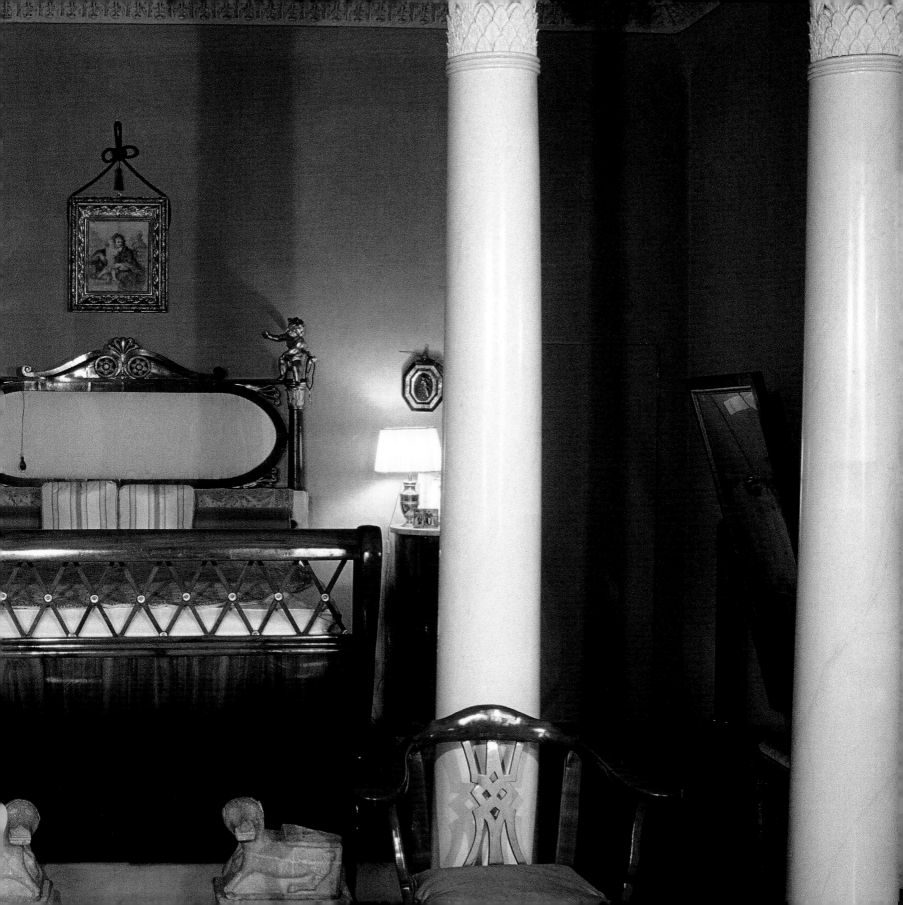

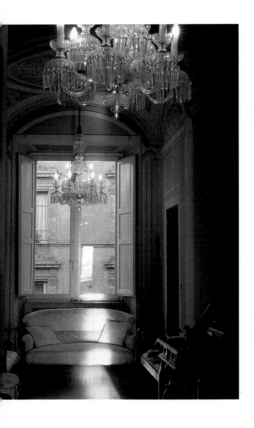

Siena, Between City and Country

Near the church of Santa Maria del Carmine stands the Palazzo Sergardi, with its austere façade of undressed brick. Before being converted into a private residence, the building (designed by Riccio in 1554) was occupied by a religious order—the Derelitti, or Daughters of Dereliction—as reflected by an inscription and the vestiges of a pediment. The palace's main charm is perhaps the view of the Siena countryside it affords. Guido Fineschi Sergardi showed me photographs he's taken over the years from the terrace off the main floor, now occupied by his father, Lorenzo. The view is never twice the same, and his most impressive shots were taken in winter, when the hilltops are almost completely veiled in clouds of dense mist—a vision reminiscent of mountains as viewed from an airplane. I first saw this view on a fine spring afternoon, as behind me the sun warmed the library and the intriguing eighteenth-century painted decor of the salon. The flowering fruit trees dotted among the kitchen gardens below the palace added a touch of short-lived color to the ravine bordering city.

A RAY OF SUNLIGHT GLEAMING AT THE END OF THE GALLERY RUNNING THROUGH THE PALAZZO SERGARDI IN SIENA (ABOVE). ELEGANT LATE-EIGHTEENTH-CENTURY FURNISHINGS HARMONIZE WITH THE NEOCLASSICAL DECOR OF THE MAIN SALON (RIGHT). ON THE SIDE OPPOSITE THE STREET, THE PALAZZO SERGARDI OPENS ONTO OPEN COUNTRYSIDE — HERE, A FLEMISH PAINTING IN THE LIBRARY GILDED BY THE SETTING SUN (FAR RIGHT).

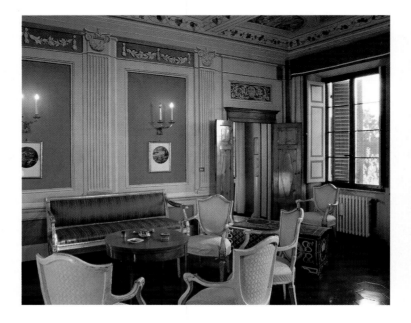

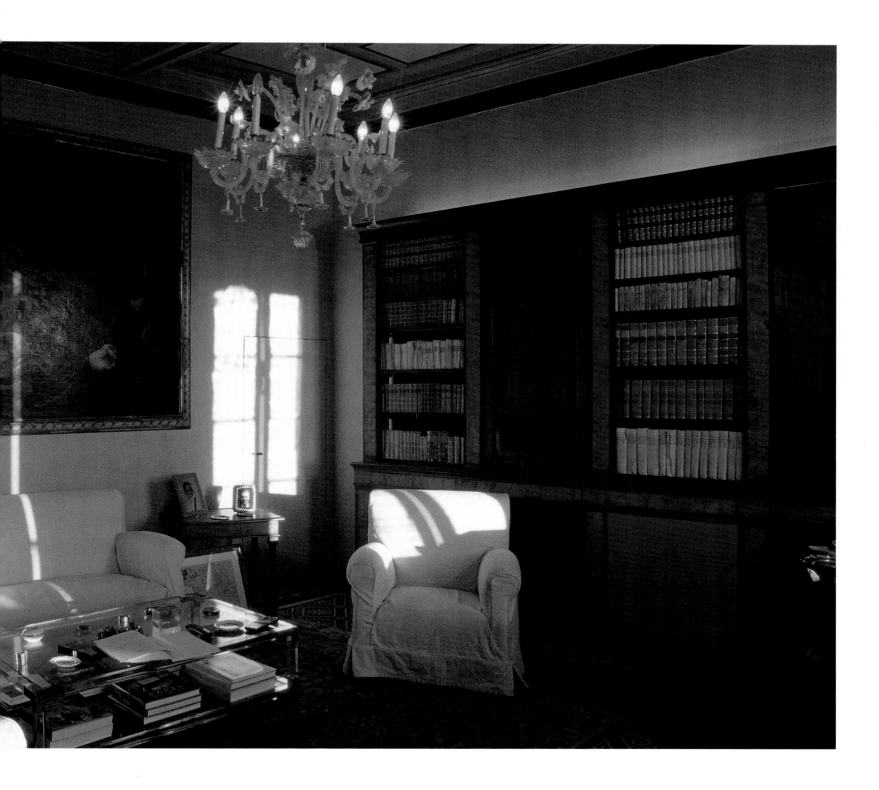

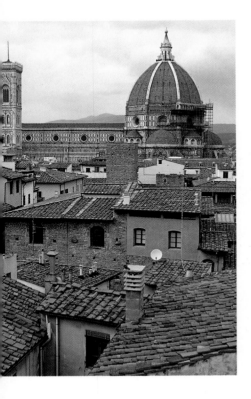

In the Heart of Florence, the Terraces of a Palace

The Palazzo Gondi on the Piazza San Firenze stands at the medieval heart of Florence. It is one of the major works by Sangallo, who also designed the stunning fireplace on the upper floor. The palace has always belonged to this ancient family, one branch of which moved with Catherine de' Medici to France, earning fame there through the notorious Cardinal of Retz, Archbishop of Paris—an accomplished schemer and racy memoirist. The Marquese Amerigo Gondi was the first descendant of this great line to move out of the main floor of the palace, settling in the attic. At the age of 91, he refers laughingly to his "penthouse," which boasts a large family portrait that grazes the ceiling. Seated before a wood fire burning brightly in the fireplace, Amerigo Gondi recalls his memories of the past with unfailing verve and mischievous wit. He speaks both English and French with ease and elegance, and it doesn't surprise me to learn that he's currently reading the *Mémoires* of Abbé Mugnier, a man who deployed his lucid and not always charitable

powers of perception to draw a coolly analytic portrait of late-nineteenth-century Parisian society. Even better, the names that fell from the famed confessor's pen are almost part of the family. Gondi talks about his father, who was deeply loyal to the Grand Duchy of Tuscany but refused to compromise with fascism. His anecdotes revive a world that has vanished or is hovering on the brink of extinction.

Amerigo Gondi's refined and intimate living quarters afford unique views of the city. The dining room opens onto a lower terrace from which the entire length of the cathedral is visible. The salon is connected by a small staircase to a sort of study hung with impressive Sienese paintings. From there, other terraces offer views of the nearby Palazzo della Signoria and the San Miniato hill farther off. At nightfall, the city's illuminated monuments stand out with stunning clarity: the Brunelleschi dome and town-hall tower project the image of a capital very few other Italian cities can match.

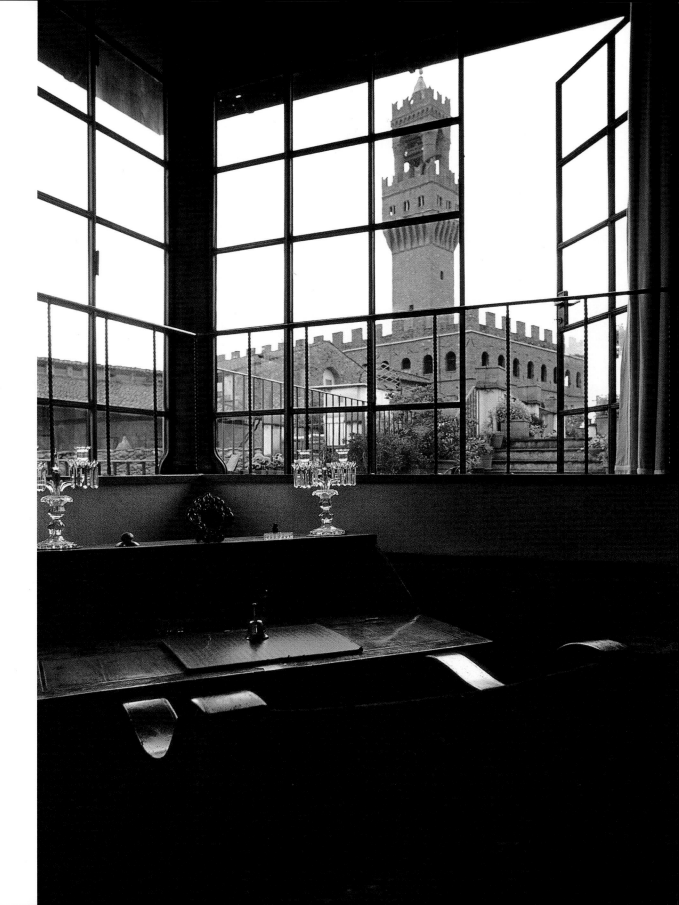

The terraces of the Palazzo Gondi, which stands in the heart of Florence, offer a panoramic view of the city's major monuments: the cathedral with its dome and bell tower (far left), and the Basilica of Santa Croce, pantheon of Florentine genius (left). The view changes continuously depending on the light and the time of day. At the advanced age of 90, the Marchese Amerigo Gondi decided to abandon his quarters on the palace's *piano nobile* and settle in this garret—which he refers to jokingly as his penthouse. The windows in the study's topmost portion frame the tower of the Palazzo della Signoria like a painting (right).

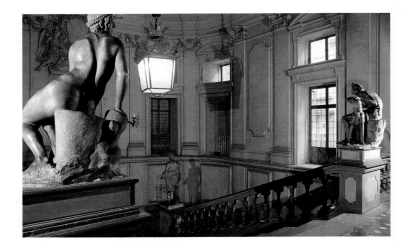

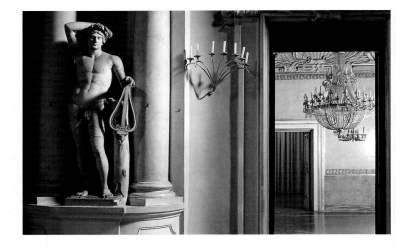

THE MAIN STAIRCASE OF THE PALAZZO CORSINI WAS REBUILT WHEN A MEMBER OF THE FAMILY WAS NAMED POPE. BUT IN FLORENCE, MAGNIFICENCE ALWAYS MAINTAINS A DEGREE OF RESERVE (ABOVE, TOP). THE FORMAL SALON OPENS ONTO OTHER RECEPTION ROOMS, WHICH ARE ESPECIALLY STUNNING BY CANDLELIGHT (ABOVE BOTTOM). LINED ON ONE SIDE WITH WINDOWS FACING THE ARNO, THE GALLERIA DELL'AURORA SEEMS DESIGNED TO UNDERSCORE THE SUPERB DOORWAY AT ITS FAR END AND THE CORSINI COAT-OF-ARMS COVERING IT (RIGHT).

At Florence, on the Banks of the Arno

The Palazzo Corsini is also steeped in history. The face it presents to the narrow Via del Parione is an austere one, but on the Arno side these seventeenth-century buildings have a monumental aspect not devoid of grace. The Corsini family is one of the most illustrious in Florence. Its rise dates from the thirteenth century, when banking and trade in wool and silk earned it economic power and political influence. But its apogee was reached in 1731 when Lorenzo Corsini, still amazingly energetic at the advanced age of 79, was elected pope under the name of Clement XII. Members of the family branch remaining in Florence continued to fill important posts up through the twentieth century—Prince Tommaso Corsini, for example, father of the palace's current owners; and Anna Lucrezia Sanminiatelli and her sister, whose conduct throughout World War II was exemplary. The palace was seriously damaged by the war, in 1944; and then by the flood in 1966. It has only recently been possible to conduct a thorough renovation of the ground floor, long since broken up into rental properties. This part of the palace was once used as the family's summer quarters—the walls and ceilings are covered with frescoes in breezy colors, and openings in the floor allow cool air from the cellars to circulate above. More striking still is the interior marine grotto carpeted with seashells, mother-of-pearl, Venetian glass, and rock crystal. It was constructed inside the building because the property is not large enough to accommodate a garden outside. Restoration work on the house is well advanced, and the ground-floor apartments can now be used for the display of temporary exhibitions. The Antique Dealers' Biennale has already been held in these spacious, light-filled rooms, and other exhibitions are planned. A monumental formal staircase, the center of which is dominated by a statue of the Corsini pope, leads to the *piano nobile*, used primarily for ceremonial occasions. The grand salon, with its two huge candlelit chandeliers and the Galleria dell'Aurora, give some idea of the Florentine court's former opulence. One room of the palace has been set aside for archives. It is here—through the record of events both large and small, carefully consigned to the protection of heavy leather bindings—that history speaks.

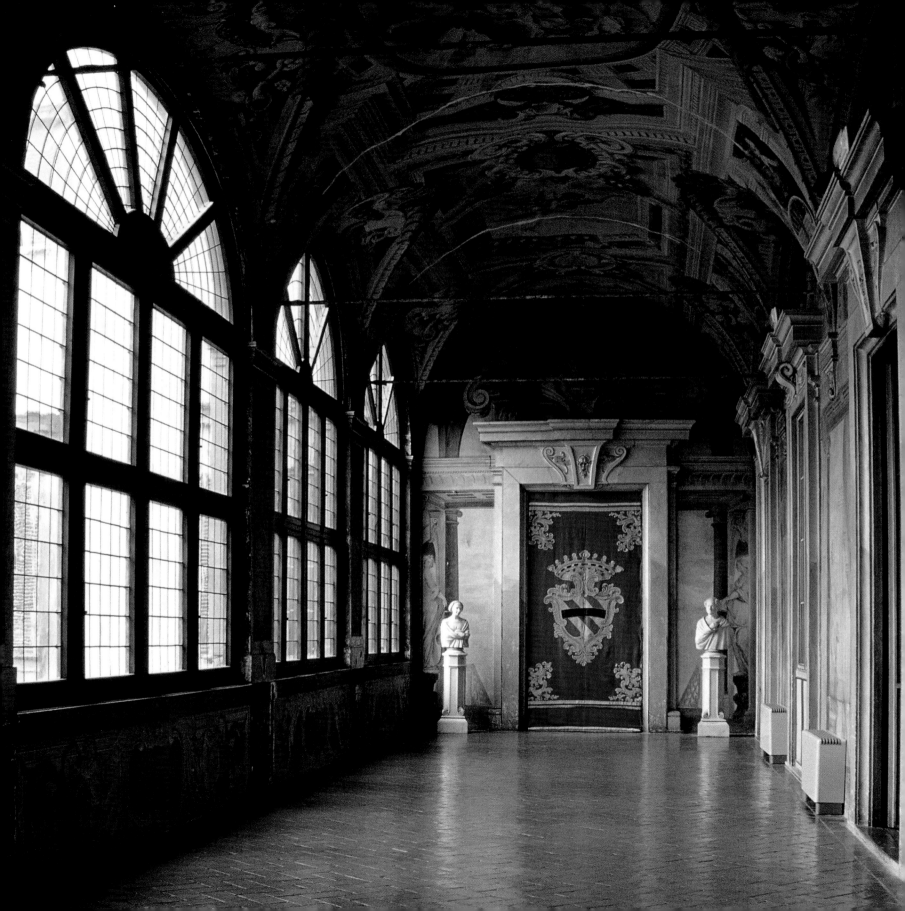

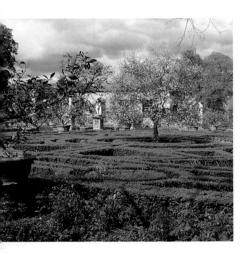

THE PALAZZO CORSINI AL PRATO
OPENS ONTO A MARVELOUS
ENCLOSED GARDEN. THE SIXTEENTH-
CENTURY LOGGIA CAN BE GLIMPSED
THROUGH THE BRANCHES OF
AN ORANGE TREE (ABOVE, TOP).
THE MAGNIFICENT GARDEN
IS DIVIDED BY BOXWOOD HEDGES
(ABOVE BOTTOM).

A View Over the Finest Enclosed Garden in Florence

The Palazzo Corsini al Prato was designed in the late sixteenth century by Buontalenti for the Acciaioli family. Standing on a site once occupied by the city's ramparts—of which only the Porta al Prato survives—it offers a total contrast to the palace described above. For example, the façade is so plain it passes almost unnoticed. The sole embellishment on the garden side is the loggia that supports a spacious terrace opening off the upper-story rooms. It was acquired in 1620 by the Corsini family, which still owns it. The relatively unchanged apartments have retained the distinctive charm associated with places that are lived in. Not all of the magnificent furnishings are Tuscan: the Florentine branch of the Corsini family inherited from their Roman cousins a number of admirable baroque consoles reflecting the Eternal City's penchant for opulence. The dining room, its gallery decorated with medallions of the Roman emperors, and the red salon dominated by the portrait of an Indian ancestor are all very fine indeed.

But the palace's true marvel is its garden. Although this part of Florence—where numerous convents once stood—is located inside the old ramparts, it still has a rural flavor. The expansion of the city has bypassed this rustic spot, where the belfry of a Protestant church recalls an English village. The palace garden, designed for the Corsini family by Gherardo Silvani, heralds the transition to the baroque style. Its main axis, starting at Buontalenti's loggia, splits it into two symmetrical halves before ending at the vast orangeries used to shelter citrus trees for almost six months of the year. Herbs and flowers are planted inside patterns of meticulously trimmed, interlocking boxwood hedges. Other parts of the garden are designed in a more romantic spirit. The ground-maze carpeted with acanthus, for example, resembles a dream world that might have sprung from the imagination of a French writer Jean Cocteau.

A garden this vast and intricate runs the risk of being envied and coveted. In a determined effort to preserve it, Princess Giorgiana Corsini has thus turned it into a cultural resource: each year her garden is the scene of a fair featuring works by carefully selected master artisans, which are displayed inside the orangeries.

At the Palazzo Corsini
al Prato, sunlight glinting
on a settee (left).
The patterns of the formal
chairs' silk upholstery echo
that of the wall hangings
(above, top). This painting
depicts a family ancestor
(above, bottom).

THE PORTABLE ICON RESTING
ON A PRIE-DIEU IN THE BEDROOM
IS A REMINDER OF THE MARCHESE
EMILIO PUCCI'S RUSSIAN ANCESTORS
(BELOW).
THE BED ITSELF IS A MASTERPIECE,
FOR BOTH THE BEAUTY OF ITS SILKS
AND THE VIRTUOSITY OF ITS
SCULPTING (DETAIL, FAR RIGHT).

THE PALAZZO PUCCI BOASTS SOME
MARVELOUS DECORS, SUCH AS THIS
BLUE-AND-WHITE ROOM (ABOVE
RIGHT) WITH ITS PAINTED DOORS
AND CRYSTAL CHANDELIER (ABOVE).

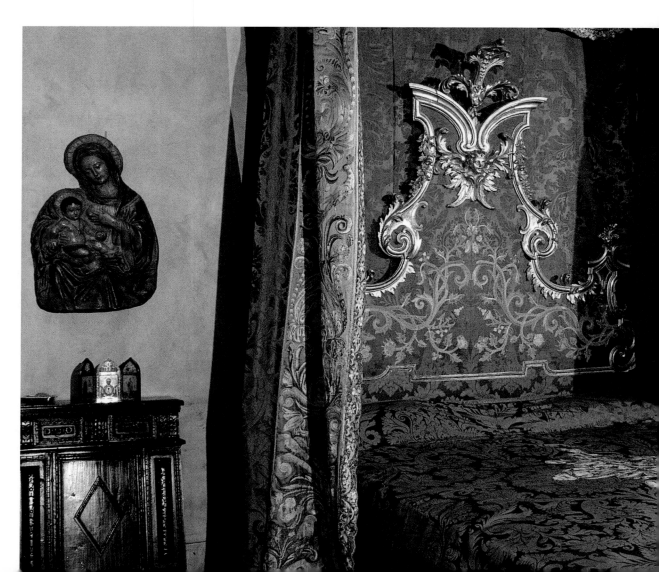

The Residence of a Noble Florentine Fascinated by Fashion

The Palazzo Pucci, located near the Duomo, is an exceptional spot where history and the present meet. It is almost impossible to appreciate the full extent of the building and its triple façade from the narrow Via dei Pucci. The central, oldest, and most ornate portion bears the emblem of Cardinal Lorenzo Pucci, whose brother married the sister of Pope Paul III Farnese. The Pucci family has lived in Florence since the late thirteenth century and was notable for its loyalty to the Medici, who turned a blind eye to a few previous plots against them. The palace thus remained in the family, and its interiors bear the mark of successive generations. Orazio Roberto Pucci was mayor of Florence at

THE DINING ROOM, WITH ITS FRESCOED DECOR, ITS IMPOSING CONSOLES, AND ITS TABLECLOTH, IS A HYMN TO BEAUTY. IT IS EASY TO UNDERSTAND HOW EMILIO PUCCI, RAISED IN THIS SETTING, ACQUIRED HIS UNERRING SENSE OF ELEGANCE (FOLLOWING DOUBLE PAGE).

the time of the Napoleonic annexation, and hosted sumptuous fêtes in honor of the emperor's sister Elisa, Duchess of Lucca and Piombino. The most prominent member of the family in the twentieth century was without question Emilio Pucci, one of the greatest European fashion designers, born in 1914 and only recently deceased. In his youth, an academic scholarship to the United States introduced Emilio to a freedom of style unknown in the Old World. On his return to Italy, he began designing easy-to-wear clothing for his own use. Fate then stepped in, sealing his destiny. The prominent Agnelli family often invited him for winter holidays in the Alps. While there, he noticed that one of the great industrialist's extremely beautiful daughters lacked a proper ski outfit, so he lent her his own. A photograph of the young woman, dressed in Pucci's outfit, was published in the famous American magazine *Harper's Bazaar*—earning the talents of designer Emilio Pucci immediate fame worldwide. He was the first man to understand that the era of constricting, artificial clothing for women had passed; that it was time to bring in a breath of freedom, and to accept bright colors and trousers. His success was immense, predictably, and lasted well into the 1960s. The following decade, by contrast, marked a long eclipse—but Emilio Pucci trusted his own instincts and refused to change his style. Already suffering from the illness that was to take his life in 1992, he had the pleasure of seeing his convictions vindicated at last. He was consecrated anew by *Vogue* and *Harper's Bazaar* in the late 1980s.

Cristina Pucci always speaks with barely contained emotion when she describes the figure of her husband sitting "Indian-style"—as the Italians nicely put it—humming to himself and totally absorbed in sketching his latest ideas on every available scrap of paper. A foundation will soon be established to preserve and promote the considerable archives left by Emilio Pucci. Tempted for a time by politics, he was twice elected Liberal Party deputy. His innate sense of dignity and abiding love for Florence endowed him with unique authority on the City Council. His living quarters in the palace reflect a timeless concept of elegance and art in a setting where the impact of old paintings, frescoes, and moldings is enhanced by fine silks woven at the Antico Setificio Fiorentino, an enterprise saved from ruin by . . . Emilio Pucci.

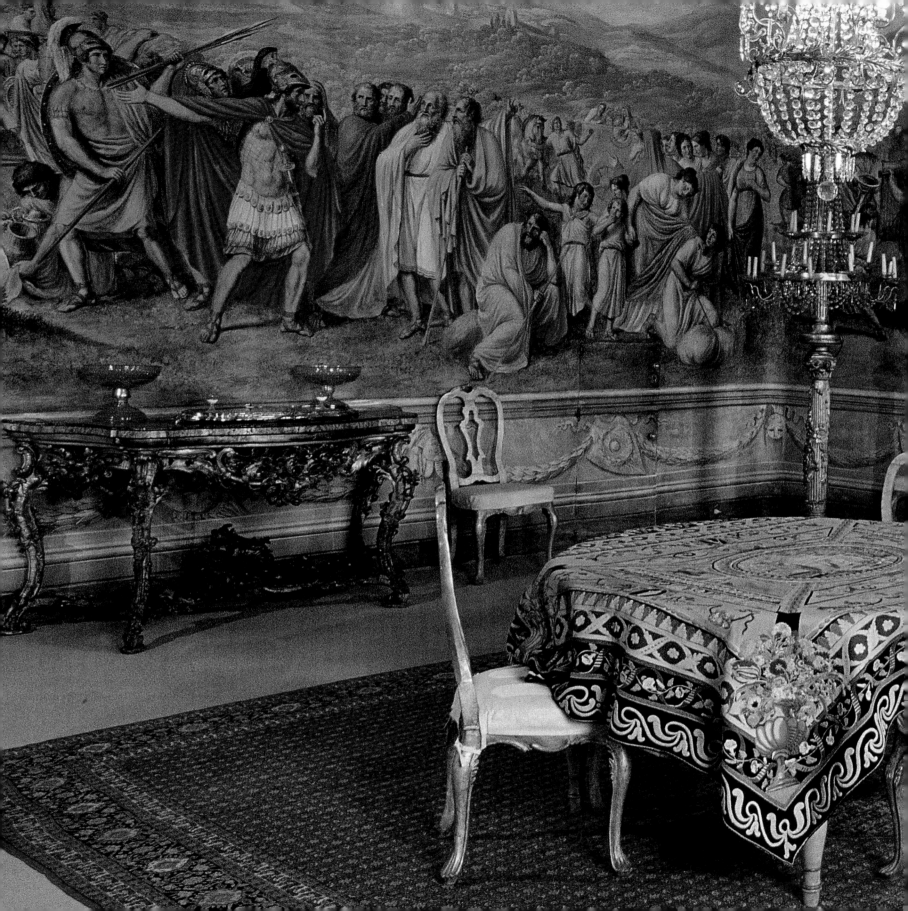

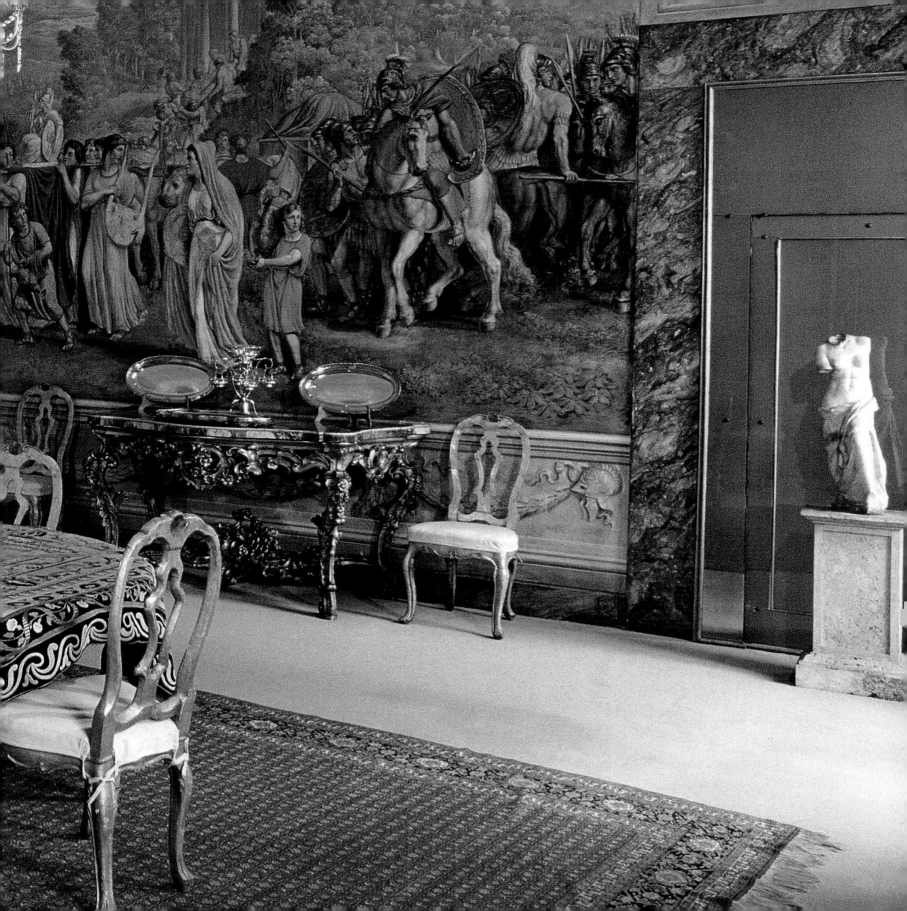

THE RUSPOLI COAT-OF-ARMS ON
THE FAÇADE OF LILLIANO CASTLE
(ABOVE, TOP).
THE DINING ROOM WALLS ARE
STUDDED WITH HUNTING TROPHIES
FROM AFRICA (ABOVE, BOTTOM).
THE COLORS OF THE SOFA, THE
PATTERNS ON THE CUSHIONS
AND THE VENETIAN MIRRORS STRIKE
A VIVID NOTE IN THE BILLIARD
ROOM (RIGHT).

WINE-GROWING ESTATES

Tuscany takes pride in the great estates—most of them aristocratic in origin—where its famous wines are made. The only comparable region from this point of view is Bordeaux. Occupied year-round by the families that have owned them for centuries past, these estates provide the context for an art of living that appears to exist outside the boundaries of time. And yet, they form the core of an economic activity that has adapted effortlessly to the age of the Internet. Our itinerary thus leads us through domains in which history blends seamlessly with the present . . .

Lilliano, A Keen Huntsman's Estate in Chianti

The hamlet of Lilliano lies near Castellina in Chianti. The castle's unadorned, cubic shape is visible through a grill opening onto a small square. Located on the border separating Florence from Siena, Lilliano was twice totally demolished before the definitive triumph of the Medici. The interior, demolished anew during the bombing raids of World War II, has since been entirely restored. However, the restoration has in no way diminished the charm of this country manor house in which big-game hunting is a respected tradition—as reflected by the impressive display of African trophies in the dining room. But the estate is also a thriving business anchored in the dual activities of wine-making and rural tourism. A very fine medieval cellar houses the French oak casks used for aging one of the celebrated "Super-Tuscan" wines—a new breed of wines that many connoisseurs consider superior to Chianti Classico—and Lilliano was one of the first estates to initiate on-site bottling. Rural tourism, in turn, has made it possible to find a productive use for, and thus to preserve, ancient tenant-farmhouses that are often three or four centuries old. The characteristic landscape of this part of Chianti, with its hills and panoramic views, has thus remained unspoiled. Lilliano is ideally positioned between Siena and Florence. One side of the house faces Castellina in Chianti, with its modern grain elevator resembling a medieval fortress when seen from afar; and the other looks out on the towers of Monteriggioni rising through the mist.

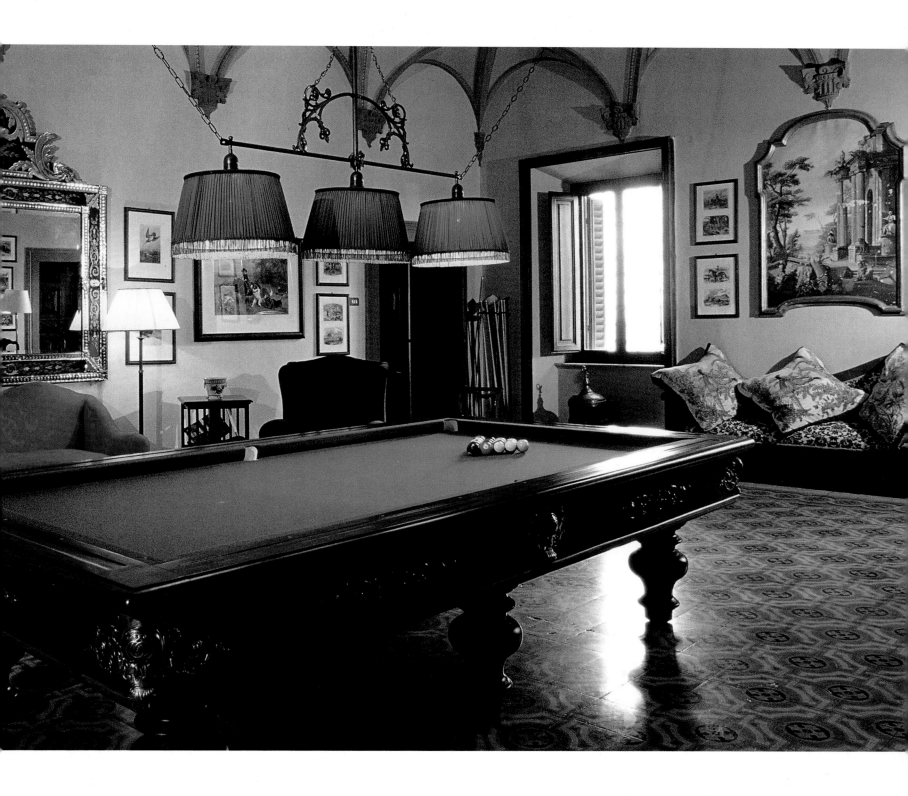

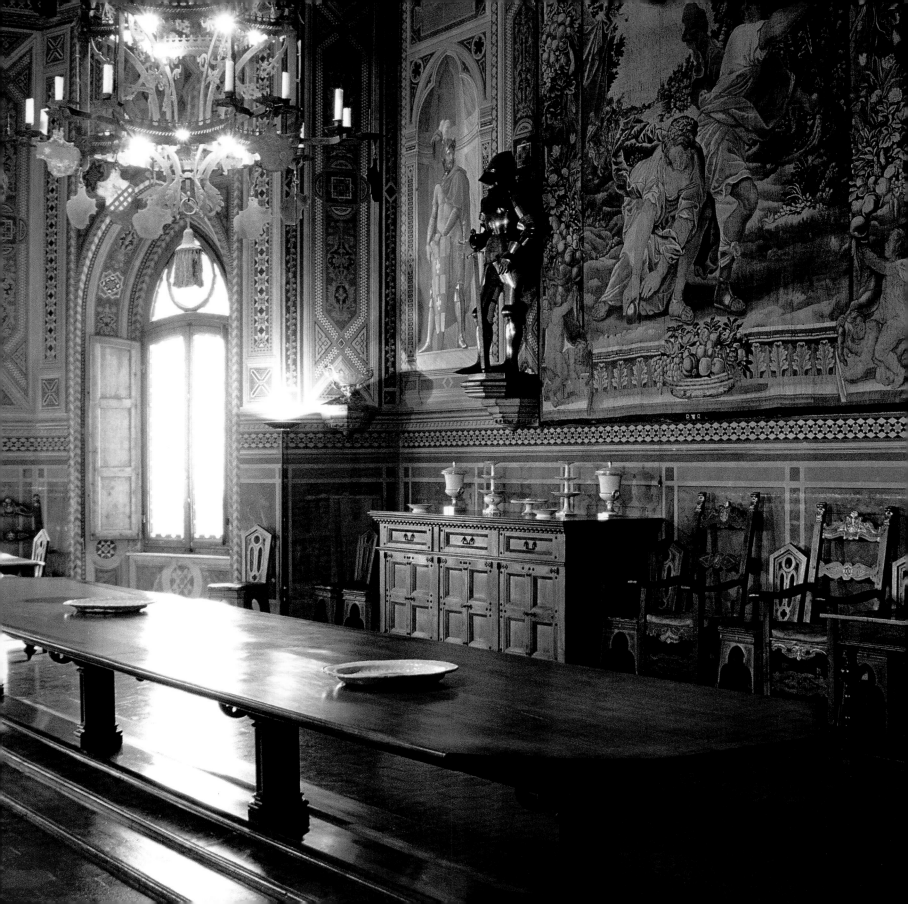

Brolio, Where the "Iron Baron" Invented Chianti Classico

The presence of the Ricasoli family in Brolio is recorded in a document dating from 1140. The little fortified village between Florence and Siena was replaced early in the thirteenth century by a powerful defensive stronghold. This coveted strategic outpost was subjected to numerous sieges. In the fifteenth century it was breached, sacked, and temporarily held by Siena. Following this turbulent interlude, the fortress was restored by Baron Bettino Ricasoli, who had the brick buildings almost totally reconstructed in the mid-nineteenth-century neo-Gothic style. Ricasoli, who occupies a major place in Italian history as an apostle of Italian unification and successor to Cavour, was known for his discipline and austerity. Possessed of a universal spirit and wide-ranging intellectual curiosity—as demonstrated by the breadth of his library—he is also the man to whom we owe the formula for Chianti Classico, a standard that was to remain unchallenged for over a century. Brolio seems still to be inhabited by this energetic individual, whose mark is visible everywhere. His modern-day descendant of the same name welcomed us to the impressive residence with the exquisite courtesy he also shows to erring tourists who stumble into the private living quarters. The room with the most stunning decor by far is the formal dining room, once an armory. Suits of armor and frescoes, neo-Gothic furnishings and stained-glass windows lend it an almost regal majesty. The family sitting room, on the other hand, which is also decorated in neo-medieval style, has retained a more intimate feel, to which the portraits on the walls—familiar rather than forbidding—contribute. This imitation Gothic decor, until recently viewed by connoisseurs with some disdain, is now appreciated on its own terms. Those parts of the castle that escaped the nineteenth-century restoration exhibit a simpler spirit, their white walls underscoring austere patterns of bare gray stone. One of the rooms contains a bronze bust dented by an artillery shell during World War II. However, thanks to its thick walls, the castle was otherwise undamaged by the merciless combat the Allies were forced to wage in this region against the Germans.

But the part of Brolio that impressed me most is the library. It lies beyond a vast room once containing archives subsequently donated to the nation. Its

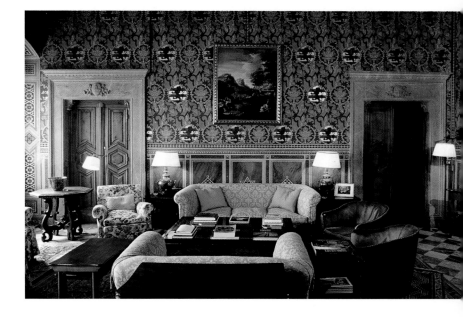

THE DINING ROOM AT BROLIO CASTLE IS AN IMPRESSIVE EXAMPLE OF THE NEO-GOTHIC STYLE (LEFT). A HERALDIC LION GUARDS A STONE STAIRCASE, AND AUTHENTIC SUITS OF ARMOR ECHO THE EFFIGIES OF KNIGHTS ADORNING THE WALLS (ABOVE, LEFT AND RIGHT). THIS NEO-MEDIEVAL SALON FILLED WITH SOUVENIRS IS AN INTIMATE FAMILY REFUGE (ABOVE).

THE LIBRARY AT BROLIO, WITH
ITS TIERS OF BOOKSHELVES, IS
AN IMPRESSIVE SPOT IN WHICH
IT WOULD HARDLY BE SURPRISING
TO ENCOUNTER BARON BETTINO
RICASOLI, THE "IRON BARON"
WHO PLAYED A CRUCIAL ROLE IN
THE UNIFICATION OF ITALY. AMONG
THE STATUETTES, A NUMBER OF
PORTRAIT-CARICATURES PROVE THAT
SELF-MOCKERY WAS NOT FOREIGN TO
THIS AUSTERE STATESMAN (RIGHT).

STAINED-GLASS WINDOWS IN THE
BROLIO DINING ROOM ILLUSTRATE
THE COATS-OF-ARMS OF THE
RICASOLI FAMILY AND ITS VARIOUS
BRANCHES. THE FAMILY OWNS
SEVERAL ESTATES IN THE REGION,
INCLUDING THE NEARBY MELETO
CASTLE (ABOVE, LEFT AND RIGHT).

walls are hung with two large paintings illustrating the castle's history. One depicts King Victor Emmanuel on a visit to Brolio—a courtesy call on the part of the sovereign to the "Iron Baron," following the latter's resignation from the presidency of the Council. The other, even more monumental, depicts Baroness Ricasoli receiving her new son-in-law—presented by her daughter Elisabetta on the couple's wedding day—as she lies on her death bed. By marrying a distant cousin, Elisabetta Ricasoli ensured that the great statesman's descendants would bear his name. The library occupies considerable space under the rafters. Works from every era are shelved in wall cabinets protecting them from sunlight and mice. A spiral staircase leads to an upper level where more books are stored in similar fashion. Scattered over tabletops and stuffed into drawers are quantities of memorabilia and precious documents, such as a laisser-passer signed by Louis XIV and Colbert for an ancestor of the family's who served as ambassador under the Grand Duke of Tuscany. A collection of figurines caricaturing Bettino Ricasoli suggests that this austere man was also capable of self-mockery. The tower's windows open onto sublime views—the castle and its outbuildings on one side, the vineyards of Chianti on the other, with the bell towers of Siena visible in the distance through the mist.

Badia a Coltibuono, Home of Lorenza de' Medici

The Abbey of Coltibuono, a place of meditation and prayer, has also traditionally been concerned with more worldly matters. Until the dissolution of the order in 1811, the monks earned a large part of their income from the vineyards they owned in the Chianti region. The Stucchi Prineti, descendants of the family that acquired the estate in the middle of the nineteenth century, supervised the elevation to the highest rank of their Coltibuono wines—not to mention their other products, which of course include olive oil. Roberto Stucchi Prineti's wife Lorenza de' Medici subsequently conceived the idea of starting a cooking school—in which the largest student contingent is made up of American women.

The ancient and still consecrated church is open to the public, but only a favored few are allowed to cross the threshold of the monumental gateway leading to the rest of the estate. Visitors enter a sun-drenched courtyard that is like the anteroom to a more tranquil world. The abbey living quarters and outbuildings are covered with a magnificent golden patina. An arcaded walkway leads to the garden visible below. Absolute calm reins in this enclosed yet luminous space. The entrance to the living quarters leads to the darker and more introspective cloister surrounding a stone well.

The formal salon, once the abbey's refectory, opens off the cloister. With its original frescoes, its inscriptions encouraging meditation and detachment, and its vast windows opening onto the garden, this sparsely furnished room is a marvelous example of the Tuscan style. Symbolizing the abbey's dual heritage as spiritual refuge and vineyard, two seventeenth-century paintings hung on either side of the door to the cloisters depict scenes of drunkenness taken from the Bible.

The kitchen is a feast of copper pots, wicker baskets, and bottles of local olive oil, wine, and vinegar. Less grandiose than some castle kitchens, it throbs with Lorenza de' Medici's self-imposed vocation: to teach others the thousand subtleties of Tuscan cuisine. Badia a Coltibuono is thus the locus, alternately, of absolute serenity and bustling gastronomic activity.

THE FORMER MONKS' REFECTORY AT BADIA A COLTIBUONO AND ITS DECOR OF FRESCOES IS NOW THE STUCCHI PRINETI FAMILY'S SITTING ROOM. THE MODERN FURNISHINGS FEATURE UNCOMPROMISING SIMPLICITY. THE LARGE WHITE SOFAS ALMOST MELT INTO THE WALLS, BLENDING SEAMLESSLY INTO THE ROOM'S ORIGINAL SPIRIT (LEFT).

THE KITCHEN AT BADIA A COLTIBUONO, WITH ITS WICKER BASKETS AND GLEAMING COPPER POTS, IS THE DOMAIN OF LORENZA DE' MEDICI—WHOSE GREATEST JOY IS COMMUNICATING THE INFINITE WEALTH OF TUSCAN CUISINE TO OTHERS. ESTATE-PRODUCED CHIANTI WINE AND OLIVE OIL ARE OF COURSE CENTRAL TO THIS ENDEAVOR (ABOVE).

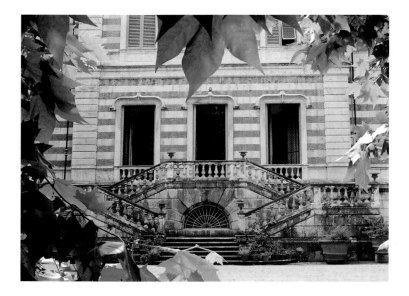

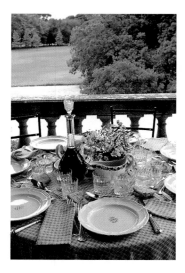

THE STONE-AND-BRICK
CONSTRUCTION OF MIGLIARINO
CASTLE REFLECTS THE FRENCH
ORIGINS OF THE SALVIATI FAMILY.
THE MANOR STANDS AT THE HEART
OF A VAST SEASIDE ESTATE IN A
REGION THAT WAS INSALUBRIOUS
MARSHLAND UNTIL THE
NINETEENTH CENTURY (ABOVE).
FACING THE PARK, A TABLE SET
WITH ELEGANCE AND SIMPLICITY BY
GRAZIA SALVIATI FOR THE
ENTERTAINMENT OF A FEW FRIENDS.
THE CARAFE OF WINE IS A REMINDER
THAT IN THE NINETEENTH CENTURY
MIGLIARINO WAS ONE OF THE
FIRST ESTATES IN ITALY TO IMPORT
FRENCH ROOTSTOCK FOR ITS
VINEYARDS (LEFT).

Migliarino, a Mansion by the Sea

I would never have dreamed I could find, so close to the *autostrada* and the city of Pisa, almost on the seaside, a spot as unspoiled as Migliarino. The Salviati's huge estate, with its acres of pine woods, is today a protected nature park. The Salviati family, whose name and titles passed to the Borghese in the nineteenth century, is one of the oldest in Florence, where it was inseparably bound to the Medici. In the fifteenth century, the family's commercial and financial dealings extended as far as Bruges, London, Lisbon, and Lyon. One branch of the family followed Catherine de' Medici to France—Ronsard dedicated several of his finest poems to Cassandra Salviati. It would take years of study and more to exhaust the fascinating family archives, which include a Machiavelli correspondence, today held by one of Pisa's universities. The Migliarino estate is located seven kilometers north of Pisa on a strip of former swampland left fallow until the nineteenth century, when one of the current Duke of Salviati's ancestors decided to cultivate it. He had close connections with France through his mother's side of the family and his marriage to a La Rochefoucauld, and he commissioned a French architect to design a castle at Migliarino departing from the accepted Tuscan style. The resulting brick-and-stone façade would not seem out of place in the Paris region, on the banks of the Loire, or at Biarritz. The interior is a magnificent example of the formal decorative style fashionable in the time of Napoleon III. French and Italian influences are combined majestically, but not without warmth, notably in the formal salon, where wallpaper and fabrics from Paris blend perfectly with the Venetian chandelier and furnishings.

In the billiard room, two huge display cases contain an amazing collection of stuffed-animal trophies, including a pelican, shot on the estate fifty and more years ago. Hunting is now banned—a regulation that unfortunately makes it difficult to maintain the ecological balance of the estate's wildlife.

It is also at Migliarino that one of the major developments in Tuscan viticulture took place. The estate's vineyards, which during the nineteenth century were replenished with French rootstock differing significantly from varieties native to the region, gave Mario Incisa della Rocchetta the idea for

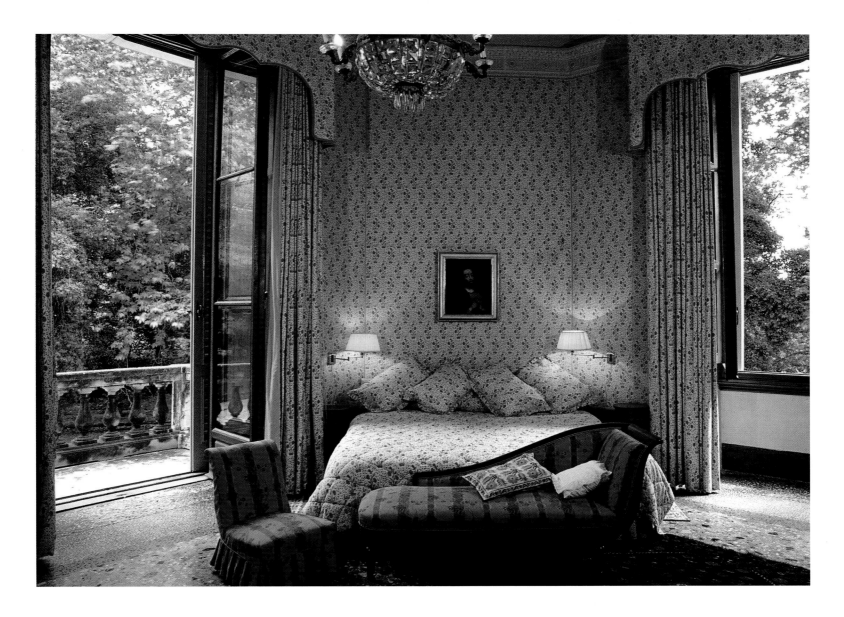

the famous Sassicaia that in just a few years has become one of the most highly prized vintages in the world. A luncheon served on the terrace provided a perfect opportunity to savor the wine of Migliarino while admiring the magnificent park which, if it wasn't for its tall parasol pines, might recall Normandy or England. Here is an unexpected view of Tuscany, one reflecting a long tradition of contacts with the rest of Europe.

A SPACIOUS, COMFORTABLE, SUNNY BEDROOM BUILT INTO A CORNER OF THE CASTLE AND OPENING ONTO THE PARK IS AN INVITATION TO REPOSE (ABOVE).

THE DECORATIVE STYLE OF THE
FORMAL SALON AT MIGLIARINO IS
TYPICALLY NINETEENTH CENTURY.
THE UPHOLSTERY FABRICS USED
FOR THE CHAIRS ECHO THE CHINESE
PATTERNS ON THE WALLPAPER
(ABOVE).
THE FOYER AT MIGLIARINO IS
DECORATED WITH MODERN FRESCOES
THAT STRIKE A FRESH, LIGHT NOTE,
ATTENUATING THE SOLEMNITY
OF THE ARCHITECTURE—AS IF
REMINDING US THAT WE'RE IN THE
COUNTRY. THE MANY PHOTOGRAPHS
ON THE PIANO ARE A SIGN THAT
THE MANOR IS STILL A FAMILY HOME
(RIGHT).

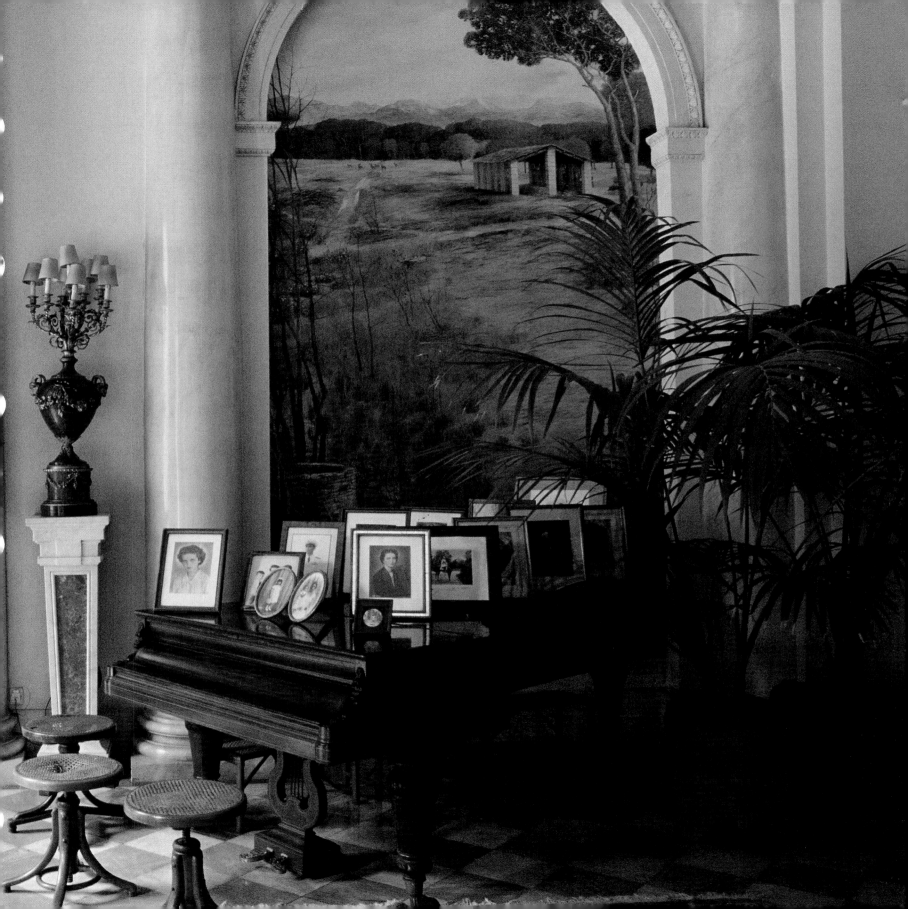

VILLAS, OR THE ART OF COUNTRY LIVING

Combining the urban with the rustic, Tuscan villas are striking not only for the beauty of their gardens, but also for the charm of their interiors. The quest for elegance is here pursued in a way that is intimate rather than opulent, though sometimes tinged with a degree of preciosity. Harold Acton has described, somewhat wistfully, what it feels like to live in a Tuscan villa—a world designed to human scale where the beauty of the gardens, the balance between civilization and nature, and the presence of historic memory hone the spirit. But then, was he not born in one himself?

The number of villas built during the Quattrocento was so great that, regardless of their subsequent fate, enough have survived to render real-estate speculation of any kind incapable of exhausting the supply. Often enclosed by walls protecting their privacy, they have succeeded better than many other types of historic residence in adapting to the imperatives of the modern world. Conversion into museums, as at La Petraia, has made it possible for several to endure. The great villas once owned by the Medici family, partially restored by successive stewards, have regained the luster that made them incomparable models of their kind. Others have been converted, either in whole or in part, into hotels: several of these, such as the Villa Villoresi or the Villa Suvera, are still family-owned and have preserved their family atmosphere. However, many jealously protect their privacy.

The following itinerary starts with one of the great Medici villas, and then takes us to three private estates near Siena and Florence that have succeeded in preserving the characteristic charm of the Tuscan style. Although they have made some concessions to modernity, time here seems to flow at a different pace.

AT LA PETRAIA, NEAR FLORENCE, A GILT CURTAIN-PULL AGAINST THE DEEP RED OF THE WALL COVERING REFLECTS THE TASTE PREVALENT IN THE NINETEENTH CENTURY, WHEN THIS MEDICI-PERIOD VILLA WAS RENOVATED FOR THE KING OF ITALY (ABOVE).

ONE OF THE SALONS AT LA PETRAIA FEATURES A DRAMATIC CONTRAST BETWEEN THE GILT FURNISHINGS AND THE PURPLE FABRIC USED FOR UPHOLSTERY AND WALL COVERINGS (ABOVE).

FOR THE INTERIOR REDECORATION OF LA PETRAIA, KING VICTOR EMMANUEL ORDERED—FOR HIMSELF AND THE COUNTESS OF MIRAFIORI, FIRST HIS MISTRESS AND LATER HIS MORGANATIC WIFE—A CLUTTERED SETTING IN AN ALMOST BOURGEOIS SPIRIT, IMITATING THE STYLE FASHIONABLE IN FRANCE UNDER NAPOLEON III. IT'S A SETTING THAT WOULD HAVE APPEALED TO VISCONTI (RIGHT).

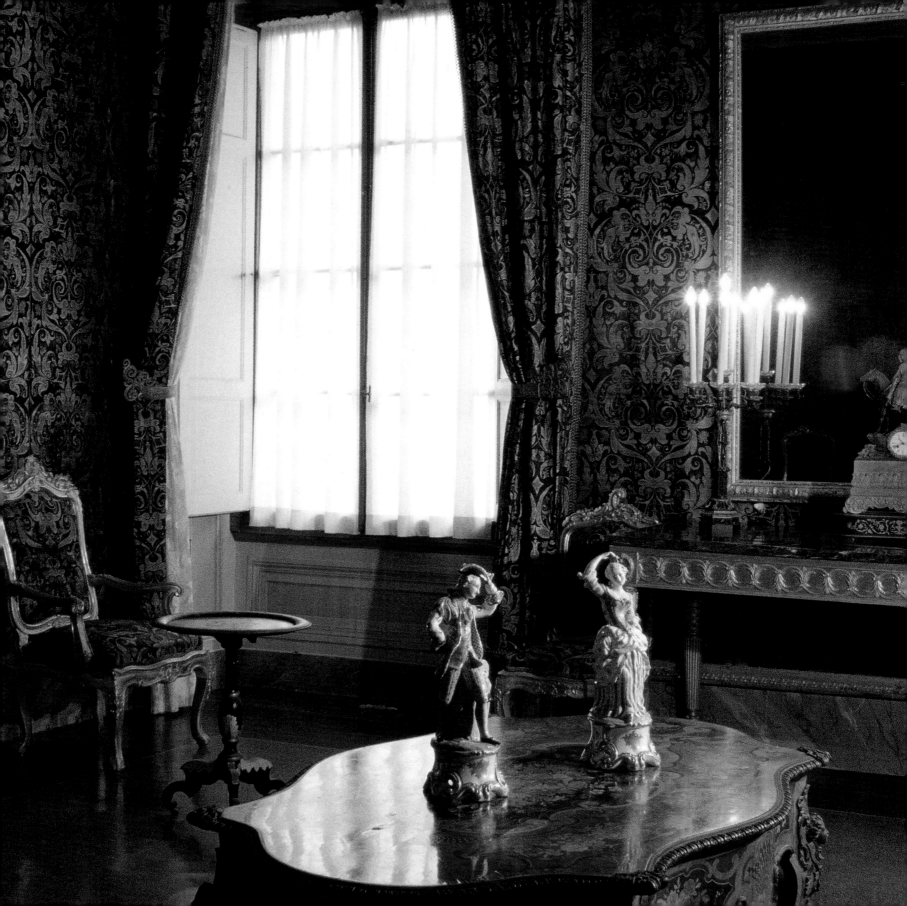

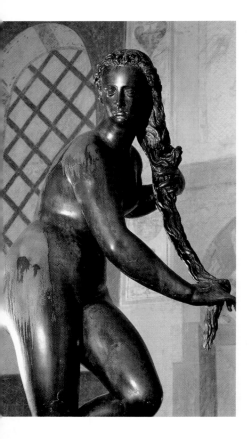

NOW A MUSEUM, LA PETRAIA
HOUSES THE ORIGINAL SCULPTURE
BY GIOVANNI DA BOLOGNA THAT
FORMERLY ADORNED ONE OF
THE FOUNTAINS IN THE GARDEN
(ABOVE).
VAST SEVENTEENTH-CENTURY
FRESCOES DEPICT THE BANQUETS
HELD BY THE MEDICI (RIGHT).
IN CONTRAST TO THE INTIMATE
DECOR OF THE VILLA'S LIVING
QUARTERS, THE DINING ROOM
IS TRULY REGAL (FAR RIGHT).

La Petraia, a Royal Residence Above Florence

La Petraia, rising from the hamlet of Castello perched above the center of Florence, is one of the great Medici villas. The end of the little road leading to it still has a rural flavor. The villa's unassuming entrance reflects a totally unostentatious spirit. La Petraia is the successor to a medieval castle confiscated from the Strozzi by the Medici in 1530. Sixty years later, Ferdinando I commissioned Buontalenti to convert the edifice into a country manor. The architect integrated the fourteenth-century watchtower into the new construction, and the façade presented by La Petraia to visitors is thus an extremely austere one. The gardens were extensively redesigned in the eighteenth and nineteenth centuries. The villa's greatest claim to fame is the fact that in 1865, during Florence's period as capital of the Kingdom of Italy, it served as the private residence of King Victor Emmanuel II. The sovereign transformed the old interior courtyard into a ballroom with murals and a glass roof resting on cast-iron columns. The private apartments were redecorated for the Countess of Mirafiori, the king's official mistress and then—following the death of the queen—his morganatic wife. Above the formal reception rooms on the ground floor are a series of more intimate apartments, some still containing their original silk wall hangings.

La Petraia's charm is thus derived less from the works of art it contains than from its abiding atmosphere of a lived-in home. The king's study, the bedroom, and the impressive game room, although decorated according to the tastes of a dynasty alien to Tuscany, reflects a lifestyle that is domestic rather than regal.

La Petraia's lovely gardens are one of its major assets. The upper level behind the villa, originally designed for hawking, was converted during the mid-nineteenth century into a romantic park of great charm. The garden as a whole forms a mass of dense greenery serving as a perfect foil for the fine orange-tinged color of the buildings. On the same level as the main house, at its eastern side, a vast square borders a copy of the Fiorenza fountain that once stood in Castello. The flower beds dotting the lawns beyond are edged with terra-cotta tiles in the shape of acanthus leaves—an original pattern copied from ancient documents. The belvedere built at the opposite corner

of the villa served as a "resting place" for Victor Emmanuel on his walks with the Countess of Mirafiori. The terraces extending from the main façade were meticulously restored by the castle's stewards, and their initial design has been preserved. On the lower level lies a vast pool that was once a fishpond. Below it, a recently restored bulb garden recalls the fascination of the Medici for these flowers, of which they collected the greatest possible number of varieties. Lower still lie square plots planted with replacements for the original dwarf fruit trees.

During the month of March the lawns are thickly carpeted with jonquils and primroses, recalling Botticelli's *Primavera*. Here at La Petraia, the effort to achieve historical accuracy—which elsewhere has at times produced a somewhat lifeless effect—constitutes the estate's main charm.

THE CHIGI DELLA ROVERE FAMILY
COAT-OF-ARMS, TOPPED BY
A CARDINAL'S HAT, WERE DEVISED
BY POPE ALEXANDER VII'S NEPHEW
FLAVIO, WHO COMMISSIONED
CONSTRUCTION OF THE VILLA
DI CETINALE IN THE SEVENTEENTH
CENTURY (ABOVE, TOP).

Cetinale, or English Taste in a Tuscan Spirit

The Villa di Cetinale, located near Siena at the foot of La Montagnola, boasts one of the most amazing gardens in Tuscany. But the villa itself is no less interesting. It is one of the finest examples of the baroque style, in its most restrained version, found in the region. Cardinal Chigi commissioned its design in 1680 from Carlo Fontana, the architect his uncle Pope Alexander VII had chosen to design the façade of Saint Peter's in Rome. The plan is a very simple one, based on an earlier design drawn up by the great Sienese architect Peruzzi early in the previous century. On the courtyard side, the villa's ground-level entrance lies behind a triple-arcaded loggia. A sort of winter garden leads into a vast hall still dominated by busts of the Chigi family. On the garden side, a double staircase made of Siena marble leads to the *piano nobile* containing salons and bedrooms. The villa's present owner, Lord Lambton, has succeeded in preserving, or restoring, the original elegant and intimate atmosphere of this manor house built to a human scale. Family souvenirs are combined with more precious objets d'art in an arrangement of artful disorder. The many dogs kept as household pets are free to roam among the antique consoles or stretch out for a nap on the fine terra-cotta tile floor. An example of the patrician simplicity characteristic of the entire villa can be found in the kitchen, where the estate's former stewards look down from portraits hung on the walls, as if still supervising the operations taking place below them.

The interior decoration of Cetinale achieves a seamless synthesis of English taste and Italian spirit. Here we have a stool adorned with the pope's coat-of-arms; there an English cabinet. French grisaille wallpapers have replaced paintings destroyed by fire, and the attentive observer will note an engraving on the wall depicting the fief of the Lambtons and their canting coat-of-arms with its three lambs. The bedrooms adjacent to the salon contain imposing beds and a multitude of personal souvenirs and photograph albums. A gray-stone staircase, unadorned except for its wrought-iron banister, leads to the upper floor where simply furnished rooms afford an even more luminous view of the Villa di Cetinale gardens and La Montagnola beyond.

THE FORMAL SALON AT CETINALE OPENS ONTO A FINE SIENA-MARBLE STAIRCASE LEADING TO THE GARDEN. INSIDE, COMFORTABLE ENGLISH-STYLE SOFAS ARE DOTTED AMONG BAROQUE CONSOLES AND MIRRORS, AND TWO LARGE LENGTHS OF FRENCH GRISAILLE WALLPAPER ADORN THE WALLS (LEFT, BOTTOM). THIS DETAIL OF THE DECOR AT CETINALE REFLECTS A COUNTRY-MANOR SPIRIT THROUGH THE LINK ESTABLISHED BETWEEN THE WALL AND THE LANDSCAPE PAINTING. THE VERY SUBTLETY OF THIS LINK CONTRIBUTES TO THE ORIGINALITY OF THE WHOLE (RIGHT).

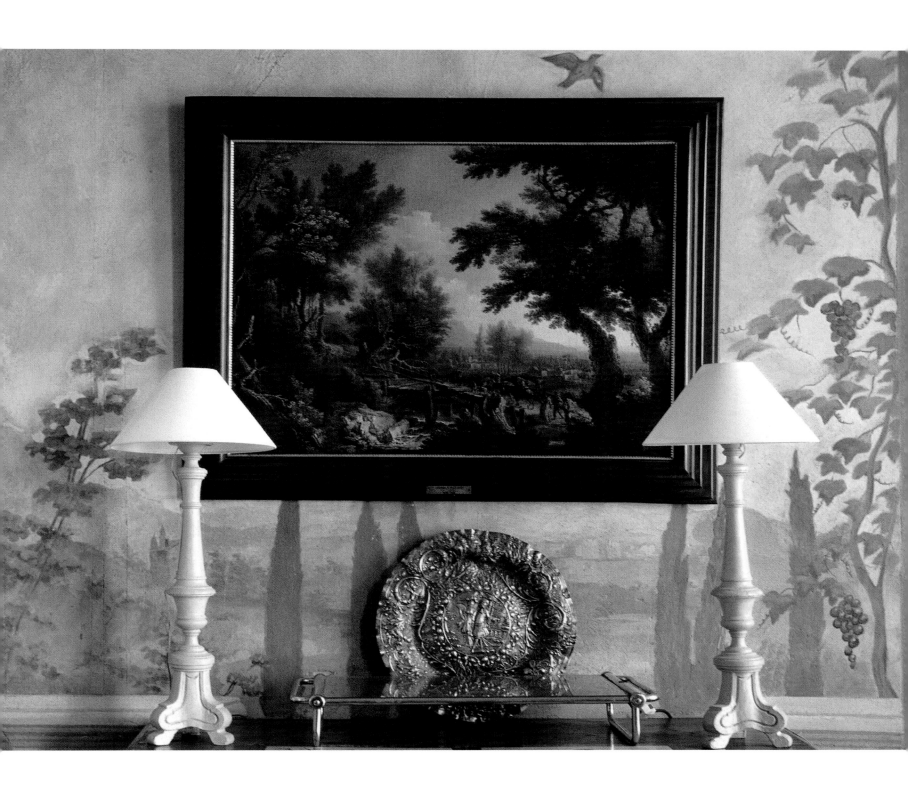

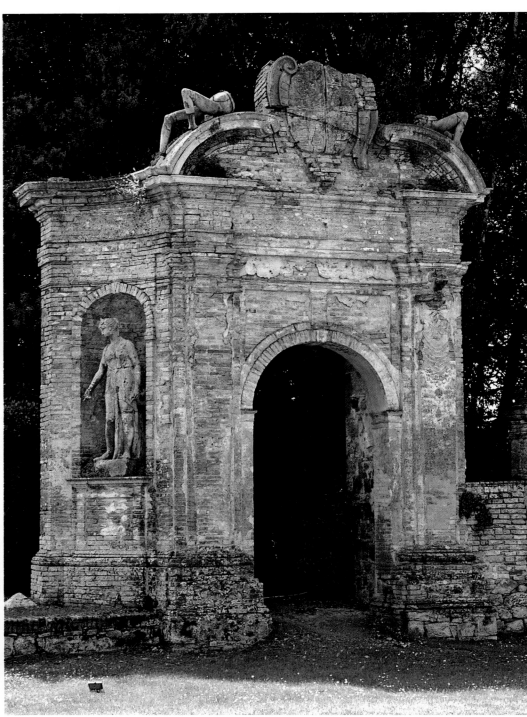

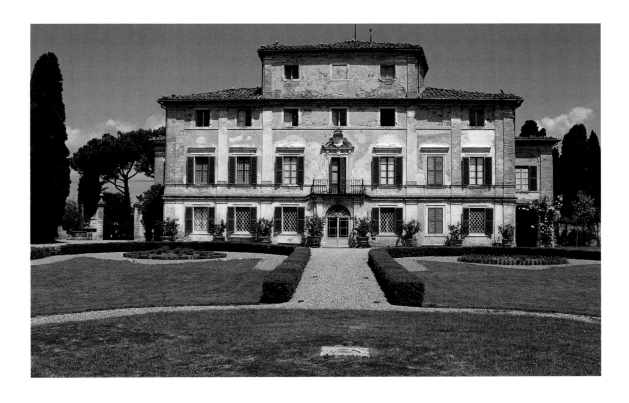

Geggiano, or Time Recaptured near Siena

It was from my friend Alvar Gonzalez Palacios that I first learned about the great classical historian and Sienese archeologist Ranuccio Bianchi Bandinelli. A fine scholar, an eccentric, and member of a very ancient Sienese family—one of his ancestors was Pope Alexander III, who triumphed over Frederick Barbarossa—Bandinelli was dubbed "The Red Count" because of his links with the Communist Party. After World War II, he ceded most of the farmsteads on the family estate of Geggiano to their peasant tenants, retaining for his own use only the main house—which must surely be one of the strangest in Tuscany. An unpretentious country house when first built in the fourteenth century, it was subsequently enlarged through a succession of additions. The building's square core, supported by two imposing arches, served for many years as the kitchen—the original cupboards are still in place—before being converted into a spacious living room that is especially appealing in wintertime, when a roaring fire blazes in the vast chimney. The

building's design, as we see it today, is the fruit of an almost total reconstruction undertaken in the very late eighteenth century following an alliance with the Chigi Zondadari family. The garden was redesigned at the same time, with the addition of a delightful open-air theater boasting remarkable acoustics. The poet Alfieri stayed here during the final years of the century—a period of deep suffering for him because of Italy's occupation by the French—and the villa's open-air theater, nestled in its wreath of laurel and cypress, once rang with his verses.

A more distant Ranuccio Bianchi Bandinelli, one of the family's forebears and a pillar of the Neapolitan administration who was named prefect of the Ombrone district created in 1811, wholeheartedly supported the 1814 restoration, thus alienating his son Mario, who insisted on maintaining his own radical convictions. Mario inherited the estate, but was cut off without a penny by his father. This political spat between father and son turned out to be a blessing in disguise for Geggiano. Due to lack of funds, it was never restored,

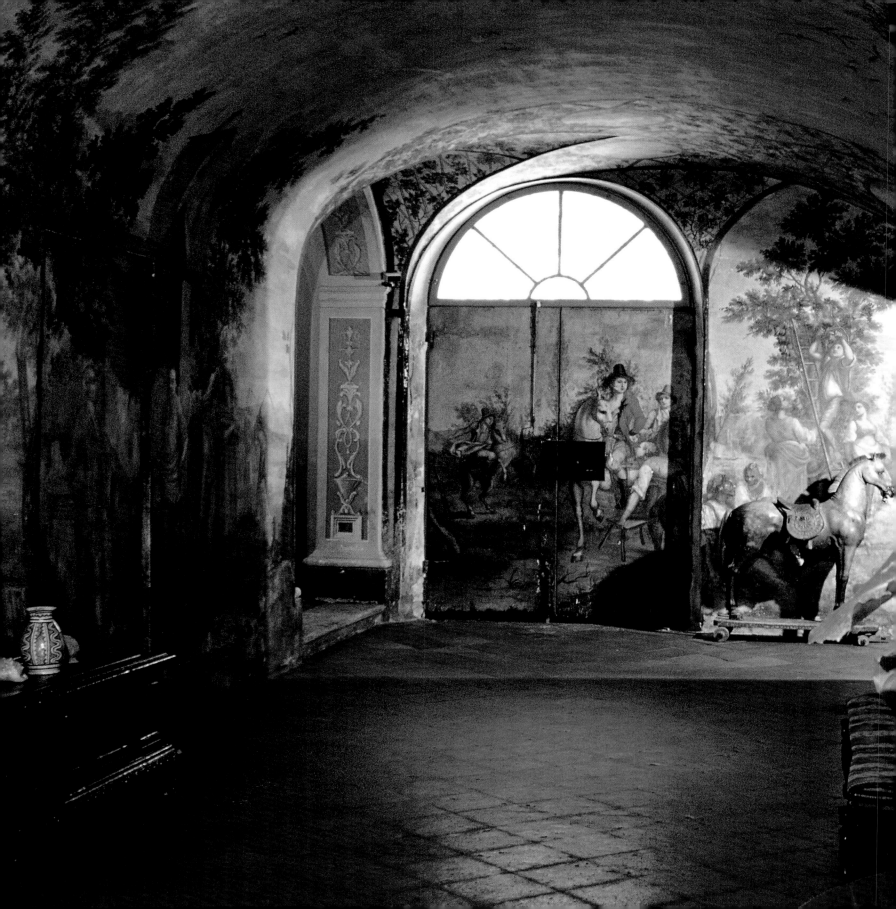

A MAGNIFICENT EXAMPLE OF
THE VILLA DI GEGGIANO'S CHARM
IS THE LONG ENTRANCE CORRIDOR
DECORATED WITH FRESCOES
ILLUSTRATING THE FOUR SEASONS.
THE DOOR AT ONE END DEPICTS
A HEROINE OF THE SIENESE
RESISTANCE TO THE FRENCH
OCCUPATION — AN IRONIC DETAIL
IN VIEW OF THE FACT THAT ONE
OF THE BIANCHI BANDINELLI
ANCESTORS SERVED AS A PREFECT
UNDER NAPOLEON. THE STUNNING
HOBBY HORSE PRESENTED TO ONE
OF THE FAMILY'S CHILDREN
BY GRAND DUKE LEOPOLD HAS
SURVIVED UNSCATHED (LEFT).

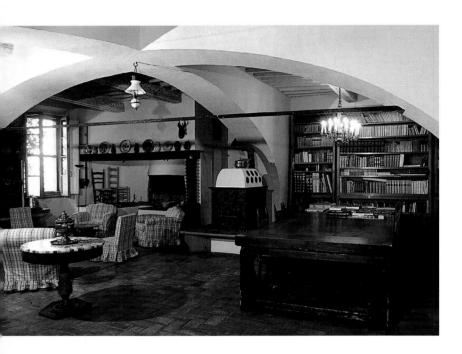

Goethe for that of Alfieri, claiming to have direct orders from Marshal Kesserling that a villa once having received the great poet must be spared. Today the house's unscathed interiors—down to the last patinated inch—can be viewed as Alfieri must have viewed them, and as they doubtless appeared thirty years later to the guests of Mario Bianchi Bandinelli: enlightened liberals who shared his ideas, one of whom, according to family tradition, was Stendhal. The Villa di Geggiano's interior is striking for a stylistic unity which extends to the smallest details. Although the house served for generations as a summer residence, and was thus occupied only sporadically, its rooms have not suffered unduly from the passage of time. Also, since the shutters were usually kept closed against the heat, the blue color of the wallpapers and the red of the *toile de Jouy* have remained undimmed. Because Ranuccio Bianchi Bandinelli's two grandsons have made the villa their permanent home, modern toys can now be seen scattered beside the wooden hobby horse presented to the family by Grand Duke Leopold. The overall impression projected by this collection is a singular one, rendered even more intimate by the light, cheerful original decor. To support this unique heritage, Andrea and Alessandro Boscu Bianchi Bandinelli exploit the vestiges of a vineyard existing since 1725. Their fondest hope is to restore the open-air theater to its original function, one it has, in fact, fulfilled episodically over the past few years.

and thus retained its original simplicity of design. In 1944, the villa also escaped the retreating German army's wrath, thanks to a white lie devised by the Ranuccio Bianchi Bandinelli of scholarly fame. Recounting the villa's history to a German commanding officer, Bandinelli deftly substituted the name of

THE OLD KITCHEN AT GEGGIANO HAS BEEN CONVERTED INTO A READING ROOM (ABOVE). THE BLUE SALON HAS REMAINED UNCHANGED SINCE THE TIME WHEN STENDHAL MUST HAVE SEEN IT (CENTER RIGHT). AN OPEN DOWNY WHITE OSTRICH-FEATHER FAN (RIGHT). ONE OF THE SALONS AT GEGGIANO IS ENTIRELY COVERED IN PAINTINGS IRONICALLY RECOUNTING THE MISHAPS OF MATRIMONY (FAR RIGHT).

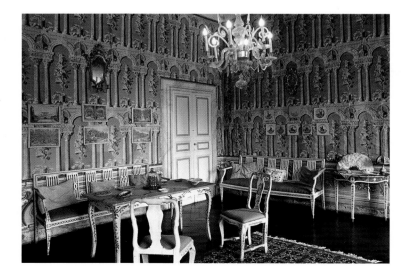

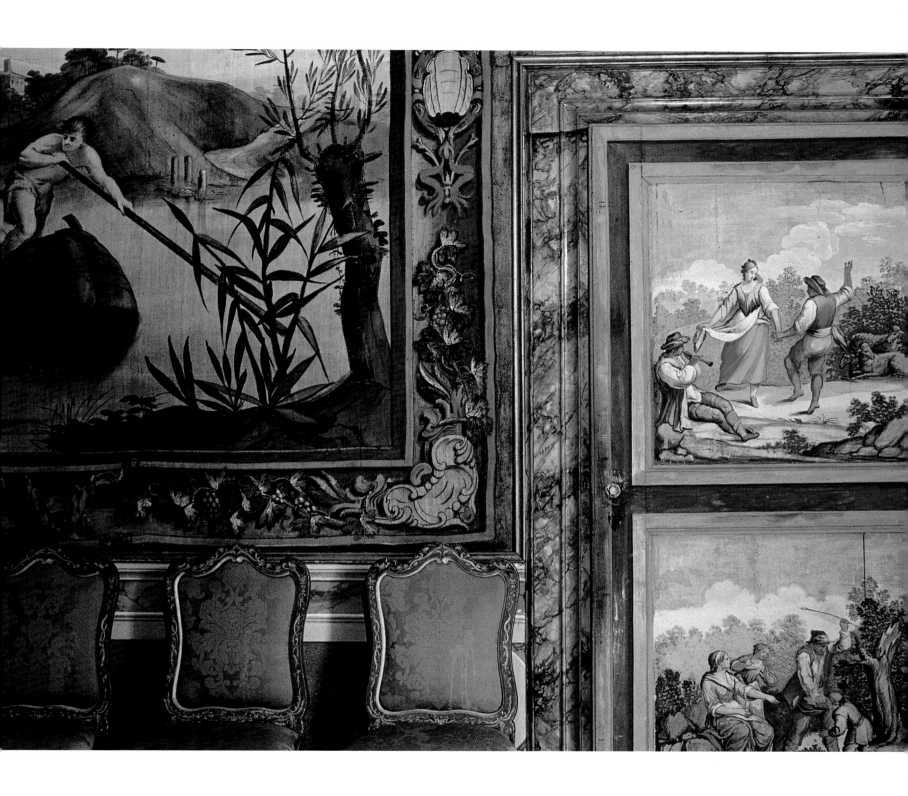

In a ladies' drawing room
teasingly dubbed CIARLATOIO
(chatter room), the shadow
of a tulle curtain that seems
to have remained immobile for
centuries contrasts with the
pattern of the floor (above).
The elegant, sun-filled bedroom
at Geggiano, where the poet
Alfieri spent the last years
of the eighteenth century,
has preserved its original
style—a French influence
is evident in the design of
the furnishings, but the
wallpaper is very Italian
(right).

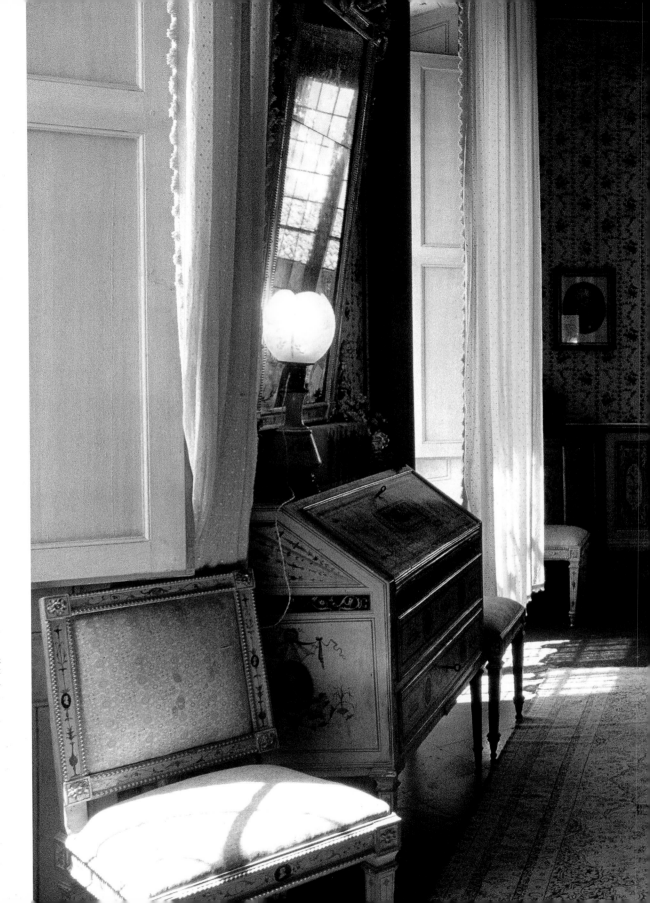

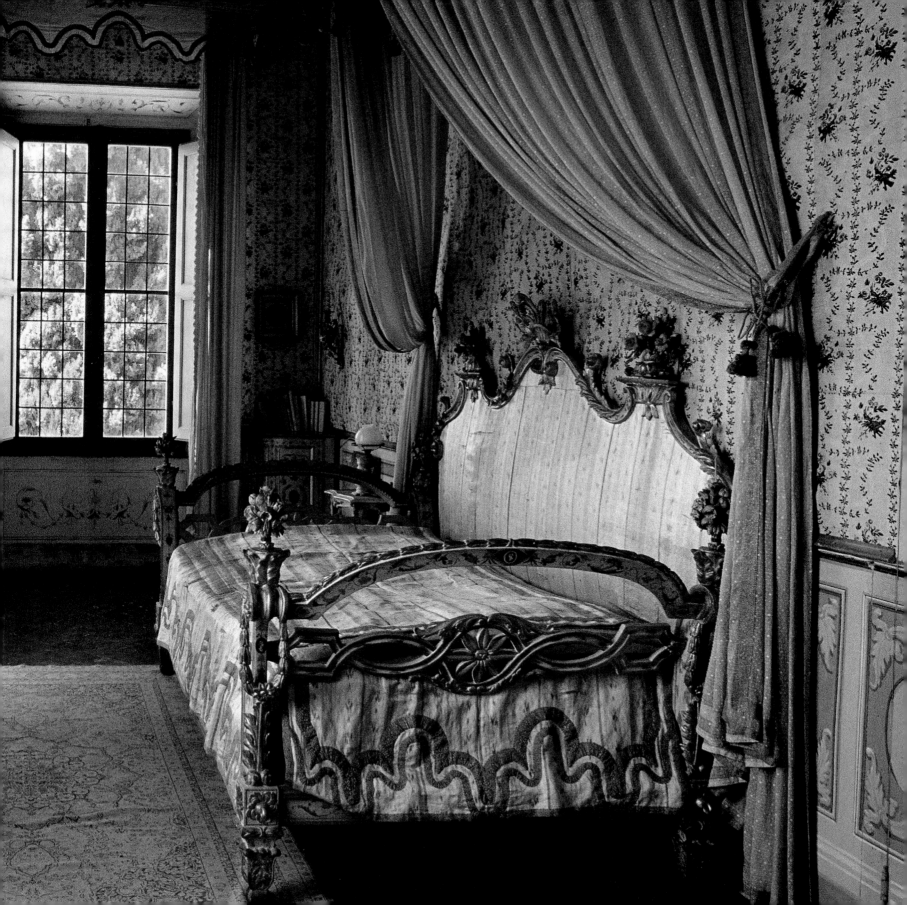

IN THE VILLA MONTECECERI DINING
ROOM, A NINETEENTH-CENTURY
WALLPAPER DEPICTS THE LEGEND
OF PSYCHE (RIGHT).

THE UPPER FLOORS ARE LINED
FLOOR-TO-CEILING WITH BOOKS
(ABOVE, BOTTOM).

THIS EMPIRE BED IS ONE OF THE
MANY EXAMPLES OF THE REFINED
NEOCLASSICAL TASTE TYPICAL OF
THE VILLA'S INTERIOR (ABOVE, TOP).

THE VILLA MONTECECERI ABOVE
FIESOLE STANDS AT THE EDGE OF
AN ESTATE LEONARDO DA VINCI
ONCE USED FOR HIS FLYING-
MACHINE EXPERIMENTS. TODAY IT'S
THE IDEAL RESIDENCE FOR LIVING
IN FLORENCE BUT AT A DISTANCE
FROM THE CITY'S CONGESTED
CENTER (LEFT). IN THE GUESTHOUSE
COURTYARD, A SHOWER OF FALLEN
RED PETALS HERALDS THE END
OF SPRING (FAR LEFT).

Montececeri, the Hill above Fiesole

When Florence begins to suffocate in the summer heat, the only solution is to head for the hills. And the Montececeri hill overlooking Fiesole is one of the highest points in the area. For centuries past it has been quarried for *pietra serena*, the gray stone seen everywhere in Florence, and its slopes are scarred with exhausted veins. It is here that C. and A. inhabit a villa built on the edge of a huge estate extending all the way up to the summit of the hill. The architecture of the house, which was constructed early in the nineteenth century and is now painted deep red, is simple and unadorned. A loggia built off the central portion of the house, on the garden side, supports a terrace for the rooms above.

The site itself is quite rugged, and offers a number of contrasting views. A swimming pool is carved from a sloping rock near the house. Beyond it lie orchards and vineyards, alternating with wild meadows and woodland. Benches placed at intervals along the path offer an opportunity to rest for a moment while enjoying the view. Depending on the vantage point, this view might be of ancient Fiesole and its Etruscan walls, the Bologna road winding through the hills, or Florence itself. One of the estate's many surprises, and not the least by any means, is the sight of Brunelleschi's dome rising from the weeds and underbrush, its impact further enhanced when we learn that part of this land once belonged to Leonardo da Vinci. In his time, the as yet treeless hill was still being quarried for stone, and its barren peak offered an ideal site from which to launch his flying machines. Today the spot has been invaded by charming woodland.

The house's interior is one of the most original I encountered in Tuscany, its decor an artful combination of Italian furnishings and objets d'art, with items reflecting neoclassical French and English taste. The dining room, for example, is hung with two lengths of wallpaper printed in Paris in 1816. On the fine marble floor of the salon stands a bookcase from the same period, placed so as to frame the niche holding a Virgin that is probably of southern Italian origin, while Chinese statuettes gaze across the room at busts by Canova or from his studio. The upper floor impressed me with the many books lining its walls. The heir to four generations of jurists and a jurist himself, C. could not imagine his home as anything other than a vast library. Old editions, some of them very rare, happily coexist with more recent ones, all arranged in a strict order leaving nothing to chance. Here, the spirit of the Quattrocento is still very much alive: a passion for scholarship combined with a love of viticulture in the ancient tradition of Cosimo the Elder— unconsciously borne out by my youthful hosts as they poured glasses of the estate's white wine to accompany our conversation.

AT HOME WITH ARTISTS AND WRITERS

Tuscany has attracted artists and writers for centuries past, and continues to attract them today. Numerous artists, both from Italy and abroad, have elected to settle in the region—if not permanently at least for extended periods—drawn by the beauty of its landscape and light, the proximity of so many masterpieces, and the skills of local craftsmen. During the nineteenth century, this tradition developed still further, spearheaded by the English, who were joined by Americans such as Henry James. The trend has since continued unabated. Artists of every stripe, from Mitoraj to Botero and Niki de Saint-Phalle, have publicized this land that is especially hospitable to them. The success of Frances Mayes's books, albeit somewhat disconcerting to Tuscans who may fail to recognize themselves in her descriptions, illustrate the power of the myth. Some of the contemporary artists and writers who have chosen to live in Tuscany were kind enough to open the doors of their homes and studios to us . . .

GÉRARD FROMANGER'S STUDIO, IN AN OLD ABANDONED CHAPEL NEAR SIENA, OPENS ONTO THE COUNTRYSIDE. IF THE HOUSE'S WALLS COULD SPEAK, THEY WOULD RECOUNT THE ESCAPADES OF THE ECCENTRIC PRIEST WHO ONCE LIVED HERE (ABOVE).

THE HOUSE IS PERCHED ATOP THIS HILL AFFORDING AN ENDLESS PANORAMIC VIEW. THE IMPRESSION IS OF TRANQUILLITY, RATHER THAN SOLITUDE (ABOVE). THE CHAPEL HAS RETAINED ITS ORIGINAL SPACIOUSNESS. A SKYLIGHT BEAMS NORTHERN LIGHT DOWN ONTO THE ARTIST'S TUBES OF PAINT AND HIS WORKS IN PROGRESS. THE RED PLASTIC BALL IS A SOUVENIR OF 1968 IN PARIS (RIGHT).

A Studio in a Chapel near Siena

Owing to I'm not sure what preconceived idea, exactly, I never expected to find Gérard Fromanger in Tuscany. Perhaps because, in my mind, his name is inseparably associated with a burlesque "happening" staged in the fall of 1968, when memories of the student uprising in May of the same year were still vivid. For this event, Gérard filled a Parisian street with big, red plastic balls, and Jean-Luc Godard filmed the bemused reactions of passersby until the police—obsessed by the threat of subversion—dispersed the crowd and destroyed the balls. But I should also have remembered Fromanger's large canvases depicting opaque silhouettes against meticulously detailed

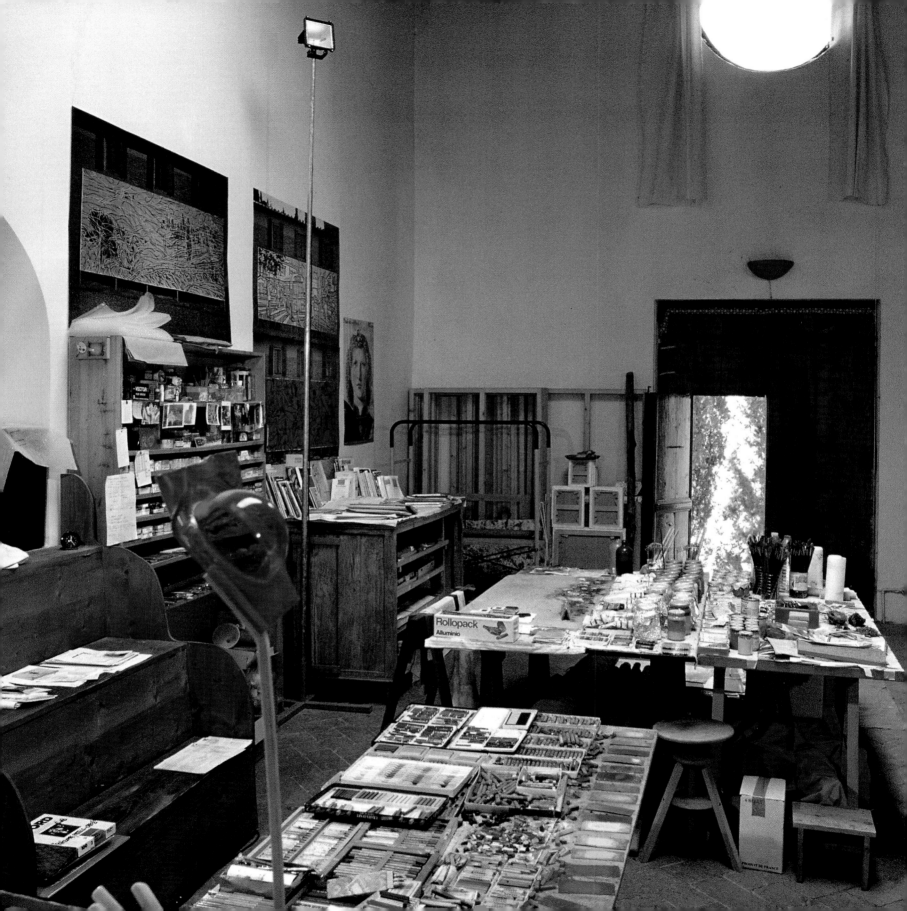

TUSCANY WINTERS TEND TO BE COLD
AND DAMP—THIS BRICK FIREPLACE
IS THUS THE FOCAL POINT OF THE
LARGE GROUND-FLOOR LIVING
ROOM, WHERE THE MASTER OF
THE HOUSE SERVES ALMOND
BISCUITS AND SWEET WINE
TO HIS GUESTS (ABOVE).
A BOUQUET OF RED TULIPS
BRIGHTENS THE TABLE IN THE
DINING ROOM, A PLACE OF
EXTREME SIMPLICITY DECORATED
ONLY WITH A MIRROR (RIGHT).

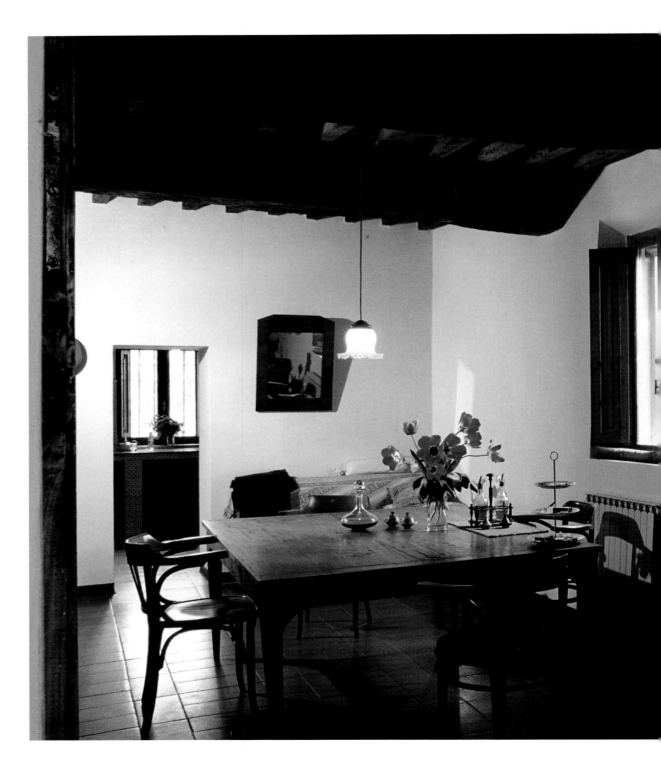

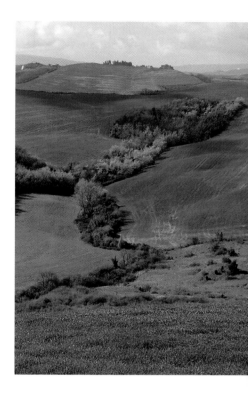

backgrounds, paintings that have inspired remarkable commentary from the philosopher Gilles Deleuze and that perforce require ample studio space and light. Fromanger has elected to work several months of the year in virtual seclusion, far from the nerve centers of current fashion. Twenty-five years ago, he found just the place he needed: a disaffected chapel and presbytery near Siena. The buildings were crumbling and the roofs collapsing, but if the walls could speak, they would tell a strange tale. Rumor has it that a slightly deranged priest once rented out one floor of the house as a love nest—in exchange for money. Thus does the building's serene façade conceal the traces of tempestuous passion. What more could an artist ask for?

Fromanger's retreat is not easy to find. You have to leave the Via Aurelia some twenty kilometers southeast of Siena and follow winding country roads through the Siena Hills. I visited for the first time on a winter's day. The landscape was bathed in mist, smoke rose from the chimneys of nearby farmhouses. The prevailing silence was only slightly disturbed by the sound of my car, and my arrival passed virtually unnoticed. A passing cat led me to the master of the house, who set glasses of white wine and some *cantucci* on the wooden table standing before the fire—this meeting of Parisians was being conducted according to the peasant rites of Siena. Gérard has lived in Tuscany for the past twenty-five years, and considers it his adoptive land. This painter, this maestro—heir to a love of art going back to the Middle Ages and rooted in an even more distant past—here finds himself surrounded by respect and esteem, a signal proof of which is the *pàlio* the city of Siena asked him to produce. Before I left, Gérard took me on a tour of the old chapel. The sole vestige of the building's original purpose is the raised altar base, which has preserved its fine black-and-white marble paving. The rest of the space is filled with tools of the artist's trade: brushes and pastels laid out on tables, stacks of easels and unfinished paintings, books and posters. An opening in the roof admits a steady stream of light, and in good weather the old chapel door is left open to the sun, framing the landscape like a painting lined with cypress trees.

GÉRARD FROMANGER'S HOUSE AND STUDIO STAND AT THE HEART OF THE SIENA HILLS REGION, IN A COMPLETELY UNSPOILED LANDSCAPE TO WHICH— FORTUNATELY—NO PAVED ROAD LEADS (ABOVE).

THE SARTOGOS HAVE CHOSEN A
MINIMALIST DECORATIVE STYLE FOR
POGGIARONE. NOTES OF COLOR ARE
PROVIDED BY THE DINING-ROOM
CHAIRS AND THE COVERLETS IN THE
BEDROOMS (ABOVE, TOP AND BOTTOM).

An Architect-Couple and Their House in Chianti

The approach to Poggiarone, some ten kilometers northeast of Siena, is signaled by a curious crown of cypress trees. This natural rotunda, resembling a Tuscan burial ground, is reached by a path branching off a little country road and leading through vineyards. The house and outbuildings stand slightly lower down, in an ideal position—as Nathalie Sartogo points out. The origins of Poggiarone are very ancient: it was an eleventh-century manorial tower, converted into a residence late in the sixteenth century and flanked by a watchtower. It was not easy for the two architects to make something of these often extremely dilapidated remains. However, by gradually shedding their preconceived ideas, they succeeded in revealing the building's soul. In collaboration with Nathalie, Piero Sartogo—who has just completed the new Italian embassy in Washington—designed interiors that are spare and understated.

The open arches of the upper-story loggia on the house's main façade are closed in winter with sliding glass panels. In summer, these panels are pushed back into the walls. The house's interior walls were primed with a mixture of whitewash and marble dust, and then painted in colors based on pigments native to the region—ocher and burnt Siena. The furnishings emphasize contrasts between the austerity of natural wood and a vivid range of colorful linen fabrics. The walls were left bare so that the eye should not be distracted from the windows framing views of sky, countryside, and flowering gardens that are paintings in themselves. A similarly unadorned style is evident in the former watchtower, now a guesthouse. Piero and Nathalie worked around the vast well of light that affords a strong sense of verticality when entering the structure. The garden is designed in the same spirit, echoing the shapes and colors characteristic of the surrounding countryside—gray-green olive leaves, dark green cypresses. Brighter touches of color are limited to white (the roses), yellow (santolina), and violet (lavender). The clear, unobstructed view from Poggiarone includes Geggiano in the foreground, with Siena and the hills of Chianti beyond. As I watched the couple's children running in and out, I understood Nathalie's apt description of her home as "a sunny house."

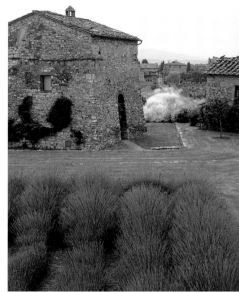

THE MAIN HOUSE, BEHIND
AN ANCIENT CYPRESS TREE, HAS
BEEN RESTORED TO ITS ORIGINAL
STYLE IN A VERY SENSITIVE WAY
BY PIERO SARTOGO—ONE OF
ITALY'S FINEST CONTEMPORARY
ARCHITECTS—AND HIS WIFE
NATHALIE (LEFT).
BEYOND A FIELD OF LAVENDER
STANDS THE OLD WATCHTOWER,
NOW A GUESTHOUSE.
THE PANORAMIC VIEW FROM
THE GARDEN EMBRACES SIENA
AND THE CHIANTI HILLS, FROM
A SPOT BATHED IN SUNLIGHT
MORNING AND EVENING (ABOVE).

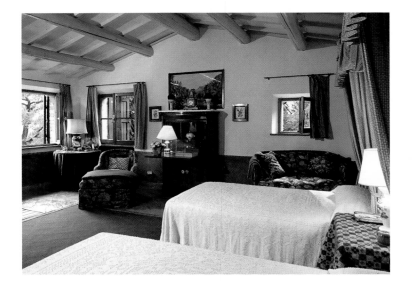

THE VAST AND SUNNY GUESTROOM
INSTALLED BY FEDERICO FORQUET
AT CETONA IS NOTABLE FOR
THE REFINEMENT OF THE SMALLEST
DETAILS, SUCH AS THE MAGNIFICENT
GOUACHE LANDSCAPE OVER THE
SECRETARY (RIGHT).

IN THE PAVILION THAT SERVES AS
A STUDY, AN ARCHED BAY WINDOW
AFFORDS A SUPERB VIEW OF CETONA
AND ITS HILLS. THE CONSCIOUS
SYMMETRY OF THE INTERIOR DESIGN
ENHANCES THE IMPACT OF
THE RUGGED LANDSCAPE, WHICH
HAS BEEN MADE AN INTEGRAL PART
OF THE OVERALL DECORATIVE
SCHEME (RIGHT).

An Elegant Country House in Cetona

Having already visited the gardens of Federico Forquet's Romanesque residence near Cetona, I could easily imagine the elegance of the three houses he designed with the help of Matteo Spinola. The first you encounter on the road serves as a sort of studio or study. It is composed of two sunny rooms filled with the art magazines that Federico, a renowned interior designer, uses in his work. The second—through a bay window inserted into its arched ceiling—affords a magnificent view of Cetona, an ancient Etruscan town perched on a hilltop. A path edged with lavender leads from the first house to the second. The ground floor contains a series of living rooms that in every detail recall the landscape architect's art. Here, we see objects painted in fern patterns; there, old drawings and print fabrics. The walls of the final salon are covered with nineteenth-century pictures, often freely executed studies or sketches purchased in Paris. Based on a subtle interplay between indoors and outdoors, every imaginable shade of green echoes back and forth from one side of the walls and windows to the other. On the upper floor a vast, sunny guest room opens onto an inner courtyard and its garden of boxwood—where I caught sight of a turtle . . . just ambling quietly along.

The picture salon does not open onto the courtyard, but rather onto an orchard that in spring is a riot of bloom. This is where the music pavilion

stands: there are no books in this room opening onto an extensive view of the garden, but many recordings. The main house, located below the guesthouse on the other side of the "turtle" courtyard, is the only one of the three containing signs of its ancient origin. Most of it, however—despite these vestiges from the past—was constructed more recently. The interior contains a synthesis of Federico's tastes. A touch of antiquity, displayed in the various objects arranged on a console at the entranceway and in the decor of another study, recalls his Neapolitan background and his penchant for archeology and neoclassical furnishings. But the whole is conceived in a country-house spirit, and the many openings to the outdoors constantly underscore a close relationship with nature, even when tamed by man. The study, treated like a winter garden, is separated from the salon by a window free from decorative artifice but fully integrated into the house's subtle play of inside-outside transitions. The house is ever fresh, continuously offering new views of the outside, new variations of light and shadow. It forms an unbroken whole with the garden and the swimming pool, given a natural treatment, serving as its logical extension. Like the Tuscan landscape around it, this spot is sometimes tinged with melancholy, but it is also imbued with an appealing lightness of touch that adds an introspective dimension to the lifestyle of the houses' occupants.

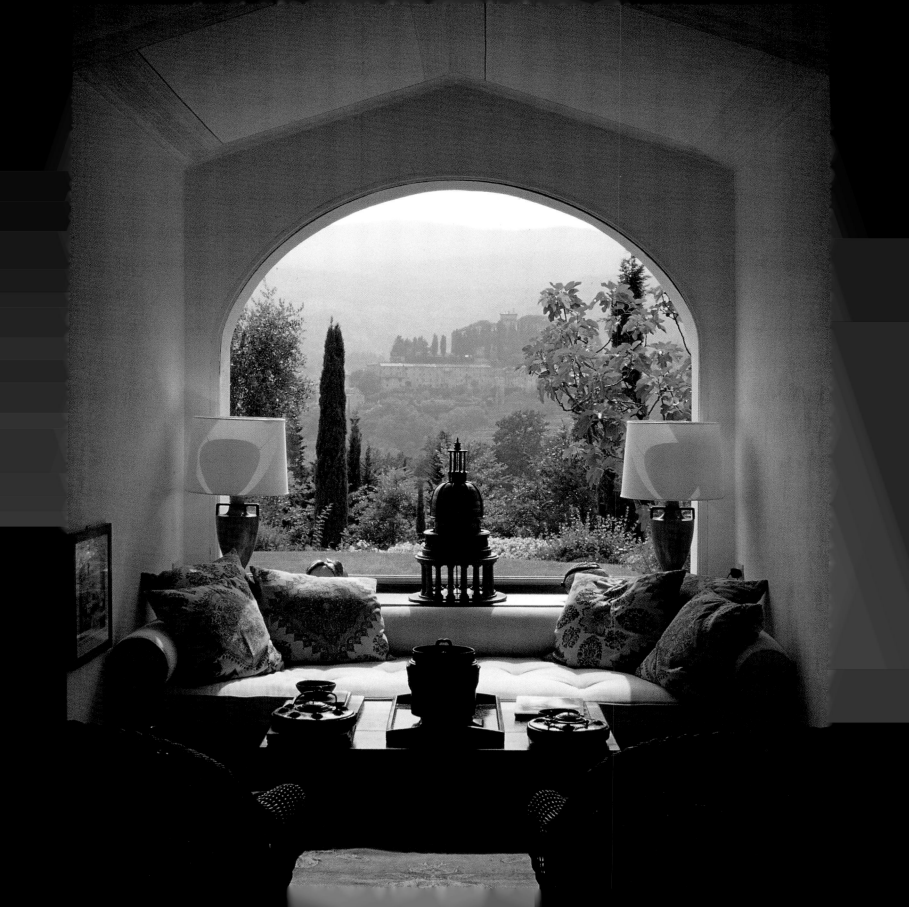

A WICKER CHAISE LONGUE IS
THE MAIN PIECE OF FURNITURE
IN THE CETONA MUSIC PAVILION.
IN A TRIBUTE TO THE BUILDING'S
ORIGINS, FEDERICO FORQUET
COVERED THE FLOOR WITH
VARNISHED NEAPOLITAN TERRA-
COTTA TILES, WHICH LEND A TOUCH
OF VIVID COLOR UNUSUAL
IN TUSCANY (RIGHT).

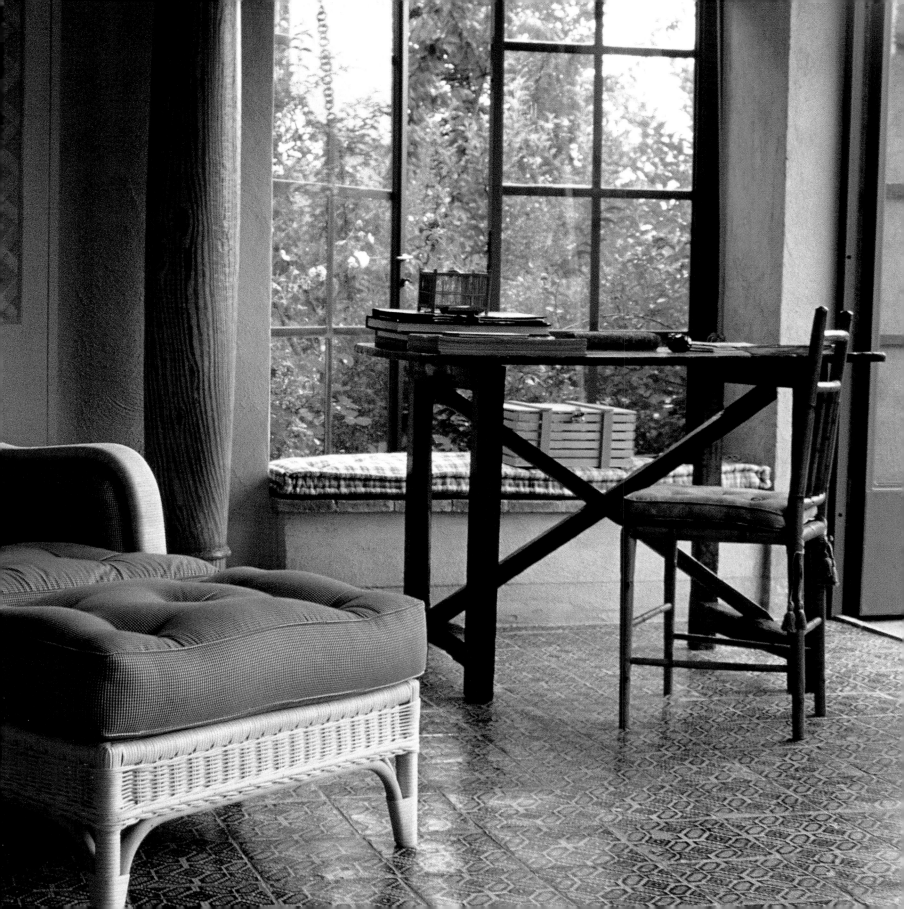

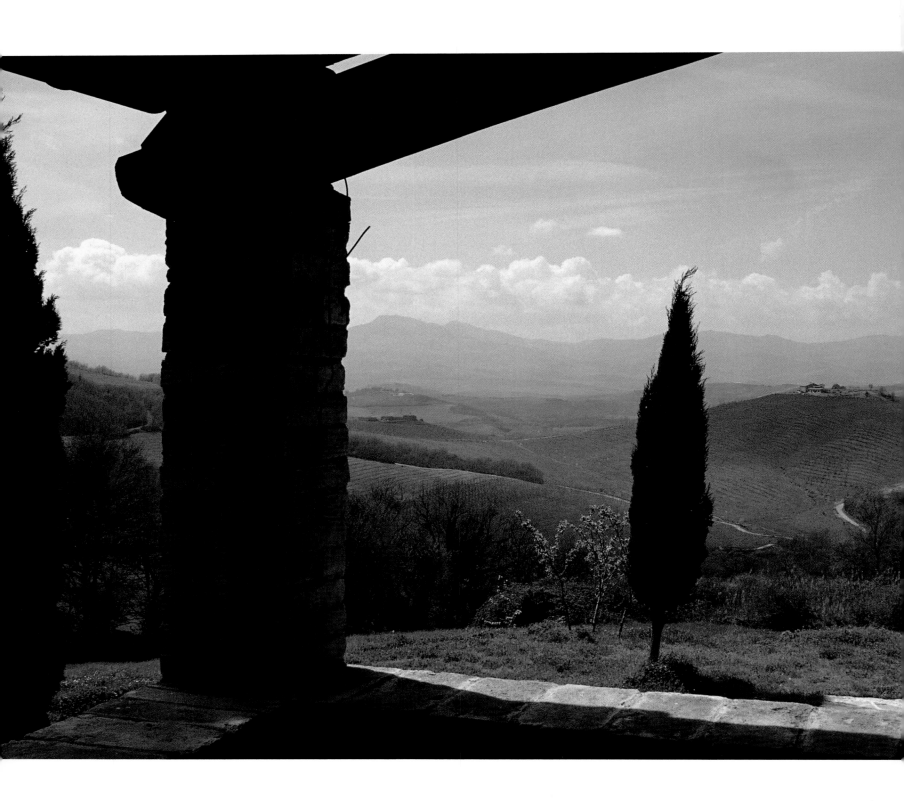

A New York Artist in San Casciano dei Bagni

Because I often used to run into Joseph Kosuth in Rome, I was aware that for many years he had owned a house in the southern tip of Tuscany, near San Casciano dei Bagni. This region, which is even wilder than the Siena Hills, had attracted the prominent New York artist's interest long before he decided to live in Rome for part of every year. His house stands at the end of a dirt road and faces a panoramic view of San Casciano, Radicofani, and Monte Amiata that forms almost a complete circle. It is surrounded by olive groves, oak forests, and meadows full of grazing sheep watched over by a Sardinian shepherd—the absolute antithesis of the American metropolis and, to a lesser degree, of the Italian capital as well. If it were not for the distant presence of two villages, Podere del Frassino and Fresne, we might think we had reached the end of the world. As in most of the region's farmhouses, the ground floor was once used as a stable, with the living quarters above it. Joseph has converted this lower level into a kitchen, dining room, and guestroom.

The hallmark of the house is its unpretentiousness. The upper floor contains bedrooms for Joseph, his wife Cornelia, and their two daughters. Wall posters advertise Joseph's exhibitions, particularly those held at the Querini-Stampalia Foundation in Venice and the Villa Medici in Rome. They stand in ironic contrast to a nineteenth-century academic Belgian painting—a nude male contemplating a skull—recalling the artist's lengthy stay in Ghent. The house is not designed to accommodate many guests. It is first and foremost a refuge for the artist; a place where, in absolute peace and quiet, he can execute the preliminary studies for projects that will be realized later in the United States, Australia, Turkey, or Germany. Outside, a wooden table and benches under the sloping roof offer a quiet spot for sipping a glass of chilled wine while admiring one of the loveliest views in Tuscany, embracing the huddled outline of San Casciano and a scattering of old farmhouses—a nearby one belongs to Dutch artist Jan Dibbets. But the view is perhaps at its most magical when night falls, with the villages forming a garland of twinkling lights along the horizon and (in June, at least) hundreds of fireflies flickering among the olive trees.

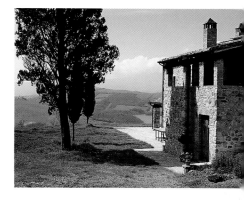

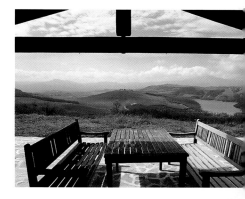

FROM THEIR BEDROOM TERRACE, JOSEPH AND CORNELIA KOSUTH ENJOY A SUPERB VIEW OVER THE SAN CASCIANO DEI BAGNI REGION. IN THE VILLAGE ITSELF (LEFT, IN THE DISTANCE), CORNELIA RUNS A SMALL GALLERY.
THE KOSUTHS' HOME EXHIBITS THE SIMPLICITY TYPICAL OF OLD FARMHOUSES. A TABLE AND CHAIRS ON THE TERRACE ARE AN INVITATION TO CONVERSATION (ABOVE, TOP AND BOTTOM).

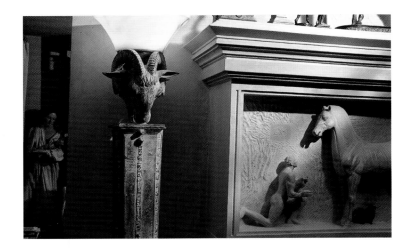

IVAN THEIMER DESIGNED THIS BRONZE LAMP AND SCULPTED MANTLE OVER THE FIREPLACE IN THE SALON FOR HIS MONTEGGIORI HOUSE NEAR CARRARA. IN THE BACKGROUND, TO THE LEFT, STANDS A CURIOUS FEMALE FIGURE WITH A FACE THAT SEEMS ALMOST ALIVE (ABOVE, TOP).

THE ARTIST'S INSPIRATION IS VISIBLE IN THE SMALLEST DETAILS OF HIS HOUSE. IVAN'S GROUND-LEVEL STUDIO IS CRAMMED WITH THE PLASTER MODELS HE MAKES (ABOVE, BOTTOM). FOR MODEL-MAKING, HE PREFERS WAX TO CLAY AS IT IS EASIER TO CARVE (RIGHT).

Near Pietrasanta, in the Land of Marble and Bronze

I first met Ivan Theimer in 1988, at the opposite end of Tuscany, near Lucca. Our meeting came about because the City of Paris, for which I was then serving as director of cultural affairs, had commissioned Theimer to design a major monument celebrating the rights of man for the bicentenary of the French Revolution. The project included a number of bronze pieces—life-size statues and two large obelisks—to be completed under a tight deadline. The artist was worried about the progress of the casting, so I went to the foundry in Pietrasanta myself to see how things were going. We needn't have worried. Thanks to Thiemer's detailed instructions and the local artisans' skill, the monument was ready in plenty of time for its inauguration beneath the Eiffel Tower on the Champ de Mars.

Ivan and Olga Theimer own a little house clinging to a hillside in Monteggiori, not far from Pietrasanta. The village overlooks the coastal plain of Viareggio and Versilia, formerly insalubrious marshland but now covered with greenhouses for the cultivation of fruits and vegetables. Monteggiori, which was gradually losing its local population, began to attract foreigners drawn by the beauty of the site. The Theimers' house is built on three levels, and the artist's studio opens onto a garden containing a medlar tree, an orange tree, and two cypresses. The interior is decorated in a contemporary minimalist spirit. Its pale walls, unbleached-muslin curtains on wooden rings, and chaste window frames are strongly reminiscent of a painting by Fra Angelico, *The Healing of the Deacon Justinian*, a postcard of which I glimpsed in a pile of miscellaneous papers. The door and window frames are made of unpolished marble—a costly luxury elsewhere but here, just a few kilometers from Carrara, an everyday commodity. The simplicity of the house's interior decoration heightens the impact of the many paintings, drawings, sculptures, and books covering every available space. Many of the smaller paintings recall Ivan's passion for travel, depicting the Mediterranean, Egypt, India, and of course the area in France's Drôme region with the strange name of La Roche Saint Secret.

Evocations of classical antiquity are omnipresent, particularly in forms or emblems favored by this artist: turtles, for example; and obelisks—on the

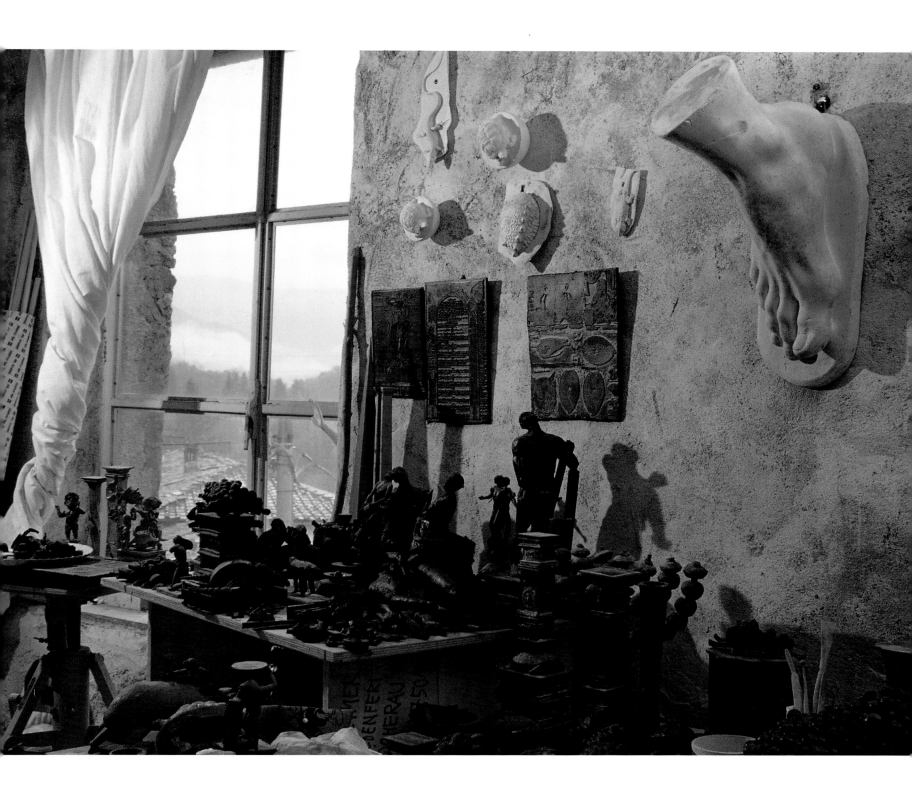

Books on art and art history
are piled on every available
surface in the house, as here
in a corner of the salon
dominated by one of Ivan's
large oil paintings (above).
The bathroom at Monteggiori,
with its antique dressing table,
drawings on the walls, and
unpolished Carrara-marble
window frames, also reflects
the overall spirit of the house.
Every moment of everyday
life is enlivened by a host
of intriguing objects (right).

subject of which Jean Clair wrote a splendid article for an exhibition held at the Ingres museum in Montauban. Also everywhere in evidence are signs of Ivan's consuming interest in formal patterns, something I first noted in 1989 when I observed him making casts of French revolutionary medallions held by the Musée Carnavalet in Paris. Ivan's own works, above and beyond their geometric and rational structure, are just as striking for their wealth of baroque detail.

The obelisk, symbol of a controlled aspiration toward the infinite, is thus also used by Ivan as a vehicle for the accumulation of myriad symbols subverting the structure's reassuring formal equilibrium. Does this really come as a surprise, in view of the fact that Ivan was trained in the ultra-classical tradition of a formerly "Eastern European" fine arts academy, and is thus the product of a region responsible for some of the finest works of the baroque period?

Attentive observers will gradually realize that this proliferation of the infinitely small carried to extremes extends to every detail in the house: not only on the fireplace and the balustrade of the staircase, sculpted from Urbino stone, but also on the window handles and some of the feet on the furniture. And yet, there is no sense of claustrophobia amid all this clutter crammed into such a small space. The house is open on three sides to the sun—the windows and the terrace above the studio afford magnificent views of both mountains and Mediterranean. In good weather you can see a far as Corsica. It is on this terrace that, of a summer night, we'd talk for hours while savoring a glass of local wine, the plain below sparkling with a thousands lights stretching all the way to the dark mass of the sea. The house and its contemporary style presents the same contrasts, if not outright contradictions, as Ivan himself: a nomad passionately attached to his roots, married to an Italian from Friuli (the region closest to the Slavic world), who divides his time between Tuscany and Paris, filling real or imagined landscapes with evocations—inevitably marked by a mysterious gravity—of Olga and their two sons.

AT ALAIN VIDAL-NAQUET'S HOUSE
NEAR CORTONA, OBJECTS FROM
ALL OVER THE WORLD RECALL HIS
ITINERANT LIFE (FAR LEFT). THIS
OLD FARMHOUSE IS AN IDEAL SPOT
FOR READING AND WRITING (LEFT).
PROTECTED BY A HILLSIDE,
THE HOUSE RECEIVES THE SUNLIGHT
THROUGHOUT THE DAY (RIGHT).

An Author and Diplomat Near Cortona

In the course of a long career—begun at the Palazzo Farnese with Gaston Palewski, General de Gaulle's ambassador to Italy, and continued at the United Nations in Rome and New York—Alain Vidal-Naquet felt the need for a refuge, a "desert," as it would have been called in the seventeenth century. In 1963, near Cortona at the heart of ancient Etruria, he purchased an unpretentious country house inaccessible to anyone unfamiliar with the road. It was known as the Casa del Gatto (Cat's Home) because the previous owner had a reputation for being able to see in the dark. As is often the case with rural buildings, the structure's architecture is unremarkable, but its position on the site carefully planned. The house is exposed to the sun throughout the day in both summer and winter, when the weather can be quite harsh. The nearest village straddles the border between Tuscany and Umbria, but Lake Trasimeno (Trasimenus), famous as the site of Hannibal's victory, is hidden by the hills in which the Carthaginian cavalry prepared their ambush, and cannot be seen from the house.

The view is vast, however, extending to Monte Amiata, Montepulciano, and the Val di Chiana. Alain Vidal-Naquet has made the house his full-time residence since 1990. Over the past thirty years the region has opened up, and numerous foreigners—writers and painters in particular—have settled there. But it would be erroneous to assume that local intellectual life developed only recently.

The area's largest mansion, owned by the noble Morra family, was a rallying point for the freedom-loving intelligentsia of the fascist era. It is here, for example, that Moravia wrote *The Time of Indifference*. Severini was a famous native of Cortona, and that city's museum holds a large number of his paintings. In other words, Alain Vidal-Naquet's "desert" has always been an active cultural center, and it is hardly surprising that this man born into a family of intellectuals and philosophers found himself drawn to it. The Casa del Gatto is a typical "writer's home." None of its few room are large and they are all crammed with books and souvenirs. There is a sunny study on the upper floor with windows too small for the studious to be distracted by the view. It is in this room, beneath a pencil portrait of himself drawn by the painter Balthus's wife, Setsuko, that Alain—after finishing his lengthy reports on world famine and development—turns to the study of local archives. I myself discovered among them an amusing letter penned by Karl Marx in answer to his French publisher, who had suggested bringing out *Das Kapital* in installments. Alain also keeps his many souvenirs here, and it is with equal zest that I listened to thousands of anecdotes gleaned in the course of a life spent as diplomat and international administrator, "my brushes with history" as Alain puts it.

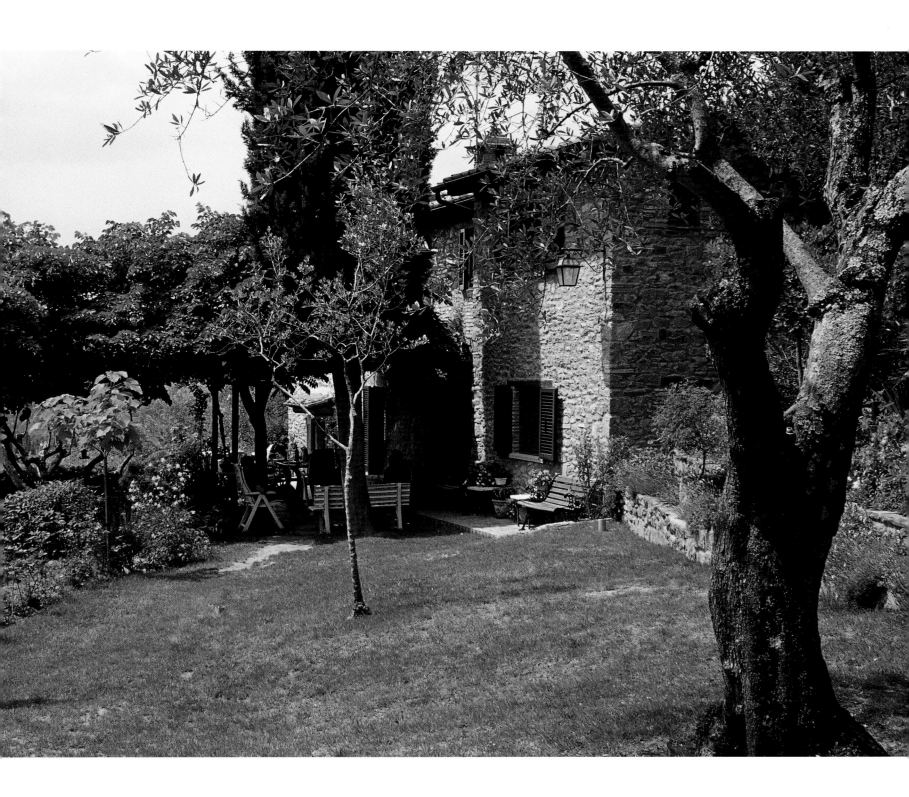

ARTISTIC HERITAGE

Tuscany, a land where everyday life is imbued with art, offers a host of hidden treasures in addition to its more famous monuments and museums. Artists, craftsmen, and little-known museums open their doors to us.

The people of Tuscany take pride in their peerless artistic heritage, but they also realize this wealth must not become synonymous with sclerosis and immobility. Even museums, those temples of conservation, have not escaped the Europe-wide movement toward greater accessibility. But the crucial issue, here as elsewhere, is how to preserve the traditional skills without which creativity itself would be undermined and how to conserve works from the past that are endangered. Innovation and restoration are two sides of the same coin.

This chapter is not by any means a comprehensive inventory, but its purpose will be achieved if it succeeds in giving some idea of the diversity offered by small museums, and the tenacity of artisans who—while forced to obey the iron-clad rules of financial profitability—have succeeded in maintaining and adapting ancient techniques.

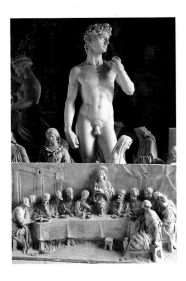

THE OLDEST SURVIVING MARBLE WORKSHOP OF PIETRASANTA, NOT FAR FROM CARRARA, POSSESSES A REMARKABLE COLLECTION OF PLASTER MODELS. HERE, A REDUCED-SCALE MODEL OF MICHELANGELO'S *DAVID* STANDS ABOVE A BAS-RELIEF OF *THE LAST SUPPER* (ABOVE). THE STIBBERT MUSEUM IS HOUSED IN ITS FOUNDER'S FORMER RESIDENCE, A COMPOSITE VILLA PROGRESSIVELY ENLARGED IN ORDER TO ACCOMMODATE HIS EXPANDING COLLECTIONS. LOCATED OUTSIDE THE CITY CENTER IN THE FOOTHILLS OF A STILL-RURAL LANDSCAPE, IT OPENS ONTO A PARK IN WHICH THIS ELEGANT ROTUNDA HAS SURVIVED (RIGHT).

THE STIBBERT MUSEUM REFLECTS THE ECLECTIC TASTES AND ELEGANT LIFESTYLE PRACTICED BY ONE OF THE NINETEENTH-CENTURY ANGLO-FLORENTINE COMMUNITY'S MOST UNUSUAL MEMBERS (PREVIOUS DOUBLE PAGE). ONE OF THE MUSEUM'S FINEST GALLERIES CONTAINS ANTIQUE SIENESE CONTRADA BANNERS, THEIR FABRIC PRECIOUS BUT EXTREMELY FRAGILE (ABOVE).

MUSEUMS WITH CHARM

A land of incomparable artists, Tuscany has also been a breeding ground for collectors and patrons of the arts. The concept of the modern museum sprang largely from the Medici dynasty's passion for art. Years of repeated visits are required of anyone intent on becoming truly familiar with the great museums of Florence. All of Tuscany's major cities possess one or more museums, some of which—such as the Siena Pinacoteca—contain collections that are unique in the world. Even small cities such as Chiusi, Pienza, Montalcino and Sansepolcro display treasures of inestimable value. It is also important to bear in mind that in Tuscany, more than elsewhere, museums are not reserved for a cultivated elite. They represent a shared heritage, providing the continuous contact with masterpieces from the past that here is a part of everyday life.

FEDERICO STIBBERT WAS
A REMARKABLE CONNOISSEUR
OF THE DECORATIVE ARTS,
AS SHOWN BY THE TOOLED
LEATHERWORK IN THIS GALLERY
OF THE MUSEUM (ABOVE). BUT
STIBBERT'S GREATEST PASSION
WAS ARMOR AND WEAPONRY.
AN IMMENSE NEO-MEDIEVAL
GALLERY HOUSES A SERIES
OF ARMORED KNIGHTS (RIGHT).

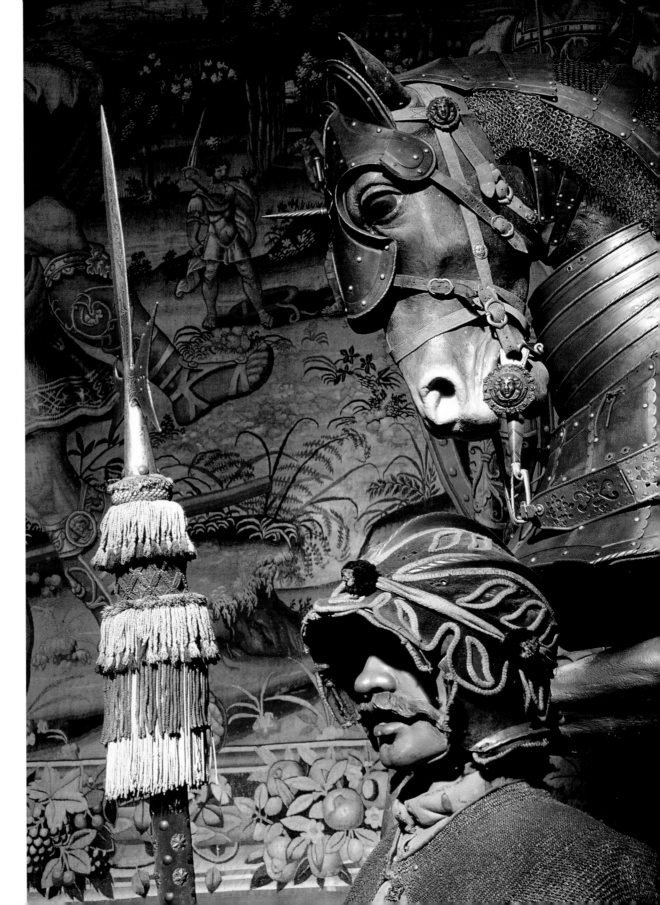

The Lesser-Known Museums of Florence

Florence is a special case, of course. The Horne Museum, for example, located near Michelangelo's tomb in the Basilica of Santa Croce, is a little-known gem that adds much to the city's charm because its collection, built up by a single individual, has retained a very human spirit. Originally established by English art historian Herbert Percy Horne as a home for his personal collection, the building seems inhabited by its founder's passion for the Quattrocento, despite being tinged with a certain melancholy—an impression visitors will find echoed (after completion of the current restoration) in the Palazzo Davanzati, which houses the Museo dell'Antica Casa Fiorentina (Ancient Florentine Household Museum).

The much more spectacular Stibbert Museum, although at a disadvantage because of its location in the northern foothills some distance from the city center, is one of those remarkable institutions that deserves to be better known. Federico Stibbert, born in 1838, was the son of a British Army colonel and his Tuscan wife. He ultimately inherited the considerable fortune amassed by his paternal grandfather in India. Stibbert was fascinated by the Middle Ages, and his museum displays a statue of its founder costumed in period armor for the gala festival held in 1887 to celebrate completion of the Duomo façade. He became one of the greatest contemporary connoisseurs of armor and military uniforms, and his curiosity also extended to heraldry, fashion, and furnishings. He dedicated his entire life to the collection of objects connected with the styles and customs of the past. Having been rocked to sleep as a child with tales of the family's adventures in India, he was naturally one of the first collectors, when Japan opened to the outside world, to become interested in relics of the Samurai civilization, its helmets and lacquered armor. The Stibbert Museum also contains a uniquely elegant collection of paisley-patterned Indian armor.

Some of the galleries in the Stibbert's huge villa are particularly intriguing. Apart from the cavalcade gallery, in which two lines of armored horsemen appear ready to set off on a march, there are others—smaller and admirably furnished—reflecting a lifestyle of great refinement. Some of the building's rooms seem to have been only recently vacated by their inhabitants. The villa,

which was progressively enlarged in order to accommodate Stibbert's expanding collection, is itself a remarkable example of the fascination with the Middle Ages shared by so many of the nineteenth-century English expatriates who settled in Florence. But Federico Stibbert's taste for the neo-Gothic went far beyond a mere esthetic penchant. When objects in his collection needed to be restored or replaced, he hired teams of skilled artisans and set up a workshop for them in the palace he owned in the city. Other parts of his house reflect a more modern taste and a desire to create settings of greater intimacy for everyday family life. The museum is run by a foundation entrusted with the mission of maintaining unchanged the haunting atmosphere of Stibbert's museum-home, gradually restoring each gallery in the spirit decreed by its founder, and also improving the vast grounds outside.

In the Contrada del Nicchio museum in Siena, the *pàlio* designed by Valerio Adami is one of the most recent (right). The decorative scheme of the Palazzo Viti marvelously evokes the style of the nineteenth-century bourgeoisie. Luchino Visconti used it as a setting for one of his most opulent films, *Vaghe stelle dell'orsa* (right and facing page).

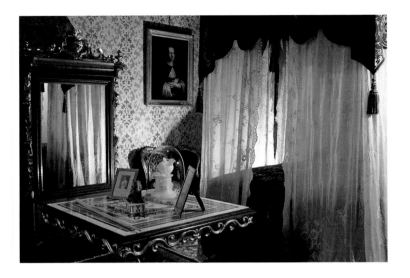

The Riches of Siena

Siena cannot be said to lag behind Florence. The Pinacoteca Nazionale offers a comprehensive survey of the Siena school, and the Museo dell'Opera Metropolitana possesses its own special charm. One of its holdings, Duccio's polyptych *Maestà*, was carried aloft by cheering crowds of Sienese from the artist's studio to the high altar of the cathedral when it was completed in 1311. This fervent, introspective work is not an isolated example, however: visitors to the museum will also want to linger before the smaller paintings Duccio executed for modest country churches. A staircase leads to the top of the cathedral's vast unfinished façade, or *facciatone*. There are some two hundred steps to climb, but the views from the terrace and tower are unforgettable.

Even less well known are the small museums maintained by each of Siena's *contrade* (districts). These true repositories of the city's soul contain Palio trophies, banners, and costumes, but are unfortunately only rarely opened at any time other than the period when the race is held. However, the Nobile Contrada del Nicchio allowed us to visit the sanctuary displaying its many trophies—including a Palio scene painted by Valerio Adami and a collection of threadbare eighteenth-century silks. This museum adjoins a chapel in which, under the *contrada*'s seashell-and-coral emblem, the horses are blessed before the race begins.

The Museums of Volterra

The city of Volterra, with a population of only twelve thousand, boasts at least four museums worthy of interest. The Etruscan museum is perhaps the best known, due to its exceptional collection of alabaster and terra-cotta cinerary urns. The Pinacoteca standing on the mansion-lined Via dei Sarti contains some first-class works, such as Rosso Fiorentino's extraordinary *Deposition from the Cross*. After the museum of sacred art, the Palazzo Viti also deserves a visit. This late-sixteenth-century edifice was designed by the great architect Ammannati for a noble family from Volterra. It was acquired in 1850 by an alabaster merchant, Benedetto Giuseppe Viti, who traveled widely. One of the paintings in the museum shows him transporting alabaster in the Andes, and he was even awarded the title of vizier and emir of Nepal. The formal dress he wore for this occasion is displayed in a showcase, but the precious gems with which it was once encrusted have been replaced by imitations. The palace was elaborately decorated in honor of a visit by King Victor Emmanuel II in 1861, and its rooms have remained unchanged ever since. Permission to visit must be obtained from the Viti family, which still occupies the palace. This strange dwelling, containing two huge alabaster candelabra commissioned by Emperor Maximilian, has a singular charm: Luchino Visconti knew what he was doing when he chose it as the setting for his film *Vaghe stelle dell'orsa*.

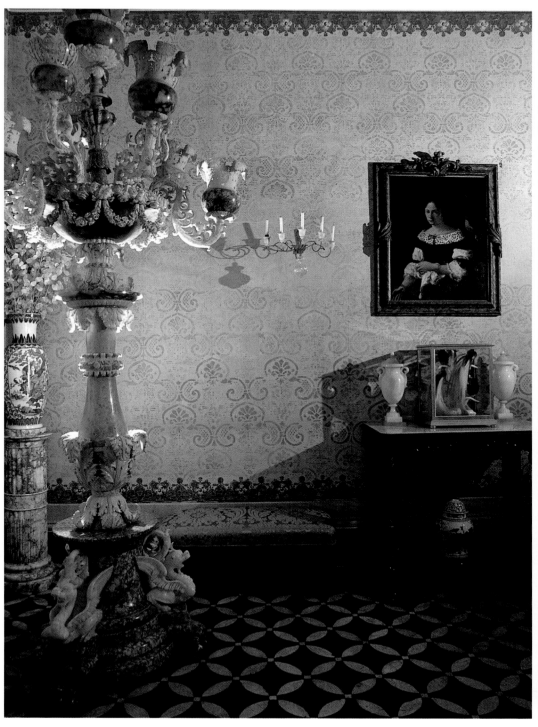

TRADITIONAL ARTS AND CRAFTS

The quality of Tuscan craftsmanship has been renowned for centuries. Although Florence proudly claims to represent most of the craft guilds, there is no city that does not have at least one specialty of its own. Volterra is thus the city of alabaster; Arezzo of silver and goldsmiths, Impruneta of terra-cotta. An aristocratic and mercantile tradition, added to the grand dukes' support for manufacturing, enabled Tuscany to play a considerable role in Europe. The present is a continuation of this prestigious past—evident, for example, at the Sesto Fiorentino porcelain museum, a repository for collections from the Ginori factory founded by one of Florence's great families. Unsurprisingly, Tuscany is also home to numerous eminent antique dealers and the scene of events ranging from the prestigious Florence Biennale to the monthly antiques fair held in Arezzo.

These ventures are not solely commercial. One of Florence's major antique dealers, Giovanni Pratesi, director of cultural activities for the Biennale, has published a remarkable catalogue of seventeenth- and eighteenth-century Florentine sculpture. His passion for Tuscan baroque makes his galleries in the Palazzo Ridolfi a stunningly vivid museum.

Technological progress has resulted in the disappearance of various traditional skills, but others have been adapted to modern methods. More importantly, innovation and creativity—notably in the trades connected with fashion—have spread the fame of Florence and Tuscany even farther afield. Our itinerary is far from comprehensive but, thanks to advice from Tuscan friends, it is intended to redress the image projected by "souvenir" industries offering all too many lackluster trinkets to tourists.

THIS DECK OF CARDS SPREAD OUT AGAINST A BLACK BACKGROUND IS ONE OF THE FINEST ANTIQUE SURVIVALS FROM BIANCHI OF FLORENCE, SPECIALISTS IN THE SCAGLIOLA TECHNIQUE USED TO CREATE PERFECT IMITATIONS OF MARBLE MOSAICS (ABOVE).

A TERRA-COTTA FEMALE BUST ON A PEDESTAL REFLECTS THE ART OF TERRA-COTTA AS PRACTICED FOR CENTURIES IN IMPRUNETA, A SMALL TOWN SOUTH OF FLORENCE (ABOVE).

SCULPTORS FROM THE WORLD OVER COME TO PIETRASANTA, NEAR CARRARA AND LUCCA, WHERE WORKING IN MARBLE AND BRONZE IS A CENTURIES-OLD TRADITION. IN THE WORKSHOPS OF THE MASSIMO DEL CHIARO FOUNDRY, A LEAPING RABBIT BY BARRY FLANAGAN STANDS BESIDE PLASTER MODELS OF ANTIQUE SCULPTURES (RIGHT).

MODERN MECHANIZED METHODS
FACILITATE THE TASK OF THE
ARTISANS WHO SCULPT MARBLE,
BUT TRADITIONAL SKILLS ARE
ALSO STILL USED BY PIETRASANTA'S
MARBLE CRAFTSMEN (ABOVE, TOP
AND BOTTOM).

In the Sculptors' Realm

Let us begin our journey with marble and bronze, two crafts still practiced today that have remained unchanged since ancient times. Forty types of marble continue to be extracted from the three valleys still quarried in the Apuan Alps, and particularly from Colonnata. The Carrara and Pietrasanta region is also renowned for its sculpture workshops and foundries.

Pietrasanta, a small city located in the foothills north of Lucca, seems still to throb with the memory of Michelangelo. The big café on the main square, in a setting seemingly unchanged since the last of the Tuscan grand dukes, bears his name. The outskirts of Pietrasanta, however, contain an unbroken series of modern, mechanized marble-cutting workshops. The vast Raffi establishment, for example, was built to accommodate the huge blocks of marble brought here from the quarries. In the yard outside, a combination sand-blaster and mechanical saw bites into the stone. An operation that would take many months if executed by hand can now be completed in just a few days. It is now also possible to cut slabs of marble to a thickness of only fractions of an inch. But the most striking sight is the pile of marble slabs from veins that are now exhausted. A *Foresta Perduta*, as sculptor Ivan Theimer titled the group he arranged like a stone grove around the Pietrasanta square. The composition at the Raffi workshop is more mysterious and unpremeditated—a complex maze offering tangible contact with the beauty of these stones and their bizarre tracings.

On the little square in front of the gate to Pietrasanta stands the curious façade to one of the region's oldest marble workshops: Ferdinando Palla, founded in the nineteenth century. Above a fine cast-iron grill is a balcony sporting two bronze figures with the heads of monsters, and in the wall niches reign busts of the greatest Florentine sculptors. Behind the grill, a vast entrance paved with antique marble serves as a repository for a jumble of plaster models—a little museum of Tuscan statuary from the Middle Ages through the end of the nineteenth century. Using modern tools, the workshops' artisans restore ancient sculptures and produce both copies and original works. Meanwhile, however, a record of traditional methods has been preserved in the firm's office, which appears not to have changed for a century. There, plaster casts stand beside marble samples of every type, and many hundreds of old photographs on glass plates that—along with numerous blueprints—provide insights into work done in the nineteenth century. Not far from the Palla workshops are those of Cervietti, also famous for marble-cutting expertise. It was there that I was able to view, before shipment to the Brazilian who commissioned it, an extremely faithful reproduction of Michelangelo's *David* weighing over thirty tons. With the help of a pantograph, absolutely any model can be enlarged . . . to any size desired.

THE FERDINANDO PALLA MARBLE WORKSHOPS, THE OLDEST STILL OPERATING IN PIETRASANTA, POSSESS A FINE COLLECTION OF MOLDS. MICHELANGELO'S FAMOUS *PIETÀ* IS ONE OF THE MOST FREQUENTLY COPIED WORKS. ONLY PARTLY HIDDEN BY A WHITE DUST CLOTH, A MOTORCYCLE CREATES AN ODD CONTRAST WITH A SERIES OF STONE MOLDS (LEFT). MECHANIZATION HAS MADE IT POSSIBLE TO CUT MARBLE AT SPEEDS UNKNOWN IN FORMER TIMES (ABOVE).

A Pietrasanta foundry's workshop exhibits startling contrasts, such as this meeting between a *Padre Pio* and a young girl (above, left). The reclining nude is by Botero, who lives in the region (above, right). A thin layer of red wax pressed between two layers of clay will be melted, discarded, and replaced with molten metal (right).

The del Chiaro foundry was transferred some ten years ago into vast buildings more suitable than its former quarters for the work it does. The many artists who have called on this foundry's skills include De Kooning, Karel Appel, César, Botero, Enzo Cucchi, and Barry Flanagan. Ivan Theimer, a loyal patron of the firm, has tried explaining to me the various steps involved in lost-wax casting—a lengthy process that begins with the enlargement of models supplied by the artists. However, despite his patience, it was only by observing these operations directly that I was able to understand their meticulous complexity. Even the greatest vigilance is no proof against the risk of flaws due to such mishaps as a bubble of gas, a trace of moisture, or metal that has cooled more than necessary. The workshop contains a collection of plaster models offering a picturesque spectacle. One of Barry Flanagan's leaping rabbits stands next to an Olympian Zeus, Botero's bloated sculptures next to neo-Sulpician effigies of the Padre Pio, which—judging from the number of them in the process of being manufactured or waiting to be shipped—must be in great demand.

The Potters of Impruneta

Before returning to Florence, let's make a stop at Impruneta, a little town located a few kilometers to the south and reached by a road offering magnificent views. This is the land of terra-cotta, one of Tuscany's most venerable crafts to judge by the number of these objects unearthed by archeologists. The large pots and vases containing flowers or citrus trees commonly found in this region's gardens all have the name "Impruneta" etched on their sides. Among Impruneta's many busy potteries, Ugo Poggi has the distinction of possessing since 1919 one of the oldest kilns in the region, dating from the late sixteenth century. It has been restored, and is still in operation. These artisans, who work entirely by hand, are famous for the carved moldings embellishing their large vases and jars. The local clay, here known as *terra turchina* (turquoise-blue) produces a terra-cotta that is remarkably resistant to changes in temperature and to frost, and can therefore last for centuries. The patina is given special attention: natural wax and careful polishing makes the material exceptionally soft to the touch.

AFTER LENGTHY PROCESSING, THESE
SKEINS OF SILK YARN WILL BE WOVEN
INTO THE SUPERB FABRICS THAT ARE
THE PRIDE OF THE ANTICO
SETIFICIO FIORENTINO, AN ANCIENT
MANUFACTORY SAVED FROM RUIN
IN THE TWENTIETH CENTURY
BY EMILIO PUCCI (ABOVE, TOP).
THE SETIFICIO IS THE ONLY
WORKSHOP STILL USING
EIGHTEENTH-CENTURY
LOOMS (ABOVE, BOTTOM).
BOLTS OF MULTICOLORED SILK
FABRIC ON THE SHOP'S DISPLAY
RACKS (RIGHT).

Silk, a Unique Industry

Although legend attributes the spread of silk to the voyages of an Oriental
princess, it was probably first brought to Italy in the twelfth century by
missionaries returning from Asia. Florence quickly became a European
capital of the precious fabric, and the silk trade provided a major source for
the increased wealth enjoyed by the city's great families. Each of these
families had their own craftsmen, and their own patterns symbolizing their
acquired rank. In the seventeenth century several of them—including
the Corsini, Pucci and della Gherardesca families—decided to combine
their production facilities into a single manufactory, the Setificio
Fiorentino. To support the important economic role played by this new
group, Grand Duke Pierre Léopold of Lorraine financed a set of looms that
are still in use today. Florence thus enjoys the privilege of continuing to use
eighteenth-century looms constructed before the Industrial Revolution.
Occupying its present buildings since 1786 and incorporated in 1914,
the Setificio was saved from extinction by Emilio Pucci, a descendant
of one its founding families.

After repairing the terrible damage caused by the 1966 floods, the
workshop resumed its prestigious operations. Now meticulously restored, a
warp beam made in the eighteenth century from blueprints by Leonardo da
Vinci and even older shuttles are again functioning perfectly. The firm's
archives, miraculously spared by the flood waters, contain a considerable
number of drawings dating from over four centuries ago, and the collection
is continuously expanded with modern custom-designed patterns. From the
prodigiously complex loom emerge Renaissance damask, lampas, and
brocade, in addition to other typically Florentine fabrics such as *ermisino*
(the shot-silk taffeta depicted in so many mannerist portraits and still used
today for the banners of the Siena Palio), Turkish satin, and tussah. The
Antico Setificio Fiorentino shop, open to the public, is bathed in an
atmosphere scented by pots-pourris wrapped in tiny silken bags.
Maintaining a manufactory such as this one may be a costly folly, but no
one leaves this overwhelmingly charming spot without feeling eager to
support its continued existence.

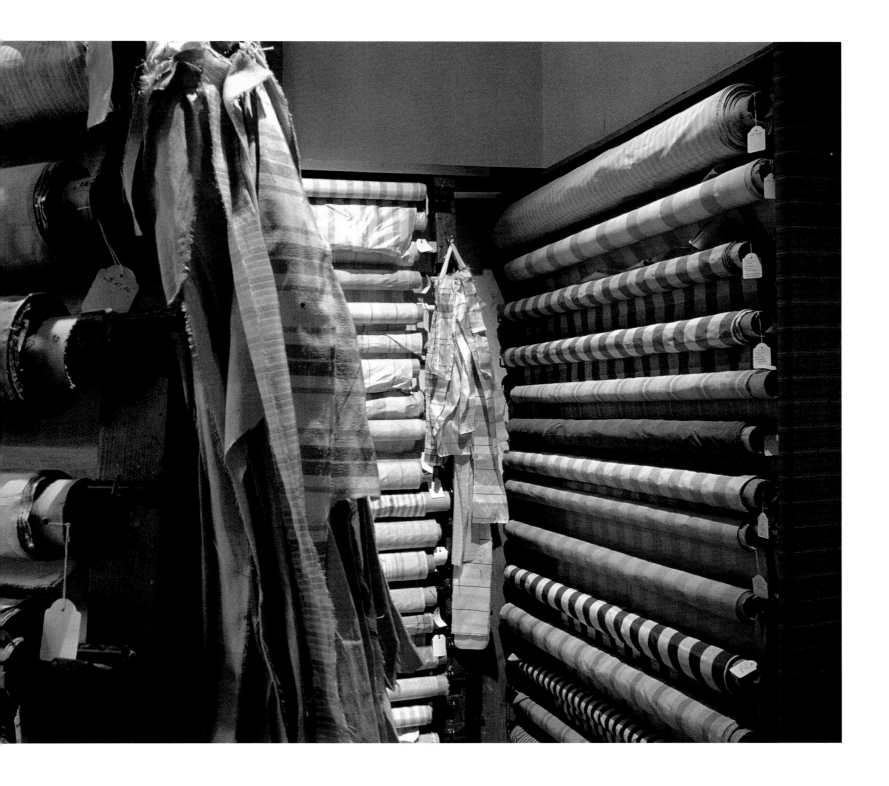

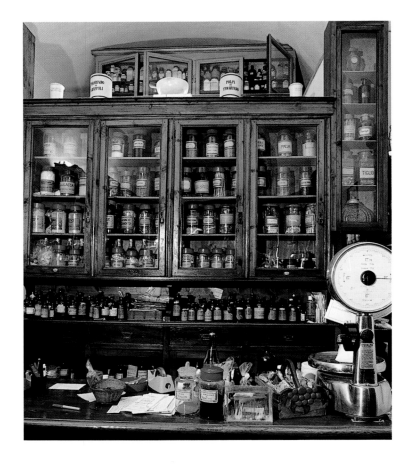

The old-fashioned inscriptions, the bottles filled with crystals and powders, the multicolored tubes, all demonstrate this firm's commitment to the spirit prevailing at its founding in 1842. The interior enfolds visitors in indefinable fragrances and aromas wafting from dozens of jars and bottles. The wooden counter and ceiling-high glass-fronted cabinets were brought here from the shop's original location on the Piazza della Signoria. And yet, there is nothing old-fashioned about the members of the Bizzarri family. They welcome you with kindness and warmth, encouraging you to ask a thousand questions. Perfumers, photographers, artists, chefs, and musical-instrument makers come here for their supplies—not to mention those who just want to purchase a piece of soap scented with carrot or mint, cut to order on the counter. The labels sometimes bear strange names. And perhaps you will learn the secrets of how a specifically Florentine liqueur, *alkermès*, is made: its bright red color is derived from a cochineal dye, and its flavor from cloves, cinnamon, and cardamom.

When it comes to perfume, one of the most inventive creators in the field can also be found in Florence. Lorenzo Villoresi's story is a curious one. Some time ago, while pursuing his philosophy studies in the Middle East, he began casually collecting spices and essences, especially in Egypt. At first (this was in 1981) he used them himself, for cooking. Then, responding to requests from friends, he concocted a few spicy blends—*piccole combinazioni*, to use his own phrase. A lifelong fascination with experimental distillation led him still farther. Rumors of what he was doing reached the Fendi firm, which at the time was planning to produce a comprehensive range of "ambience" fragrances. It was at this point that Lorenzo Villoresi abandoned his study of ancient philosophy and religion—the price he had to pay for responding to Fendi's demands. His apartment above the Ponte Vecchio on the Via dei Bardi was gradually converted into a laboratory. Lorenzo receives his customers at home, where he produces custom-designed fragrances for them. Open at the start to only a favored few, his workshop now attracts a growing number of connoisseurs, from Roberto Capucci (a major name in the world of fashion) to Sting, who bought one of the elegant crystal bottles in a blue leather case as a gift for Madonna.

Essences and Fragrances

The European fascination with the Orient exemplified by the silk trade also extended to "spices," as they were then called. But the art of concocting elixirs and perfumes was also integral to a long local tradition often preserved in monasteries or other religious communities. This was the case, in particular, for the pharmacies run by medieval hospitals. The Santa Maria Novella pharmacy in Florence is the most renowned heir to a centuries-old body of knowledge governing the art of extracting the most varied remedies from plants. The beauty of its decor and antique apothecary jars make it well worth a visit.

In a related field, the display offered by the Bizzarri shop in the narrow Via Condotta, just off the Piazza della Signoria, is also a treat for the eyes.

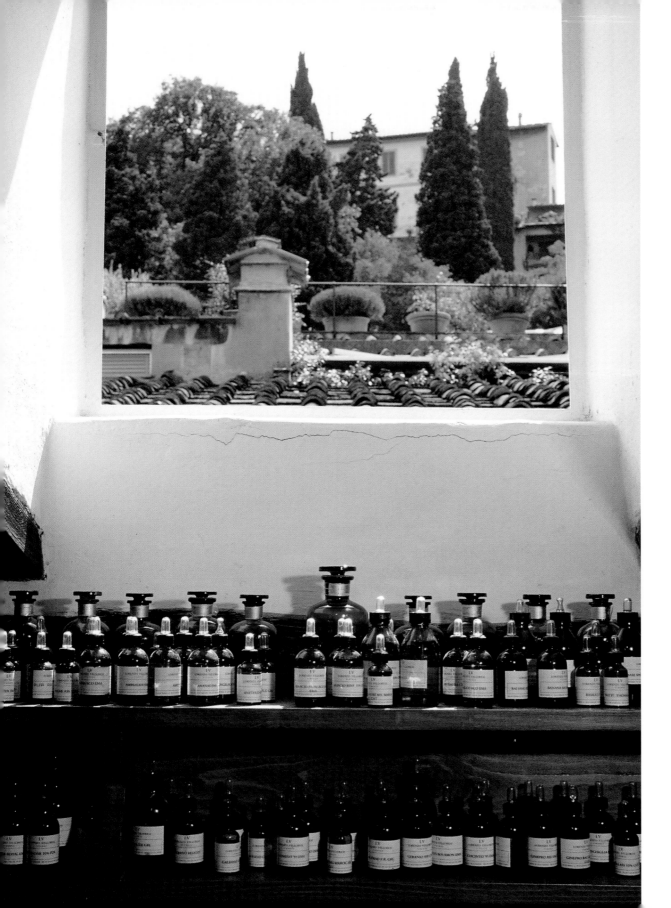

Just a step from the Piazza della Signoria, Alessandro Bizzarri's shop is one of the most intriguing in Florence. It contains thousands of essences used in perfumery, photography, and the manufacture of musical instruments. It also markets scented products for the home (far left).

The former apartment of Lorenzo Villoresi, on the top floor of a palazzo (above), is now a laboratory where he prepares his perfumes.

The rich and famous from all over the world know that when they want a customized perfume, they'll find it at Lorenzo Villoresi's, where they can make their selections while admiring the view of the nearby Ponte Vecchio (left).

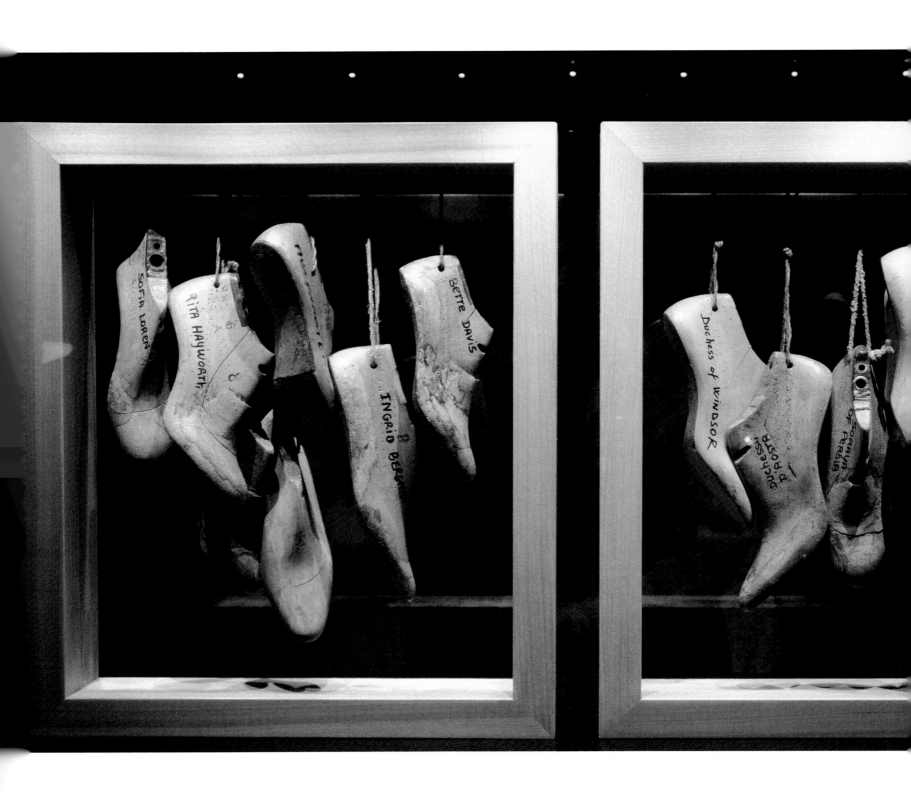

Salvatore Ferragamo, the Leather Genius

On the other side of the Arno, at the end of Via Tornabuoni, stands the thirteenth-century Palazzo Feroni-Spini, which still resembles a fortified castle. However, because it is now inseparably associated with the great designer, the Florentines refer to it as the "Palazzo Ferragamo." Salvatore Ferragamo's life is like a fairy tale. Born at the turn of the century in a village on the outskirts of Naples, he began his career by saving his family from dishonor on the occasion of his sister's First Communion. She had no proper shoes to wear. Quickly rising to the emergency, he made a pair for her out of bits of canvas and cardboard. This persuaded his parents, who until then had opposed his chosen vocation, to let him begin an apprenticeship. At the age of fourteen he set off for the United States. The youthful Italian's talents were immediately recognized by the firm he worked for there, and he went on to become a favorite of the stars during Hollywood's golden age. But he was unable to find artisans capable of meeting his high standards. Salvatore thus returned to Italy, settling in Florence—a city with a long tradition of fine leather craftsmanship. He was soon employing some six hundred leather workers to meet the orders still flowing in from America. No other designer before Ferragamo had ever given such careful attention to the comfort of the foot, and none had ever used such a broad range of materials.

The firm's operations were expanded after its founder's death in 1960, and now cover every field in fashion. But Salvatore Ferragamo's own distinctive hallmark can be still be appreciated by visitors to the remarkable museum located above the fabulous shop in the Palazzo Feroni-Spini, which is open to the public. In an impeccably modern presentation, the museum displays shoes worn by the most famous names in Hollywood, from the days of silent film onward. Sometimes all we see are the customized lasts marked with the names of great actresses or celebrities such as Princess Soraya and the Duchess of Windsor. Photographs and film clips show images of Greta Garbo and Marlene Dietrich, Ingrid Bergman, Ava Gardner, and Audrey Hepburn at the peak of their careers. The firm's collection is so large, the exhibition is changed every two years. There are few such spectacular or moving examples of the magic alchemy that occurs when a secular tradition is combined with creative genius.

COBBLERS' LASTS DISPLAYED AT THE FERRAGAMO MUSEUM, INSCRIBED WITH FAMOUS NAMES FROM RITA HAYWORTH TO SOPHIA LOREN (LEFT). GRETA GARBO IN THE PAST, AND MADONNA TODAY, ARE AMONG THE MANY STARS WHO HAVE ENTRUSTED THEIR FEET TO FERRAGAMO (ABOVE, TOP AND BOTTOM).

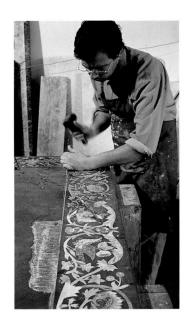

La Scagliola, or the Art of Mosaic

The art of scagliola, which originated in northern Italy, was brought to
Florence in the seventeenth century. Scagliola is an "economical" version
of mosaic, using stone dust and chips. Developed in Florence by the Medici,
it survives today at the Opificio delle Pietre Dure (founded in 1588), where
the precious tradition is maintained primarily for the restoration of ancient
works. The Pitti Palace contains numerous examples of the perfection
attained by these Florentine artisans, whose skills are displayed on
extraordinary cabinets and—in a larger format—at the Church of San
Lorenzo's famed Princes' Chapel.

The scagliola technique makes it possible to obtain elegant results using
materials such as lapis lazuli, agate, and onyx that are less costly than
precious gems. The first step is to carve the piece's meticulous patterns into
the stone that will serve as its base. The next step involves the use of
foliated gypsum, a scaly (*scaglie*) mineral. This material is heated and then
pulverized, forming a powder that can be blended with pigments and
animal glues. The colored paste is applied to the cavities of the pattern
carved during the first step. It is allowed to harden, and then carefully
polished. This operation is repeated for each separate color. A final buffing
and the application of beeswax give the design its definitive luster. Scagliola
can sparkle with vivid colors or play on less gaudy contrasts between black
and white. This demanding technique, which cannot be mechanized,
is still practiced in Florence by craftsmen proud of maintaining a tradition
that has made a not inconsiderable contribution to the city's fame.
Alessandro Bianchi, for example, has followed his father, the elder Bianchi,
as director of the family workshop. Its former premises were flooded in
1966 and ancient, irreplaceable pieces destroyed, but operations were
resumed at new headquarters in Pontassieve, a little town east of Florence.
However, the firm's age-old ties with the great Tuscan capital are still
represented in an exhibition space—almost a small museum—on Florence's
Viale Europa. In this field, as with other traditional crafts, the bond
between creation and restoration is a close one: the present is continuously
nourished by the past.

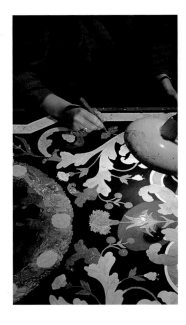

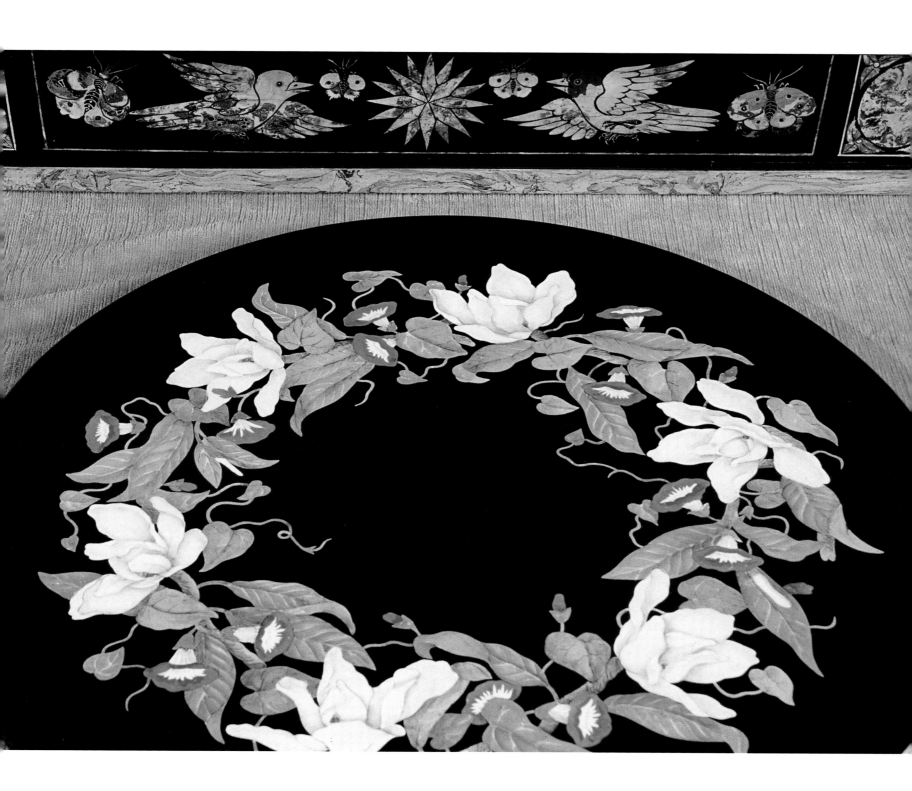

For the manufacture of hand-crafted marbled paper, the sheets are laid one-by-one on a plaque covered with colored inks. When the paper has soaked up the colors, it is immediately hung up to dry.

Marbled Paper

Designed, like scagliola, to create an illusion, marbled paper is another product for which Florence is famous. These specialty papers are used as endpapers in leather-bound books, and as coverings for boxes, jewel-cases, and notebooks. A renowned name in the field is the Il Papiro chain, which has a shop located near the Duomo. The finely crafted papers are actually manufactured on the city's southern outskirts, however. Although the factory itself is hardly picturesque, the various steps in the production process have their own esthetic appeal. First, colored inks are sprayed onto a wax-paste surface. A scraper is then used to blend the inks into random patterns. In the final step, a sheet of paper is pressed onto the inked wax. It soaks up the colors at once and must be removed again quickly. No two patterns are ever the same, and nothing is more suggestive to the imagination than these forms resembling a fusion of the elements.

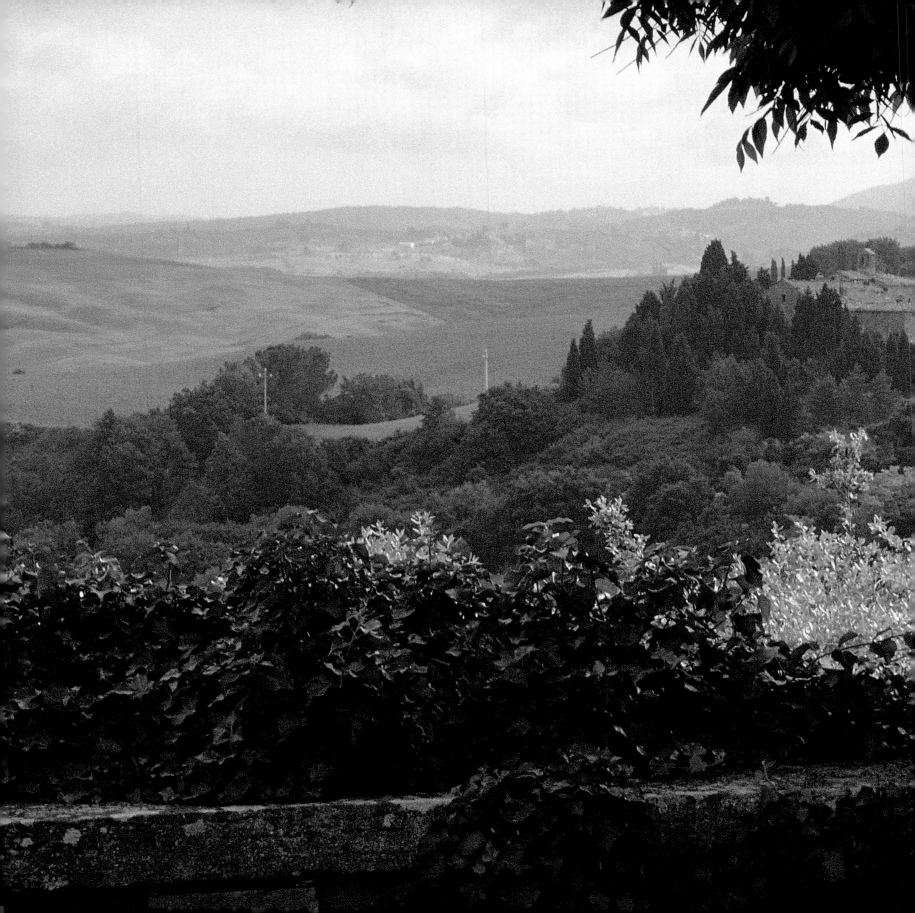

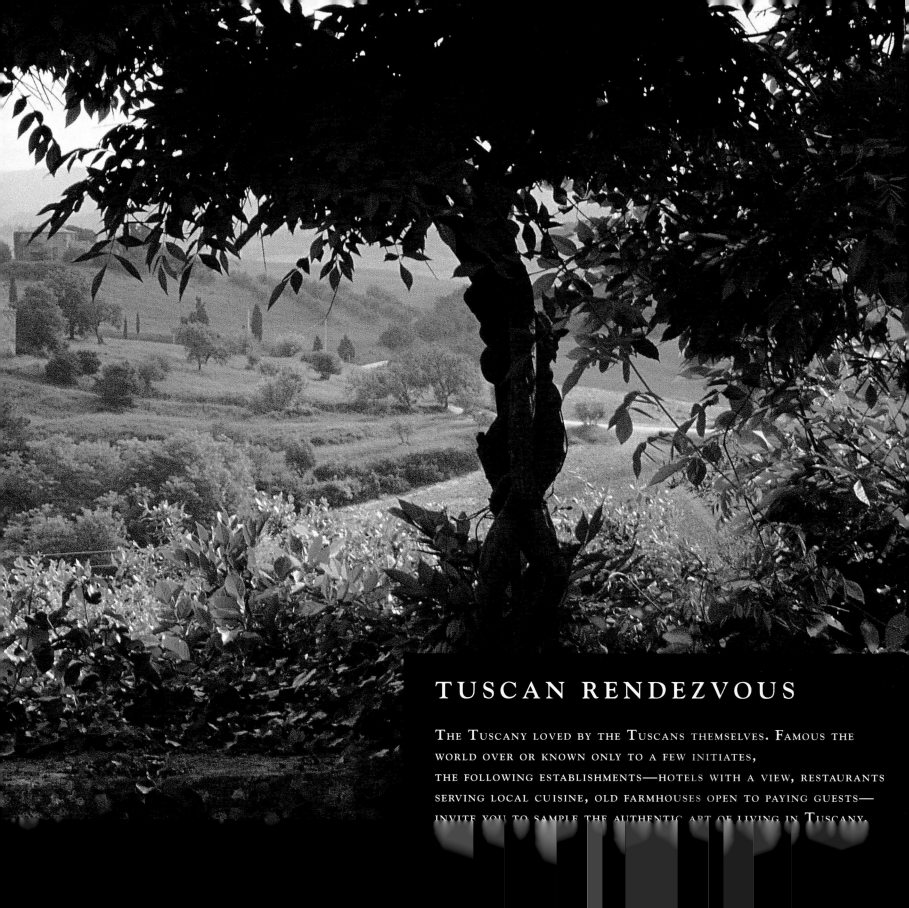

TUSCAN RENDEZVOUS

THE TUSCANY LOVED BY THE TUSCANS THEMSELVES. FAMOUS THE
WORLD OVER OR KNOWN ONLY TO A FEW INITIATES,
THE FOLLOWING ESTABLISHMENTS—HOTELS WITH A VIEW, RESTAURANTS
SERVING LOCAL CUISINE, OLD FARMHOUSES OPEN TO PAYING GUESTS—
INVITE YOU TO SAMPLE THE AUTHENTIC ART OF LIVING IN TUSCANY.

Tuscany, a land esteemed for its way of life over a span of two centuries and more, first by a cultivated elite of connoisseurs and more recently by a growing number of visitors from all over the world, offers almost infinite resources to those seeking pleasures for the palate or unusual places to stay. Whether in an opulent or unpretentious vein, elegance and refinement are ever-present. One of Tuscany's hallmarks is its abiding capacity to imbue everyday life, at every level of society, with an incomparable degree of civilization. The Tuscans themselves have become increasingly attached to this heritage as awareness has grown of the threat posed to it by the hordes of invading tourists. They are willing to share its secrets only with those foreigners demonstrating a genuine sympathy for the region. When they do decide to accept you, they will take you on a journey of discovery to the places they love themselves—the authenticity of which they are struggling to preserve.

THE VIEW OF THE SIENA HILLS FROM COSONA CASTLE, IN THE TRANQUIL PIENZA COUNTRYSIDE, IS ONE OF MATCHLESS BEAUTY (PREVIOUS DOUBLE PAGE). IN LUCCA, THE STRAW-CLAD, ROUNDED CHIANTI BOTTLES SOON DESTINED TO DISAPPEAR. A DECISION TO MODERNIZE THE WINE'S BRAND IMAGE, COMBINED WITH MANUFACTURING CONSTRAINTS, NOW FAVOR THE "BORDEAUX" TYPE OF BOTTLE (ABOVE).

SUNLIGHT SPARKLING ON BAGS OF THE DRIED *FUNGHI PORCINI* MUSHROOMS USED TO ACCOMPANY MEAT, PASTA, AND RICE (ABOVE). FLORENCE'S MERCATO CENTRALE IS THE CITY'S LARGEST AND, OF ALL TUSCANY'S TEMPLES TO GASTRONOMY, PROBABLY THE LIVELIEST (RIGHT).

GASTRONOMY

Tuscan cuisine is probably the most familiar of all those for which Italy is famous. It owes this distinction to its long history, its remarkable diversity (thanks to the varying soils making up the region), and also to the fact that many expatriate Tuscan chefs have spread it throughout the rest of Italy and the world. Going back in time, we might also note the impact of Medici matrimonial policy on gastronomy, and its contribution to the international renown of Tuscan cuisine.

Although there are exceptions, as in the Colle di Val d'Elsa region where the use of animal fat was once the rule, olive oil—perhaps the best in Europe—plays a crucial role in Tuscan cuisine. A few drops are routinely

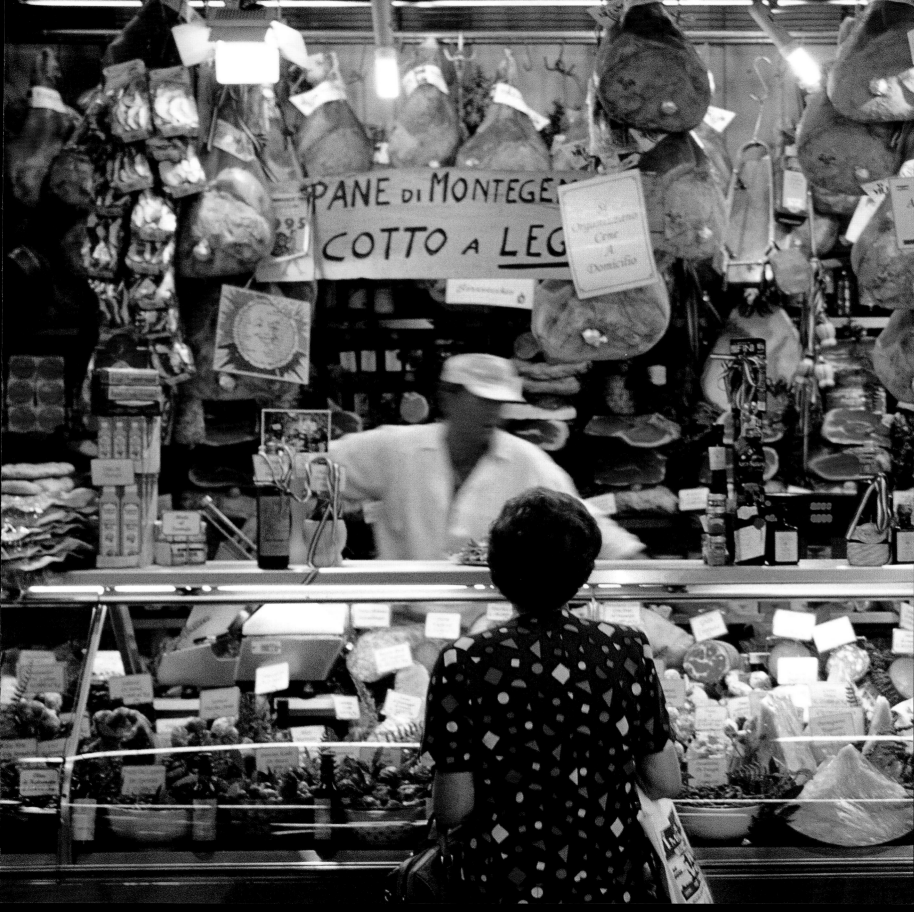

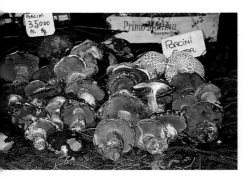

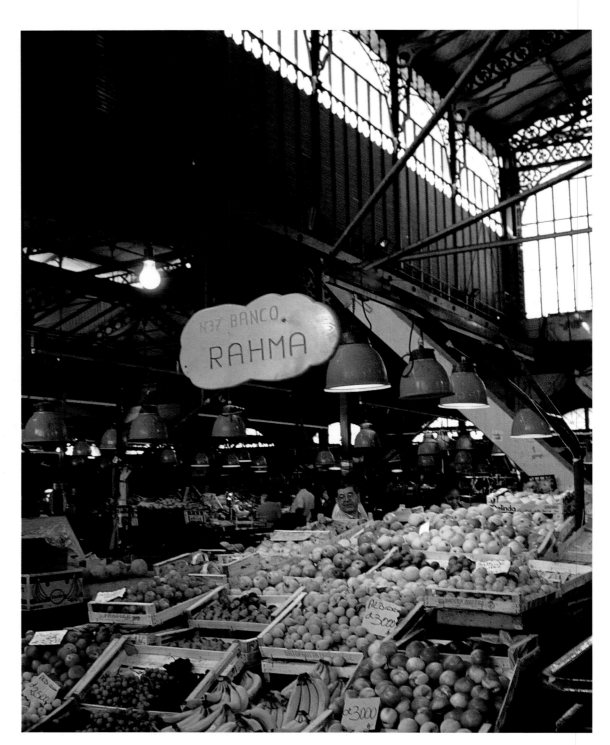

sprinkled on the *crostini* (canapés spread with chicken liver and the like) and *bruschetta* (a slice of bread rubbed with garlic or herbs) often served as hors d'oeuvres. Olive oil also serves as the finishing touch to the thousands of varieties of soups with which Tuscan meals often begin. Among the most delicious of these soups is *ribollita*, especially popular in winter, made with vegetables cooked in water or bouillon and served with the addition of haricot beans, pasta, and bread. The Siena and Maremma regions play a number of variations on this theme, all called *acquacotta*, which I sampled in Grosseto and Livorno. In Siena, the soup's characteristic flavor comes from cèpes, but elsewhere it can also contain tomatoes, onions, bread, or eggs. The coastal regions are of course famous for the quality of their fish soups: *cacciuco*, for instance, typical of Livorno and served with slices of toast rubbed with garlic, which I tasted in an excellent seafood restaurant in Cecina; or its Monte Argentario variant, *caldaro*, featuring shellfish native to this rockbound part of the coast. In the same spirit, the inland regions— notably Montepulciano—offer *tegamaccio*, made with local freshwater fish.

The white haricot beans known as *fagioli* are found in a number of more or less thick soups such as *minestra*, and also in Livorno's *bordatino*, a liquid corn-meal polenta blended with the puréed beans. Also worth noting is *fagioli al fiasco*, white beans placed inside a bottle, cooked in the embers of an open fire, and flavored with olive oil just before serving. A springtime specialty in Lucca is the delicious *garmugia*, a blend of fresh haricot beans, peas, artichokes, and minced meat.

In the realm of pasta, a Tuscan favorite is *pappardelle*, a kind of broad tagliatelli that in game-hunting regions is customarily seasoned with the pan juices from roast hare, wild boar, or duck. Some types of pasta are found only in a limited geographical area, such as the *pici* or *pinci* served in and around Montalcino. In the Lucca region, popular types include the oversize ravioli with an extremely rich stuffing known as *tordelli*—which I discovered at the Vipore restaurant located in the hills overlooking the city—and *tacconi*, a square pasta often garnished with cèpes.

When it comes to meat, the highest rank is definitely occupied by *bistecca*, a thick cut of exceptionally tender grilled beef. *Bistecca* is without

TUSCAN CUISINE MAKES NO COMPROMISES WHEN IT COMES TO THE QUALITY OF INGREDIENTS. AT FLORENCE'S MERCATO CENTRALE, WHERE BASKETS ARE BECOMING A THING OF THE PAST, THE DISPLAYS FEATURE BOTH REGIONAL AND EXOTIC PRODUCTS (FACING PAGE). IN TUSCANY, AS IN THE REST OF ITALY, THE STAPLE FOOD IS PASTA—SUCH AS THESE VARIED TYPES DISPLAYED BY A GROCER IN LUCCA (ABOVE).

IN A SMALL VILLAGE IN THE
CHIANTI REGION, POET-BUTCHER
DARIO FOLLOWS A DICTION LESSON
OVER THE TELEPHONE (RIGHT).
THE BUTCHER SHOP OPENS ONTO
A ROOM USED AS A CONCERT
AND EXHIBITION HALL (BELOW,
BOTTOM). FLANKED BY TWO
ANGELS, THE DOORWAY FRAMES
THIS UNUSUAL BUTCHER AS HE
RECITES FROM DANTE (BELOW, TOP).

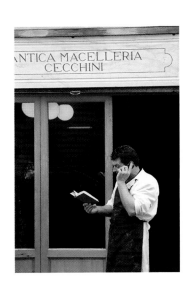

doubt one of the glories of Florentine cuisine, prepared in such generous portions that one serving is usually ample for two diners. *Tagliata*, typically made from a mixture of minced beef and veal seasoned with rosemary and a dash of olive oil, is also a treat. Tuscany Chianina steers and calves from Valdichiana provide some of the best beef and veal in Europe. If you want to appreciate the important role played by meat in Tuscan cuisine, you should visit the small village in Chianti where a man named Dario has his butcher shop, and observe the loving care with which he trims and prepares each cut. Dario, who can recite entire pages from Dante by heart (and from the heart), is quite extraordinary. Although there's perhaps no other butcher quite like him in Tuscany, he could exist nowhere but in Tuscany. As if in celebration of some ancient religious sacrament, his meat is the focal point of a solemn ritual to which all are welcome, and which often includes a convivial glass of wine and tray of cold cuts for guests.

Fall and winter is the season for game, particularly the wild boar that roams throughout most of Tuscany. The omnipresence of the pig in this region explains the importance here, as elsewhere in Italy, of sausage and salami. In the winter, small villages still employ a pork specialist or *norcino*—often from the mountains—to bleed and butcher slaughtered pigs. In accordance with a long-established country tradition, this event is the occasion for lengthy festivities accompanying the various operations involved in making sausage and trimming ham (which will then be aged for several months). A particularly delectable specialty, and my personal favorite, is Colonnata boiled bacon, once the staple food of marble masons. Offal (variety meats) are less popular than in neighboring Latium, but the Florentines love tripe, sometimes stuffed into the rolls known as *lampredotto* and once eaten as snacks—a custom that a few connoisseurs such as Fabio Pichi, chef of the Cibreo in Florence, is determined to maintain.

In the domain of cheese, sheep's-milk pecorino toscano is produced throughout the region, but this fine, compact white cheese is virtually indistinguishable from pecorino romano. It comes in a multitude of regional and local varieties—of which some of the best can be found in Pienza—depending on the length of aging and the different flavorings added.

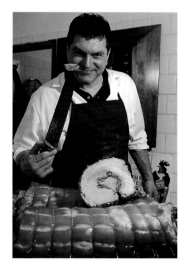

Dario using the tip of a knife to examine a savory slice of his delicious *porchetta* (above, top). He often invites customers to sample his salami and other appetizers with a glass of wine (above, bottom). Dario works like an artist, even when executing a simple gesture such as salting the sausage meat (right).

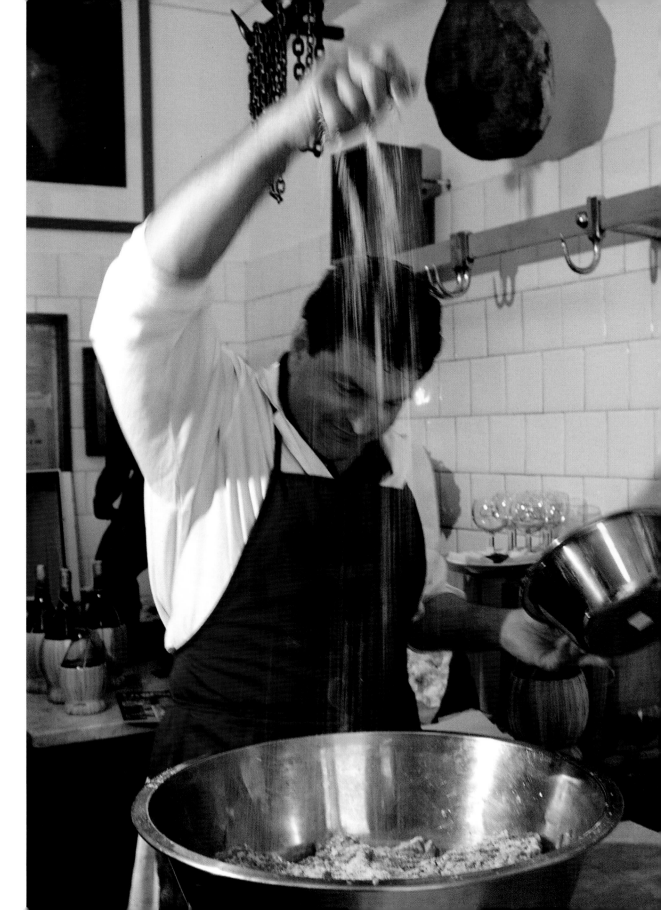

SIENA *PANPEPATO*, IN ITS
CHARACTERISTIC PACKAGING
WITH THE RED-WAX SEAL, IS ONE
OF THE MOST DELICIOUS VARIATIONS
ON THE FAMOUS *PANFORTE*,
A PASTRY TO WHICH SPICES AND
HONEY GIVE AN INIMITABLE
TEXTURE AND FLAVOR (RIGHT).

Tuscan pastries are often heavy and firm in texture. This is the case with the famed Siena *panforte*—containing a blend of walnuts, hazelnuts, spices, honey, and candied fruit—and its variant *panpetato*, a specialty at Naninni; and also with *castagnaccio*, a delicious finger-thin cake made from chestnut meal combined with walnuts, raisins, rosemary, pine nuts, and olive oil. At dessert time, the delectable little *cantucci* almond cakes, served with a glass of sweet Vinsanto wine, are ubiquitous.

You'll find restaurants and specialty shops bursting with treats of every kind all over Tuscany. Hushed elegance should not be the universal criterion, however, since the unsophisticated cuisine of a good country trattoria often affords as much pleasure as more complicated preparations. Eminent chefs offering imaginative variations on traditional themes are nevertheless probably the most irresistible of Tuscany's gastronomic ambassadors.

Alessandro Pinchiorri directs the kitchen at Florence's famed Enoteca Pinchiorri, often rated Tuscany's top restaurant. However, he faces strong competition from Fulvio Pierangelini of the Gambero Rosso, one of the best restaurants for seafood south of Livorno; and from the Trovato brothers, who run the Arnolfo in Colle Val d'Elsa. Fabio Pichi, with his wife Benedetta the founder of Florence's celebrated Cibreo, is not the least

of the stars in this firmament. Pichi governs a small empire he created near the Mercato di Sant'Ambrogio. Today his premises embrace a restaurant, a trattoria for casual diners, a café with fine old wood paneling, and a fancy grocery store. Fabio Pichi's skill and art are immediately obvious, starting with his first-course soups, such as a squid-ink velouté that's as smooth as antique marble. And always with that signature dash of olive oil, swirled on the soup's surface like an Oriental calligraphy. The main dishes and desserts are just as good. My fondest memory is a dish of lambs' brains *en papillote* displaying extraordinary finesse.

However, Tuscan cuisine should be sampled in all of its regional varieties, as at Colle Val d'Elsa, for example. Tuscany's coastal towns also have their own special character, which can be appreciated at the Antico Moro in Livorno or the Scacciapensieri in Cecina, to mention two spots less costly than the Gambero Rosso. I had my own first taste of Tuscan regional culinary traditions in the province of Lucca. During my visits to Ivan Theimer, the Vipore restaurant was one of the first to attract my notice, and I've been loyal to it ever since. The restaurant's setting is definitely part of its charm—the present building, offering a magnificent view of the Lucca plain, replaced an extremely ancient inn surrounded by a chestnut forest alluded to by Montaigne in his time. The site was once thought to be infested with snakes, which explains the restaurant's name and emblem. The chef always invites us into his kitchen, fragrant with herbs grown in a small garden nearby. The Vipore's *tagliata* with herbs is one of my earliest culinary memories of Tuscany, along with the thousands of ways to serve the cèpes gathered in the underbrush of forests that blaze with color when the leaves change in autumn.

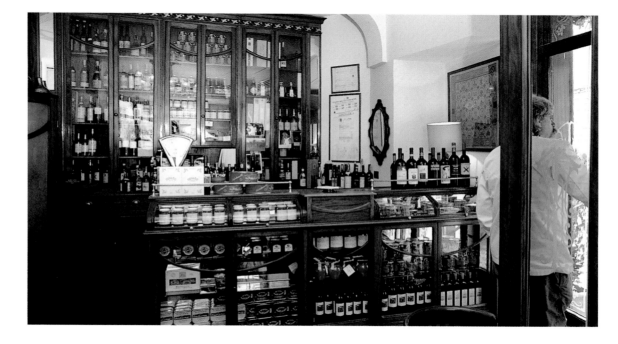

AFTER A MORNING AT THE MERCATO CENTRALE, A RESTFUL STOP AT THE NEIGHBORING BAR (ABOVE, TOP). A DISH OF MARINATED TUNA WITH HARICOT BEANS IN A VILLAGE TRATTORIA (ABOVE, BOTTOM).

SWEET-PEPPER SOUP TOPPED BY AN OLIVE-OIL CALLIGRAPHY, A PLATE OF TOMATO ASPIC AND ANOTHER OF BEANS WITH PECORINO ILLUSTRATE THE TALENTS OF FABIO PICHI (STANDING AT THE DOOR), FOUNDER OF FLORENCE'S CIBREO (ABOVE TOP, LEFT AND RIGHT; ABOVE). SUMMER IS THE TIME FOR OUTDOOR DINING, AS HERE IN AREZZO (LEFT).

THE WINES OF TUSCANY

The grapevine, like the olive tree, is inseparably associated with Tuscany. The Etruscan idea of heaven was a never-ending banquet to which both men and women would be invited. Although little is known about the vineyards of ancient times, it is interesting to note that the main Tuscan rootstock, Sangiovese ("The Blood of Jupiter") draws its name from Greek mythology. In his *Purgatorio*, Dante immortalized Vernaccia, the wine of San Gimignano.

In the seventeenth century, the wines of Chianti and Montepulciano acquired a fame extending well beyond the grand duchy's borders. The vast wine-growing estates owned by the great Tuscan families and cultivated by sharecroppers were further enlarged following the expropriation of ecclesiastical lands in the nineteenth century. This was the period during which Cavour's successor, Baron Bettino Ricasoli, established the definitive "formula" for Chianti Classico, raising Sangiovese to the first rank. His formula continued unchanged for over a century, until after World War II. At that point, the rural exodus, rejection of the sharecropping system by a "red" peasantry, and declining sales of wines that had become synonymous with mediocrity resulted in a complete overhaul of the system. Some of the great historic names—Antinori, Frescobaldi, and Ricasoli—were able to maintain their status by modernizing and adopting a rigorous approach, but a new class of vintners also came to the fore. Breaking with Bettino Ricasoli's time-honored formula, which specified blending different rootstocks in varying proportions, their efforts were primarily directed toward improving Sangiovese and the conditions under which it is aged in oak casks. The example of Vino Nobile di Montepulciano, which has always been made exclusively from this rootstock, was extended to Chianti, and the Montalcino vineyard was quick to follow suit with its magnificent Brunello (another name for Sangiovese Grosso). This return to tradition through improved quality was also accompanied by spectacular innovations fostered by the arrival of new estate-owners and cellarmasters who often had no previous links with Tuscany—and some of whom had even received their training in California. The introduction of Cabernet Sauvignon and Merlot rootstocks gave rise to some remarkable successes, both in areas that had once been marginal (Livorno's Maremma, for example) and in traditional wine-producing regions where the new "Super-Tuscans" were developed— as I learned from Giulio Ruspoli when he had me compare a Chianti Classico

BOTTLES OF WINE AGING IN THE
DARKNESS BENEATH THE BADIA
A COLTIBUONO CLOISTER (LEFT).
THE NEW BADIA CELLARS OFFER
A FINE EXAMPLE OF PIERO
SARTOGO'S STREAMLINED
ARCHITECTURE (FAR LEFT).

ALL OF THE CASKS AND ROOF BEAMS
HAVE BEEN REPLACED (BELOW, LEFT).
THE SECOND GLORY OF TUSCANY,
AFTER WINE, IS OLIVE OIL — ITS FINE
GREEN TINGE HERE ENHANCED
BY THE ELEGANT SHAPE OF THE
BOTTLES (BELOW, RIGHT).

OLIVE OIL

Tuscany's other glory, after wine, is olive oil. The hallmark of the Tuscan landscape everywhere is, along with the cypress, the olive tree. The region around Lucca is especially famed for the quality of the olive oil it produces, although olive groves are generally more closely associated with the hills of central Tuscany. It is here that a group of producers with particularly high standards formed a cooperative for the production and marketing of Laudemio. This olive oil meets strict quality criteria specifying both where

the trees should be grown and how the production process, from harvest to bottling, should be conducted. Thanks to this quality-control policy, the oil now occupies the rank it deserves. Everything possible is done to highlight its beautiful color, with even the design of the bottle— hexagonal for Laudemio—and label contributing to the overall effect. Olive groves and vineyards are usually found in the same

with a Super-Tuscan from his own Lilliano vineyards. One of the outstanding newcomers to have marked the past three decades is the Sassicaia that Nicolò Incisa della Rocchetta, following in his father's footsteps, grows on his Bolgheri estate, and which is now renowned throughout the world. The idea for this extraordinary wine, which is made with Cabernet Sauvignon, was conceived at a tasting session featuring a wine produced by his Salviati cousins at the Migliarino estate. Today Tuscany can thus lay claim to a range of wines differing dramatically from those of some thirty years ago, and worthy of comparison with the very best in the world. Nothing reflects this revolution more dramatically than the elimination of the familiar rounded, straw-clad Chianti bottle—symbol of an era that had its hour of glory, but on which the page must now be turned.

regions, as in Badia a Coltibuono. This is not always the case, however, as can be observed at Fiesole's magnificent Fattoria di Maiano, which served as the setting for some scenes in James Ivory's film *Room With a View*. Excellent olive oils are available from Desideria Pasolini dell'Onda at Barberino Val d'Elsa; from the Frescobaldi, whose estates around Florence and beyond produce a fine oil with a sustained green tint; and from the Antinori, whose antique olive press stands on their Santa Cristina estate in the center of the Chianti region. Tuscan olive oil, now restored to the highest rank, can be more or less fruity and at times slightly sharp. It enhances both the simplest dishes, such as *bruschetta*, and more sophisticated ones like the *passata* served at Florence's Cibreo. Happily, with olive oil—unlike wine—there is no fear of adulteration.

WHERE TO STAY IN TUSCANY

Tuscany is one of the regions of Italy offering the widest range of accommodation, whether for visitors seeking luxury establishments or those interested in the infinite resources of *agriturismo*—the expanding country-stay tourism sector enabling back-country areas to maintain their prosperity despite the rural exodus.

One of Tuscany's major attractions is unquestionably the many hotels occupying historic buildings. Some are former aristocratic mansions, most often villas that have retained the charm of their gardens and imposing locations; others have taken over former convents; and others, lastly, are buildings such as the old paper mills in Colle Val d'Elsa that no longer serve their original purpose.

An extremely old wisteria curving along the façade of Fiesole's Villa San Michele, formerly a convent and now one of Europe's legendary hotels (above).

Through the arches of its long gallery, the view of the Tuscan capital below is incomparable (right).

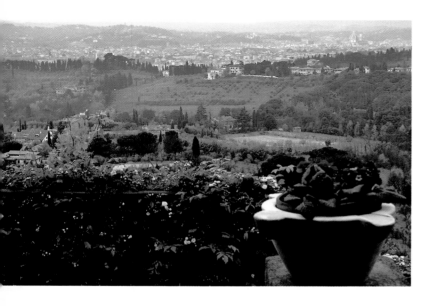

The Fiesole hill provides a superb vantage point for admiring Florence. Located here, La Pensione Bencistà offers its guests a spectacular view (above).

The Most Beautiful Hotels in Europe

Fiesole's Villa San Michele, overlooking Florence and the Arno plain, is probably the finest example of its kind. This estate, once owned by the Davanzati family, housed a convent before being converted into a hotel. Its splendid 1599 architecture, the work of Santi de Tito, opens through a long portico onto marvelous terraced gardens. Its view of Florence is deservedly one of the most famous. Stunning details mark every step within: the foyer below the altar, the dining room in the former refectory and its painting of *The Last Supper*. With its warm welcome and impeccable service, this is definitely the crown jewel of Italian hotels and, if the truth be told, it has few rivals anywhere in Europe. Meanwhile, a less costly choice is offered by a little gem nearby: the Pensione Bencistà, also an institution in its own way. Run for several generations by the same family, this ancient residence

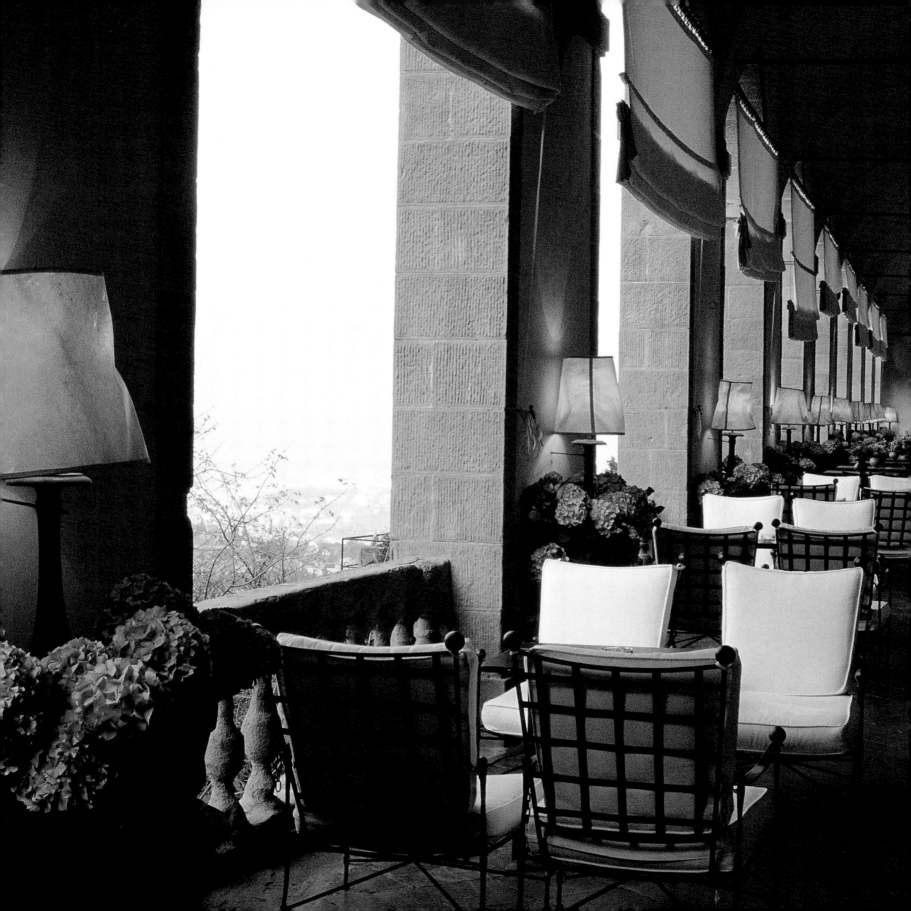

THE PENSIONE BENCISTÀ
HAS RETAINED THE PROPORTIONS
AND SPIRIT OF A FAMILY HOME
(ABOVE, TOP AND BOTTOM; RIGHT).

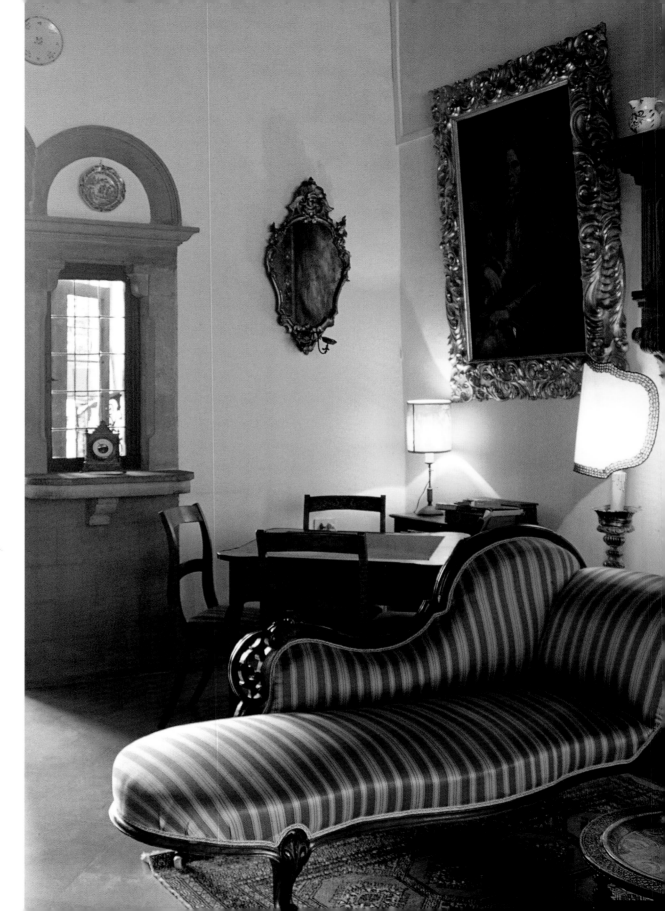

redolent of beeswax furniture polish also affords a view of Florence from its
flower bedecked terrace that is unforgettable, especially at sunset.

Although they may not equal the luxury of legendary establishments
such as the Villa San Michele, numerous other manors offer an opportunity
to travel back in history while also enjoying a more family-style
atmosphere. The Villa Villoresi in Sesto Fiorentino, on the outskirts of the
Tuscan capital, has preserved its country-house charm intact. This old
twelfth-century fortress, in which Dante's wife stayed during the poet's
exile, was converted into a country manor during the Renaissance. The
forty-meter-long loggia was added at that time. The house also contains
rare decorative distemper paintings dating from the early nineteenth
century, when the estate was acquired by the Villoresi family. The villa has
remained in the same hands ever since, preserving its original spirit and
offering to demanding and cultivated guests a stay that is without question
one of the most appealing anywhere. North of Florence, the Villa
Campestri, still owned by the family that acquired the estate more than
six centuries ago, provides guests with an opportunity to enjoy the natural
setting of the Mugello region, where the Medici built their first villas.
In the little town of Montaione southwest of Florence, the Palazzo
Mannaioni has recently been converted into a hotel, the old library of
which has a special charm. La Suvera and the Villa San Lucchese, near
Poggibonsi between Siena and Florence, are both ideal starting points for
exploring central Tuscany. La Suvera is also notable for having once been
owned by Luchino Visconti. The Ricci family has converted the
outbuildings into guestrooms, and installed a few luxury suites inside
the sixteenth-century villa.

The area around Siena is filled with historic hotels, the best-known of
which are the Certosa di Maggiano and the Locanda dell'Amorosa. Both
offer rare treats in terms of both architectural beauty and friendliness. The
restaurant at the Amorosa is especially famous. The Villa Arceno in
Castelnuovo Berardenga is a vast and perfectly preserved estate on which a
fine seventeenth-century villa has been converted into a hotel, and the
surrounding farmhouses also restored. The Villa Scacciapensieri, on the

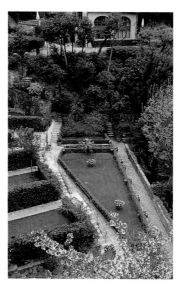

THE SUITES AT THE VILLA
SAN MICHELE OPEN ONTO
A METICULOUSLY TENDED
TERRACED GARDEN (LEFT).
THE HOTEL'S DINING ROOM
IS BORDERED BY A CLOISTER,
ITS RESTRAINED ARCHITECTURAL
DESIGN TYPICALLY FLORENTINE.
HERE LUXURY IS SYNONYMOUS
WITH ELEGANCE, BUT NEVER
OSTENTATION (BELOW).

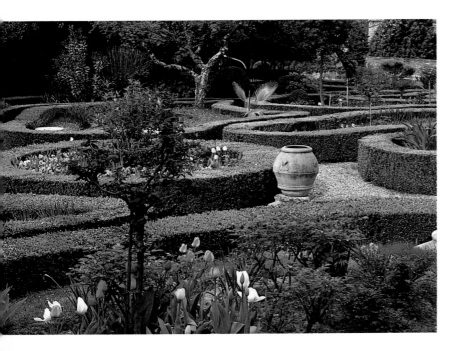

fringes of the city, has all the charm of an old family mansion surrounded by a delightful Italian garden. In Pienza, the Il Chiostro inn occupying a former Franciscan monastery has retained a touch of the monks' austerity, but the calm of its cloister and beauty of the views from rooms opening onto the Val d'Orcia make it a highly recommended stop. The Castello di Montebenichi between Siena and Arezzo on the border of Chianti is a magical spot, furnished with impeccable taste by its English owners in the tradition of the great nineteenth-century collectors.

Toward the seaside, the recently inaugurated Castello di Magona near Livorno is ideally located for side trips into to Tuscany, and also benefits from the proximity of the long sandy beaches on the Tyrrhenian coast. The Villa di Corliano between Pisa and Lucca is a totally charming spot that, despite a certain lack of comfort, one can only hope will endure. Near Lucca, great eighteenth- and nineteenth-century villas recall the city's brilliant social life under the enlightened reign of Napoleon's sister. Fine examples include the Villa La Principessa, the Villa San Michele, and the Principessa Elisa hotel.

More rustic but no less memorable inns dot the countryside in Chianti and around Siena. The Olmo is an old and tastefully restored seventeenth-century farmhouse near Monticchielo, a tiny medieval village not far from Pienza. The Val d'Orcia region, less well known than Chianti, offers a number of charming places to stay: the Castello di Ripa d'Orcia, for example, or the rooms attached to the Cantina il Borgo restaurant in the little medieval village of Rocca d'Orcia. The Sette Querce in San Casciano dei Bagni is an attractive stop in this southern part of Tuscany. Farther to the north, Il Casale del Cotone, two kilometers from San Gimignano, is a restored farmhouse with a few guestrooms and apartments, as is Casanova di Pescille with its remarkable views of the city's towers. In the Siena Hills region, the Azienda Piccolomini Bandini is a good base for trips into the fascinating countryside around San Giovanni d'Asso. In many instances, the distinction between country inns and farmhouses with guestrooms is a tenuous one.

The range of accommodation in Florence is infinite, but often costly. Some of the more opulent establishments recall the elite golden-age tourism of the nineteenth- and early twentieth-centuries. The Excelsior on the banks of the Arno, and the recently renovated Savoy on the Piazza della Repubblica are among the most typical representatives of this tradition. But visitors will perhaps find greater charm in less luxurious settings, such as the Loggiato dei Serviti located on the Piazza Santissima Annunziata, designed by Brunelleschi and one of the city's finest Renaissance squares; the Villa Medici, a step away from the Palazzo Corsini al Prato; and a number of pensions as legendary as the more prestigious hotels, such as the Pensione Quisiana, where connoisseurs always ask for number 22—E. M. Forster's famed "room with a view." At the foot of San Miniato hill, along the Viale Michelangelo, a number of old villas from the Liberty period have been converted into tourist accommodation; however, as is so often the case in Florence, visitors will have to choose between a view of the city and a little peace and quiet. The Torre di Bellosguardo, with its charming garden, is deservedly one of the most popular in Florence—precisely because it does not face visitors with this dilemma.

THE VILLA SCACCIAPENSIERI
IS A CHARMING FAMILY RESIDENCE
ON THE OUTSKIRTS OF SIENA. IN
ADDITION TO ITS VIEW OF THE CITY'S
BELL TOWERS, IT ALSO BOASTS
A PLEASANT ITALIAN GARDEN
AND ONE OF THE CITY'S BEST
RESTAURANTS (FAR LEFT).

THE VILLA VILLORESI IS LOCATED
IN SESTO FIORENTINO, NEAR
FLORENCE (CENTER LEFT).
THE HOTEL'S BEDROOMS OPEN ONTO
A LOGGIA PROUDLY CLAIMED TO BE
THE LONGEST IN TUSCANY (BELOW).
THE INTERIOR HAS RETAINED
MUCH OF ITS REMARKABLE ORIGINAL
DECORATION (LEFT).

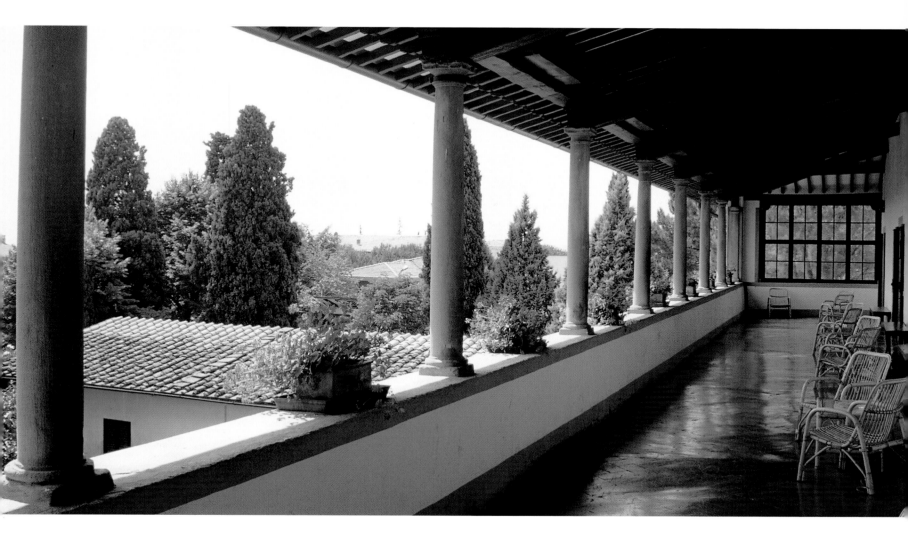

A ROSEBUSH COVERED WITH WHITE BLOOMS MARKS THE ENTRANCE TO ONE OF THE GUESTHOUSES ON THE LILLIANO ESTATE NEAR CASTELLINA IN CHIANTI (RIGHT). THE INTERIOR DECORATION RESPECTS THE SPIRIT OF THESE FORMER PEASANT DWELLINGS, WHICH WOULD HAVE FALLEN INTO RUINS WITHOUT THE CURRENT FASHION FOR WHAT THE ITALIANS REFER TO AS *AGRITURISMO*.

"Green" Tourism

During the rural exodus that occurred in the aftermath of World War II, whole villages and innumerable farmhouses were vacated in the space of a single generation. Near Castellina in Chianti, an estate like Lilliano—not the largest by any means—possessed thirteen farms (*casali*) that were all deserted by their occupants during the 1950s and 1960s. The region's characteristic rooftops require constant maintenance, and neglect soon results in irreparable damage. "Green" tourism, or the recent fashion for simple country holidays, has made these dwellings economically viable once more by restoring their function as residences, even if only intermittently. Divided into apartments or rented as single units, they offer Tuscan holiday accommodation in settings that are sometimes exceptional. The formula is ideal for anyone who wants to vacation with family or friends free of the constraints (and services, of course) typical of a hotel.

Some of these sites, especially those in Chianti, are practical bases for exploring the countryside around Florence and Siena, Volterra and Arezzo.

Visitors looking for somewhere to relax beside the pool with a good book can also be sure of finding just the place for them. My own fondest memories include a May night at Lilliano when thousands of fireflies glimmered in the meadows, and the absolute peace of Cosona when I was staying in a house on the Bichi Ruspoli estate, where the view of the Pienza, Montalcino, and Siena Hills region is outstanding. But everyone has their own favorites, many of which will be found in Chianti. American friends of mine recommended the Fattoria La Loggia, ideally located atop a small hill in Montefiridolfi, south of Florence. This property is owned by a connoisseur of contemporary northern Italian art, and boasts a garden with magnificent views. The Ferragamo family also rents a range of residences in the hamlet of Borro, at San Giustino Valdarno, where lovers of horseback riding will feel at home. An identical formula is available at the Castello di Volpaia at Radda, in Chianti. Although the old peasant way of life is now a distant memory, little villages that would long since have died are currently experiencing renewed life—to the delight of everyone eager to combine culture with the art of living.

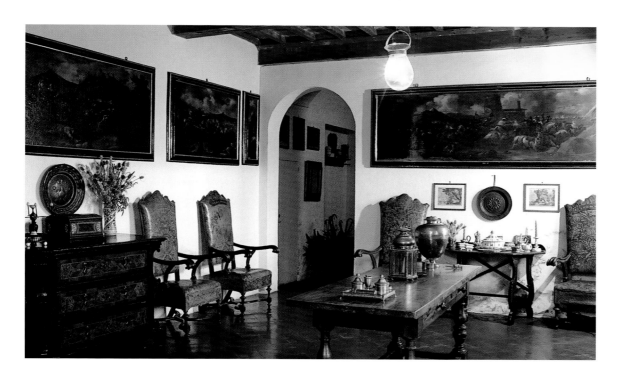

THE FOYER OF CORSONA CASTLE
NEAR PIENZA (LEFT).
GUEST ACCOMMODATION IS
AVAILABLE IN THE MANOR'S
OUTBUILDINGS (BELOW, RIGHT).
A WELCOMING PINE-NUT CAKE
SET OUT ON A TABLE OVERLOOKING
THE UNSPOILED COUNTRYSIDE OF
SOUTHERN TUSCANY (BELOW, LEFT).

AMID THE VINEYARDS OF CHIANTI,
THE OLD FARMHOUSES ON
THE LILLIANO ESTATE OFFER
IDEAL ACCOMMODATION FOR
THOSE EXPLORING TUSCANY
(FOLLOWING PAGE).

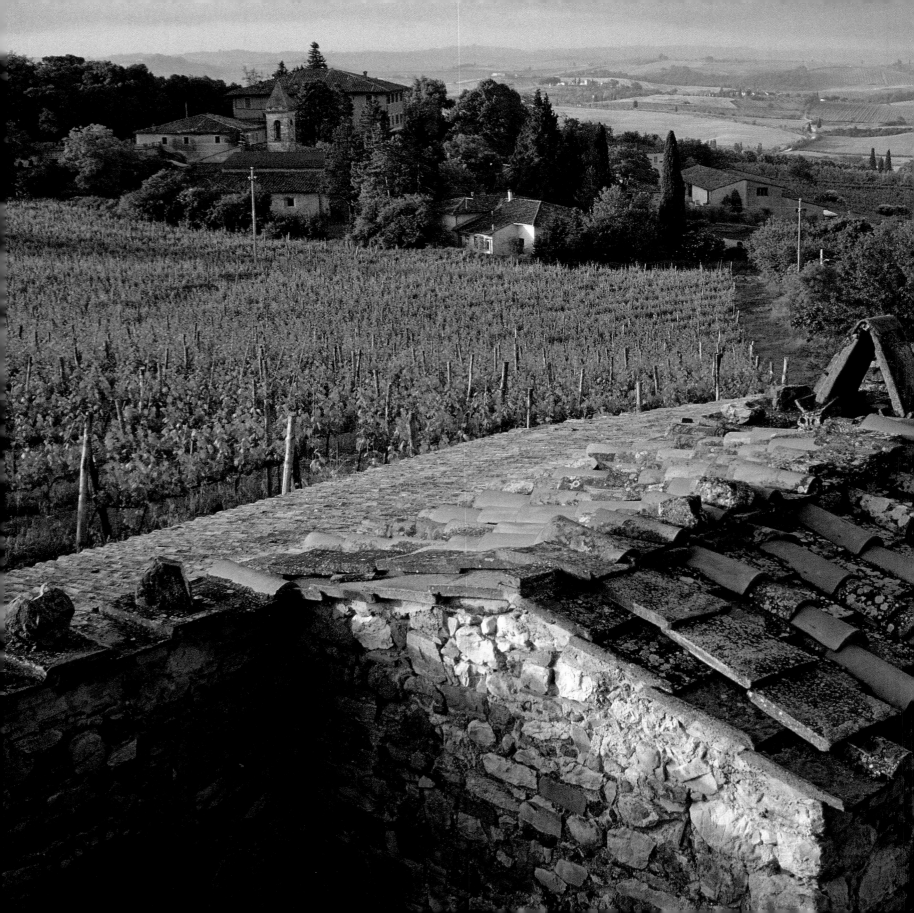

VISITOR'S GUIDE

GOOD ADDRESSES
AND TIPS FROM TUSCANS
FOR THOSE SEEKING
A ROOM WITH A VIEW
OR A RESTAURANT SERVING
REGIONAL CUISINE,
A MUSEUM OR
A MASTER CRAFTSMAN.

Discovering Tuscany could take a whole lifetime. However, thanks to the highways that connect the north of Italy to Rome, Tuscany is easily explored and remains what it has been for centuries: a region of incredible diversity and contrast. However, there are unifying elements, from vestiges of the ancient Etruscans to the reign of the grand dukes, not to mention the language that developed in the Middle Ages and has since been adopted by all of Italy, despite resistance in some quarters. A Tuscan is first and foremost a Florentine or a Sienese, a Pisan or a Luccan. Regional identity emerged through the affirmation of these city-states that had far-reaching powers. Pisa alone dominated a large part of the Mediterranean in the twelfth century.

The Florentine miracle, namely the emergence of such universal geniuses as Leonardo da Vinci and Michelangelo, who will never cease to fascinate, has made Tuscany and its capital a second home for people who are passionate about culture. The grandeur of this past could easily crush the present, just as the political, economic and artistic decline of the grand duchy had appeared inevitable from the seventeenth century. However, even reduced to being just another region of Italy, Tuscany remains remarkably dynamic. Despite the growth of cities and the rural exodus, among other factors, the Tuscan countryside has retained its legendary equilibrium and harmony.

As a place to live, it is still unrivalled. Daily life here is imbued with beauty and elegance. And even if Tuscans, and Florentines in particular, have a hard time shedding a certain sense of superiority, the region has for centuries been one of the most open to the outside world: many foreigners have settled in Tuscany, beginning with the English at the turn of the twentieth century. Today, the most celebrated sites have fallen victim to mass tourism, but even in Florence, and especially in the smaller villages and the countryside, it's possible to feel the same sense of wonder that travelers must have experienced in times past.

It cannot be emphasized too strongly that the best time to go is mid-season. Winter, although it can be cold and wet, also has its advantages, being the only time during the year for example to visit the Uffizi in peace. Finally, remember that when traveling on small roads distances are always covered slowly. That is why the following suggestions—courtesy of generous Tuscan friends—are classified according to location.

FLORENCE

Florence is a world of unending riches. It is home primarily, but not exclusively, to a wealth of artistic treasures. It has retained the rather aloof air of a capital city undiminished by the tourist invasion, which is not without respite. Florence remains a symbol of elegance and refinement, albeit with a streak of conservatism: whether in fashion or food, audacity for its own sake is avoided, and inventiveness and creativity always remain within the limits of good taste.

Dense and compact, the city offers infinite possibilities in a space that is easily covered on foot. It is rather as if a single Parisian arrondissement contained nearly all the museums, the antique shops of the Faubourg Saint-Germain, the great fashion designers of the Avenue Montaigne and the Faubourg Saint-Honoré, the jewelers of the Place Vendôme, the street markets and the best restaurants.

The following addresses give only a hint of what can be found there.

HOTELS

Despite the noise, there are many addresses of note in the center of town. Some are prestigious, others are simpler and less expensive.

EXCELSIOR
3 Piazza Ognissanti
Tel: 055-264201, fax: 055-210278
The Excelsior overlooks the Arno, next to the Ognissanti Church, where Botticelli painted his admirable *Saint Augustine*. It is the quintessential grand hotel in the purest tradition.

HELVETIA E BRISTOL
2 Via dei Pescioni
Tel: 055-287814, fax: 055-288353
This luxurious hotel, which used to be very popular with the intellectual elite, opens onto a narrow street in the historical center, near the Palazzo Strozzi. It is once again one of Florence's finest.

SAVOY
7 Piazza della Repubblica
Tel: 055-283313, fax 055-284840
This hotel looks onto a vast nineteenth-century square, which is equally famous for its turn-of-the-century cafés (notably the Gilli). It was renovated recently.

REGENCY
3 Piazza Massimo d'Azeglio
Tel: 055-245247, fax: 055-2346735
The Regency is situated just outside the city center, in the north of the Santa Croce quarter, which is easily accessible by car. This is one of the most pleasant of the city's great hotels and has retained the atmosphere of the patrician villa it was originally.

GRAND VILLA MEDICI
42 Via Il Prato
Tel: 055-2381331, fax: 055-2381336
This opulent establishment is situated close to the Porta al Prato and the Palazzo Corsini al Prato. It has a sublime garden (see page 196) and a private swimming pool.

J AND J
20 Via di Mezzo
Tel: 055-2345005, fax: 055-240282
There is an interesting blend of old and new in this sixteenth-century dwelling. The original parts have been restored with great care, while the rooms have been decorated in a contemporary style. Close to the Santa Croce.

BRUNELLESCHI
3 Piazza Santa Elisabetta
Tel: 055-290311, fax: 055-219653
Vast hotel housed in an ensemble of buildings situated in the pedestrianized historical center. The terrace and some of the rooms afford a magnificent view of the cathedral's dome and the city.

CAVOUR
3 Via del Proconsolo
Tel: 055-282461, fax 055-218955
This hotel is located almost directly opposite the Bargello museum. Its terrace offers an exceptional panoramic view of the historic center.

LUNGARNO
14 Borgo San Jacopo
Tel: 055-27261, fax: 055-268437

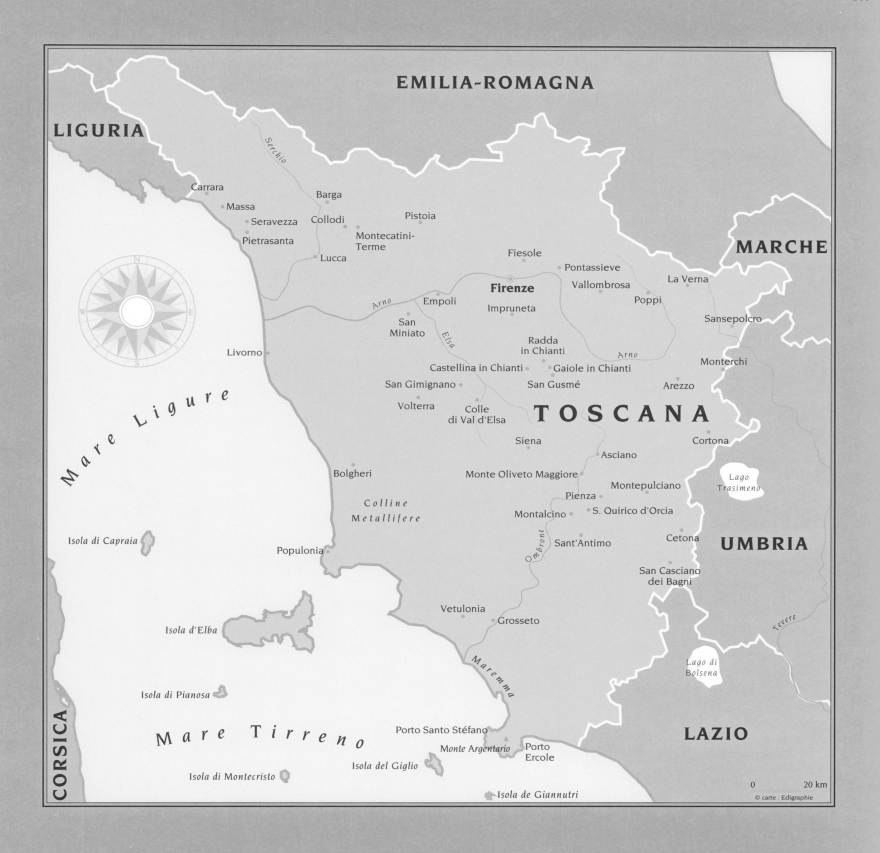

EMILIA-ROMAGNA

LIGURIA

MARCHE

Serchio

Carrara

Barga

Massa

Collodi

Pistoia

Seravezza

Montecatini-Terme

Pietrasanta

Lucca

Fiesole

Pontassieve

Firenze

Vallombrosa

La Verna

Arno

Empoli

Imola

Imbruneta

Poppi

San Miniato

Elsa

Radda in Chianti

Arno

Sansepolcro

Livorno

Castellina in Chianti

Gaiole in Chianti

Monterchi

Mare Ligure

San Gimignano

San Gusmé

Volterra

Colle di Val d'Elsa

TOSCANA

Arezzo

Siena

Cortona

Asciano

Bolgheri

Monte Oliveto Maggiore

Lago Trasimeno

Montepulciano

Pienza

Colline Metallifere

Montalcino

S. Quirico d'Orcia

Isola di Capraia

Ombrone

Sant'Antimo

Cetona

UMBRIA

Populonia

San Casciano dei Bagni

Vetulonia

Grosseto

Mare Maremma

Isola d'Elba

Tevere

Isola di Pianosa

Lago di Bolsena

CORSICA

Mare Tirreno

Porto Santo Stéfano

LAZIO

Monte Argentario

Porto Ercole

Isola del Giglio

Isola di Montecristo

Isola de Giannutri

0 20 km

© carte : Edigraphie

This hotel is best known for the superb view of the Ponte Vecchio from its salon and some of the rooms.

HERMITAGE
1 Piazza del Pesce-Vicolo Marzio
Tel: 055-287216, fax: 055-21208
From the terrace of the hotel, situated at the corner of the Ponte Vecchio, the view encompasses both banks of the Arno. A word of warning, however: despite being pedestrianized, this neighborhood remains quite noisy. The rooms overlooking the courtyard are quieter.

LOGGIATO DEI SERVITI
3 Piazza della Santissima Annunziata
Tel: 055-289592, fax: 055-289595
This hotel has the distinction of being situated on one of the city's most beautiful Renaissance squares, with the superb loggia designed by Brunelleschi for the Hospice for the Innocents. And yet the place is rarely overrun. Certain rooms look onto the garden of the Accademia, one of Florence's finest museums. Soberly elegant, it is one of my favorite hotels in Florence.

HOTEL DAVID
1 Viale Michelangelo
Tel: 055-6811695, fax: 055-680602
Close to the Arno, at the foot of the San Miniato hill, this hotel is set in a nineteenth-century villa which has been expanded, modernized, and tastefully decorated with antique furniture. The rooms at the back of the villa are the quietest. The welcome here is charming.

PENSIONE PENDINI
2 Via Strozzi
Tel: 055-211170, fax: 055-281807
This welcoming hotel that is more than a hundred years old has several rooms which look onto the Piazza della Repubblica. It is not the

quietest of places, but conditions are obviously more advantageous here than at the Savoy opposite.

Around Florence

TORRE DI BELLOSGUARDO
2 Via Roti Michelozzi
Tel: 055-2298145, fax: 055-229008
Dominated by a medieval tower, surrounded by a beautiful garden, carefully furnished with an old-fashioned elegance that has far more charm than the icy comfort of more modern interiors, this exceptional hotel numbers only a few rooms, which are obviously highly sought after.

VILLA BELVEDERE
3 Via Benedetto Castelli
Tel: 055-222501, fax: 055-223163
This place may not have the exceptional charm of the Torre di Bellosguardo (see above), but prices are more affordable and it has a beautiful garden and a swimming pool, as well as a stunning view of the city.

Fiesole: two legendary addresses

VILLA SAN MICHELE
4 Via Doccia
Tel: 055-59451, fax: 055-598734
Located in a former Renaissance monastery, surrounded by magnificent Italian gardens, the Villa San Michele has an admirable view of Florence, especially at sunset. It is without doubt one of the most beautiful hotels in Europe. The interior and furnishings are magnificent, the service refined, and the prices, not surprisingly, are high. But even a brief stay in the Villa San Michele will leave with you an indelible memory (see pages 192, 193, 195).

PENSIONE BENCISTA
4 Via Benedetto da Maiano
Tel/fax: 055-59163
Since my first visit to this

traditional family-run hotel more than a quarter of a century ago, it has lost none of its charm or atmosphere. The rooms, decorated with antiques, have simply become a little more comfortable. The view of Florence is unforgettable, so having to take at least one meal a day here is hardly a problem. The prices are very reasonable for such an astonishing place (see pages 192, 194).

RESTAURANTS

ENOTECA PINCHIORRI
87 Via Ghibellina
Tel: 055-242777
This luxurious family-owned restaurant in a sixteenth-century palace near the Santa Croce is one of Tuscany's—and Italy's—most famous. During the summer, the tables are set out in the courtyard. The wine cellar is renowned and the menu, devised by Alessandro Pinchiorri, is both traditional and innovative.

CIBREO
8 Via Andrea del Verrocchio
Tel: 055-2341100
Not surprisingly, this is one of the most popular restaurants in the city. The warm personality of Fabio Picchi, the quality of his cuisine—always full of tasty new surprises—and the elegance of the atmosphere make it my personal favorite. In addition to the main restaurant, there is a trattoria and a café (see pages 189, 190).

CAFFÈ CONCERTO
7 Lungarno Cristoforo Colombo
Tel: 055-676493
This elegant restaurant, which has a garden, is one of the most creative in Florence, thanks to chef Fulvio Pietrangelini. In addition to selected classics, he always offers some remarkable novelties.

SABATINI
9A Via Panzani
Tel: 055-282802
Situated near the train station, this restaurant specializes in excellent Tuscan cuisine. Try, for example, the duck Maremma-style (*anatra alla maremanna*).

SOSTANZA
Via della Porcellana
Tel: 055-212691
This was originally a grocery store in the Santa Maria Novella neighborhood. The menu centers around the usual traditional dishes and the interior is packed with foreigners and regulars. What makes it special is the warm, lively atmosphere.

IL LATINI
6R Via dei Palchetti
Tel: 055-210916
This restaurant in the historical center is situated in the stables of the Palazzo Rucellai, one of the city's major monuments. Excellent Tuscan cuisine. Try the *bistecca alla fiorentina* (Florentine steak).

BUCA LAPI
1 Via del Trebbio
Tel: 055-213768
This charming restaurant is situated in the cellars of the Palazzo Antinori.

CANTINETTA ANTINORI
3 Piazza Antinori
Tel: 055-292234 or 2359827
Located on the ground floor of the Palazzo Antinori, a beautiful Renaissance residence, this place was originally opened by this old Florentine family to sell its various wines, but it has become better known as a sought-after dining spot.

COCO LEZZONE
26R Via del Parioncino
Tel: 055-287178
This tiny restaurant not far from the Ponte Vecchio serves typical

examples of traditional Tuscan cuisine to a discerning clientele. Among the many delectable choices, try the *pappa al pomodoro*.

L'OROLOGIO
86 Via G.P. Orsini
Tel: 055-6811729
Situated at the foot of the San Miniato hill, near the Arno, this trattoria is faithful to the Tuscan tradition. Among the typical dishes, try *budellina di vitello*, calves' tripe with a very subtle flavor. Welcoming staff.

ALLA VECCHIA BETTOLA
32R Viale Ludovico Ariosto
With its large tables and walls decorated with old engravings, this restaurant has a lively Florentine atmosphere. The delicious traditional cuisine is greatly appreciated by locals.

LA CASALINGA
9R Via dei Michelozzi
Tel: 055-218624
La Casalinga is typical of a certain type of Tuscan trattoria that is unpretentious yet uncompromising when it comes to the quality of its food. To prove the point, one often runs into staff from the nearby Pitti Palace—and it isn't just the kindness of the owner that attracts these connoisseurs.

FIASCHETTERIA CAMBI
1R Via S. Onofrio
Tel: 055-217134
This restaurant is on the ground floor of an old palace around the corner from the Antico Setificio Fiorentino, in the authentic yet relatively tourist-free San Frediano neighborhood. A lively place showcasing the cuisine and wines of Tuscany.

LA LOGGIA
1 Piazzale Michelangelo
Tel: 055-2342832
The restaurant has one of the best

views of the city. Try the *carpaccio di spigola marinata*, slices of sea bass marinated in oil.

OMERO
11R Via Pian dei Giulari
Tel: 055-220053
Situated in the hills to the south of the city, not far from the Villa Poggio Imperiale, this restaurant has a warm atmosphere and a beautiful view. Try the *ribollita*.

In Fiesole, we recommend

LE CAVE DI MAIANO
16 Via delle Cave
Tel: 055-59133
A pleasant, traditional trattoria that has succeeded in retaining its identity in a tiny town overrun with tourists.

FOOD AND WINE

Florence is peppered with stores where food lovers can find a vast choice of gastronomical specialties, some typically Tuscan, others not. Here, presentation becomes an art in itself: the beautiful color of olive oil, the elegance of wine bottles and their labels, and the multicolored pasta compose an ever-changing symphony. Among the dozens of stores available, here are a few recommended names.

ALIMENTARI
19R Via Parione
This grocery store near the Palazzo Corsini offers all the ingredients necessary to make delicious sandwiches, or *panini*.

DOLCI E DOLCEZZE
41R Via del Corso
For many, this is the best bakery in town, thanks to the artistry of Giulio Corti.

ENOTECA ALESSI PARIDE
27-29R Via delle Oche
Offers an extensive range of wines

from Tuscany and Italy, together with a few "historic" bottles.

PITTI GOLA E CANTINA
16 Piazza Pitti
A boutique for gourmets, well stocked and ideally situated.

CAFÉS

A Florentine institution if ever there was one, cafés have played an important role in the intellectual life of the city, especially during the nineteenth century. With their elegant decor and service, they are slightly reminiscent of an English club, but remain fundamentally Mediterranean in spirit.

RIVOIRE
5 Piazza della Signoria
Tel: 055-214412
Founded by a man from the Piedmont, this was originally one of the best chocolate-makers in town. Today, the café has the best view of the Piazza della Signoria. Whenever I return to Florence, it is always a pleasure to drink a hot chocolate seated at one of the outside tables.

CAFFÈ STROZZI
16R Piazza Strozzi
Tel: 055-212574
This is the hip version of the traditional café: the decor is modern, the clientele young, and it stays open late.

GILLI
39R Piazza della Repubblica
Tel: 055-296310
On a square that typifies the urbanism imported in the nineteenth century by the Piedmontese, when Florence was the ephemeral capital of the Kingdom of Italy, this historic café is a monument to that period's taste for the ornate, with mirrors, chandeliers and bronze torches.

GIUBBE ROSSE
13–14 Piazza della Repubblica

Tel: 055-212280
Located opposite the Gilli, this was a meeting place for intellectuals during the twentieth century. The waiters wear red vests, hence the name.

PROCACCI
64 Via Tornabuoni
Tel: 055-211656
Behind the magnificent old storefront, you will find all sorts of delicacies (including Procacci's renowned truffle sandwiches), in what is more of a gourmet grocery store than a café.

MUSEUMS

In addition to the famous museums, which from April to December are crammed with tourists, Florence also has a multitude of less well-known museums which are well worth visiting. They range from the **Museo della Casa Fiorentina Antica** located in the Palazzo Davanzati (Via Porta Rossa, tel: 055-2388610) to the recently renovated **Horne Museum**, the product of a cultivated Englishman's passion for Renaissance art (Via de' Benci, tel: 055-244661).

The more eccentric **Stibbert Museum** (see pages 158–161) arose out of the passion of an eclectic collector, half-English, half-Tuscan, for medieval armor (26 Via Federico Stibbert, tel: 055-475520).

Numerous museums testify to the fact that Florence was also a hotbed for scientific thought. Don't miss the **Museo La Specola**, near the Palazzo Pitti, which showcases a disturbing collection of anatomical wax models from the end of the eighteenth century (17 Via Romana, tel: 055-288251). The **Museo di Storia della Scienza** displays, in a modern but rather cold presentation, a fabulous collection of scientific instruments, the most imposing being

Ferdinando de' Medici's three-meter-long armillary sphere in gilt wood (1 Piazza dei Giudici, tel: 055-293493).

ARTS AND CRAFTS

Because of the skill and know-how of the city's artisans, Florence is full of temptations. Tourism has of course stimulated the production of souvenirs, which by their very nature fail to meet the highest standards, but even in this field quality is respectable.

Naturally, the genuine arts and crafts are of greater interest. Here as elsewhere they are under threat, but some practitioners are doing more than merely surviving.

Fashion is a strong presence here, represented by houses founded by Florentines such as Emilio Pucci for haute couture in the 1950s and Guccio Gucci for leather in 1904, or by such brilliant designers as Salvatore Ferragamo (see pages 174, 175).

The Via Tornabuoni, in the middle of the historic center, is home to a succession of elegant and exclusive boutiques. Florence has a large number of antique shops, some of which are renowned throughout Italy. They are concentrated in several areas of the city. On the Via Maggio, on the same side of the Arno as the Palazzo Pitti, a succession of them occupies the ground floors of the many palaces: among others, one can find Giovanni Pratesi, the great specialist of Tuscan baroque at no. 13, and Guido Bartolozzi at 18R. The Borgo Ognisanti houses several famous names, such as Paolo Romano at 20R and Alessandro Romano at 31. The most venerable of all is the Galleria Luigi Bellini based in a medieval palace at 3-5 Lungarno Soderini, where Luigi Bellini follows a centuries-old tradition. His father was one of the founders

of the international Bienniale, which is held at the Palazzo Corsini.

The following addresses highlight this wealth of crafts and craftsmen, some of whom have attained world renown. In such cases, prices are commensurate with the excellence of the work.

Embroidery

LORETTA CAPONI
4R Piazza Antinori
Tel: 055-213668
Loretta Caponi embodies simultaneously the best of traditional hand embroidery and a spirit of invention that has brought her great fame. Orders can be monogrammed or personalized. The workshop has a good collection of old patterns.

Leather

FERRAGAMO
16R Via Tornabuoni
This store situated in an eighteenth-century palace is next door to a footwear museum that retraces the career of Salvatore Ferragamo, who left Naples to conquer Hollywood before settling in Florence—the only city capable of meeting his demands while permitting him to satisfy a growing clientele. Enchanting (see pages 174, 175).

GUCCI
73R Via Tornabuoni
This address is a long way from the original workshop that Guccio Gucci opened on the Via della Vigna to provide elegant customers with luxurious footwear. The label has now become one of the most counterfeited in the world. A look at the originals will remind you of the exceptional quality of the materials used and the unparalleled finish that have given the brand such a high reputation.

IL BISONTE
11 Via del Parione
Located in the same street as the Palazzo Corsini, this company, which also has outlets in Milan, New York, and Paris, makes handbags, luggage, and other articles in attractively simple designs.

BOJOLA
25R Via Rondinelli
This venerable company was founded in Florence in 1861, when the city became capital of Italy. In addition to traditional pieces, such as a chic umbrella, it offers a very sporty line of leather products.

TADDEI
6R Piazza Pitti and 11 Via Santa Margherita
This artisanal establishment has been making small objects in leather for three generations, specializing in all kinds of boxes and cases.

UGOLINI
20-22R Via Tornabuoni
This is where you will find the best gloves in Florence, in all materials and for all uses.

Paper

EDIZIONI
82R Via della Vigna Nuova
Remarkable producer of hand-made paper.

IL PAPIRO
24R Piazza del Duomo
Tel: 055-215262
Marbled paper in all its splendor and varieties for a range of uses. The boutique, ideally situated, is a goldmine of coordinated gifts that will never fail to please (see pages 178, 179).

PINEIDER
13R Piazza della Signoria
Tel: 055-284655

Everything you need for correspondence on luxury paper.

Scents and perfumes

BIZZARRI
32R Via Condotta
Tel: 055-211580
In this tiny boutique situated near the Piazza della Signoria, you will find, in addition to a warm welcome, all sorts of products necessary for a lady's toilette (see page 172).

OFFICINA PROFUMO-FARMACEUTICA DI SANTA MARIA NOVELLA
16 Via della Scala
Tel: 055-216276
People from all over the world come to admire this venerable convent pharmacy that has preserved its old decor and secular formulas: scented soaps, eaux de toilette, Armenian paper and such astonishing curiosities as snail oil cream (to combat dry skin). The fame of these products has spread throughout Europe since the sixteenth century.

LORENZO VILLORESI
14 Via dei Bardi
Tel: 055-2341187
Lorenzo Villoresi has transformed his old apartment overlooking the Ponte Vecchio into a laboratory. This scent enthusiast, initiated into the trade by the perfumers of Cairo, can create personalized scents to order. He also sells potpourris and products for the home. Everything is presented with extraordinary taste and refinement (crystal bottles, leather cases, etc.). The store is as exceptional as its founder, who started out studying ancient philosophy (see page 173).

Mosaics and scagliola

BIANCO BIANCHI E FIGLI
117 Viale Europa
Tel: 055-686118

SHOPPING IN FLORENCE

Florence undoubtedly has some of the most mouthwatering store windows in all of Europe. The Via Tornabuoni in particular is one of those mythical streets, like the Via Condotti in Rome, which is lined with the great names in fashion. **Gucci**, the only one originally from Florence, has two addresses: 57-59R and 73R; **Salvatore Ferragamo** (see pages 174, 175), an adoptive Florentine, is at 16R; **Armani** can be found at 35-37R, **Fendi** at 27R, **Trussardi** at 34-36R and **Versace** at 13-15R. **Ugolini**, the best glove-maker is at 20-22R.

The jeweler **Settepassi-Faraone**, who left the Ponte Vecchio, the traditional area for jewelers which is now overrun with tourists, has moved to 25R. This old Florentine company is best known for its pearl collection. **Buccellati** exhibits its incredible jewels at 71R. If the price tags of these two make your hair stand on end, you could try Cascio, specialists in handmade copies, which are often very successful. They have two addresses: one at 32R and the other, ironically, on the corner of the Ponte Vecchio, at 1R Via di Por Santa Maria. And don't forget to try a truffle sandwich at **Procacci** (no. 64) to keep you going.

The area around the Via Tornabuoni is equally well endowed. **Valentino** is at 47R Via della Vigna Nuova. **Emilio Pucci** on the other hand has only one address, that of the large, rather austere edifice at 6 Via dei Pucci, on the north side of the cathedral. **Luisa Via Roma**, at 19-21R Via Roma, sells international fashions and promotes young designers. In the same street, at 25-29R, **Raspini** sells, in addition to shoes and other leather goods which are among the most famous in the city, a range of brand-name clothes. A good place to buy leather goods is **Il Bisonte** (35A/R Via del Parione), as is **Bojola** (25R Via Rondinelli), founded in 1861 and well known for its sportier items and umbrellas, which established the company's reputation long before it settled in Florence.

Close by is **Richard-Ginori**, at 17R Via Rondinelli, a good address for china. The name is the result of a merger in the nineteenth century between the Milanese company Richard and the famous manufacturer Ginori, founded in the eighteenth century by the renowned Florentine family of the same name.

Ideas for presents abound, such as a deliciously perfumed silk sachet of potpourri at **Antico Setificio Fiorentino** (also sold at **Officina di Santa Maria Novella**, 16 Via della Scala), or little leather boxes at Taddei, 6R Piazza Pitti.

For marbled-paper lovers, there is **Il Papiro**, Piazza del Duomo (see pages 178, 179). The **Edizioni** house at 82R Via della Vigna Nuova has acquired a reputation for hand-made paper objects. Finally, everything you might need for correspondence can be found at **Pineider**, 13 Piazza della Signoria.

An original idea for a present is a photograph from the historical archives of **Alinari**. The museum and boutique are both at the Palazzo Rucellai, 46-48R Via della Vigna Nuova.

The house restores objets d'art using scagliola, a technique introduced to Florence in the eighteenth century to imitate mosaics incrusted with marble and gems. The workshop also reproduces patterns and creates new designs to order (see pages 164, 176).

FIORENZO PACI
13 Via S. Monaca
Tel: 055-290742
Artisan specializing in stone and semiprecious stone mosaics, a Florentine specialty since the sixteenth century.

UGOLINI
66-70R Lungarno Acciaioli
Tel: 055-290742
This is one of the oldest stores specializing in stone mosaic. The workshop is at the back of the store, whose location on the banks of the Arno very near the much-visited Ponte Vecchio has doubtless helped make it one of Florence's most high-profile stops.

Fabrics

ANTICO SETIFICIO
FIORENTINO
4 Via Bartolini
Tel: 055-213861
Located next door to the manufacturer, unique in Europe, whose weaving techniques date back to the eighteenth century, this exhibition and sale room offers the opportunity to admire Florentine silks and their historic patterns. This establishment, which was saved from financial ruin by Emilio Pucci, was founded several centuries before by the grand families of Florence, some of whom are his own ancestors. This is a sublime place, where the scent of the textiles blends with that of the silk potpourri sachets (see pages 170, 171).

AROUND FLORENCE

Further out from Florence, some thirty to forty kilometers from the city center, one finds both industrial landscapes and well-preserved countryside. Towns like Prato or Pistoia, even if they have lost much of their old charm, still proudly show off their fine monuments. Prato Cathedral, with its frescoes by Fra Lippo Lippi, merits a lengthy visit. These two towns also have a number of good restaurants. These parts of Tuscany are unjustly ignored by tourists. The landscapes of Mugello or Impruneta are superb, as is the road from the Colli Alti that leads to Sesto Fiorentino.

Historical villas dot the countryside, especially those of the Medicis; most are open to the public, notably the park of the Villa La Ferdinanda in Artimino, that of the Villa Demidoff in Pratolino that contains an astonishing sculpture by Giambologna, and the Castello di Trebbio (open for group tours) in San Piero a Sieve in the Mugello. The abbey at Vallombrosa, further to the east, is also worth visiting, if only for the wild beauty of the site.

HOTELS

Artimino

HOTEL PAGGERIA MEDICEA
3 Viale Papa Giovanni XXIII
Tel: 055-8718081, fax: 055-8718080
This hotel was opened in one of the annexes of the Villa La Ferdinanda, built by the Grand Duke Ferdinand I to plans by Buontalenti. It's considered one of the most beautiful Medici villas.

Prato

VILLA RUCELLAI
16 Via di Canneto
Tel: 0574-460392, fax: 0574-460392

This beautiful villa has belonged to one of Florence's oldest families for two centuries. The terrace garden is superb.

Sesto Fiorentino

VILLA VILLORESI
2 Via Ciampi
Tel: 055-443212, fax: 055-442063
Originally a medieval chateau, the Villa Villoresi is ideal for those who want to sample the atmosphere and beauty of the Renaissance. Several rooms have remarkable frescoes. The villa is also unique in that it has the longest loggia in Tuscany. It is managed by the sister of Lorenzo Villoresi, the great Florentine perfumer. This hotel, which also has a reputable restaurant, has an agreeable, family-run feel. All in all, it's an exceptional place (see page 197).

Vicchio di Mugello

VILLA CAMPESTRI
19/22 Via de Campestri
Tel: 055-8490107, fax: 055-849010
This historic villa, which has been in the same family since the Middle Ages, is situated in the heart of a vast natural estate. Visitors will be able to explore the region of Mugello, which remains quite wild in places. Many tourists pass through it on the Florence-Bologna *autostrada* oblivious to the beauty of the chestnut forests.

BED AND BREAKFASTS

The countryside begins just a few kilometers outside of Florence, offering some interesting possibilities.

Montefiridolfi

LA FATTORIA LA LOGGIA
Tel: 055-8244288, fax: 055-8244283
This estate belongs to a Milanese

who loves horse riding and contemporary art.

Pontassieve

LA TENUTA BOSSI
Tel: 055-8317830, fax: 055-8364008
The Gondis have converted several farms on one of their properties, the Tenuta Bossi.

RESTAURANTS

Empoli

CUCINA SANT'ANDREA
47 Via Salvagnoli
Tel: 0571-73657
Although the old village has lost most of its charm, despite the remarkable façade of the Church of Sant'Andrea, this recently opened restaurant is well worth a visit. The reception is warm and friendly, and the regional cuisine excellent.

Montespertoli

IL FOCOLARE
147 Via Volterrana Nord
Localita Montagnana
Val di Pesa
Tel: 0571-671132
The road from Florence to Castelfiorentino, the Via Montespertoli, dates back to the Etruscans. It is one of the most charming and best-preserved areas around Florence, and provides a good pretext for trying this simple, family restaurant, where the quality of the *bistecca* has been recognized as exceptional by the Italian Academy of Cooking. The same can be said of the delicious house pastries.

Pistoia

LA CUGNA
288 Via Bolognese
Tel: 055-475000
This restaurant, which dates back to the nineteenth century, is a

perfect example of a traditional family restaurant, offering simple cuisine that is remarkably tasty. Try the mushroom soup (*zuppa ai funghi porcini*) when it's in season.

SAN JACOPO
15 Via C. Crispi
Tel: 0573-27786
Excellent regional cuisine is served in this restaurant located in an old palace.

LA BUSSOLA DI GINO
Località La Catena
35 Via Vecchia Fiorentina
Tel: 0573-743128
A welcoming restaurant that in season serves excellent game, especially rack of venison in Carmignano red wine.

Piteccio

IL CASTAGNO DI PIER ANGELO
Località Castagno
Tel: 0573-42214
This excellent restaurant lies west of the village of Piteccio, which is ten kilometers north of Pistoia. Try the pigeon with herbs.

Prato

VILLA SANTA CRISTINA
58 Via Poggio Secco
Tel: 0574-595951
This restaurant, where one can have lunch outdoors during the summer, is located in an eighteenth-century villa which is also a hotel.

IL PIRANA
110 Via Valentina
Tel: 0574-25746
This elegant restaurant specializes in seafood, which is cooked with imagination.

TRATTORIA LA FONTANA
1 Via di Canneto
Tel: 0574-27282

Simpler than the preceding restaurant, this place combines tradition and creativity. The prices are very reasonable considering the quality.

San Casciano in Val d'Elsa

LA TENDA ROSSA
Località Cerbaia
Tel: 055-826132
Over the years, this restaurant has acquired the reputation of being one of Tuscany's most inventive. New ideas abound, such as puréed fava beans with olive oil and thin slices of *foie gras*. The menu varies from season to season. Unforgettable.

Scandicci

BELLA CIAO
Via Volterrana Frazione Giogoli
Tel: 055-741502
Scandicci is not one of the most charming parts of Tuscany, but this friendly and lively restaurant is well worth visiting. The Bella Ciao specializes in tripe in all its forms, a Florentine specialty that tourists are either unaware of or unwilling to try.

MUSEUMS

In Sesto Fiorentino, it is well worth visiting the very interesting **Museo delle Porcellane di Doccia**, 31 Via Pratese. This is the museum of the Ginori factory, founded by the family in 1737 in Doccia and then transferred to Sesto in the 1950s. The museum collection retraces two centuries of fine tableware. There is also a porcelain fireplace and copies of artworks.

ARTS AND CRAFTS

In Impruneta, a town fifteen kilometers to the south of Florence,

there are several manufacturers of terra-cotta artefacts.

UGO POGGI
16 Via Imprunetana
Tel: 055-2011077
This company has one of the town's oldest kilns, dating back to the sixteenth century. The potters use it to make vases, jars and pots made from a local clay that gives the objects exceptional longevity.

The tradition of Florentine ceramics is perpetuated at Montelupo Fiorentino, on the road to Pisa, where it first came to prominence during the Renaissance. See, for example, the **Consorzio della Ceramica**, at the town hall, or Tuscia, 264 Via Chiantigiana. At the end of June, the Festa Internazionale della Ceramica meets there. The **Museo Archeologico e della Ceramica** (tel: 0571-51352) displays a wood kiln that remained in use until 1998.

SIENA

Siena, Florence's ancient rival, is a city full of fascinating secrets, home to saints, artists . . . and bankers. Even though the Renaissance flourished here, Siena has retained more of a medieval atmosphere, helped by the popularity of the Gothic style in the nineteenth century.

The site, consisting of numerous changes of level on either side of a winding backbone, mirrors the social make-up of the town, which is both unified and compartmentalized. The division of the city into districts that compete with each other during the Palio is an essential characteristic of the city: it is also a symbol of Tuscany as a whole.

The city's narrow streets and sun-filled squares are bursting with artistic treasures in the form of paintings and sculptures. We know

that Duccio's famous Maestà was transported in a procession by enthusiastic citizens from the artist's studio to the cathedral. There is not a church or palace that is not worth visiting, especially the cathedral museum and the Pinacoteca, which are considered Italy's finest art museums. A walk through the less frequented streets will present you with constant surprises and discoveries. The city, which is shrouded in a mist of melancholy, as depicted in the paintings of Beccafumi (one of the last great Sienese painters), is buoyed by an extraordinary surge of energy during the Palio. Siena doesn't want to be a museum-city, fixed in the past. It resembles Florence in many respects, but the overall mood is less cerebral.

HOTELS

Such is Siena's fame that there are a number of charming hotels in the medieval city and its environs, although they tend to be expensive. The following are of particular note:

CERTOSA DI MAGGIANO
82 Strada di Certosa
Tel: 0577-288180, fax: 0577-288189
This hotel, which only has a small number of rooms and suites, is located in a fourteenth-century Carthusian convent.

HOTEL VILLA SCACCIAPENSIERI
10 Via di Scacciapensieri
Tel: 0577-41441, fax: 0577-270854
Enclosed by a large, delightful garden, this hotel situated out of town has a distant view of the city. The warmth of the welcome, which doesn't seem to have changed in twenty years, makes for a wonderful stay. The restaurant is another plus: it is one the best in Siena, although sadly it is closed in the winter. Try, for example, the *stuzzichini* of fried sage (see page 196).

In town

HOTEL SANTA CATERINA
7 Via Enea Silvio Piccolomini
Tel: 0577-221105, fax: 0577-271087
Located just beyond the medieval wall, on the ancient Via Cassia, this hotel has a superb garden with a spectacular view of the surrounding countryside. Remember to ask for a room overlooking this haven of peace rather than the street. The old engravings and paintings give the atmosphere a homey touch, as do the friendly owners.

HOTEL ANTICA TORRE
7 Via di Fieravecchia
Tel/fax: 0577-222255
This establishment occupying a sixteenth-century tower is always in great demand because it has just eight rooms, two on each of its four floors. Situated in the Porta Romana neighborhood, but inside the ramparts, this address should be booked long in advance.

RESTAURANTS

OSTERIA LE LOGGE
33 Via del Porrione
This restaurant, which won an award from the Italian Academy of Cooking, is situated in what used to be a grocery store. The menu offers a range of typical Sienese dishes.

DA MUGOLONE
8 Via dei Pellegrini
Tel: 0577-283235
One of Siena's best traditional restaurants. Very reasonable prices.

LA VECCHIA TAVERNA DI BACCO
9-11 Via Beccheria
This restaurant is situated not far from Saint Catherine's birthplace and, unlike the previous ones, is less frequented by tourists. The homey cuisine is pleasant, the

setting totally unpretentious, and the staff young and attentive.

ANTICA OSTERIA "DA DIVO"
29 Via Franciosa
Tel: 0577-284381
Situated in a street that is very evocative of old Siena, near the Duomo but away from the tourists, this restaurant has just been restored. The cooking is as tasty as ever and the exceptional setting has retained its charm. The restaurant is located in a series of subterranean rooms, the oldest of which were cut out of the tuff by the Etruscans.

TRATTORIA TULLIO AI TRE CRISTI
(Antica Trattoria della Giraffa)
1 Vicolo di Provenzano
Tel: 0577-280608
On the corner of a small street in the heart of a working-class neighborhood that has remained unchanged, behind the Church of Santa Maria di Provenzano, this restaurant well known to the Sienese has remained faithful to a tradition which dates back to 1830.

Near Siena

In addition to the excellent restaurant of the Villa Scacciapensieri, the following restaurants are of note:

ANTICA TRATTORIA BOTTEGANOVA
29 Strada Chiantigiana di Montevarchi
Tel: 0577-284230
The menu varies according to season and from day to day, but always features traditional local dishes.

TRATTORIA FÒRI PORTA
1 Via C. Tolomei
Località Valli
Tel: 0577-222100
Situated beyond the Porta Romana,

but still fairly close to the historic center, this restaurant allows you to discover the tastiest Sienese specialties, like *pici al dragoncello*, fresh pasta filled with cheese and tossed in a tarragon sauce. This place is not well known to visitors to the town, but is well situated for those staying near the Porta Romana.

FOOD AND WINE

NANNINI
95 Via Banchi di Sopra
This address right by the Piazza Salimbeni is one to remember for those searching for Siena *panforte*, that delicious mixture of flour, candied fruits, almonds and spices which can be more or less light and sweet. The traditional recipe for *panforte nero*, made with cinnamon, is called *panpepato* and is sold in paper sealed with wax. There is another branch of the store in Siena, but this one still has an old decor adding greatly to its charm.

NUOVA PASTICCERIA
37 Via Duprè
This pastry shop is not as famous as the preceding one, but it is perhaps more authentic. Try the *ricciarelli*, a kind of soft macaroon made with almonds.

PIZZICHERIA DE MICCOLI
95 Via di Città
This small, old-fashioned grocery store in one of Siena's most beautiful streets is more than just a feast for the eyes. Wild boar meat is a specialty.

VINAIO IL GRATTACIELO
8 Via dei Pontani
This wine bar situated at the end of a small dark alley carries an ironic name. Here you can taste the traditional *mescita* (a glass of wine accompanied by toast flavored in different ways).

AROUND SIENA

Siena is an ideal base for exploring a diversity of landscapes. Toward Florence and Arezzo lies the Chianti region, with its hills and vineyards. To the south, the Crete Senesi extend to Pienza, the Val d'Orcia and the Monte Amiata. To the east lie the hills of the Montagnola and the high valley of the Elsa. In this part of Tuscany untouched by the autostrada, you can undertake a real voyage along tortuous back roads and, if need be, the unpaved strade bianche.

Seeking out monuments is often less important than experiencing the atmosphere of the small towns and villages, where vines, olive trees and tourism have managed to sustain real life, despite a massive rural exodus. Prosperous Chianti is one the most coveted regions of Europe and its old farm estates go for high sums.

English and German are sometimes heard more than Italian in this area. The Val d'Orcia, poorer and more Mediterranean, doesn't receive as many visitors, but that will change in time. There are little-known marvels, such as the minuscule village of Mensano, south of Casole d'Elsa, with its millennial church and its unforgettable landscape. There are many towns to discover: places such as Colle Val d'Elsa are almost always neglected in favor of San Gimignano, which is crammed during the summer and on weekends with dozens of cars.

No season lacks charm in this region, but the "fauvist" autumn colors, whether in the vineyards or the forests, are surely the most beautiful, providing visitors with a multitude of choices for their stops. The benefits of agriturismo are especially evident here: I particularly cherish the memory of spring nights in the Chianti, when thousands of fireflies light up the countryside.

HOTELS

Castellina in Chianti

PALAZZO SQUARCIALUPI
26 Via Ferruccio
Tel: 0577-741186, fax: 0577-740386
This hotel occupies a fifteenth-century palace in the middle of a medieval village, a few steps from the highly evocative Via delle Volte. The ground and basement floors have retained their original function as a place where the Chianti Classico "La Castellina" is left to age.

Colle di Val d'Elsa

RELAIS DELLA ROVERE
Località Badia, Colle di Val d'Elsa
Tel: 0577-924696
This prestigious hotel is fortunate to occupy the sumptuous villa of Cardinal Della Rovere, who went on to become Pope Jules II. Situated in a hamlet on a hill, this beautiful building has been magnificently restored.

ALBERGO LA VECCHIA CARTIERA
5-7-9 Via Oberdan
Tel: 0577-53035
This hotel has made the most of the architecture of an eighteenth-century paper mill. The restaurant has an excellent reputation.

Monteriggioni

HOTEL MONTERIGGIONI
53035 – Monteriggioni (Siena)
Tel: 0577-305009, fax: 0577-305011
This new hotel has been created in a former factory in the heart of this charming little medieval fortified town. Tastefully furnished, it has a beautiful garden bordered by the ramparts and the welcome is very cordial.

CASTEL PIETRAIO
33 Strada di Strove
Località Castel Pietraio

Tel: 0577-301038, fax: 0577-1221376
This castle, surrounded by a group of buildings the oldest of which date back to the Middle Ages, belonged during the thirteenth century to the husband of Sapia Salvani, who featured in Dante's *Purgatory*. Transformed into a charming dwelling in the eighteenth century, it has recently been restored by its owners. Some of the old outbuildings have been turned into apartments that can be rented weekly. Castel Pietraia is less than four kilometers from Monteriggioni, past the pretty medieval abbey of Badia Isola that was the last stop before Siena for pilgrims on the Via Francigena.

Pienza

HOTEL RELAIS IL
CHIOSTRO DI PIENZA
26 Corso Rossellino
Tel: 0577-748400, fax: 0577-748440
This new hotel, situated in a former fifteenth-century Franciscan convent, is an ideal place for those who want to explore southern Tuscany. The rooms have a monastic simplicity and look out either onto a peaceful cloister or the superb landscape of the Val d'Orcia. In the summer, there is also a swimming pool and an outdoor restaurant in the terraced garden.

L'OLMO
53020 – Monticchiello
Tel: 0578-755133, fax: 0578-755124
Situated close to the tiny medieval village of Monticchiello, which is part of Pienza, this place could serve as a model for how an old farm should be transformed into a country inn. The well-restored seventeenth-century buildings have been tastefully adapted to accommodate a small number of apartments and rooms. This is an ideal place for those seeking

THE PALIO OF SIENA

No other Italian festival is as well known as the Palio of Siena. Its origins date back to the Middle Ages, when the city was structured into parishes corresponding to specific geographical areas. Each of these *contrade* has its own emblem and hierarchy. There are now only seventeen of the original fifty-nine *contrade* left, each of which elects a captain, *capitano*, who retains certain powers. Each *contrada* symbol, usually a real or mythological animal, is linked to a certain virtue, such as courage for the panther. Each one has a house, a chapel and a fountain. Those with sharp eyes will notice, especially in the less touristy parts of town, reminders of these distinctive symbols: utility-company meters on the sides of houses often bear the symbolic emblems and colors of the banners that can be seen everywhere, from windows to Vespas.

This social organization remains very much alive and continues to pervade people's attitudes. A Sienese may hold a degree from an American university, but his primary allegiance will always be to the *contrada* to which his family belongs—even if he lives in a different part of the city or somewhere else altogether.

The relationships between the different *contrade* are complex, ranging from unity to overt hostility. To illustrate this combination of solidarity and conflict, an anecdote is often recounted in which young men from opposing *contrade* interrupt a fist-fight long enough for one of them to find his wedding ring. Twice a year, these contradictory emotions culminate in the Palio, held on July 2nd and August 16th.

The competition itself—a horse race around the Piazza del Campo—lasts no more than a few minutes, but the preparations keep the city in a state of excited anticipation for several days in advance. On the eve of the race, a draw assigns a horse to each of the ten *contrade* taking part (the seven who did not take part the previous year plus three others drawn by lot). Each *contrada* selects a jockey (*fantino*), usually from outside the city. These are prudently kept apart, to be sure they do not fall victim to any treachery from the other competitors. On the morning of the race, horse and rider are blessed in the chapel of the *contrada*. Then a costumed procession takes place around the Piazza del Campo: each *contrada* marches with its drummers behind the standard-bearer (*alfiero*), who has practiced handling the banner for a long time. To represent the now defunct *contrade*, riders in mourning on black horses also take part in the procession. The race itself consists of three circuits of the square: a difficult task despite the sand strewn on the ground, because of the sloping ground and the difficulty of the turns, not to mention the blows the *fantini* give each other in their effort to win. A riderless horse that reaches the finish line first can also win. The winning *contrada* carries the *palio*—the banner with the effigy of the Virgin on it—created specially for the occasion, and keeps the trophy in a museum attached to its chapel (see page 162). Street banquets continue late into the night, overflowing with joy (for the winners) or tinged with sadness (for the losers).

refinement in the middle of the Tuscan countryside.

Pievescola di Casole d'Elsa

RELAIS LA SUVERA
Tel: 0577-960300, fax: 0577-960220
Luchino Visconti admired this historic sixteenth-century structure, with its beautiful loggias. The magnificent outbuildings were turned into hotel rooms, while sumptuous suites were created in the villa itself.

Poggibonsi

VILLA SAN LUCCHESE
5 Via San Lucchese
Tel: 0577-934231, fax: 0577-934729
Situated between Siena and Florence, near the town of San Gimignano, this hotel occupies a Renaissance villa overlooking the Val d'Elsa.

San Casciano dei Bagni

SETTE QUERCE
Tel: 0578-58174, fax: 0578-58041
This hotel was opened recently in an old house. This southern Tuscan village, known since antiquity for its thermal baths, has retained its authenticity while attracting many artists. The rooms, or rather suites, are painted in fresh, lively colors and the staff are attentive and friendly.

San Gimignano

LA CISTERNA
24 Piazza della Cisterna
Tel: 0577-940328, fax: 0577-942080
This establishment is located on the Piazza Cisterna which, together with the adjoining Piazza del Duomo, forms the heart of the city. Needless to say, it is best to avoid staying here during the high tourist season or at weekends. The La Terrazza restaurant has a magnificent view of the town.

L'ANTICO POZZO
87 Via San Matteo
Tel: 0577-942014, fax: 0577-942117
A fifteenth-century palace that has

been tastefully converted into a hotel.

HOTEL PESCILLE
Località Pescille
Tel: 0577-940186, fax: 0577-943165
This country hotel on the outskirts of San Gimignano is renowned for its spectacular view of the medieval town's towers.

VILLA SAN PAOLO
Tel: 0577–955100,
fax: 0577–955113
This old villa between San Gimignano and Certaldo has been converted into a hotel. Its park is enchanting and has a beautiful view of the countryside and the town.

San Giovanni d'Asso

LUCIGNANELLO BANDINI
Localita Lucignano d'Asso
Tel: 0577-803068, fax: 0577-803082
Lucignano d'Asso is a medieval jewel in the heart of the Crete Senesi, not far from the famous Monte Oliveto Maggiore abbey. It consists of a group of small detached houses in a village which, despite growing tourism and the rural exodus, remains essentially agricultural.

San Quirico d'Orcia

CASTELLO DI RIPA D'ORCIA
53023 – San Quirico d'Orcia
Tel: 0577-897376, fax: 0577-898038
Accessible from San Quirico d'Orcia via an unpaved road, the hamlet of Ripa d'Orcia, dominated by an imposing quandrangular keep, has been restored to provide rooms and apartments for visitors. This wonderfully preserved spot is ideal for exploring southern Tuscany.

Sinalunga

LOCANDA DELL'AMOROSA
Località L'Amorosa

Tel: 0577-679497, fax: 0577-632001
This is one of the best-known addresses near Siena, in the Chianti region. The buildings, some of which date back to the fourteenth century, were restored about thirty years ago. The manor has been transformed into guest accommodation, while the restaurant is in the former stables. The wine cellar is famous both for its beauty and its contents.

BED AND BREAKFASTS

Tuscany is the region of agriturismo, or "green tourism." The choice is infinite and covers a multitude of options, from an apartment to an entire old farm, with or without swimming pool. The tourist office in the Piazza del Duomo in Siena (tel: 0577-241268, fax: 0577-241251) can provide a list, as can the local tourist offices in villages and small towns. Here are some good addresses:

LILLIANO (see page 198)
Near Castellina in Chianti
Tel: 0577-743070, fax: 0577-743036
Giulio Ruspoli has converted several farms on this large wine estate. The houses have been immaculately restored and the setting is very peaceful.

CASTELLO DI VOLPAIA
Radda in Chianti
Tel: 0577-738066, fax: 0577-738619
The Stianti Mascheroni family has restored several houses in the old village. Very convivial atmosphere (see pages 122, 125).

PODERE COLLELUNGO
A few minutes from Castellina in Chianti
Tel/fax: 0577-740489
Restored with great taste by an Anglo-Italian couple.

VIGNAMAGGIO
Near Greve in Chianti

Tel: 055-854661, fax: 055-8544468
A beautiful Renaissance villa.

CASTELLO DI MONTALTO
Near the Castelnuovo Berardenga
Tel: 0577-355675, fax: 0577-355682
The owners of this castle offer part of it and a few of the carefully restored houses in its little hamlet for rent. A swimming pool and tennis court are available.

COSONA
The castle and hamlet of Cosona are located in the Val d'Orcia south of Siena. The castle offers accommodation with sublime views of the Crete Senesi and Montalcino.

In the same region, there is the **Azienda Piccolomini Bandini** in Lucignanello Bandini, near San Giovanni d'Asso (tel: 0577-823068, fax: 0577-823082). Five houses in this small village have been nicely restored. This is reputed to be one of the best areas for truffles in the autumn (see page 198).

RESTAURANTS

Casole d'Elsa

OSTERIA DEL CAFFÈ CASOLANI
39/41 Via Casolani
Tel: 0577-948733
This pleasant place is situated in the heart of the hill village of Casole d'Elsa, to the south of the Colle di Val d'Elsa. It is well worth visiting for one of the best panoramic views of Tuscany, extending all the way to the hills which descend to the Maremma.

Castellina in Chianti

ANTICA TRATTORIA LA TORRE
Piazza del Comune
Tel: 0577-740236

Situated on the main square of the village, in the heart of Chianti, this award-winning restaurant offers local versions of Tuscan cuisine. It is very popular with the Sienese, as well as with the numerous visitors to the region.

Castiglione d'Orcia

CANTINA IL BORGO
Rocca d'Orcia
53023 – Castiglione d'Orcia
Tel: 0577-887280,
fax: 0577-887280
Situated in the heart of this medieval village, which is dominated by a very old fortress, this restaurant looks out onto a small square that would be austere if it were not for a charming twelfth-century well. Here you can sample regional cuisine and the delicious wines made locally. The establishment also has three reasonably priced rooms decorated in tasteful simplicity.

Cetona

LA FRATERIA
Convento San Francesco
Tel: 0578-238015, fax: 0578-239220
This unique place was formerly a convent, founded by a Franciscan monk, Father Eligio, who restored it to serve as a communal center for juvenile delinquents. The garden is a marvel, as is the restaurant, which serves dishes mostly made with products grown on the estate. Some rooms have been decorated with great refinement.

Chiusdino-Frosini

CASTEL DEI FROSINI
Tel: 0577-751047
Excellent cuisine served in beautiful old rooms. Try the delicious Ghibelline salad (*insalata alla ghibellina*) flavored with truffles.

Colle di Val d'Elsa

ANTICA TRATTORIA
23 Piazza Arnolfo
Tel: 0577-923747
This restaurant located in a historic residence mixes tradition and innovation for its rich, tasty recipes, such as the pheasant (*faraona*) stuffed with cèpes and truffles.

ARNOLFO
8 Via Francesco Campana
Tel: 0577-922020
Considered by some to be the best restaurant in the Siena region, the Arnolfo is distinguished by its elegance and refined cuisine. Here, a respect for tradition doesn't get in the way of innovation. If it's on the menu, try the rabbit with figs on a bed of potatoes with balsamic vinegar.

LA VECCHIA CARTIERA
5-7-9 Via Oberdan
Tel: 0577-924116
This hotel-restaurant in a converted paper mill is not as expensive as the Antica Trattoria and attempts to stay absolutely faithful to tradition.

SAPIA TEA ROOM
14A Via Castello
This small, friendly establishment is situated on the most beautiful road in Colle Alto (those listed above are in the lower part of town). The menu is not extensive, but consists of good Tuscan specialties.

Montalcino

POGGIO ANTICO
Località Poggio Antico
Tel: 0577-849200
A few kilometers from the hilltop village of Montalcino, this well-known restaurant allows you to enjoy the region's rich cuisine, magnificently complemented by the famous Brunello di Montalcino.

Montepulciano

CAFFÈ POLIZIANO
27-29 Via del Voltaia nel Corso
Tel: 05780-758615
This establishment dates back to 1868 and has an interesting Art Nouveau decor, which was restored in 1992. It prides itself on having had such illustrious customers as Pirandello, Malaparte, and Fellini. Situated in a street lined with the Renaissance palaces of Montepulciano, it has a magnificent view of the Chiana valley. There is a light but tasty fixed-price menu at lunchtime; a tea room with all sorts of chocolate in the afternoon; and a restaurant in the evening.

LA GROTTA
Località San Biagio
Tel: 0578-757479
This restaurant facing the San Biagio Church is located in one of my favorite places in Tuscany. Beautiful sixteenth-century rooms and an interior garden provide a great setting in which to enjoy the traditional Tuscan cuisine and well-stocked wine cellar.

Monteriggioni

IL POZZO
2 Piazza Roma
Tel: 0577-304127
Located on the main, and only, square in Monteriggioni, that forms a charming backdrop with its traditional central fountain, this restaurant offers excellent Tuscan cuisine at reasonable prices, featuring such dishes as *zuppa ai fagioli* (bean soup). The welcome is warm, as you would expect in a village. The ideal complement to the pleasant Monteriggioni hotel, which does not have a restaurant.

Pienza

IL PRATO
1/3 Viale Santa Caterina

TOURING THE VILLAS

Tuscany's beautiful historic villas embody everything that is refined about the region. Most are at least partially open to the public. Although they can be difficult to find for people unfamiliar with the back roads, they are well worth seeking out.

For both public and private villas, it is advisable to telephone for opening hours, which vary according to season and ownership status. The great Medici villas closest to Florence are **La Petraia** (see pages 92, 122–125) and **Castello** (see pages 122, 125). The interior and gardens of the former, now a national museum, can be visited. In the case of the latter, only the gardens are open to the public. Both are located in the small town of Castello and are open nearly every day of the year (for information on La Petraia, tel: 055-451208).

To the north, the **Medici Villa** in Careggi, a medieval castle transformed into a villa by Cosimo the Elder, can be visited daily, except Sundays (21 Viale Pieraccini, tel: 055-4279755). At the **Villa Demidoff** (tel: 055-2760538, villa closed from November to February), little remains of the complex built for Ferdinand I apart from the superb park, redesigned in a romantic style in the nineteenth century. One of the highlights here is the extraordinary colossal sculpture of *Appennino* by Giambologna.

On the road to Pistoia stands **Poggia a Caiano**, a masterpiece by Giuliano da Sangallo dating from 1497. The interior and gardens are open nearly every day (tel: 055-877012). **La Ferdinanda** in Artimino was built in 1594 by Buontalenti and has now been converted into a conference center, hotel, and restaurant.

In Settignano, where Berenson had his villa **I Tatti**, you should on no account miss the garden of a historic villa which did not belong to the Medicis: La Gameraia (Via del Rossellino, tel: 055-697205).

The villas in the region around Lucca form an extraordinary group. The **Villa Reale di Marlia**, which was the residence of Napoleon's sister, Elisa Baciocchi, perhaps possesses the most beautiful garden of all (guided tours of the park, tel: 0583-30108). The **Villa Mansi** at Segromigno (tel: 0583-90234) and the **Villa Torrigiani** (see pages 62, 80, and 83) at Camigliano (guided tours of the park and the apartments from March to November, tel: 0583-928008) are both marvels of imagination and balance.

To this group of villas can be added the extraordinary park of the **Villa Garzoni** at Collodi, birthplace of the creator of Pinocchio (tel: 0572-429116).

Tel: 0578-749924
Lying just outside the center of Pienza, this establishment is attractively located in a vast, vaulted room with plenty of space between tables. There are good specialties to choose from and a wine cellar stocked with top-quality wines.

LA BUCA DELLE FATE
38-A Corso Rossellino

Tel: 0578-748448
Well situated on the main road fittingly named after the great architect who redesigned Pienza in the sixteenth century, this restaurant offers good regional cuisine.

SPERONE NUDO
3 Via Marconi
Tel: 0578-748641

For those who want a simpler approach than that offered by more traditional establishments, this pleasant restaurant offers a small choice of regional dishes: soup, a plate of pork or wild boar charcuterie with pecorino—a goat's cheese that has become a Pienza specialty—and a slice of nut cake. Warm and friendly family service.

San Casciano dei Bagni

DANIELA
Tel: 0578-58041
Run by the same friendly family that opened the Sette Querce hotel, this restaurant with beautiful vaulted rooms is very pleasant. I thoroughly enjoyed the truffle *gnocchi* in the company of American artist Joseph Kosuth, who has a house nearby.

San Gimignano

BEL SOGGIORNO
Tel: 0577-940375
Situated at the entrance to the town just beyond the Porta San Giovanni, this restaurant is attached to the hotel of the same name. It is without a doubt the best in San Gimignano, a town which cannot really be enjoyed until after the tourist season. In winter, try the *zuppa del Granduca*.

Santangelo in Colle

LA FORTEZZA DEL BRUNELLO
1-3 Costa Castellare
Tel: 0577-844175 or 844012
A small, tastefully decorated restaurant where the chef serves delicious and refined cuisine, particularly delectable during the hunting season. It was then that I ate *lardo di colonnato* for the first time—very high fat content, but delicious all the same. Excellent wine cellar.

THE BEST WINES OF TUSCANY

Let us begin our journey with the Chianti Classico zone and one of the region's most successful names, **Antinori**, who since the 1970s have successfully met the challenge of modernization, notably with their Tignanello (Palazzo Antinori, 3 Piazza degli Antinori, Florence, tel: 055-23595; no tasting on site).

Heading south to Barberino Val d'Elsa, we find two beautiful estates where wine tastings can be booked (as is the case with the estates listed below): **Isole e Olena**, at Isole, near Paolo De Marchi (tel: 055-8072763), where one can try, in addition to the Chianti Classico, an innovative series called Cabernet De Marchi Collezione, and the **Castello di Monsanto**, belonging to the Bianchi family (tel: 055-8059000), with its remarkable Poggio di Monsanto Riserva. Continuing toward Siena, not far from Monteriggioni, there is **Tenuta di Lilliano** (see page 198), owned by Giulio Ruspoli, where the Anagallis is particularly interesting (tel: 0577-743070).

Northeast of Siena, it is well worth stopping at the **Villa di Geggiano** (see pages 129–135), where the interior hasn't changed since Stendhal's time. Here, the Azienda Agraria Bianchi Bandinelli produces, in small quantities, an excellent Chianti Classico. Further on, **Castello di Brolio** (see pages 112–115), fief of the Ricasoli, where in the nineteenth century the "Iron Baron" established what would remain the formula for Chianti Classico for more than a century. Following a period of decline, a remarkable effort at modernization was made and Brolio's wines have returned to pre-eminence, especially the Casalferro, made using only Sangiovese.

Next we come to **Castello di Ama**, part of the commune of Gaiole in Chianti (tel: 0577-756031), with its remarkable Vigna l'Apparita. Our tour of Chianti finishes at the enchanting site of **Badia a Coltibuono** (see pages 116, 117 and 191), home of Roberto Stucchi Prineti and Lorenza de'Medici (tel: 0577-749498), who recently created one of the most modern wine cellars of the region.

For **Brunello di Montalcino**, the product of a single grape variety (a variety of Sangiovese) and an exceptional climate, you should travel to Montalcino to visit Tenuta Biondi-Santi, named after the family that created this remarkable wine in the nineteenth century (tel: 0577-848087). A more recent estate producing a good version of this wine is the Azienda Agricola San Filippo-Fanti at Castelnuovo dell'Abate (tel: 0577-835628).

Brunello di Montalcino must be aged several years before being put on the market, and the same applies to the famous **Vino Nobile de Montepulciano**, which, after decades of decline, once again offers some very fine wines. A good example of Vino Nobile is produced by the Azienda Avignonesi de Montepulciano (tel: 0577-757872), which also attaches great importance to the production of **Vin Santo**, a sweet wine for drinking with a dessert of *cantucci*, dry almond cookies.

One of the most remarkable accomplishments of recent decades is Sassicaia, made at Tenuta San Guido in Bolgheri. This outstanding wine was developed by Mario Incisa della Rochetta, who was succeeded by his son, Niccolò, in 1985. This vineyard, inspired by those of Bordeaux, is situated in the Maremma, south of Livorno (tel: 0565-762003).

Finally, having started with the Antinori, let us finish with another illustrious name, that of the **Frescobaldi**, whose wineries are situated in the Chianti Rufina area to the east of Florence. Try, for example, the Montesodi, or some remarkable recent innovations, such as the Luce (11 Via Santo Spirito, Florence, tel: 055-27141).

MUSEUMS

In Pienza, don't miss the **Museo Diocesano**, 13 Via Ricasoli (tel: 0577-846014). Located in the palace of a cardinal at the court of Pious II, it houses precious paintings, Sienese sculptures, and also an extraordinary cloak said to have come from the Orient, but actually a thirteenth-century masterpiece by English embroiderers listed in the inventories of the popes of Avignon. Montalcino also has an interesting museum located in an old convent. All the exhibits come from the churches of this tiny town, underlining the close relationship in Tuscany between art and daily life.

ARTS AND CRAFTS

Colle di Val d'Elsa has maintained its long tradition of glassmaking.

CIGNI BORENO
Vicolo delle Fontanelle
Tel: 0577-920326
This is the last craftsman to have a workshop in the old town.

Modern buildings situated below the historic town contain vast glassmaking workshops, which you can arrange to visit:

ARNOLFO DI CAMBIO
Pian dell'Olmino
Tel: 0577-929665
53 Vilca Fratelli Bandiera
Località Gracciano
Tel: 0577-929188

FROM THE TYRRHENIAN SEA TO PISA

The coast of Tuscany presents a wide variety of landscapes. Rocky breakwaters punctuate the long stretches of formerly insalubrious marshes: the Maremma. The rugged back country numbers several towns or hilltop villages, usually of great beauty: Volterra and Massa Maritima are the most important and richest artistic centers.
It is well worth exploring further inland, near Larderello and the metal-rich hills, or from Grosseto toward stunning medieval villages: Roccalbegna and the area around Saturnia, an old thermal spa, and the beautiful villages of Pitigliano, Sorano, and Sovana. There are impressive vestiges of the Etruscans, especially at Populonia-Barati and Vetulonia.

If Grosseto lacks charm, the same is not true of Livorno and Pisa. Both are unjustly neglected, for differing reasons. The fame of the leaning tower—which engineers are attempting to correct through a complex system of cables—is such that the rest of Pisa tends to get overlooked. Livorno is generally only seen by those catching boats to the island of Elba. These are both cities worth exploring at a leisurely pace.

Monte Argentario and Porto Ercole form a small "high society" enclave on the coast. As you might expect, the site is superb, with the massive rock emerging majestically from the predominantly flat coastline. There is something irritating about the facile, picturesque image of the Maremma cowherds, but nobody could fail to be charmed by the poetry of its old marshes, many of which have been converted into nature reserves.

The gastronomy is very rich, with seafood playing a central role. The region of Bolgheri, eloquently praised by the nineteenth-century poet Carducci, produces a wine of exceptional quality: Sassicaia.

HOTELS

Campiglia Marittima

CASTELLO DI MAGONA
27 Via di Venturina
Tel: 0565-851235, fax: 0565-855127
This former residence of Grand Duke Leopold II is one the few historical manors of the Maremma to have been converted into a hotel. The owners have succeeded in maintaining the atmosphere of a large family house. The proximity of the sea is an additional advantage in this part of Tuscany slightly neglected by mass tourism.

Rigoli (San Giuliano Terme)

HOTEL VILLA DI CORLIANO
50 Via Statale
Tel: 0508-18193, fax: 0508-18897
This is a superb sixteenth-century villa, where time has left its patina everywhere. Comfort is not as modern as it could be, but that is part of the charm, as is the sometimes reserved demeanor of the owner. The park is also delightful.

Volterra

VILLA NENCINI
55 Borgo San Stefano
Tel: 0588-86386, fax: 0588-80601
Situated just beyond a gateway in the medieval wall, this hotel is a great place to enjoy the beauty of the site, even if the modern extension has marred slightly the charm of the older part.

RESTAURANTS

Bolgheri

OSTERIA L'ANTICO BORGO
2/3 Piazza C. Ugo
Tel: 0565-762173
The small village of Bolgheri, its castle protecting it from attacks by sea, is typical of the northern Maremma. The poet Carducci spent his childhood here at the beginning of the nineteenth century. As it is one of the region's sites with the most character, there are several restaurants to be found here. This one is notable for the pleasant welcome and the simple authenticity of the cuisine. It was here that I tasted for the first time, in the form of *tagliata*, the delicious beef from the indigenous Chianina cattle. Good local wines, of which a few are highly sought-after bottles from the nearby Antinori vineyards.

Castello di Populonia

IL LUCUMONE
Tel: 0565-29471
In the heart of this small fortified village that brings to mind one of the great Etruscan cities and overlooks the sea in a magnificent setting, this very agreeable restaurant offers nothing but very fresh fish and shellfish dishes.

Cecina

SCACCIAPENSIERI
22 Via Verdi
Tel: 0586-680900
One of the best fish restaurants in the Livorno region. Aldo Buonazia always gives his guests a warm welcome. Well worth trying is the famous *cacciucco*, the region's typical fish soup. However, because it requires several different types of fish, it is not always on the menu.

Grosseto

CANAPONE
3 Piazza Dante
Tel: 0564-24546
Grosseto is not totally lacking in charm, and this establishment sprawls out into the arcade of the town's main square, in the heart of a pedestrian zone within the old walls built by the Medicis. The restaurant is famous for the quality of its fish dishes, and for Maremma specialties such as *acquacotta* (thick soup).

Livorno

ANTICO MORO
The port of Livorno, unknown to tourists except as a departure point for Elba or Corsica, is still a place worth visiting. The Antico Moro, situated on the edge of the pedestrian zone, is one of the most charming restaurants I have visited. The curious decor features a combination of various utensils and paintings (some dating back to the *macchiaioli* period). The cooking is authentic and delicious, especially the seafood. In the evening, you can round off dinner by ordering a café-punch, prepared in a nearby bar, the Civili. It's the best I've ever tasted.

LA BARCAROLA
63 Viale Carducci
Tel: 0586-402367
Excellent traditional restaurant in a Belle Époque villa. Try the cod Livorno-style (*baccalà alla livornese*).

Montopoli in Val d'Arno

QUATTRO GIGLI
1 Piazza San Michele
Tel: 0571-466878

This small restaurant thirty kilometers from Pisa offers, among other things, ancient Etruscan recipes. The cuisine uses savory regional products, including the white San Miniato truffle. Not to be missed.

Pisa

TRATTORIA SANT'OMOBONO
6 Piazza Sant'Omobono
Tel: 050-540847
This small restaurant in a pedestrian zone showcases authentic local cooking, featuring recipes such as the excellent *zuppa alla pisana*.

Volterra

DON BETA
39 Via G. Matteotti
Tel: 0588-86730
This restaurant in an old palace offers good dishes typical of the Volterra region, notably the rabbit *alla Vernaccia* (white wine from San Gimignano).

ETRURIA
6/8 Piazza dei Priori
Tel/fax: 0588-86064
Opening onto the town's most beautiful square, this well-known restaurant serves "Etruscan" dishes based on regional products.

IL VECCHIO MULINO
Località Saline di Volterra
23 Via del Mulino
Tel: 0588-44238
Although located on the plain and not in the old town of Volterra, this restaurant has very high standards and deserves to be better known. If it's available, try the *tagliata di chianina*.

MUSEUMS

The Pisan school, one of the richest of the Middle Ages, is on display at the **Museo San Matteo** in Pisa. In Livorno, one can visit the beautiful

Villa Mimbelli, which contains a remarkable late-nineteenth-century collection created by a family of entrepreneurs with eclectic tastes. The Villa Mimbelli also houses a museum devoted to Giovanni Fattori, native Pisan and head of the Macchiaioli movement, without doubt the most important in Italian painting during the nineteenth century. It includes works by artists such as Telemaco Signorini and Silvestro Lega (tel: 0586-804847). Any trip to Volterra should definitely include a visit to its museums: the Museo Etrusco "Mario Guarnacci," which owns one of the most important collections of Etruscan artefacts in Italy; the Pinacoteca with the amazing *Deposition from the Cross* by Rosso Fiorentino, a masterpiece of Florentine classicism painted in 1521 which alone is worth the trip (tel: 0588-86347); and the Palazzo Viti (tel: 0588-87580), where the unique atmosphere (see page 63) helped Visconti produce one of his masterpieces: *Vaghe Stelle dell'Orsa*.

ARTS AND CRAFTS

Volterra has been the town of alabaster since antiquity. The industrial era spawned an abundance of mediocre products, but by touring the different artisans, especially in the historical center, one can still find items of quality. The Palazzo Viti contains some candelabras carved for Maximilian that were never delivered to the ill-fated emperor of Mexico: these elaborate pieces reflect the quality of traditional craftsmanship.

LUCCA AND ITS ENVIRONS

A little-known town despite its location, Lucca has a charm which is far from old fashioned. It's a lively,

(see page 63)

IN PURSUIT OF THE TRUFFLE

Tuscany is a treasure trove of food and wine. Olive oil and wines such as Chianti are obviously the best-known regional products. The following itinerary will enable visitors to discover another treat that is less famous but just as delectable: the white truffle. The cult of the truffle is practiced primarily on several weekends at the end of October and November, a period of the year when the weather is not always ideal, but which has the advantage of being largely free from tourists.

Around the same time, several truffle fairs and markets are held in four centers that are also historic towns or villages. The most important of these is Volterra, capital of the white truffle from the Val di Cecina. This old Etruscan city, rich in relics and treasures from its long history, is the seat of various truffle-centered festivities lasting for several days and including popular song and poetry contests. The town's restaurants join in the celebrations, using truffles in a variety of delicious dishes. This is definitely a time of year when this slightly austere town is most joyous.

Equidistant from Volterra, Pisa and Florence, the village of San Miniato, dominated by the last

remaining turret of Frederick II's castle, has held a similar event for the past thirty years. The renown of the local truffle reached the United States in 1954, when President Eisenhower was presented with one weighing more than two and a half kilos (five pounds), a record that seems unbeatable. Here, too, in addition to various cultural events, several weekends in November provide local restaurants with a chance to show their creativity.

Heading northeast toward Bologna, you reach Mugello and its capital, Borgo San Lorenzo. This small, old town is unique in having some original Art Nouveau decor from the 1930s. The surrounding woods are superb in the autumn. The fair provides an opportunity to discover regional products, some flavored with truffles. There are also shows with trained dogs who demonstrate their truffle-hunting skills.

Finally, heading due south into the heart of the Crete Senesi, is San Giovanni d'Asso, where the large castle has been the scene of a similar event for over a decade. Here is a golden opportunity to spend some time in this region of unique landscapes, where each village seems to have come straight out of the Middle Ages.

thriving place, a center for various activities, not least gastronomy. Lucca is built to a very human scale and still has the pride of a city that has remained free for centuries. The Piazza dell'Anfiteatro, following the form of the ancient Roman monument, is one of Italy's most astonishing squares.

All the churches and palaces are worth a close inspection, but the admirable Ilaria del Carretto at the cathedral should on no account be missed. Another unique aspect of

Lucca is the number of stores in the Via Fillungo that have retained their original Art Deco interiors.

Lucca is surrounded by patrician villas with gardens that are among Tuscany's finest, all of them open to the public: the Villa Reale in Marlia, the Villa Mansi in Segromigno and the Villa Torrigiani in Camigliano. The coast of Versiglia offers magnificent beaches of fine sand, while Carrara and Pietrasanta remain the kingdom of marble. The back country and notably

Garfagnana, a region that extends far inland to the northwest, is well preserved—but this is not really Tuscany any more.

HOTELS

Lucca

The hotels in the town itself are generally lacking in charm, but the following is an exception:

HOTEL UNIVERSO
1 Piazza del Giglio
Tel: 0583-493678
Well situated very near the cathedral.

The environs of Lucca, especially Massa Pisana, number several remarkable hotels, including:

VILLA LA PRINCIPESSA
Tel: 0583-370037, fax: 0583-379019
This magnificent late-eighteenth-century villa bears witness to Lucca's greatest period under the rule of Napoleon's sister and the Bourbons.

VILLA SAN MICHELE
462 Via della Chiesa
Località San Michele in Escheto
Tel: 0583-370276, fax: 0583-370277
A beautiful villa dating from the seventeenth century, whose origins date back even farther. The communal areas are furnished with antiques. It is located in a beautiful area with woods and olive groves (see pages 192, 193, 195).

HOTEL HAMBROS
197 Via Pesciatina
Lunata
Tel: 0583-935355
This hotel is located in a nineteenth-century villa surrounded by a beautiful park. Its rooms are furnished with tasteful simplicity.

Forte dei Marmi

HOTEL BYRON
46 Viale A. Morin
Tel: 0584-787052, fax: 0584-787152
Created when two aristocratic villas were combined at the beginning of the twentieth century, this hotel has attempted to preserve the original atmosphere and maintain the charm of its Art Nouveau decoration.

Lido di Camaiore

HOTEL VILLA ARISTON
355 Viale Cristoforo Colombo
Tel: 0584-610633, fax: 0584-610631
D'Annunzio, Eleonora Duse, Puccini and Marlene Dietrich all stayed in this typical 1930s villa. The park, close to the ocean, is superb.

Montecatini Terme

GRAND HOTEL E LA PACE
1 Viale della Torretta
Tel: 0572-75801, fax: 0572-78451
Even for those who are not especially attracted to thermal spas, prestigious or otherwise, this recently restored hotel built in 1870 is an exceptional monument. The baths themselves with their incredible decor of marble, frescoes and mosaics, are equally impressive.

Montignoso

IL BOTTACCIO
1 Via Bottaccio
Tel: 0585-340031, fax: 0585-340103
The famed hotel and its equally well-known restaurant are housed in a former oil mill dating from the eighteenth century. A charming place.

Viareggio

HOTEL PLAZA E DE RUSSIE
1 Piazza d'Azeglio
Tel: 0584-44449, fax: 0584-44031

Its name conjures up *fin de siècle* splendors, and yet this hotel, built in 1871 when Viareggio was still in its infancy, is of relatively modest proportions. It is situated on the sea front, and the view from certain rooms and terraces is magnificent. Double glazing helps to minimize nocturnal noise during the summer. The staff are very welcoming.

RESTAURANTS

Lucca

BUCA DI SAN ANTONIO
1-3 Via della Cervia
Tel: 0583-55881, fax: 0583-312199
Housed in an old palace, this high-quality restaurant attaches great importance to local traditions and offers particularly tasty dishes, such as cod with chickpeas and spit-roasted kid. First-rate wine list.

ANTICO CAFFÈ DELLE MURA
2 Piazza V. Emmanuele
Tel: 0583-47962
This establishment's garden offers a view of the town fortifications, which are well preserved and encircled with greenery. The menu offers a large choice of traditional dishes.

GLI ORTI DI VIA ELISA
17 Via Elisa
Tel: 0583-491241
This friendly, family-run establishment remains faithful to local tradition and maintains high standards. It can also be recommended for its reasonable prices.

There are some remarkable restaurants in the vicinity of Lucca, notably:

LA MORA
1748 Via Sesto di Moriano
Località Ponte a Maiano
Tel: 0583-406402

This restaurant is in the countryside, not far from the famous Villa Reale, but it is nonetheless one of Lucca's most famous and sought-after establishments. A friendly welcome is guaranteed.

VIPORE
4469 Via Pieve Santo Stefano
Località Pieve Santo Stefano
Tel: 0583-394065
This restaurant in the wooded hills above Lucca, on the old Camaiore road, can be tricky to find for those unfamiliar with the region. However, it has become my favorite of all Tuscan restaurants since Ivan Theimer introduced it to me. The view of the town by day is superb and the staff are friendly. The traditional cuisine is delicious, thanks in part to fresh herbs from the garden.

Camaiore

EMILIO E BONA
Località Lombrici
Tel: 0584-70350
This establishment is located in the picturesque and unusual setting of an old mill. Very popular, it offers authentic regional cooking.

Pietrasanta

DA COPPO
121 Via Aurelia
Tel: 0584-70350
This unpretentious restaurant offers hearty traditional cuisine, including—for those who like it—baked tripe.

DA SCI
3/7 Vicolo Porto a Lucca
Tel: 0584-790983
In the past, this modest trattoria used to be frequented mostly by marble-cutters. Twenty years ago, you could still sit at a large table for lunch. This practice has disappeared, due to new laws and

a new clientele that includes many foreign artists, but you still go to the kitchen to choose your dishes.

OSTERIA ALLA GIUDEA
Antonio e Barbara
4 Via Barsanti
Tel: 0584-71514
This friendly restaurant near the main square is said to be located on the site of an old synagogue.

Viareggio

DA ROMANO
122 Via Mazzini
Tel: 0584-31382
This restaurant in a well-known seaside resort offers elegance at a rather high price, but the cuisine is superb and combines tradition with invention. The fish is especially good.

GUSMANO
58 Via Regia
Tel: 0584-31233
This is another excellent fish restaurant.

ARTS AND CRAFTS

Among the numerous studios in the Carrara and Pietrasanta region, the following are among the most distinguished:

DITTA FERDINANDO PALLA DI PALLA CLAUDIO
25 Piazza Carducci
55045 Pietrasanta
Tel: 0584-71528, fax: 0584-735891
One of the oldest sculpture studios in Pietrasanta. Today the descendants of Ferdinando Palla share the charming old buildings (see page 167).

FRANCO CERVIETTI
53 Via S. Agostino
55045 Pietrasanta
Tel: 0584-790454, fax: 0584-790925
This studio can produce life-size

copies of Michelangelo's *David*, like the one I saw being made in 2000.

CARLO NICOLI
Piazza 27 Aprile, Carrara
Tel: 0585-85310
This is the oldest surviving studio in town.

AREZZO AND CORTONA

Eastern Tuscany has a varied topography in which richly cultivated plains like those of Arezzo and Valdichiana alternate with wilder regions where the Tiber and the Arno have their rise. These remote areas far from the hordes of tourists contain many delightful places that are well worth discovering, such as the small medieval town of Poppi or the abbey of La Verna.

A pilgrimage in honor of Piero della Francesca will take you from Arezzo to Sansepolcro, his birthplace, and to the tiny village of Monterchi, where the amazing Madonna del Parto has unfortunately been removed from the chapel wall on which it was originally painted to be exhibited— temporarily one hopes—in a school. Cortona, perched on its rocky promontory, is an ancient Etruscan town made fashionable by Frances Mayes's bestseller. Famous or not, however, Cortona is one of the Tuscan towns that has been most successful in preserving its essential character.

HOTELS

Cortona

ALBERGO SAN MICHELE
15 Via Guelfa
Tel: 0575-604348, fax: 0575-630147
A friendly place in the center of Cortona, a town that has preserved its charm and

OLIVE OIL COUNTRY

Olive oil is produced throughout Tuscany. This centuries-old crop returns to life after each frost thanks to the olive trees' extraordinary capacity to revive in response to human labor. The producers in the hills of central Tuscany deserve particular mention. They have formed an association: the **Consorzio del Laudemio**. In the past, the term *laudemio* referred to the part of production that the peasants set aside for the owner, which indicates that oil produced under this appellation obeys the strictest rules. The olive oil obtained in this way has a beautiful green color and slightly spicy taste. The following brands are all highly recommended. You can buy olive oil in Florence of course, even directly through the two great producers: **Frescobaldi** (11 Via San Spirito, tel: 055-218751), whose estates are scattered in several zones in central Tuscany; and **Antinori** in their palace on the Piazza degli Antinori (tel: 055-23595).

If you prefer to tour the different properties, you will find at Pontassieve, just east of Florence,

Fattoria Cerreto Libri, which belongs to Massimiliano Baldini Libri (90 Via Aretina, tel: 055-8368010) and **Tenuta di Bossi**, which belongs to the Gondis (32 Via dello Stracchino, tel: 055-8317850). Even further east, in Reggelo, is **Tenuta I Bonsi**, which belongs to the Budini Gattai (tel: 055-8652118). In Fiesole, the **Fattoria di Maiano** (Via Benedetto di Maiano, tel: 055-597089) belongs to the Miari Fulcis, as does the superb villa which served as a setting for several scenes in the film *Room With a View*. To the south, good oil is produced by Desideria Pasolini dell'Onda in Barberino Val d'Elsa (5 Via Francesco di Barberino, tel: 055-8075019). At Tavernuzze, southwest of Florence, there is the Marchi family's **Fattoria I Collazzi** and its magnificent sixteenth-century villa (101 Via Colleramole, tel: 055-2022528). Finally, to complete the circuit, which of course is not exhaustive, excellent oil is produced by Remo Giannelli's **Azienda Agricola I Mori** in Ginestra Fiorentina (22 Via Maremmana, tel: 055-878276).

character. The hotel is located in a Renaissance residence.

Montebenechi-Terme

CASTELLETO DI MONTEBENICHI
19 Piazza Gorizia
Tel: 055-9910110, fax: 055-9910113
This hotel, housed in a small castle in a medieval village, is halfway between Arezzo and Siena. The owners have filled it with valuable works of art and antique furniture, in the tradition of English collectors like Horne, who wanted to re-

create the spirit of Renaissance manors in Florence. There are only a few rooms, which adds to the feel of a family home.

San Martino a Bocena

RELAIS IL FALCONIERE
Tel: 0575-612679, fax: 0575-612927
A hotel has recently been opened in this seventeenth-century villa set in a beautiful rural landscape near Cortona. The restaurant is also highly regarded. The ten guestrooms and two suites are furnished with beautiful antiques.

BED AND BREAKFASTS

The area around Sansepolcro has a number of possibilities, including: Azienda Agricola La Conca (Località Paradiso, tel: 0575-733301); and, near Arezzo, the Azienda Agricola Magnanini, 47 Via Fontebranda (tel: 03575-27627). On the Chianti border, I recommend Villa La Selva, in Montebenichi (tel: 055-998203, fax: 055-998181), which in summer plays host to several different cultural events.

RESTAURANTS

Arezzo

DA CECCO
215 Corso Italia
Tel: 0575-20986
Situated on the main highway through Arezzo, this hotel and restaurant offers excellent traditional cuisine. The "della Sora Adele" ravioli are especially delicious.

Cortona

DA TONINO
1 Piazza Garibaldi
Tel: 0575-630500
This modern hotel and restaurant is located on the Piazza Garibaldi, which is adjacent to the old walls of the town. The panoramic view is magnificent. Try the truffle and pecorino ravioli.

Sansepolcro

DELL'OROSCOPO
66/68 Via Togliatti
Tel: 0575-734875
This well-known restaurant, situated in Pieve Vecchia just outside Sansepolcro, offers very creative cuisine. It is a good stop for those visiting Piero della Francesca's birthplace. The municipal museum has several works by him, notably the extraordinary *Resurrection*. You can reach Sansepolcro from Arezzo by taking one of Tuscany's most charming roads.

MUSEUMS

The church of **San Francesco** at Arezzo contains Piero della Francesca's most beautiful series of frescoes, depicting *The Legend of the True Cross*, an achievement Bernard Berenson compared to the friezes of the Parthenon. Also worth visiting in Arezzo is Giorgio Vasari's house (**Casa del Vasari**, Via XX Settembre, tel: 0575-300301), which Vasari himself decorated, notably the astonishing room depicting the triumph of the will. The **Museo d'Arte Medievale e Moderna** should also not be overlooked (Via S. Lorenzo, tel: 0575-23868): it houses one of Italy's most important collections of majolica. In Cortona, Fra Angelico's *Annunciation* at the **Museo Diocesano** (Piazza Signorelli, tel: 0575-630415) must be seen, as should the **Museo dell'Accademia Etrusca** (tel: 0578-20177). In addition to Etruscan art, the latter also has a gallery of works by the twentieth-century painter Severini. Finally, the **Museo Archeologico Nazionale** in Chiusi (Piazza del Duomo, tel: 0575-62830) contains some of the most beautiful Etruscan sarcophagi.

ARTS AND CRAFTS

Arezzo is famous for its many goldsmiths. Of particular interest are **La Boite d'Or** (4 Piazza Risorgimento, tel: 0575-22257) and **L'Artigiano** (22 Via XXV Aprile, tel: 0575-351278), one of the last goldsmiths still practicing the technique of Florentine mosaic.

BIBLIOGRAPHY

Ideally, no one should travel to Tuscany without having immersed themselves in the seminal texts of Italian literature. Dante (1265–1321), followed by Petrarch (1304–1374) and Boccaccio (1313–1375), established the language that, for good or ill, became unified Italy's national tongue. There have been various English translations of Dante's *Divine Comedy*, of which one of the best is by John Ciardi (Penguin Books). Another key work is Machiavelli's masterpiece of political thought *The Prince* (translated by W. K. Marriott, Knopf). Written in the sixteenth century and inspired by events of the time, it has lost none of its relevance.

Although more recent centuries have not given birth to comparable geniuses, notwithstanding the "Italian Victor Hugo," Carducci, Tuscan literature has not dried up. Twentieth-century Florence has appeared in the novels of Vasco Pratolini (*Family Chronicle*, translated by Martha King, Italica Press), while melancholy Siena is featured in novels by Federigo Tozzi, which date from a slightly earlier period. Also worth mentioning, if only for its provocative title, is *Maledetti Toscani* ("Those Damned Tuscans") by Curzio Malaparte, a native of Prato. Novelist Antonio Tabucchi's beautiful book *Little Misunderstandings of No Importance* (New Directions, 1987) uses Tuscany as a backdrop.

The history of the region is brought to life through ancient and modern biographies of its inhabitants, the most famous being *The Autobiography of Benvenuto Cellini*, translated by George Bull (Penguin Classics) and Vasari's *Lives of the Painters, Sculptors and Architects* (translated by Gaston Du C. De Vere, Everyman's Library). For a comprehensive history of the Medici family in Florence and page-turning Renaissance suspense, read *The House of Medici—Its Rise and Fall* by Christopher Hibbert (Quill). Ancient Etruscan history is examined in *The Etruscan Cities and Rome*, by Howard H. Scullard (Johns Hopkins University Press), tracing the rise and fall of the Etruscan civilization.

Travelers' diaries provide an almost inexhaustible mine of information. Two of the most famous are Michel de Montaigne's journal of his voyage to Italy (in *Complete Works*, edited and translated by Donald M. Frame, 1957) and Goethe's *Italian Journey* (Penguin Classics), written in 1790. In his *Italian Hours* (Penguin Books), Henry James depicted the backdrops that he used in his fictional works. E. M. Forster's *Room with a View* (Penguin Books), made popular by James Ivory's film version, takes place partly in Florence. Mary McCarthy's *The Stones of Florence* (Harcourt Brace), first published in 1959, serves as both a travel guide and an art history book. Good recent books

with an autobiographical slant include *Within Tuscany—Reflections on a Time and Place* by Matthew Spender (Penguin Books), which is informative and entertaining, and Ferenc Maté's *The Hills of Tuscany: A New Life in an Old Land* (G. K. Hall & Co.), which describes how he and his wife uprooted from New York to begin a new life in Tuscany. Frances Mayes's *Under the Tuscan Sun* is also based on personal experience.

Not surprisingly, there are many books relating to art in Tuscany, beginning with Vasari (see above). Other classics include Berenson's *The Italian Painters of the Renaissance* (Oxford University Press), Burckhardt's *The Civilizaion of the Renaissance in Italy* (Penguin Books), and Hartt's *History of Italian Renaissance Art* (Thames and Hudson). John Ruskin's literary and knowledgeable *Mornings in Florence* were prototypical travel guides. *With or Without the Medici: Studies in Tuscan Art and Patronage 1434-1530*, edited by Eckart Marchant and Alison Wright (Ashgate Publishing Co.), is a useful volume of essays.

Visitors to Tuscany have a large selection of up-to-date guide books to choose from, including the Blue Guides, Dorling Kindersley Eyewitness Travel Guides, Michelin Green Guides, Rough Guides, Lonely Planet, Frommer's and Fodor's. The Touring Club of Italy has published a guide to Tuscany, as well as a separate one for Florence,

both available in abridged or unabridged versions. Don't forget to consult travel magazines or newspapers that might have special sections on traveling and staying in Tuscany.

There are also a number of illustrated books on Tuscany. *Italian Parks and Gardens* and *Hidden Tuscany: Unusual Destinations and Secret Places* both feature stunning photographs by Massimo Listri (both Rizzoli). *The Most Beautiful Villages of Tuscany* by James Bentley and Hugh Palmer is also a feast for the eyes (Thames and Hudson), as are two books which could be an inspiration to many interior decorators: *Private Tuscany* (Rizzoli) and *Country Houses of Tuscany* (Taschen). For a wonderful introduction by Edith Wharton, read *Italian Villas and Their Gardens* (Da Capo Press).

Finally, there are a number of good books on food in Tuscany, notably *A Taste of Tuscany* (Abbeville Press) by John Dore Meis and John Ferro Sims, *Tuscany, The Beautiful Cookbook: Authentic Recipes from the Provinces of Tuscany* (Collins Publishers) by Lorenza De'Medici Stucchi, and *Flavors of Tuscany: Traditional Recipes from the Tuscan Countryside* (Broadway Books) by Nancy Harmon Jenkins. As for wine, Hugh Johnson has written the definitive guide on the subject, *Tuscany and its Wines* (Mitchell Beazley), illustrated with lovely photographs by Andy Katz.

INDEX

ACKNOWLEDGMENTS

This book would not have been possible without the unflagging assistance of my wife, Béatrice, and the friendly collaboration of Alain Fleischer and Danielle Petit. I warmly thank all those who have so generously opened the doors to their dwellings or gardens: Marco Bagnoli, near Empoli, Marquis Tommaso Bichi Ruspoli in Cosona, Andrea Boscu Bianchi Bandinelli in the Villa Geggiano, Princess Vittoria Colonna in the Villa Torrigiani at Camigliano, Princess Giorgiana Corsini in the Palazzo Corsini al Prato in Florence, Countess Cesarina d'Elci in the Palazzo d'Elci at Siena, Federico Forquet and Matteo Spinola in Cetona, Lorenzo and Guido Fineschi Sergardi in the Sergardi Palace at Siena, Gérard Fromanger in his home in the Crete Senesi, Marquis Amerigo Gondi in the Palazzo Gondi in Florence, Joseph and Cornelia Kosuth in San Cascianod ei Bagni, Lord Lambton in Cetinale, Anna and Lorenzo Mazzini in the Villa Medici in Fiesole, Lorenza de'Medici in Badia a Coltibuono, Benedetta Origo at La Foce, Marchioness Cristina Pucci at the Palazzo Pucci in Florence and at the Antico Setificio Fiorentino, Livia and Giancarlo Pediconi in Celsa, Baron Bettino Ricasoli in the castle of Brolio and his daughter Teresa Giunta, Prince Giulio Ruspoli in Lilliano, Duke and Duchess Salviati in Migliarino, Countess Anna Lucrezia Sanminiatelli in the Palazzo Corsini in Florence, Pietro and Nathalie Sartogo near Siena, Ivan and Olga Theimer in Monteggiori, Alain Vidal-Naquet near Cortona, the Viti family in the Palazzo Viti at Volterra, as well as all those who prefer to remain anonymous.

Federico Fusi was a marvelous guide to the secrets of Siena, while Mario Lolli Ghetti and Fausto Calderai performed a similar service for Florence, as did Alvar Gonzalez Palacios, who lived in the Tuscan capital during the great times of the Longhis and the Berensons. Viviana Pecci Blunt, Daria Cervini, Enzo Crea, Giorgio Galletti, Caterina Piccolomini and Letizia Signorini assisted us enormously with their advice. Due to renovation work, we were unable to photograph either La Pietra, the former home of Harold Acton, despite authorization from New York University, or I Tatti, Bernard Berenson's villa. However, we were given a most warm welcome by William Kayser at the latter, which now belongs to Harvard University. Dottoréssa Piacentini gave us generous permission to photograph the Stibbert Museum in Florence, as did the prior of the Contrada del Nicchio in Siena for its museum. We were very warmly welcomed at the home of Fabio Pichi in Cibreo, who taught us much about Tuscan cuisine, at the home of Lorenzo Villoresi, who invents scents on the Ponte Vecchio, at the Antico Setificio Fiorentino, at Salvatore Ferragamo's, and at the homes of all the artisans who gave us access to their studios and stores: Palla, the marble workers and the Fonderie del Chiaro in Pietrasanta, the potter Ugo Poggi in Impruneta, Bianchi di Pontassieve, the scagliola makers, the Il Papiro marbled paper workshop, and the Bizzarri store in Florence. Various regional officials supported us greatly in our project: in particular, I would like to thank Dottoréssa Marcucci and Sauro Servadei. Hotels and restaurants were invariably helpful: in particular, Villa San Michele and the Pensione Bencistà in Fiesole, Villa Villoresi in Sesto Fiorentino, Villa Scacciapensieri in Siena, the Monteriggioni Hotel in Monteriggioni, the Cibreo restaurant in Florence, Vipore near Lucca, and Daniela in San Casciao dei Bagni. Finally, I would like to thank Ghislaine Bavoillot for giving us the opportunity of continuing the work started with *Living in Rome*, together with her assistants Hélène Boulanger, Anne Bouvier, Julie Cribier, Maud Hannon and Nathalie Labrousse.

Bruno Racine

This book owes its existence to my wonderful partnership with Béatrice and Bruno Racine, and to the friendly trust of the latter, who researched, planned and arranged my journey in images. In this adventure of seeing, my vision would have been blinkered without the third eye of Danielle Schirman. I also extend my sincere thanks to all those who received us so warmly. And finally, I would like to thank Ghislaine Bavoillot for having placed her trust yet again in this tandem on its second wonderful Italian voyage.

Alain Fleischer

Series editor: Ghislaine Bavoillot
Design: Karen Bowen
Typesetting: Studio X-Act, Paris
Translated from the French by Louise Guiney
Visitor's Guide adapted and translated by Luisa Weiss
Copy-editing: Bernard Wooding
Color separation: Sele Offset

Originally published as *L'Art de Vivre en Toscane*
© 2000 Flammarion
English-language edition
© 2001 Flammarion Inc.

ISBN 2-08010-553-1
FA0553-III-01
Dépôt légal: 05/2001

Printed and bound by G. Canale, Italy.